ART NOUVEAU
1870-1914

ART NOUVEAU
1870-1914

by

JEAN-PAUL BOUILLON

SKIRA

Rizzoli
NEW YORK

© 1985 by Editions d'Art Albert Skira S.A., Geneva

Reproduction rights reserved by A.D.A.G.P. and
S.P.A.D.E.M., Paris, and Cosmopress, Geneva

Published in the United States of America in 1985 by
RIZZOLI INTERNATIONAL PUBLICATIONS, INC.
597 Fifth Avenue/New York 10017

Printed in Switzerland

Library of Congress Cataloging-in-Publication Data

Bouillon, Jean Paul.
 Art Nouveau, 1870-1914.

 Bibliography: p.
 Includes index.
 1. Art nouveau–Europe. 2. Aesthetic movement
(British art). 3. Art, Modern–19th century–Europe.
4. Art, Modern–20th century–Europe. I. Title.
N6757.B65 1985 709'.03'49 85-42919
ISBN 0-8478-0627-8

CONTENTS

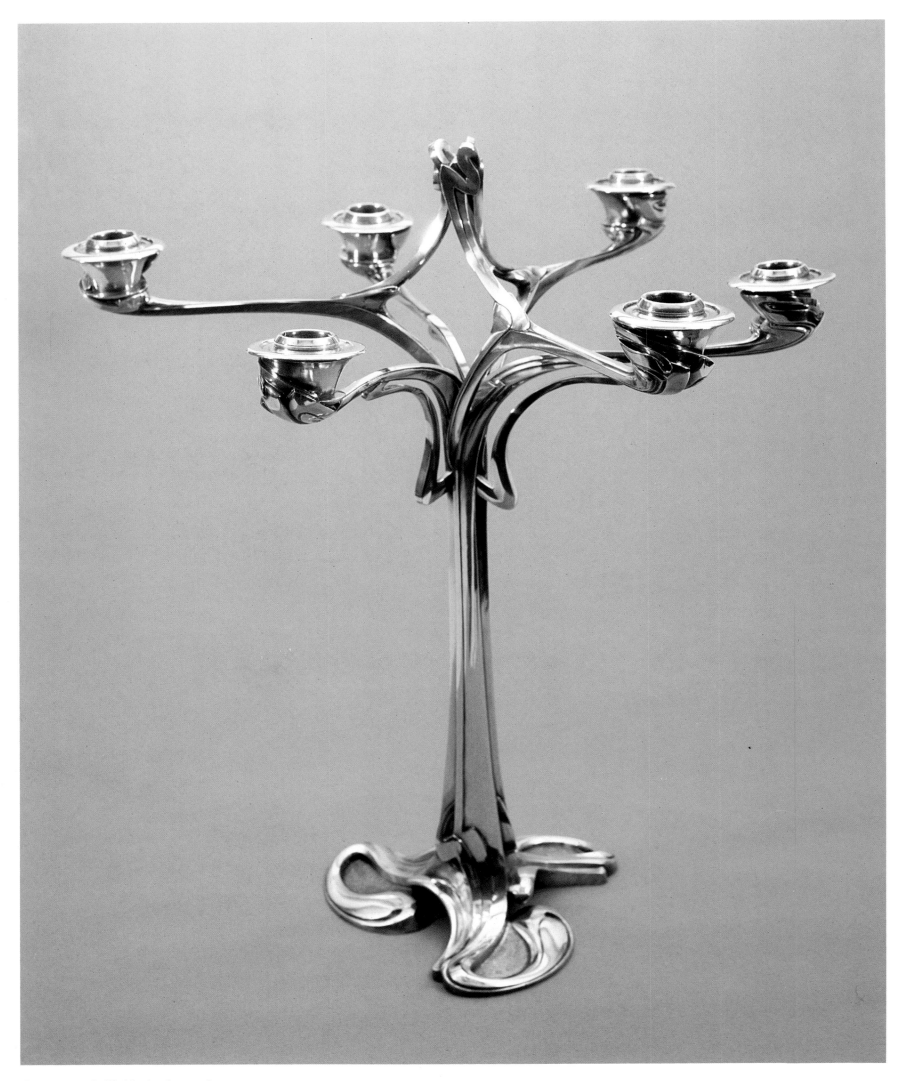

Henry van de Velde (1863-1957):
Six-branched candlestick, 1898-1899.
Silver-plated bronze.

INTRODUCTION

Candlestick, Dancer and Death

Shortly before 1900, a silver-plated bronze candlestick with six branches: a functional, utilitarian object, as indicated by its stable base, its easily grasped stem, its candle-holders rationally set out in a circle. But its function attracts attention less promptly than the original form it has adopted, even though the skilful workmanship and material refer back to the great tradition of eighteenth century French goldsmiths' work, that of François-Thomas Germain for example.

The form of that candlestick, however, is not the result of a decoration applied to a structure: the "ornament" is the structure itself. The three curving stems of the base, rising in a vigorous upsurge, go to constitute the body of the object, until they again jut out and coil around the candle-holders. And yet these stems have no root. There is no precise reminder of plant forms. At the base, the line turns upon itself and rises slightly, to mark its independence; at the top, the branches come together in the centre, with the same characteristic rebound, ruling out any analogy with plants. The ornament is the structure, and the structure is organic, but the whole as determined by its function is yet autonomous and abstract.

What in the end justifies the forcible growth of the line, and its twists and turns, is the engendering of its own space. The turnings of the foot, the upspringing of the stem, the outspread of the branches in a gentle curve, and the final upturn of the cupped holders—all this conveys a strong sense of the three dimensions, but not those of a geometric space in which the object is "placed"; the dimensions rather of a living space, quickened by the impetuous expansion of an inner force driving form into existence.

This unpretentious candlestick is in fact a masterpiece concentrating in itself the very essence of Art Nouveau and its utmost ambitions. Yet it is the work of a painter who in his early days aspired to follow in the wake of Van Gogh and the Neo-Impressionists. But Henry van de Velde, destined to become the central figure of Art Nouveau, its inspirer and indeed its conscience, soon felt the urgency of another task: to lead society back into the right path, through the novelty and truth of those forms amid which people live and which they make lifelong use of—forms of today, not outmoded forms borrowed from the past. Though technically the candlestick was a relic of that very past (and thus one of the contradictions of the venture), it was meant to symbolize the coming of a new age of enlightenment.

Koloman Moser (1868-1918):
The American Dancer Loie Fuller, c. 1900.
Watercolour and ink.

The candlestick was made for the Weimar house of Count Kessler, one of the most cultured and cosmopolitan Europeans of that day, as much at home in Paris and London as in his native Germany. The Count's furniture was designed by Van de Velde and the house was decorated with paintings by Maurice Denis. The Art Nouveau object did not simply stand in a physical space: it called for a social space. Having left Belgium, Van de Velde worked first in Berlin, then settled in Weimar in 1901. In Germany he saw a better chance of carrying out his ideas about design in their universal application to architecture and the applied arts—design, in his view, as a means of improving, of reforming, the whole social fabric of modern life.

At about the same time a Viennese artist, Kolo Moser, made an astonishing drawing of Loie Fuller, the American dancer who since the 1890s had taken Paris and all Europe by storm with the fluttering veils and coloured lighting that made her numbers so distinctive. Colours are applied throughout in uniform flat areas, and the dancer's head is the only figural element which permits the theme to be identified or recognized. In Moser's handling of it the ritual of the stage has given way to the ritual of the drawing sheet,

a plane surface which for the artist is an invitation and pretext for a purely decorative pattern. In this Kolo Moser follows the example of Toulouse-Lautrec, for whom this dancing girl had also been a stimulating pretext for one of his boldest works (a lithograph of 1892). Here Moser stands opposed to the profusion of "1900 Style" imagery which, in trinkets, illustrations and posters, simply embroiders its arabesques around a body, not around a form.

Loie Fuller scored her greatest triumph at the Paris World's Fair of 1900, where her theatre was one of the main attractions; and that theatre was itself a curious piece of architecture designed in the image of the dancer. Not far away from it, on the fair grounds, was the Italian pavilion. There the place of honour was given to the man who was considered modern Italy's greatest painter, Giovanni Segantini, who had died in 1899 at the age of forty-one. His last great painting, the triptych called *Life, Nature and Death*, had been intended for exhibition at the Paris World's Fair, and the choice of this subject to represent him there, on the threshold of the new century, was significant.

When he painted it Segantini was at the height of his powers. For some years already his work had been an integral part of Art

Nouveau, as he had moved away from his early symbolism and come to grips with the problems of form. Here, in the panel entitled *Death*, he conveys the harmony between nature and human activity by purely pictorial means, by the reanswering lines of roof, path, fence and mountain ridges, and by the enigmatic cloud which sums up and concentrates them all in its gathering swirl.

To this bereavement of nature answers a human bereavement: "The terrific whiteness of this snow makes one understand why for Orientals white is the colour of bereavement," wrote Arsène Alexandre after seeing the picture. Does it announce the coming of morning or of night, the hope of a rebirth or the resignation of an ending life? It is hard to say, and this uncertainty was the uncertainty of Art Nouveau itself at that time when, threatened by its fashionable success, it seemed to hesitate at the turn of the century, uncertain whether to mark the end of an era or to announce the advent of the new society to which it aspired.

Segantini's painting is there to remind us, too, that as at every decisive moment in the history of forms, Art Nouveau was a matter of major art, because it was first and foremost a matter of space. It is a mistake, and still a persistent one, to suppose that Art Nouveau was concerned solely with the arts of decoration. These latter were often in the foreground, naturally enough, in a venture whose aim was the complete remodelling of society. But they cannot be allowed to obscure the fact that the finest achievements of Art Nouveau, the most complete and lasting, were the work of architects and painters.

Candlestick, dancer, and death: three artists utterly unlike, from three different countries, show here, around 1900, their community of purpose, their common approach to design. This means that the broad movement of aesthetics and ideas which we call Art Nouveau cannot be grasped by dealing with its different aspects separately: the different art forms which it handled, the different countries where it arose, the different personalities who led the way. Each of these aspects has to be considered and given its due weight as part of a sequence. But the movement must be seen as a whole, as an overall aesthetic and social venture, in the full extent of its historical development, over and above fashions, anecdotes and present-day rehabilitations. As such, it has a place of its own in the history of art, in which it stands out as one of the finest moments.

Giovanni Segantini (1858-1899):
Death, 1896-1899. Oil.
Panel from his triptych *Life, Nature and Death*.

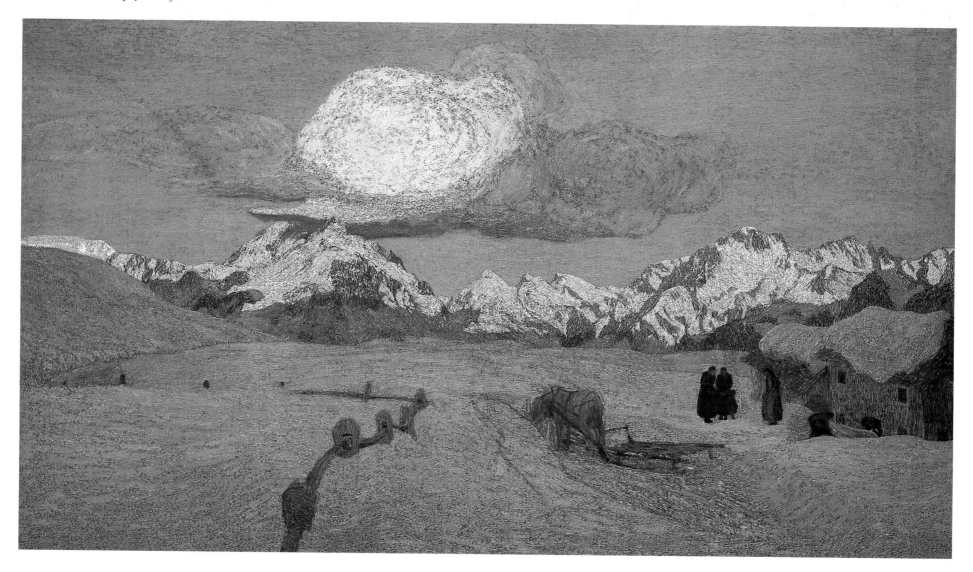

Towards a New Era

To speak of reconstructing a world after 1870 would be going too far. The upheaval of the Franco-Prussian War and the Paris Commune made itself felt in Europe for many years to come, but it did not lead to anything like the same obsession with a "clean sweep" which caused the rise of new and revolutionary art forms in Europe around 1789 and again after 1914. In the 1870s there was no sense, or not yet a sense, of any urgent salutary need for a "great utopia," to use one of the terms familiar in the avant-garde circles of 1910-1920. Things moved more slowly, through underground channels. It is true, however, that the art world could no longer maintain quite the same relation with the social and political world, or more generally with the realities of the external world. Even if forms had already begun to change, it was the 1870s which really marked the end of the "realism of 1848": Courbet's trial and sentence in 1871, for his part in the destruction of the Vendôme Column, symbolized the end of the art he stood for.

The shift, or aesthetic reaction, that then occurred indicates this break: if the world was to be reconstructed or transformed, it would be by forms, by the organization of forms, not by images. This was felt most sensibly and urgently in France, where the breakdown of ideologies cleared the way for the rationalist approach to objects and forms, an approach made easier and timely by the progressive triumph of the positivist philosophy. But the shift or reaction was felt no less in England, where an aesthetic and moral reform of society had been under way since the middle of the century: the Aesthetic Movement. The latter, the precursor of an Art Nouveau which at that time and place could not really develop, had ambiguous connections with its predecessors, William Morris and his friends, and their disciples in the Arts and Crafts movement—ambiguous, because the aesthetic reaction was combined with the ambition to reform the surroundings of life, if not society as a whole.

France and England were not the only two countries concerned, but they were the two where the problems of the new industrial society were felt most acutely, and they accordingly moved in parallel along the two paths leading to the art of the future: on the one hand, the specific creation of objects and forms; on the other, reflection on the problems of style and the function of the artist-craftsman.

As for the younger generation of French painters, all of them intent on the problems of "pure" painting, they too were prompt to react against the last embodiment of realism: Impressionism and its obstinate pursuit of visual truth. The crisis and mutations of painting, sometimes thought of as secondary manifestations, played a no less important part in the rise of Art Nouveau, for the apparently unforeseen outburst of the early 1890s came in fact at the end of a long prelude rich in both promise and achievement.

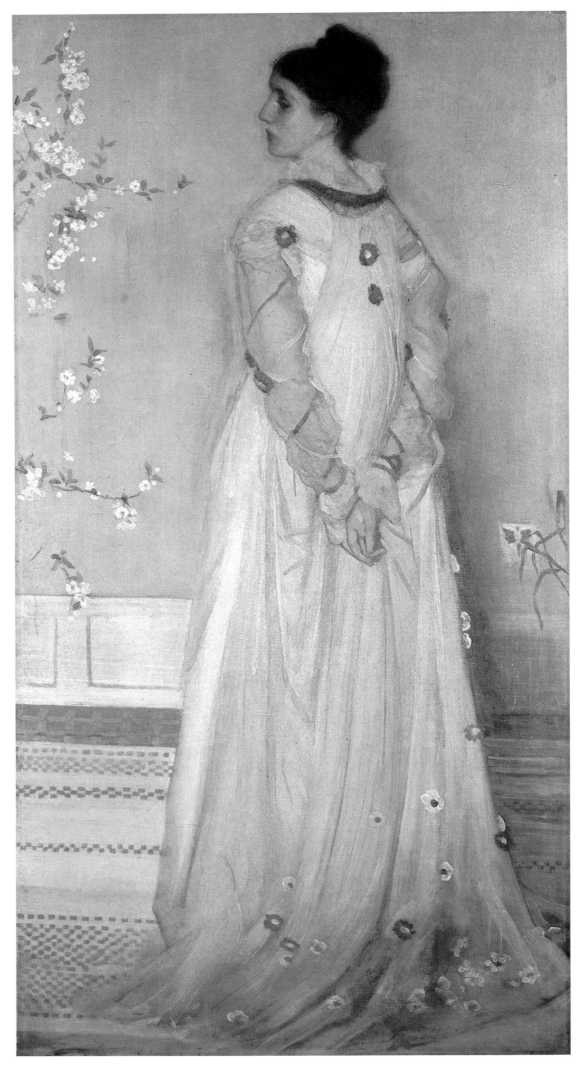

James McNeill Whistler (1834-1903):
Symphony in Flesh Colour and Pink:
Portrait of Mrs Frederick R. Leyland, 1873. Oil.

The Aesthetic Movement in England

HE origins of Art Nouveau may be traced back, in part at least, to the house which William Morris built for himself in 1859 with the help of the architect Philip Webb. In sharp reaction against historicist pastiches, Red House flaunted its asymmetry and free plan like a provocation; exposed to view the rawness and plainness of its materials (tiles and red bricks), and affirmed the need for a conceptual unity of architecture and interior decoration. The house which Van de Velde in turn built for his family in 1895, for the same reasons and in the same spirit, was its direct echo. In 1861 Morris drew upon his personal experience in founding his famous firm of "Fine Art Workmen in Painting, Carving, Furniture and the Metals," thereby marking "the beginning of a new era in Western Art" (Nikolaus Pevsner): the artist (and in particular the painter) emerged from his studio and his ivory tower to take charge of the whole setting of life.

When, in 1876, Whistler undertook to remodel the dining room of his friend and patron Frederick R. Leyland at 49 Prince's Gate in London, he apparently adopted the same outlook. But the room that would become famous under the name of the Peacock Room nevertheless signalled a new direction. The combination of figured and abstract patterns (based on the peacock's feathers), their broadly asymmetrical arrangement, their handling in flat areas of colour, the canny counterpoint of empty and filled spaces, and above all that "harmony in blue and gold" by which Whistler himself designated his work, no longer had scarcely anything to do with that art "made by the people and for the people" dreamt of by William Morris and his friends.

With Whistler, the concern to aestheticize came far ahead of the moral aims of Ruskin's disciples. And the end product of this refined conception confirmed indeed that new "will to art": the curious network of shelves with which the architect Thomas Jeckyll covered the walls of the Peacock Room was destined to put on display its wealthy proprietor's collection of ceramics and to exhibit, above the chimney-piece, the earlier painting by Whistler which Leyland already owned: *La Princesse du pays de la porcelaine* (1864).

Whistler's development itself up to that date exemplifies the genesis of the new aesthetic. Arriving in Paris from the United States in 1855, and initially the disciple of Courbet, Whistler broke with realism during the 1860s through his contact with Manet on one hand and the Pre-Raphaelites on the other. The gradual "formalization" of his painting (marked notably by the appearance of the musical titles: the "Symphonies") led him after 1870 to conquer his complete artistic independence, which he supremely asserted in 1873 with the portrait of Mrs F.R. Leyland, one of the

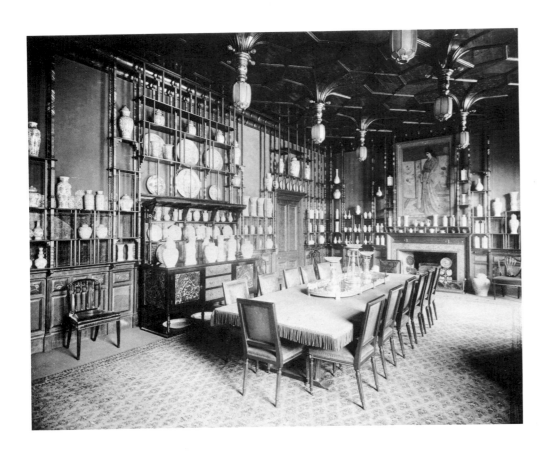

James McNeill Whistler (1834-1903):
Harmony in Blue and Gold: The Peacock Room, 1876-1877.
Photograph of 1892 showing its original state
in Leyland's house, 49 Prince's Gate, London.

The Peacock Room as reconstructed and on view
today in the Freer Gallery of Art, Washington.

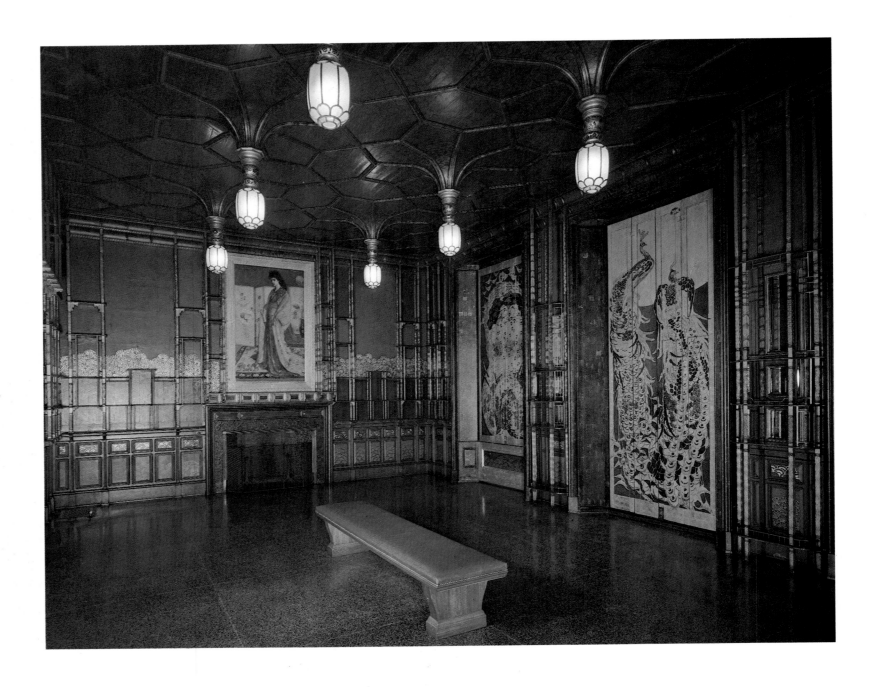

most thoroughly worked-out of the period. The intimacy of the pose and costume; the aristocratic detachment of the model; the sophistication of the Japanese-style composition; the rejection of every expressive or symbolic element external to the formal organization; the integration of the figure into the setting, the merging of the swirls of the housedress with the mosaic of the floor, which itself flows without a break into the flat tint of the wall, a method which Klimt would remember at the turn of the century; lastly, the delicate harmony of colours emphasized by the chosen title *(Symphony in Flesh Colour and Pink)*—all provided so many leading elements for the Aesthetic Movement, whose ramifications extended to Brussels, Glasgow and Vienna.

With this flower-like woman, this symphony of line and colour, and on the other hand the peacock, a living form but with the original function of adorning and organizing the surface, there appeared, what is more, two of the emblematic motifs of Art Nouveau. The second is to be found soon afterwards in a stained-glass window by a compatriot of Whistler's still too little known outside his native country: John La Farge, whose artistic route is in many ways comparable. The choice of the stained-glass window (the technique of which La Farge had taken up in 1877) and the accent placed by the drawing and colour on the inherent qualities of the material (thereby anticipating the coloured glasses of Tiffany), the resolute asymmetry of the main motif, its virtual dissolution in the colour field, are a direct response from the other side of

the ocean to the great panels of the Peacock Room: aestheticism was first of all a period movement.

In this taking possession, through form alone, of the space of everyday life, the notion of a harmonious whole plays an essential role with Whistler. It is found in his way of decorating the frames of his paintings (unlike the Pre-Raphaelites) with abstract patterns —an example soon to be followed by Seurat—as well as in the conception of his London house (the White House, built with the architect Edward William Godwin in 1878) and his other decorative ensembles (one of them exhibited, also in collaboration with Godwin, at the Paris World's Fair of 1878): "The Painter must also make of the wall upon which his work hung, the room containing it, the whole house, a Harmony, a Symphony, an Arrangement as perfect as the picture or print which became a part of it." Just as he kept his distance from the movement which he himself started with his famous *Ten O'Clock Lecture* of 1885 (translated into French in 1888 by Mallarmé), Whistler later denied that he had any connection whatsoever with Art Nouveau ("There is—there can be—no Art Nouveau; there is only Art!"). His work during the 1870s nonetheless directly ushers in the formalism and all-embracing ambition of Art Nouveau, in a complete break with French realism as with the moralism of Ruskin and the social and philosophical preoccupations of Morris and the Pre-Raphaelites. And Whistler's famous lawsuit brought against Ruskin in 1878 has, apart from the anecdotal, no other significance.

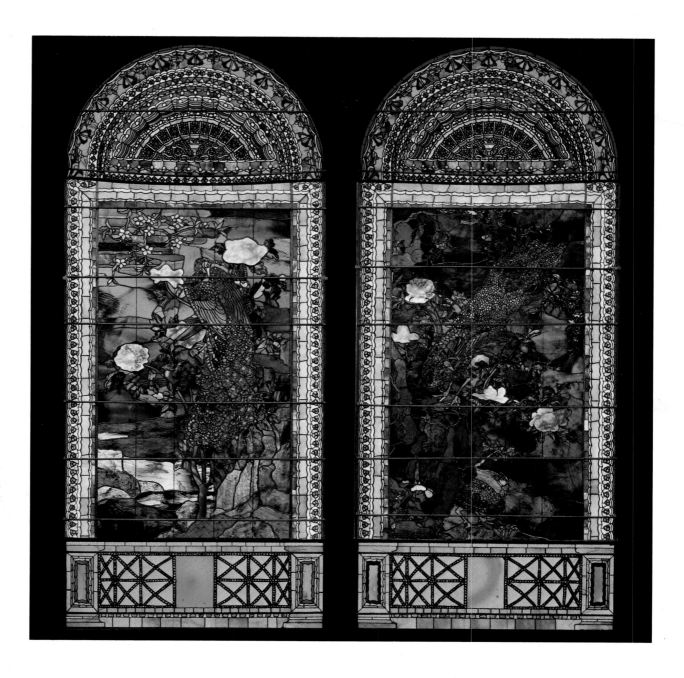

John La Farge (1836-1910):
Peacocks and Peonies, c. 1885.
Stained-glass windows from the
Frederick L. Ames residence, Boston.

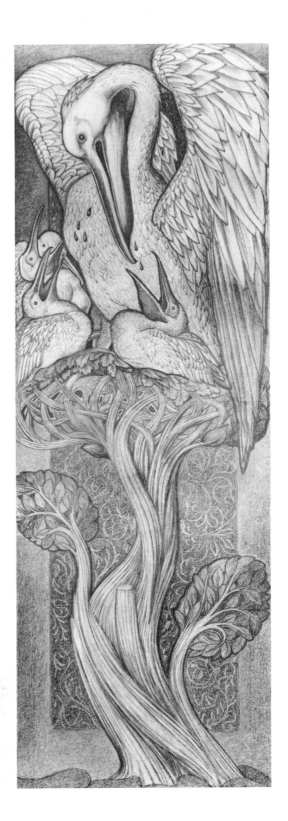

In a parallel development, the Pre-Raphaelite movement itself underwent a noteworthy change in direction. In the last decade of his life (he died in 1882), its chief founder, Dante Gabriel Rossetti, now living aloof in Chelsea, intensified the morbidness and mysticism of his previous painting, at the very time when William Morris was, on the contrary, embarking on his ardent militancy. Rossetti's *Proserpine*, painted beween 1873 and 1877 (and part of a series of eight), shows the final phase of this painting. It remains essentially literary, as indicated by the very subject, the Italian sonnet inscribed on the canvas and its complicated iconographic mounting; and at this date that is enough to distinguish it from the painting of Whistler. Yet, in the 1860s, the two painters had a shared passion for the Blue and White wares of Chinese pottery and for Japanese prints. In the dark corridor of Pluto's realm in which she is held prisoner—in the narrow and depthless space of the painting—the folds of Proserpine's garment are organized in a great arabesque flowing from the line of the neck and the movement of the arm, like an evil vapour of incense or opium issuing from the perfume-warmer. If the poisonous sensuality of the painting opens the way to the heaviest symbolism, the solidity of its plastic organization and the large overturned S supported by the edges of the picture also lead to a new mode of decorative and ornamental composition. Was it by chance that Rossetti's painting was initially intended for Leyland, and that the model was Jane Burden, Morris's wife since 1860, but still more, the painter's sole idol?

In the same way, Burne-Jones, Morris's closest friend and, like him, a theologian by training and moralist at heart, Whistler's adversary in the court case of 1878, began to have doubts, and the temptation to aesthetic reconversion crossed Burne-Jones's mind before his death in 1898: "Rossetti could not set it right and Morris could not set it right—and who the devil am I?... I have learned to honour beauty when I see it, and that's the best thing." The small stylized tree on which his *Pelican* of 1881 is perched still refers back, it is true, to the predecessors of Raphael, but the flexible line of the trunks makes a single outline with the tucking-under of the necks, just as the interlacings of the branches and the sheaf of leaves repeat the wavy line of the feathers.

Yet the essential part of this English prelude to Art Nouveau, beyond the clash of two types of painting, the Pre-Raphaelites' and Whistler's, took place on still another ground: that of the decorative arts.

Enamoured of the past, literary, hostile to industrial techniques, holding up the virtues of the craftsman's work against the alleged inspiration of the artist ("That tale of inspiration is sheer nonsense; there is no such thing: it is a mere matter of craftsmanship"), the theories of Morris nevertheless influenced the Art Nouveau artists by the rejection of styles and the rehabilitation of the applied arts, and more generally by their synthetic manner posing the problem of the artist's role in society. Even the violent moral reaction whose trace may be found in someone like Van de Velde, in the early 1890s, inspired the condemnation of historicist pastiche. In practice, too, the principles and tastes of Morris led him to decoration which respected materials and surfaces (he himself, it has rightly been pointed out, practised only two-dimensional drawing). True, nothing in this work indicated the period in which it was done, but it only needed to get rid of its ideology and slightly rearrange its stylistic elements—which Whistler's influence would bring about—to make contact once more with the century and open the way of the art of the future.

◁ **Sir Edward Burne-Jones** (1833-1898): The Pelican, 1881. Pastel cartoon for stained-glass window in St Martin's Church, Brampton, Cumberland.

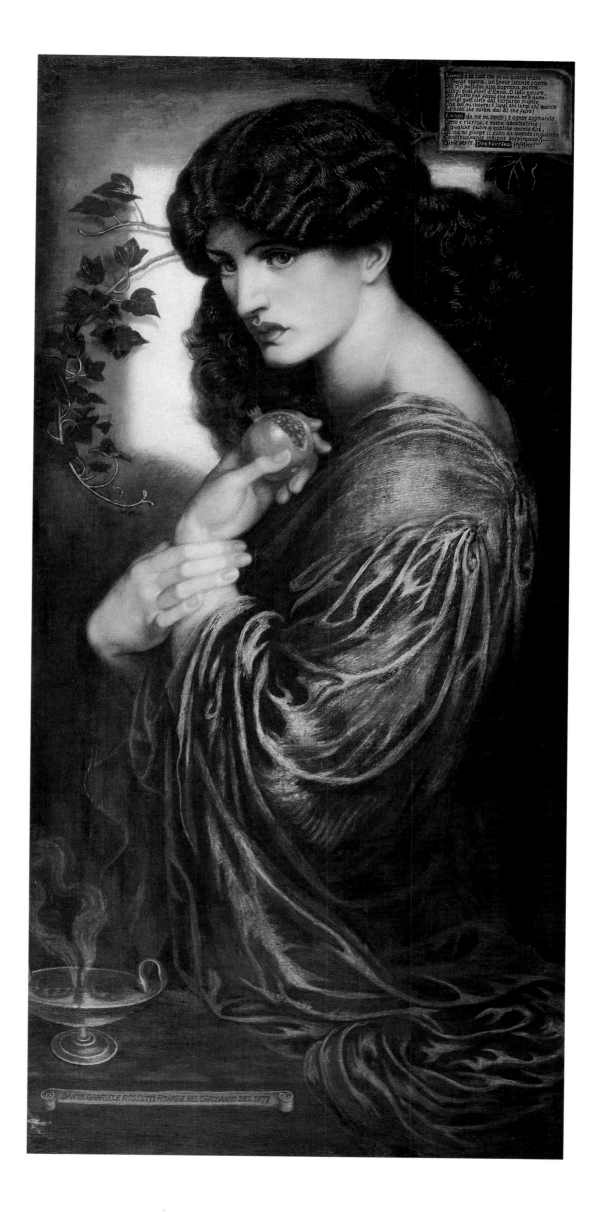

Dante Gabriel Rossetti (1828-1882): Proserpine, 1873-1877. Oil.

Arthur H. Mackmurdo (1851-1942):
The Cromer Bird, c. 1884.
Printed cotton.

*Render all branches of art the sphere no longer of the
tradesman but of the artist. It would restore building,
decoration, glass painting, pottery, wood-carving and
metal-work to their rightful place beside painting and
sculpture.*

A.H. Mackmurdo, 1882.

That, in fact, is what began to happen with the vast Arts and
Crafts Movement, launched by Morris's disciples during the
1880s. The founding of several guilds (that very word was a tribute
to their master's admiration for the Middle Ages) marked its stages
in the space of a few years: the Century Guild of Arthur H. Mack-
murdo in 1882, the Art Workers' Guild of Walter Crane and Lewis
F. Day and (together with Mackmurdo) their Home Arts and
Industries Association in 1884, Charles R. Ashbee's Guild and
School of Handicrafts, and the Arts and Crafts Exhibition Society,
formed in 1888 to promote these works to the public.

The distrust of industrial production remained, but we need
only compare one of the famous printed cottons of Mackmurdo at
the start of the 1880s (*The Cromer Bird*) with one of the most
charming and modern wallpapers designed by Morris shortly be-
fore (*Pimpernel*) to observe that the talented craftsmen of the guilds
did not remain unaffected by the Aesthetic Movement. The tight
foliated scrolls of Morris's *Pimpernel*, its systematic "stuffing" of
the surface, its faithfulness to symmetry (further reinforced during
the 1880s), keep close both to exact naturalistic observation and
to the spirit of medieval tapestry, in spite of the increased numbers
of curves, the stress on flat tints and a flexibility, an organic vitality

foreign to the ornamentalists of the mid-nineteenth century. Mackmurdo's cotton, on the contrary, displays a deliberate asymmetry and resolutely lightens the surface by the superposing of two series of differently coloured motifs, more stylized and less closely spaced, through which there runs only a long arabesque.

In the same way, the title page designed by Mackmurdo in 1883 for his book *Wren's City Churches*, one of the "incunabula" of Art Nouveau, fits well in principle with the undertaking of Morris, and in particular with his Society for the Protection of Ancient Buildings, founded in 1877 ("Anti-Scrape," as Morris called it), which aimed precisely at safeguarding the churches built by the celebrated seventeenth-century architect. But even if some relationship between these "flames" is accepted, the image of the phoenix reborn out of the ashes and the reconstruction of London churches after the great fire of 1666, this astonishing drawing by Mackmurdo has scarcely any direct connection with the contents of his book. Between the two elongated cocks framing the design, the swirl of stylized tulips forming the main part noticeably re-echo the large S of Rossetti's *Proserpine* or of the tree of Burne-Jones's *Pelican*, and on top of that the broad abstract areas of flat colour in Whistler's peacocks. Despite the distant echo of Blake, the reference to the past, this time, has almost totally vanished.

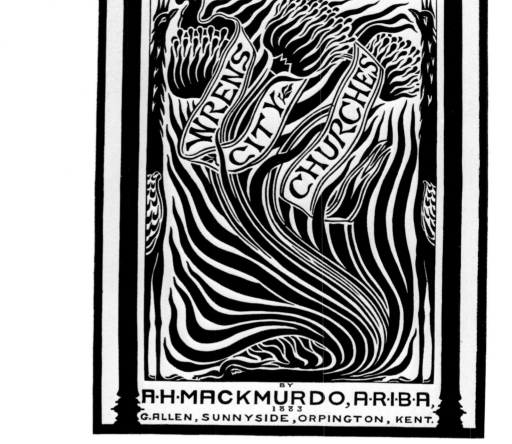

Arthur H. Mackmurdo (1851-1942):
Title page for *Wren's City Churches*, 1883.

William Morris (1834-1896):
The Pimpernel Wallpaper, 1876.

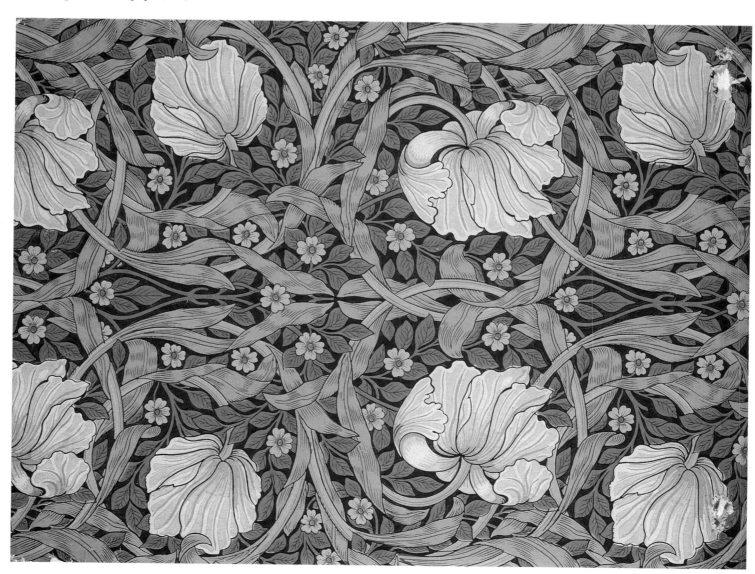

The fact that this daring composition could be used equally well for the back of a contemporary chair (of a very traditional construction, moreover) and for the title page of Mackmurdo's book is also highly significant of a new feeling for "decorative continuity" characteristic of the Aesthetic Movement, beyond taking into account the function of objects. And Mackmurdo's

The sphere of Art is in the region of the imagination, and the office of the imagination is to render us sensitive to the experience of some of the most exquisite pleasures of which our nature is capable.

Selwyn Image, 1884.

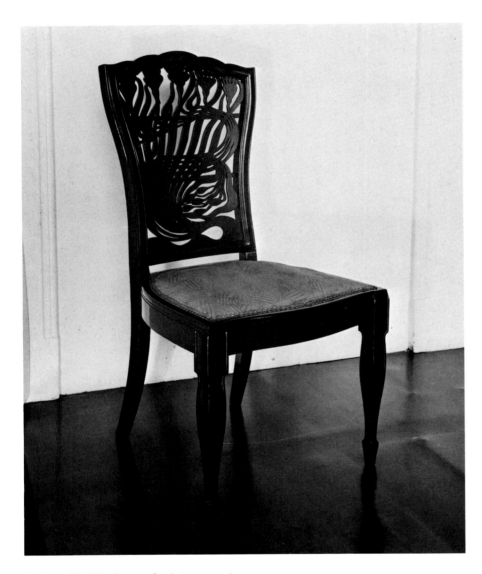

Arthur H. Mackmurdo (1851-1942):
Dining chair with fret back, c. 1882.

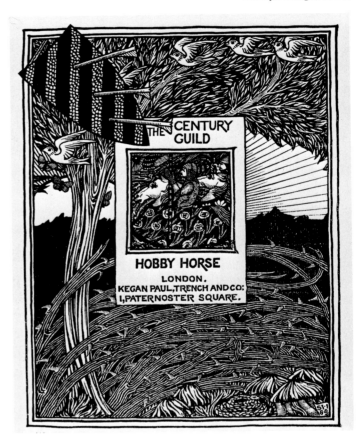

Selwyn Image (1849-1930):
Title page for the Century Guild's *Hobby Horse*, 1884.

Heywood Sumner (1853-1940):
Binding for *Undine* by Friedrich
de la Motte-Fouqué, London, 1888.

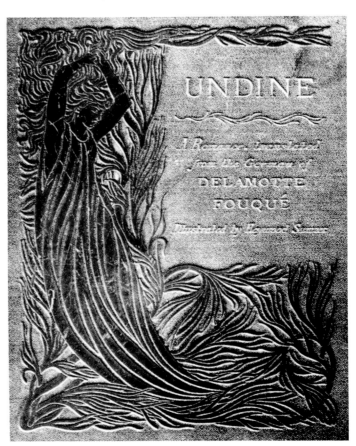

chair seems difficult to conceive of in the work of Morris and Co., whose productions in this domain on the contrary display a strict puritanism.

The Century Guild journal *The Hobby Horse*, appearing regularly from 1886 onwards, but with a title page designed in 1884 in a kindred spirit by one of its founders, Selwyn Image (himself soon to be influenced by Whistler's *Ten O'Clock Lecture*), was to give these new ideas and forms wide dissemination. In that sense it also anticipated the decisive role of the art press in the development of Art Nouveau. In the same way, the binding by Heywood Sumner for the English translation of *Undine* incorporated into the boards of the book the "image" of its heroine, which once would have given rise to a picturesque and sentimental composition: here the body loses its thickness and almost totally disappears, while the hypertrophy of the dress, the hair and the seaweed ensures the continuity and homogeneity of the decoration.

In the publishing sphere, this time preceding the research of Morris (whose Kelmscott Press was founded only in 1891), Mackmurdo and his friends opened a major field to Art Nouveau, that of the book and the graphic arts, as did another important publica-

hen lilies, turned to Tigers,
blaze
Amid the garden's
tangled maze.

Walter Crane (1845-1915):
Illustration for *Flora's Feast, A Masque of Flowers*, London, 1889.
Lithograph from line drawing washed with watercolour.

Alfred Gilbert (1854-1934):
Centrepiece for a table, 1887.
Silver and mother-of-pearl.

the floral and linear style of Walter Crane. In 1889 *Flora's Feast*, one of Crane's many illustrated children's books, may even appear in that respect to verge on pastiche. But it relaunched the important idea of the necessary union of text and picture, and by borrowing from Blake his well-aired page layout, whose single arabesque line based on a plant motif ensures its coherence, it broke with the overloading and compactness of Morris's designs. As Crane was to write the following year in the catalogue of the Arts and Crafts Exhibition Society, of which he was then president:"Plain materials and surfaces are infinitely preferable to inorganic or inappropriate ornament." The book was shown at the exhibition of Les Vingt in Brussels in 1891, and the lesson was not lost on the pioneers of Art Nouveau on the Continent.

In spite of all that separated Morris from his disciples, the Arts and Crafts Movement nevertheless kept the marks of its literary origins and the moralism of Ruskin: it was once more in its name that Voysey too would impugn Art Nouveau as being "unhealthy." And formal experiment was to go hardly further than the work of the 1880s already mentioned: the elaboration of a new style for the coming century was in fact foreign to it. More profoundly, as Nikolaus Pevsner has well emphasized, the Arts and Crafts reform movement, in an England where the body politic would be for so many years still partitioned and hierarchic, could only, despite appearances, hold interest for a tiny, privileged class. Art Nouveau was to blossom in more democratic nations or in those without the same prejudices. In England the weight of styles, as of institutions, remained considerable. In spite of Whistler, it fell to neo-Gothic, neo-Celtic and neo-Baroque to usurp the place that Art Nouveau should have occupied. The artist who perhaps came closest to it, the sculptor Alfred Gilbert, also condemned it with the greatest energy: "Art Nouveau, in reality absolute nonsense!" And it is only necessary to see the fabulous centre-piece he designed in 1887 for Queen Victoria's Jubilee to understand, through that monstrous avatar of Benvenuto Cellini's salt-cellar, how England was able to usher in and stay close to the forms of Art Nouveau without ever really accepting and assimilating its principles.

tion of the Aesthetic Movement, *The Dial*, launched in 1889 by Charles Ricketts and Charles Shannon.

With them, as with Charles F.A. Voysey, Charles R. Ashbee or Walter Crane, the "medievalism" promoted by Morris, and his extreme attention to fine workmanship were weakened in favour of artistic design and an aesthetic conception of the whole. As Nikolaus Pevsner has pointed out, the architect Voysey was in fact a designer first, and not a craftsman. At the close of the century, his architectural projects and sparely ornamented interiors would stand in closer relation to Whistler's White House of 1878 and its asymmetrical façade, its rooms with light-coloured walls decorated with only a few framed works, than to the art work of Morris and Co. and the Pre-Raphaelites.

And other references too replaced Ruskin's Gothic, such as the Japanese craze introduced into England by Whistler, or the growing fascination with the art of William Blake, already admired by Rossetti and Burne-Jones, but whose influence became conspicuously evident on the designers of the Arts and Crafts Movement (through *The Hobby Horse*, for example) and in particular on

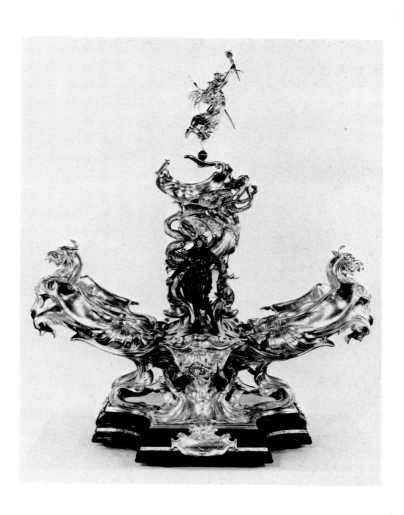

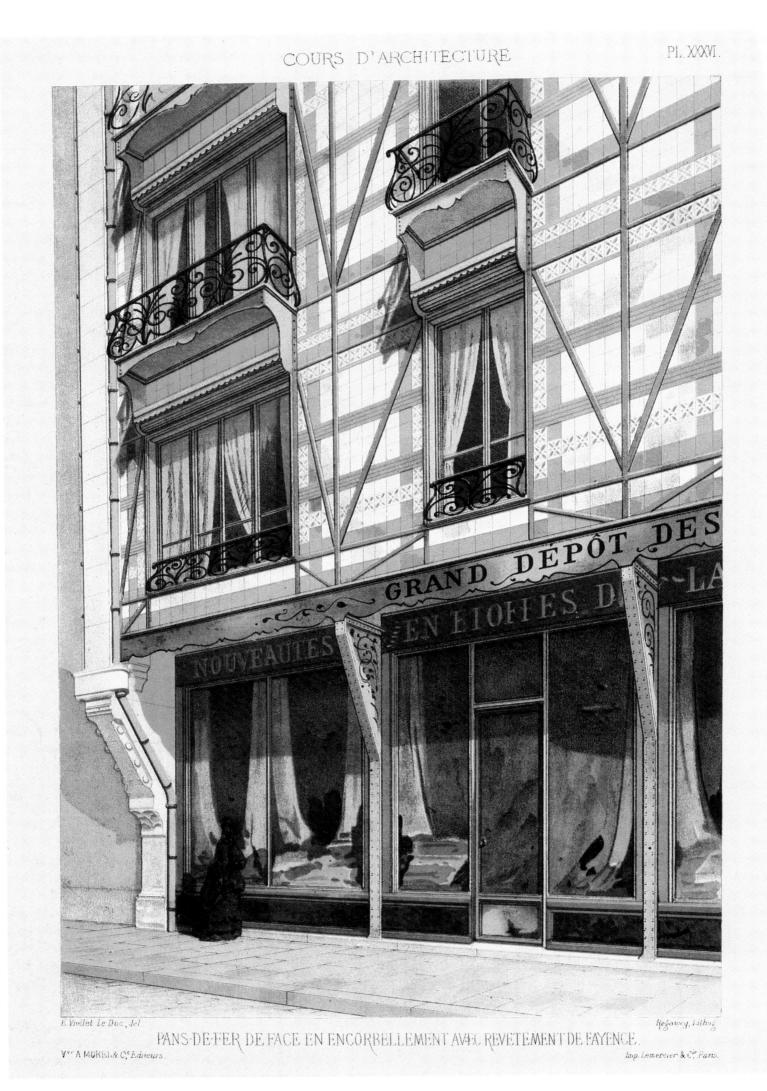

GRAND DÉPÔT DES

NOUVEAUTÉS EN ÉTOFFES DE LA

E. Viollet Le Duc, del.

Régamey, Lith.

PANS-DE-FER DE FACE EN ENCORBELLEMENT AVEC REVÊTEMENT DE FAYENCE.

Vᵉ A. MOREL & Cⁱᵉ, Éditeurs.

Imp. Lemercier & Cⁱᵉ, Paris.

Eugène Viollet-le-Duc (1814-1879):
Commercial and apartment building, with iron framing and tile facing.
Entretiens sur l'Architecture, Vol. II, Plate XXXVI, Paris, 1872.

The Rationalist Movement in France

AS OPPOSED to the aesthetic and literary debate of the English movement, we find in France the progress at once logical and empirical of the work of the ateliers, to which art writings lent the support of a rationale. For here, too, theoretical reflection was not lacking; but it depended less on ideology than on a consideration of concrete questions raised by materials, techniques, tools and, finally, the practical organization of forms.

To place the whole of the French movement under the sign of rationalism may seem excessive and paradoxical when dealing with the origin of an art in which fantasy and invention appear to play a determining role. But that is just the point: if Art Nouveau in its essence derives neither from fashion nor from kitsch, it rests on foundations more solid than the simple whims of imagination, because it actually proceeds according to a dual logic: that of materials and that of ornament.

In this respect, Viollet-le-Duc once more has the role of a founding father. Like Ruskin, he was sustained by an unqualified admiration for Gothic art, but his thought took the opposite direction. With him the issue was no longer moral, but rather one of efficiency, and he called for less of decoration than of structure, less of aesthetics than of building schedules and techniques of construction. This fundamental divergence is pretty well summed up in the matter of the utilization of iron—chiefly responsible in the course of the nineteenth century for the renewal of the art of building. For Ruskin it signified the end of Architecture, inasmuch as the eternal principles of Art came before the extension of its utilization. For Viollet-le-Duc, on the contrary, it was a major element of what might be called the "new Gothic" (as opposed to neo-Gothic imitations), because it enabled Gothic principles to be preserved while inventing, in the same spirit, structures better adapted to the demands of the modern world.

The second volume of Viollet-le-Duc's *Entretiens sur l'architecture*, which appeared in 1872 (the first was published in 1863), is of fundamental importance in this respect. Starting from the question of iron, it develops the major idea that form is logically derived from function and techniques, and not from *a priori* aesthetic principles, as in the teaching of the schools: "Let us be quite persuaded, once more, that architecture can take on new forms only if it seeks them in a rigorous application of a new structure" (XII, 67). A revolution of capital importance for the genesis of Art Nouveau, since it allows the advent of a style genuinely new insofar as it would proceed from a style radically opposed to that leading to the historicist pastiche. "There must be truth according to the building schedule, truth according to building procedures... What are taken to be pure questions of art, that is, symmetry and

Eugène Viollet-le-Duc (1814-1879):
Plates with ironwork details from his *Entretiens sur l'Architecture*,
Vol. II, Paris, 1872.

apparent form, are only secondary considerations in the presence of those dominant principles," the first volume (X, 451) already forcefully stated. Beyond the diversity of their achievements, Sullivan, Horta, Hankar, Guimard or Gaudí, all assiduous readers of the *Entretiens*, would think no differently.

It is again to Viollet-le-Duc that we owe the formulation of that central question in defining the art to come: why and how ornament, that element which seems by definition "added on" (and whose rejection would come only much later with the pioneers of the modern movement), must nevertheless be an integral part of the artistic plan. The reason is that it no longer has the job of "covering over," and of concealing, but on the contrary of making manifest the justness of the conception, the inner truth of the organization. "Decoration is already written into the structure, if that structure is sensible; it adheres to the building not like a garment, but the way skin and muscles adhere to man," is how the fifteenth *entretien* or lecture (XV, 205) admirably puts it, and in fact there is no better criterion than this organic comparison by which to distinguish the genuine productions of the new art from its superficial imitations, and even more from the lies and travesties of "1900 Art." In opposition to the eclectic ornament still advocated by Owen Jones's celebrated *Grammar of Ornament* (1856), the field was thus narrowed down logically to two main types of decoration which can also derive from rational analysis and objective observation: on one hand the geometric forms, on the other, organic and plant forms without any of the symbolic significance they might acquire elsewhere.

If Viollet-le-Duc himself merely laid the foundations, the illustrations to the *Entretiens* sum up his arguments with a clarity and force that his successors were able to turn to advantage. The first illustration of the thirteenth lecture, often quoted as an example, seems to provide the model which Horta would elaborate more than twenty years later in his first houses in Brussels: the sheet iron and the metallic scrolls placed at the intersections of the

When the secular masters of the thirteenth century worked out a structural system foreign to all those used up to then, they did not give their architecture the forms accepted by the Roman and Romanesque architects. They naïvely expressed that structure and were thus led to apply new forms, which had a distinctive look of their own. Let us try to proceed with the same logic. Let us seize naïvely on the means provided by our time and apply them without calling upon traditions which are not viable today. Only then will we inaugurate a new architecture.

Eugène Viollet-le-Duc, Entretiens sur l'architecture, Paris, 1872.

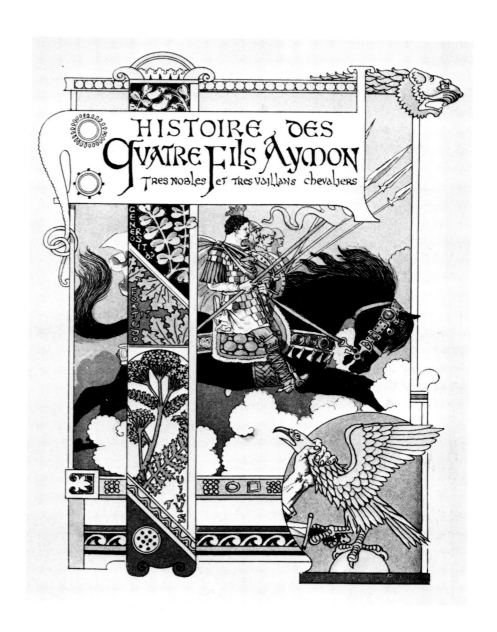

iron beams and cast-iron columns of the planned building show how an ornamentation based on the materials used (the aim, indeed, was to give it "an aspect in keeping with the nature of iron") can have a plastic function and at the same time contribute to reinforcing the structure. Less well known, the last plate of the book (XXXVI) suggests, daringly for an apartment house at that time, a corbelled façade with a tile facing, in which the small iron girders—the equivalent of medieval half-timbering—clearly expose the structure (truth) permitting generous lighting of the ground-floor shops (function). And the colour plate reveals the importance of polychromy, also autonomous, which is introduced naturally, in rectangular flat tints, into the material of the filler vaults; while the nature of the iron (balcony, corbelling brackets) makes it suitable for the arabesque decoration of a stylized floral ornament. For each function its material, for each material its form and ornament. And although he too modestly disclaims it, Viollet-le-Duc thus gives a fine example of what will be the best "architecture of the future."

It is instructive to compare this plan of a façade with the book cover which Eugène Grasset, one of Viollet-le-Duc's fervent admirers, designed for the *Story of the Four Aymon Brothers* which appeared in 1883. The book usually passes for one of the "precursor" works of Art Nouveau because of its original page layout and experimental typography. But beyond the medieval imagery and the floral theme borrowed from architecture or from the *Ornamental Flora* of Rupricht-Robert (1876) equally inspired by it; beyond, too, the Japanese-style centring of the images, the surface of the page is organized, even if with less force and sobriety, on comparable principles: co-ordination and articulation of independent motifs integrated into a structure that remains visible and respects the truth of support and technique (here, the chromotypography perfected by Charles Gillot, the financial backer). The binding which Eugène Grasset designed afterwards, and which was enamelled by Vever and Tourrette, keeps to the same principles.

Eugène Grasset (1845-1917):
Cover for *Histoire des quatre fils Aymon*, Paris, 1883.

25

The gesture, movement and situation of a body in space, and all the impingings of light on living beings and inert things, are materially expressed by the direction, extent and form of the brighter and darker "lines." What in nature is gesture, movement, feature and expression of beings, and disposition of things, becomes "lines" in the work of art.

Félix Bracquemond, Du Dessin et de la Couleur, *Paris, 1885.*

Félix Bracquemond (1833-1914): Plate with flower and ribbon design, 1879, for the Haviland porcelain factory at Limoges.

Ornament does not necessarily copy nature, even when it borrows from her all the elements that go to make it up. It modifies and transforms nature, subjects her to its conventions, draws upon her as upon a source of variations. Its infidelity towards her, its freakishness in borrowing her motifs, are due to the fact that it is solely concerned with embellishing surfaces, that it depends on the materials it has to adorn, on the forms it has to follow without altering them. So it cannot strictly imitate nature, since it is contained by a determined alignment. Its modelling, whether actual as in sculpture or simulated as in painting, has to answer to the form and material of the surface it is meant to embellish, before it can push its own claims—that is, before it can show any fidelity to nature.

Félix Bracquemond, Du Dessin et de la Couleur, *Paris, 1885.*

It was in fact in the domain of decorative arts that the changes became most visible and significant. This is particularly true of avant-garde ceramics and one of its principal renovators, the engraver Félix Bracquemond, then artistic director of the experimental workshop set up at Auteuil by the Haviland firm of Limoges (from 1872 to 1881).

The mental evolution of this artist itself provides a model, since he switched from painting and engraving to ceramics as early as the mid-1860s (his "Rousseau Service" dates from 1866). Bracquemond's craftsmanlike practice of etching and his self-taught background in a then despised genre gave to this intimate friend of Manet an acute awareness of the resources of materials and of

what may be gained for form and style themselves from the practice of a craft and from technical investigations. Among the great table services he executed for Haviland, the one commonly designated by the name "Flowers and Ribbons Service" (1879) has sometimes been represented as well among the "incunabula" of Art Nouveau. But there again, what really matters are undoubtedly less some analogies of motif (the flowers) or of design (the arabesques) than the very principles inspiring this work.

Bracquemond has set these principles out in numerous texts which must be placed in parallel with those by Viollet-le-Duc. For him, too, there must be a specific quality of the decoration to match the support which receives it: "The expression 'decorative art'

signifies nothing. It is 'ornamental art' that must be thought and spoken of. The artist who produces an object does not need to worry about creating a decorative object; he must think of ornamenting the material. Material ornamented as it should be will of necessity be decorative. Things will only be decorative... if we have been able to find in them the logical, studied, natural beauty that is theirs alone" (1891). Thus we are again referred to a logic of materials which brings in its wake a logic of ornament independent of its quality of "art design."

In the rationalist and positivist spirit which he owed to his early training (he was educated in Auguste Comte's circle), Bracquemond posed in fresh terms the problem of the relation between art ornament and nature. Both followed the same laws of "modelling," that is, of the distribution of light, of light and dark values. It was rigour in the observation of those laws that mattered, not the imitation of this or that "natural" motif: in his own materials the artist implements those laws through the arrangement of the *lines* of his decoration, as distinguished from the simple outline, drawn without thickness and therefore without light-value. In the

1879 service the floral design would thus be taken less into account than its harmonization with the form which bore it, its distribution over the surface by a judicious play of filled and empty spaces and the resulting subtle and refined balance of values and colours.

It is amusing to compare the fillip Bracquemond gave to arabesque—once more, less the "hand" and the "line" than the rational occupation of surfaces—with one of the achievements of the early Gaudí. The superb ironwork gates of the Palau Güell in Barcelona (1885-1889) do not have an essentially different origin and significance. Gaudí was first of all a craftsman, who owed to his coppersmith father and to his education a direct and thorough knowledge of wrought iron, equally attested to by the gates of the Casa Vicens in Barcelona (1878-1880). As with Bracquemond, there is thus no reason to be surprised by the "precociousness" of his decoration, and still less to celebrate his "extravagance." It is the result in the first place of work specific to the material, outside any stylistic prejudice, and of the reading of Viollet-le-Duc, whose works Gaudí covered with annotations while he was a student at the Barcelona School of Architecture.

Antoni Gaudí (1852-1926):
Ironwork grating of the Güell Palace, Barcelona, 1885-1889.

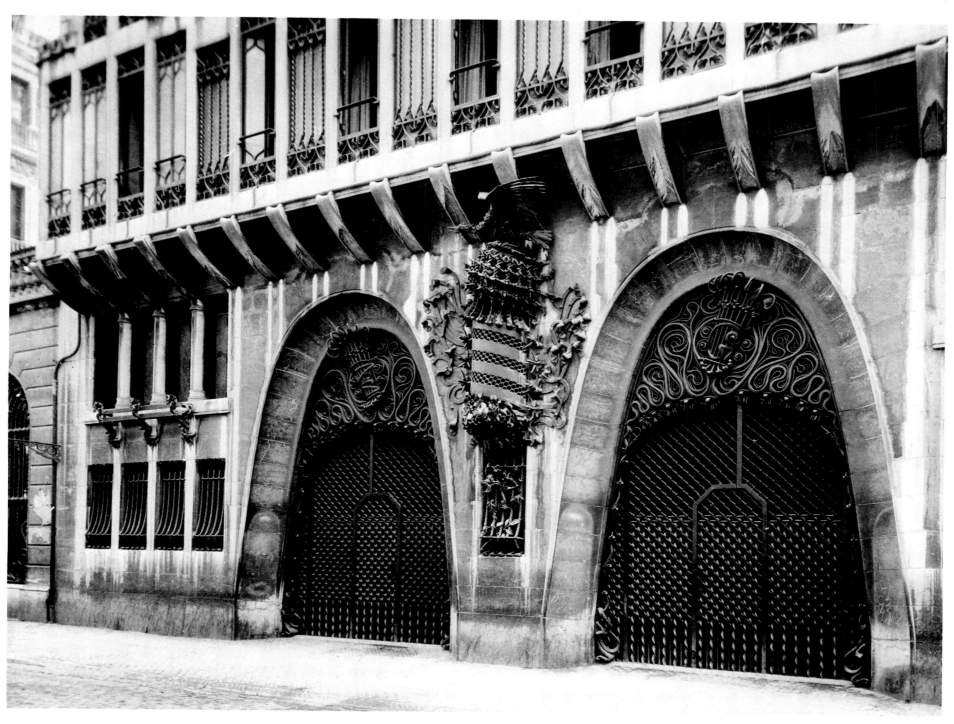

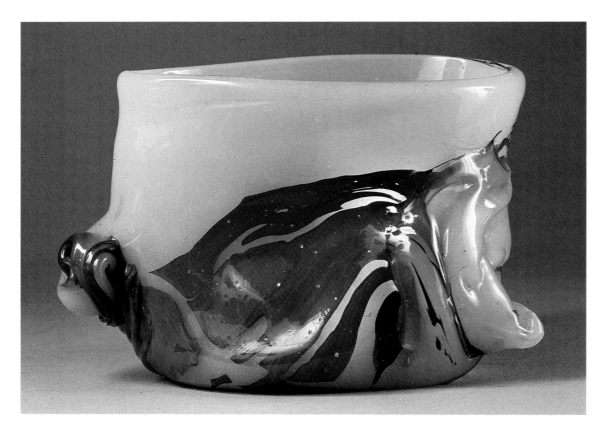

Eugène Rousseau (1827-1891):
Moulded glass flowerstand, 1887.

In the same way, by placing side by side, in a likewise unexpected comparison, the moulded glass flowerstand which the Musée des Arts Decoratifs in Paris bought from Eugène Rousseau in 1887 and the nearly contemporaneous *Danaid* by Rodin, it can be seen that the motif and the nature of the objects ultimately introduce only a secondary distinction between the two works. And the broad undulations running through them owe less to some fin-de-siècle "languidness" and a purely literary inspiration than to the concern to bring out the inherent properties of the materials and the manner of working in them by playing at the same time (and in both cases with how much mastery and refinement!) on the "laws of modelling." More than a subject, figurative or abstract, both first offer to the eye the texture itself of their material—surface and substance—deliberately left exposed even to the irregularities that bear witness to the artist's work and the technique used. In the Rodin sculpture, in particular, the contrast between the polished parts and those left in the rough (a contrast found again in the wood carvings of Gauguin) depends less on the reference to the tradition of the "*non finito*" than on taking account primarily, in reaction against the dominant current of nineteenth-century sculpture, of material on one hand and the ordering of reflected lights on the other. The same applies to the elimination of the pedestal, the insertion of the figure in the sculpted block, the link-up and continuity of forms, in which the particularity of the motif (the nude, the hair...) serves above all as a favourable pretext. As with Michelangelo's figures in the Medici Chapel, we can speak here, in Bracquemond's terms, of a fundamentally "ornamental" working, "because nature, religiously consulted and imitated, is at the same time, through the will of the creator, softened and subjected, like a simple foliated scroll which the ornamenter turns into

a cresset" (*Du Dessin et de la Couleur*, 1885, p. 179). And this places us, on the highest plane, at the heart of the problematics of Art Nouveau.

Is it by accident that Eugène Rousseau and Rodin were both close friends of Bracquemond? Rousseau (born in 1827) commissioned from Bracquemond in 1866 the famous service which bears his name. Rodin was in close touch with him at least from the mid-1860s (it was through Rodin that in 1866 Bracquemond made the acquaintance of Edmond de Goncourt, the future promoter of "yachting style"); Rodin spoke of Bracquemond as his master and paid homage to him with several plaster casts and clay models, among which was precisely that of the *Danaid*.

It was a no less significant conjunction for the avant-garde of the applied arts when, again through the master engraver Bracquemond, and during that same year 1886, Gauguin met Ernest Chaplet.

Chaplet belonged to the same generation as Bracquemond (he was born in 1835). Trained in the Sèvres porcelain manufactory, Chaplet met Bracquemond in 1871 and worked with him in the ceramic atelier opened at Auteuil in 1872 by the Haviland firm of Limoges. Then, from 1882 to 1886, Chaplet took charge of the Haviland atelier in Paris, in the Rue Blomet. It was there that he succeeded in discovering, around 1884, the secret of the famous *sang-de-bœuf* or ox-blood red of Chinese porcelain, a deep, rich, coppery red which ceramists had been trying to recreate since the middle of the century. But what first interests us here is the process and the result. Like Rousseau and his associate Léveillé when they rediscovered the lined glass and crackled glass of the Venetians, Chaplet was before all else a man of the workshop, of the laboratory even. After the overlaid decorations of Sèvres and the Second

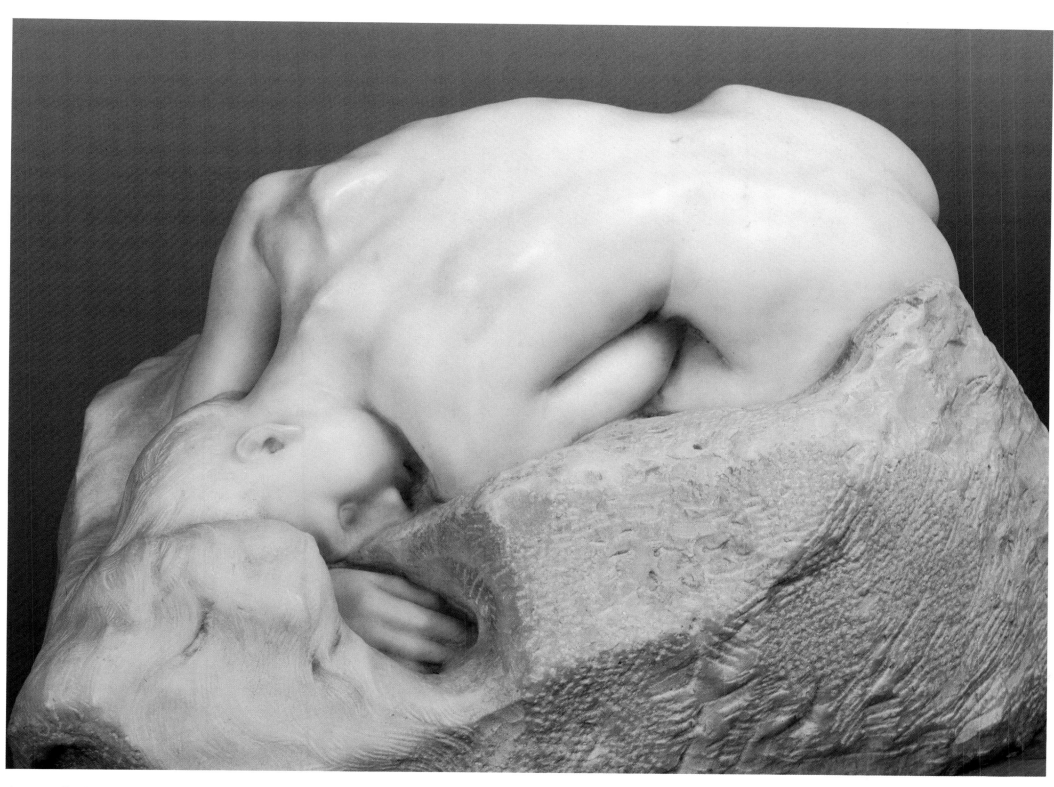

Auguste Rodin (1840-1917):
A Danaid, 1885. Marble.

Emile Bernard (1868-1941), possibly with **Paul Gauguin** (1848-1903): Carved and painted Breton corner cabinet, 1888.

France for this purpose during the 1860s, and notably the Union Centrale des Beaux-Arts Appliqués à l'Industrie (1864), finally led in 1882 to the Union Centrale des Arts Décoratifs, whose regularly organized thematic exhibitions provided strong support for innovators, paralleling those of the English "guilds." The Union, in 1880, also launched the *Revue des Arts Décoratifs* (which significantly opened with an article on an exhibition of works by Viollet-le-Duc). And the corresponding sections of the Paris World's Fairs of 1878 and 1889 also played their role: it was on that first occasion that the name of Emile Gallé, head of the future School of Nancy, came to the fore; and Tiffany, coming from New York, appeared at the second.

But from the perspective of Art Nouveau, the relaunching of these activities should not create any illusions. In themselves these different manifestations imply nothing as to the nature and quality of the products on display: eclecticism and historicism would always keep the keys to the city, as the 1900 World's Fair once more amply confirmed. Gallé himself, for example, was at that date far from being liberated from pastiche and conventional forms. And in spite of all the interest of his glasswork, motifs still continued to play an essential role without having a truly organic relationship to the bodies of his vases. Against Chaplet's Mei-Ping vase might be set Gallé's famous *Orpheus and Eurydice* vase of 1889, also shown at the 1889 Fair, with its division into horizontal bands, its mythological scenes carefully designed by Victor Prouvé, the long inscriptions accentuating the narrative and highly literary character.

Three years earlier, acting on Bracquemond's advice, Gauguin had gone to work with Chaplet. The vase decorated with Breton scenes was perhaps the most accomplished result of this collaboration. But in it there also reappears a "will to art" for which the work of the craftsman this time serves only as a fulcrum or point of departure. Following a form borrowed from the Auteuil workshop (the rouleau-shaped vases, decorated in particular by Ringel d'Illzach), the stoneware vase is adorned with enamelled figures. Gauguin, however, took over the procedure used shortly before (1884) by Chaplet and his friends of tracing circles with a pointed tool to separate the different clays inlaid in the unglazed stoneware vases ("brown stoneware"). The procedure here actually has no further technical justification, since there are no longer different clays to segregate and since the enamelling, in several places, overflows the limits traced. But Gauguin used the technique (as did other artists of the Rue Blomet workshop around 1885) to "partition off" the forms; to stress the line and aspects of a decoration which no doubt covered over the material, but without betraying it or causing it to be forgotten. This decorative option is fundamental for Gauguin (in it has been seen, not without reason, one of the origins of his self-styled synthesist painting), and for the development of contemporary ceramics: it marks the final passage from a realistic aesthetic of representation (including Impressionism) to primarily ornamental bias.

For Gauguin this temporary conversion to "applied arts" also had an economic and social significance. "Perhaps this will be a great asset in the future," he wrote to his wife at a time when his own poverty and the failure of his painting drove him to follow Bracquemond's advice (late May 1886). The withdrawal to Brittany, where he would "turn out art in a hole" (letter to Bracquemond, June 1886), led him to call aesthetic theories into question but also to cross-examine himself on the precise function of the artist in the face of the discoveries and successes—technical, at least—of craftsmen, in the same way that the architect sees his doctrines placed in doubt by the work of engineers. The cabinet which Emile Bernard built in 1888 at Pont-Aven, under Gauguin's observation if not with his collaboration, seems to bear witness

Empire in its heyday, he discovered through contact with Bracquemond that the true decoration is the one which is inscribed in the substance of the work and arises from the technique alone. The result was the superb "Mei-Ping" vase (named after its form, which goes back to the Sung dynasty), in which only the red glaze of the porcelain and its white veinings come into play: their vertical arrangement emphasizes the excessively pure form leading in the continuity of a rising movement from a narrow hexagonal base to a broad circular bulge. Matter, form and decoration are here inseparable, each referring to the purity and truth of the other two for the greater triumph of Art over Nature. "The fired surfaces cease here to be a more or less vitreous enamel; the mineralized colour presents the aspect of the seams of a hard stone, delicate and unctuous to the touch," wrote Bracquemond (*Le Rappel*, 8 August 1889) when Chaplet displayed this important vase and other similar works at the Paris World's Fair of 1889, where it was awarded a gold medal. Then came the triumph of another "raw" material, iron, in the Machine Gallery and in the Eiffel Tower, which, also for purely technical reasons, assert in a parallel way the purity and truth of the curves of their ribs.

These discoveries were, of course, part of a wider movement of the rehabilitation of the decorative arts, which had its earliest origin in the Great Exhibition of 1851 in London and the report afterwards published by the Count of Laborde on "the application of the arts to industry" (1856). The various societies, founded in

Ernest Chaplet (1835-1909):
Mei-Ping vase, 1889.
Porcelain, *sang-de-bœuf* glaze.

Paul Gauguin (1848-1903):
Vase decorated with Breton scenes, 1886-1887.
Chocolate-coloured stoneware with coloured glazes.

first of all to a wholly craftsmanlike spirit of humility that might recall the approach of William Morris and his friends. And yet this naked wood, worked with a hollow chisel, these simple forms, these designs that aim at being popular and folkloric, do not succeed in making us forget the artist's decorative virtuosity, and ultimately his entirely "aristocratic" distinction. The detour by way of handicrafts depends here in fact on a basically aesthetic manner of proceeding: Gauguin, like Whistler, never gave up painting (and in 1889 he significantly suggested to Chaplet to take on "an artist"!). But it was indeed through contact with someone like Chaplet, from a study of materials and from the example of expert craftsmen, that painting would be able in its turn to discover its new truth.

In these circumstances, although everything seems to turn him away from it, we are not surprised to see Gauguin express his enthusiasm for iron architecture at the 1889 World's Fair, in what was his first published essay: "Architecture is just beginning, in that it lacks in art a decoration at one with its material... Why, alongside these geometric lines of new character, do we find all this old stock of ancient ornaments modernized by naturalism? To the architect-engineer belongs a new art of decoration... Iron, iron and more iron!" ("Notes sur l'art, l'exposition universelle" in *Le Moderniste illustré*, 4 July 1889). From Viollet-le-Duc to Bracquemond, Gauguin and soon to Horta? The paradox is only apparent. From iron to iron, by way of ceramics, it was the French rationalist movement—structure, material, ornament—which in those two decades 1870-1890 laid in its turn the foundations of Art Nouveau.

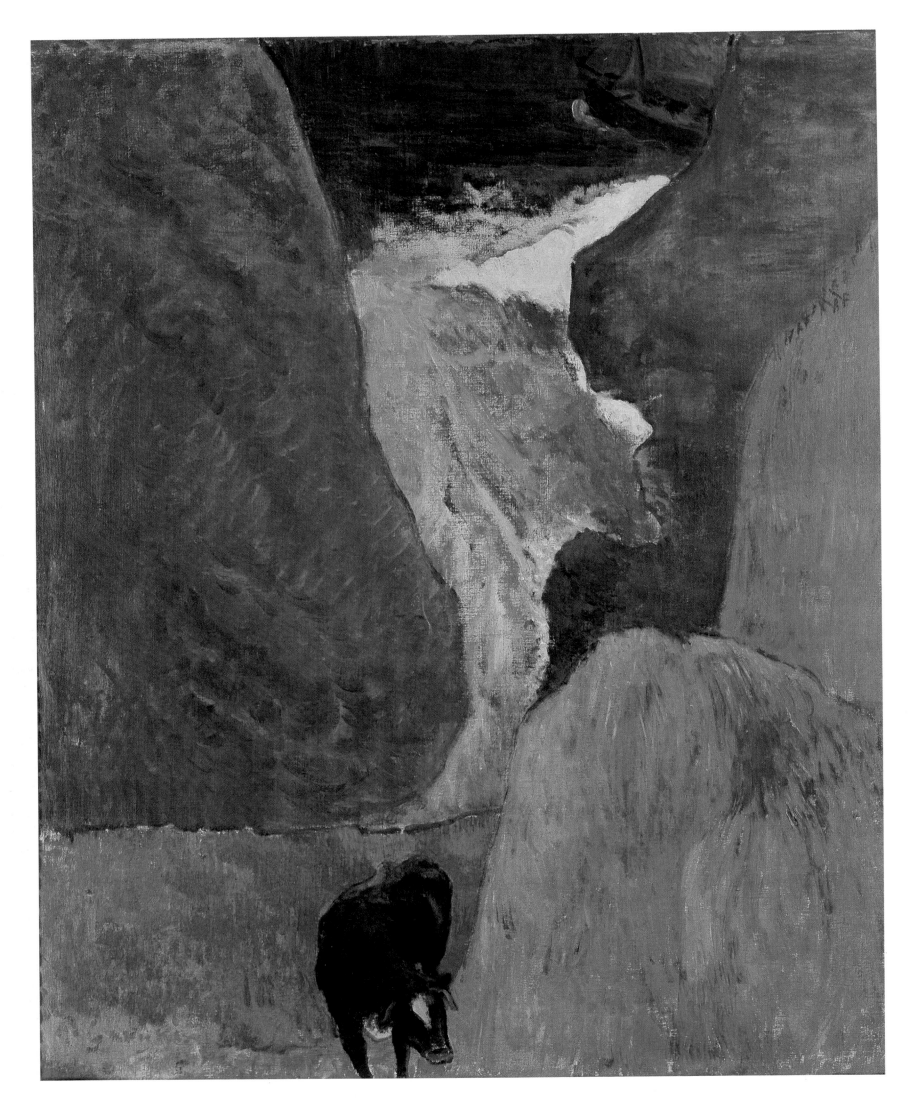

Paul Gauguin (1848-1903):
Over the Abyss, 1888. Oil.

The
Painters'
Revolution

HE eighth and last Impressionist exhibition of 1886, which, moreover, renounced the use of the term, marked the end of a crisis that had begun at the start of the eighties. Personalities and problems of the marketplace aside, it was in fact both a system of optics and a system of representation which had had their day. This obsolescence was keenly felt in the very core of the group; and Renoir, for example, gave quite explicit utterance to it: "Around 1883 something like a rupture appeared in my work. I had travelled the road of Impressionism to the very end, and I wound up by realizing that I did not know how to paint or to draw. In a word, I had reached an impasse." Pissarro would reach the same conclusions, aligning himself immediately with the Divisionism of Seurat, whom he met in 1885, after the latter's first exhibition at the new Salon des Indépendants (1884). And the shock of surprise produced by Seurat's *Sunday Afternoon on the Island of La Grande-Jatte* at the 1886 exhibition expresses the importance of this break.

From then on, avant-garde painting would bring about a spectacular reconversion in France, which in the space of a few years gave an entirely new direction to art at the close of the century. The death of Van Gogh in 1890, followed by that of Seurat in 1891, and Gauguin's departure for Tahiti in April of the same year, marked the end of this decisive period.

Many things seemed nevertheless to divide the paths then taken by Seurat, Signac and their friends on one hand and by Gauguin and Van Gogh on the other. But beyond obvious contrasts of technique, viewed from the perspective of art to come (and while Cézanne's work was paving the way for the most far-reaching transformations), it was indeed a case of two sides of the same innovatory reaction. Félix Fénéon, one of the most clear-sighted observers of the movement, noted it well, despite his avowed preference for the tendency of Seurat, when he saw the exhibition held by Gauguin's group at the Café Volpini, on the fringe of the Paris World's Fair of 1889: "The methods of the *tachiste* painters, so well suited to represent fleeting visions, were abandoned, around 1886, by a number of painters concerned to produce an art of synthesis and premeditation. While Messrs Signac, Seurat, Pissarro and Dubois-Pillet put their conception of this art into practice in paintings where incidental facts are abolished in a general orchestration obeying the laws of optical physics..., Monsieur Paul Gauguin strove towards an analogous goal, but by other practices. To him, reality was only a pretext for far-off creations."

"Synthesis" as against "fleeting visions" of the *tachistes* (the former Impressionists): that said it all, or at least the essential part of what brought the two currents together. In both cases there was

a reaction against "improvisation," against the aesthetic of "bits of nature glimpsed as through a porthole opened and shut" and their empirical transference onto canvas with a craftsmanship "scanty, rough and approximative," to quote Félix Fénéon again in 1887. The consequence is of prime importance for the advent of Art Nouveau. In spite of the different means used to get there, the concern henceforth was to build and order one's picture following rigorous procedures and in terms of purely plastic means, whereby the consideration of reality (whose disappearance was not called for until around 1912) already played no more than a secondary

something different from what I know how to do. I believe it is a transformation which has not borne fruit, but which will do so," wrote Gauguin to Schuffenecker on 8 October 1888, telling him how his most important and, in that respect, particularly "demonstrative" painting, the *Vision After the Sermon*, had been rejected. And in fact the transformation would reverberate far beyond Gauguin, making vain all subsequent discussion as to whether or not his "primitivism" was at the opposite pole from the "progressivism" and "modernism" of Art Nouveau. What matters is the effect it displays of "abstraction," spoken of by Gauguin, also to

A piece of advice: don't copy nature too much. Art is an abstraction. Derive this abstraction from nature while dreaming before it, but think more of creating than of actual result. The only way to ascend towards God is by doing as our Divine Master does, create.

Gauguin to Emile Schuffenecker,
14 August 1888.

Paul Gauguin (1848-1903):
Illustration for the catalogue
for the exhibition of the "Impressionist
and Synthetist" group of painters,
Café Volpini, Paris, 1889.

role. Thus the way opened to a decorative style of painting characterizing the essence of the new art, the theory of which the Nabi painters were soon to formulate.

It was along this path that Gauguin advanced most directly: to be precise, between 1886 and 1890, that is, before the first texts that would make him one of the heralds of Symbolism and above all, in the strong phrase of Fénéon, "the prey of literary hacks" (1891). What was operating during this period, particularly starting from his experience with ceramics, was Gauguin's determination to derive all possible advantage from the rational organization of forms in order to attain style. Contrary to future commentators who would see in his recourse to primitivism only the instinctive manifestation of a revolt against Western society, Fénéon placed this aspect well in evidence at the end of this short period: Gauguin, he said, "excelled in painting the Breton women of Emile Bernard; but, a skilful painter, he put logic into their coarseness, which, beneath fierce exteriors, was a most civilized coarseness."

No doubt this "logic" was not the same as Cézanne's: here was no geometric reduction, no skilful modulation to convey depth. But it was surely from a systematic turn of mind, and not from a simple lyrical expression or surrender to instinct, that Gauguin proceeded to effect this transition to flat tints, this suppression of shadows, this simplification of drawing, this concern for asymmetry and, finally, this heavy outlining of forms, christened *cloisonnisme*, and partly taken over from Bernard and Anquetin, which made possible the autonomous display of colours for a purely decorative end.

Little mattered, then, the "borrowings" and immediate "sources"—the new wave of Japanese mania, for example, popularized in Paris art circles by *Le Japon artistique*, the review launched by Samuel Bing in 1888. What most mattered was the will to style, in reaction to the objective and impersonal note-taking of impressionistic realism. "This year I have sacrificed everything—colour, execution—for the sake of style, trying to force on myself

Schuffenecker, in August 1888. Before Albert Aurier subsequently deduced the doctrine of "symbolism in painting" (March 1891), in which, moreover, the notion of decoration maintains its place, Fénéon gave a good analysis of its purely plastic effects: "Gauguin reorders the materials that reality provides him; scorns trompe-l'œil, even trompe-l'œil of atmosphere; accentuates the lines, restricts their number, ranks them hierarchically; and in each of the spacious divisions formed by their interweavings an opulent and heavy colour swells with gloomy pride without violating the adjoining colours, without undergoing any alteration itself" (*La Cravache*, 6 July 1889).

That is also why a pure landscape like *Over the Abyss*, which this commentary so admirably fits, gives a better account of Gauguin's contribution to the new aesthetic than does the *Vision After the Sermon*, with its cut-out pattern at once firm and sinuous and its powerful contrast of complementary colours. In like manner, Gauguin's *Woman in the Waves*, painted at Le Pouldu in 1889 and exhibited at the Café Volpini the same year, immediately transcends a motif in itself quite literary and destined for degraded repetition in the most mediocre of "1900" painting (Clairin's famous *Wave*, for example, the triumph of the 1898 Salon, then of the 1900 World's Fair). Shown from the back and abstracted as much as possible, out of all context of time and place, Gauguin's naiad is primarily a pretext for overlapping networks of arabesques spread over the whole height of the canvas—where the elimination of the sky too makes for a reduction of depth. And in her unstable and asymmetrical pose, the naiad is leaning less upon the wave than on the implied ascending diagonal of the picture.

It was this "marked tendency to synthesize in drawing, composition and colour, as well as a search for simplification of methods" of which Aurier himself spoke after visiting the Café Volpini which would now spread its influence over the European avant-garde: in Paris, among the Nabis (about 1892 Georges Lacombe would plagiarize Gauguin's *Over the Abyss* in his *Cliffs at Camoret*,

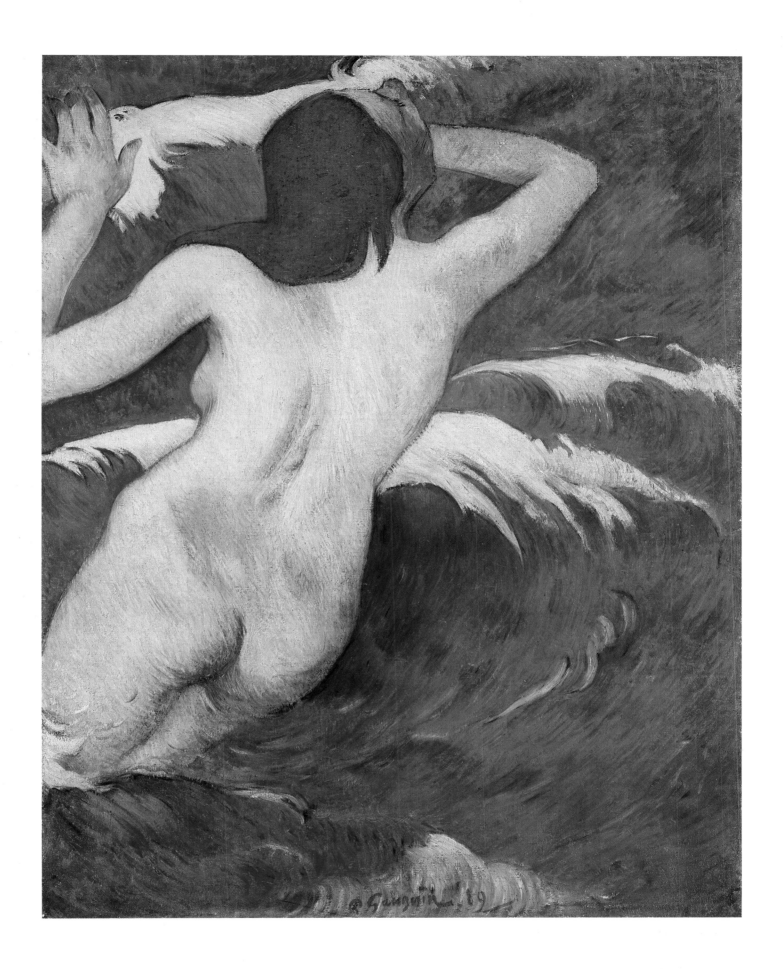

Paul Gauguin (1848-1903):
Woman in the Waves
(Undine), 1889. Oil.

now in the Brest Museum) or the Nabis' friends (in 1895-1898 Maillol would make the *Wave* into one of his most important works), and in Belgium too, where, in 1899, Gauguin exhibited twelve paintings, including the *Vision After the Sermon*.

Gauguin's meeting with Van Gogh, which was followed up by their working together at Arles from October to December 1888, resulted in a comparable move in a fresh direction. After emerging from a brief flirtation with Pointillism, Van Gogh did in fact discover in the South of France, with the continuing help of Japanese prints, how to construct a picture by outlining and simplifying, and in this way he was able to go beyond Impressionism. For him

the point was to attain a more substantial reality. But whatever his motives, the result of this quest linked up with that of the Pont-Aven painters, even before Gauguin went down to Arles. "While still working directly on the spot, I am trying to grasp what is essential in the drawing—then I fill the spaces, defined by contours, expressed or not, but always felt, with tones equally simplified, so that everything to do with the ground will share in the same violet tone, and the whole sky will have a blue tonality... No trompe-l'œil in any case" (Van Gogh to Emile Bernard, April 1888). Was that not the very method which then led Gauguin to paint *Over the Abyss*, described so aptly by Fénéon in 1889?

Pen drawings, where oil colour cannot bring to bear its expressive function, are in this respect most revealing. When Van Gogh discovered the boats on the Mediterranean at Saintes-Maries-de-la-Mer, for example (June 1888), "little green, red, blue boats, so pretty in form and colour that they made you think of flowers" (letter to Emile Bernard), it was immediately to insert them into rhythmic compositions where contrasts (of forms, directions, textures) worked systematically. The undulating lines of the waves are there less to convey the expression of a tormented soul than to echo the provoking curves of hulls and sails. And of these the painter brings out the great purity of line by counterpointing it with a Pointillist sky which also ensures, at the top of the sheet, the continuity of values and modelling. The ornamentalist preoccupation (in the sense used by Bracquemond, whom Van Gogh had read with enthusiasm in 1885) was thus indeed dominant.

The flowers Van Gogh painted at Saint-Rémy in 1889, and especially the *Irises* (afterwards one of the favourite plant forms of the Art Nouveau decorators), coming as a surprise in this dramatic period, have the same significance: the first thing was "to put style into them" (letter to Theo, 25 May 1889). Van Gogh's distinctive brushwork and impasto alone were responsible for "reinvesting" the pathos that was discovered in them only afterwards.

But for Van Gogh at that date and in spite of his brother's reproaches ("I feel that the search for style takes away the true feeling of things") there was indeed a formal imperative which it was impossible to evade: "In spite of what you say in your last letter, that the searching for style is often detrimental to other qualities, the fact remains that I feel very much driven to seek style, if you like, but by that I mean a more masculine and wilful drawing. If that should make me seem more like Bernard or Gauguin I wouldn't be able to help it" (letter to Theo, October or November 1889).

What was being achieved in these works in fact quite obviously went beyond the psychology, or psychopathology, of a personality. Further north, in Belgium, at the same time, a wholly different painter, James Ensor, was putting into practice that "common idea" of which Van Gogh spoke to Emile Bernard in June 1888. In Ensor's pen drawings in particular are found the same spirals and hooked lines which strangely recall the way Gaudí, and then Horta, twisted and bent iron. The familiar spirits who "taunted" Ensor, now living aloof at Ostend on the shores of a very different sea, took good care to round off an arabesque composition without depth, where the forms are homogenized and echo each other starting from the "flood-tide" of the artist's hair, every bit as tumultuous as the Mediterranean waters at Saintes-Maries. And their "coarse" primitivism is just as much tinged, to use Fénéon's phrase about Gauguin, with a perfectly civilized "logic."

Surely imagination is a capacity we have to develop and it alone can help us to create a nature more exalting and consoling than what we see from a single glance at reality, which we see as changing and passing away as quick as lightning.

Van Gogh, letter to Emile Bernard, April 1888.

Vincent van Gogh (1853-1890): Boats at Saintes-Maries-de-la-Mer, June 1888. Reed pen.

Arranging the colours in a picture so as to make them vibrate and set each other off by their opposition, that is something like arranging jewelry or inventing costumes.

Van Gogh, letter to his sister, about 8 September 1888.

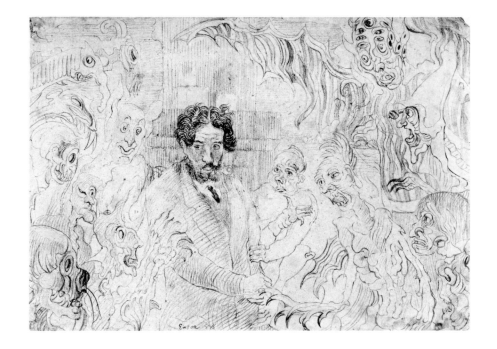

James Ensor (1860-1949):
Self-Portrait: Demons Taunting Me, 1888.
Pencil and chalk.

Vincent van Gogh (1853-1890):
Irises in a Vase,
May 1890. Oil.

Paul Signac (1863-1935):
Portrait of Félix Fénéon Against the Enamel
of a Background Rhythmic with Beats and
Angles, Tones and Colours, 1890. Oil.

In this perspective, then, can the scientific detachment of Seurat and his friends continue to be opposed to these artists? Actually, Neo-Impressionism aims no less at "style," which alone is capable of rendering an account of the deeper, eternal reality of Nature. And the network of rectangles in Seurat's *Grande Jatte* (1886), the *Bridge at Courbevoie* (1886-1887) and the *Sideshow* (1887-1888) also should not give rise to any illusions: it renders only one aspect of that inner order, and Seurat was not Mondrian. The

Louis Anquetin (1861-1932):
Girl Reading a Newspaper, 1890. Pastel.

painter's later work makes clearer its indispensable complement: the whip of his *Circus* (1890-1891) takes possession by its arabesque of the continuity of a space reduced to a flat tint and provides the model for the famous "whiplash" embroideries by Hermann Obrist some years later (1892-1894). And the buxom, and oh how undulating, forms of Seurat's mistress, Madeleine Knobloch, manage to integrate themselves with perfect naturalness into the setting of his *Young Woman Powdering Herself* (1889-1890).

This last painting is particularly baffling as long as Seurat is seen only through the equations of O. N. Rood and the mathematics of Charles Henry. These he studied and applied, to be sure, but they are only a means to an end, and the painter's own line of thought is quite different. Signac, in his book *D'Eugène Delacroix au Néo-impressionnisme* (1899), reminds us of the fact: "It seems that, before his empty canvas, the first concern of a painter must be to decide what curves and arabesques are going to break up its surface, what tints and tones are going to cover it." Closely resembling those of Gauguin, these arabesques here serve first to distribute light-values. Seurat stated that his way of seeing made him conceive the values before the lines; that it never occurred to him to begin a painting with a line—which also fits the theory of modelling set forth by Bracquemond. The values naturally lead to those "wavy luminous masses" of which Fénéon, it is too often forgotten, also spoke in connection with Seurat's paintings (1887) before describing them as "the most ambitious effort of the new art" (1888, writing about the *Models Posing*). Was it by chance that the broad spiral scrolls in graduated tones that join the strapless bra, the dress, the cloud of powder and even the bizarre pedestal table of the *Young Woman Powdering Herself* irresistibly evoke the great moving volumes—they too fragmented and unified by their patterning of mosaic ornament—of the pavilion roof of Gaudí's Park Güell or his Casa Batlló? That is what would be seen too in Brussels, where Seurat, showing as early as 1887 at the exhibition of The Twenty ("Les XX"), was to exert an influence as decisive as that of Gauguin.

The startling portrait of Fénéon by Signac admirably sums up the essence of his conquests. And it is as much a mistake to make its abstract background depend entirely on the design of the kimono which really inspired it as to look for the "source" of the picture in the scientific theories of Charles Henry. The most important

thing, for the future at least, was what the sitter himself well emphasized in his general study of Signac's work when he spoke of "outstanding specimens of an art of great decorative development, which sacrifices anecdote to arabesque, nomenclature to synthesis, the fugitive to the permanent and, in celebrations and spells, confers upon Nature, wearied at last by her precarious reality, an authentic Reality" (in *Les Hommes d'Aujourd'hui*, No. 373, 1890). Like Van Gogh's *Irises*, the cyclamen which Fénéon holds in his hand also makes a choice offering to Art Nouveau.

Thus, once again, the final impulse came from the painters—from Whistler to Gauguin, Van Gogh and Seurat. For Whistler is present there as well, appearing in force on the Continent just about the time when Mallarmé was translating his *Ten O'Clock Lecture* into French (1888). Fénéon then noticed the American artist's growing attraction at the Paris Salon: "Also increasing is the influence of Mr Whistler, precious because it is exerted on intelligent painters who don't surrender their own personality."

And in August 1888 one is not surprised to find Van Gogh speaking to Theo of his famous sunflowers—a series that delighted Gauguin—as a "symphony in blue and yellow," something far removed from the expressionism which is customarily read into them. The colours of Van Gogh's sunflowers are those of Whistler's *Peacock Room*, where, to boot, the andirons designed by Thomas Jeckyll also took the form of sunflowers, one of the emblems of the aesthetic movement.

The emphasis on surface pattern, the primacy of rhythmic composition, the directness of forms and colours conceived at first as a harmony in themselves, the abandoning of description in favour of abstraction taken as far as possible from reality, the predominance of design and pattern over representation, were so many new elements marking the break with the realist current and opening the way to the art of the future; so many new principles spreading their influence beyond painting alone. The "effect of synthesis" would be no different in the architecture of Horta, Gaudí or Mackintosh. To the anti-realist reaction of the "aestheticians," to the rationalism of the architects and decorators, with their logic of material and ornament, the painters brought the new way of organizing forms that was still wanted to found a style.

Georges Seurat (1859-1891):
A Young Woman Powdering Herself,
1889-1890. Oil.

Paul Gauguin (1848-1903):
Man with an Axe, 1891. Oil.

The Stroke of the Axe

"The almost naked man raised with both arms a heavy axe, leaving its blue imprint on the silvery sky above, its gash on the dead tree below... On the purple ground, long serpentine leaves of metallic yellow, a whole oriental vocabulary, the letters (it seemed to me) of a mysterious unknown language."

Thus did Gauguin refer in *Noa-Noa* (written from 1893 on) to one of the most important paintings he did in 1891 after his arrival in Tahiti, the *Man with an Axe*. Further on in the same book about Tahiti, he describes himself cutting down a tree in the centre of the island "all covered with forest (of desires)" which at the same time represents all his "old stock of civilized man." For him, no doubt, a cutting down of the old tree of the Western world; for us, a cutting into the tradition of representation, with those "letters of a mysterious unknown language," the language of an art to come. Their mark is to be found in more than one of his Tahiti paintings, affixing a kind of strange signature written by turns in leaves, waves, roots. But at that very time the mark of this new art was also stamped on the vignettes of Lemmen and Van de Velde, on the tapestry cartoons of Ranson, on the embroideries of Obrist and even the obsessive furrows of Toorop and the margins and simulated frames of Munch's paintings and prints. So many different meanings passing thus through the life of one and the same form which occupies surfaces at will, arising from the painting and blossoming in the drawing, in the book, the print, the wall-poster, at last on the wall itself, and in architecture: the shining example of the conquest of living-space by ornament, beginning with the work of the painters.

As for the cleft in tradition, it is, of course, as in Gauguin's painting, partly imaginary: are not the white crests of waves on the reefs and even the arabesque of the sail cleaving the horizon already in Van Gogh's drawings at Saintes-Maries in 1888? But 1890 nevertheless marks a milestone: from the example of Arles and of Pont-Aven, a new painting was becoming conscious of itself and organizing into a doctrine what had been only flashes of intuition or insecure outposts. The stroke of the axe was not to have been empty of meaning.

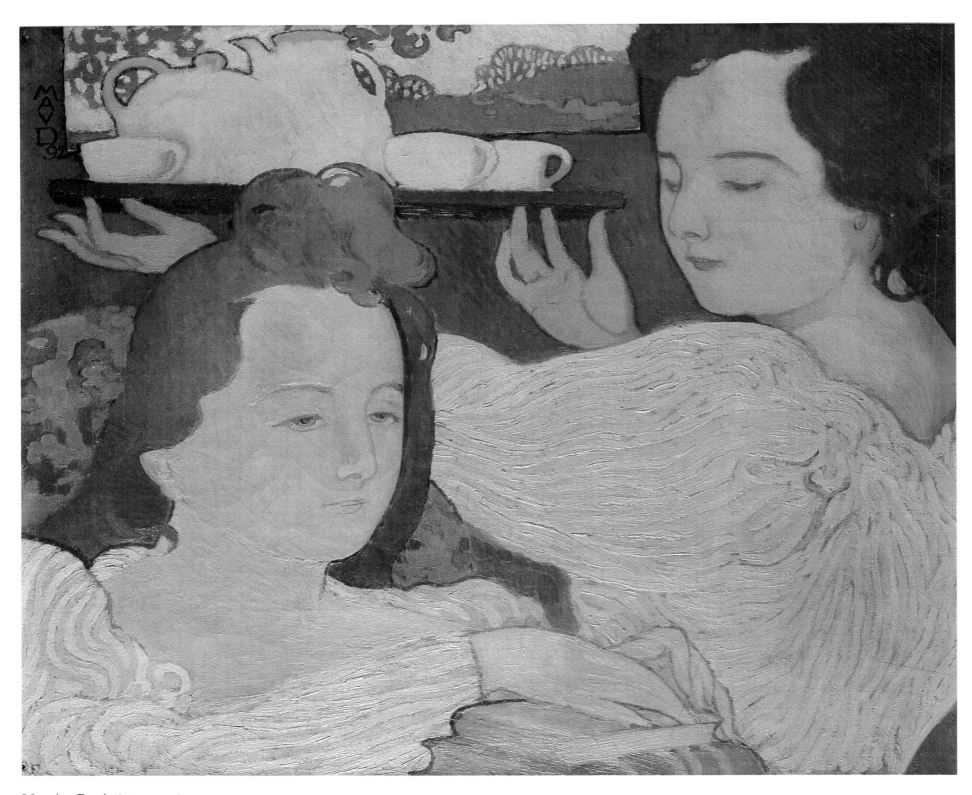

Maurice Denis (1870-1943):
The Cup of Tea, 1892. Oil.

THE INVENTION OF A FREE AESTHETIC
1890-1895

2

The New Painting

ONTINUITY or a break? In 1890 Maurice Denis published the seminal text of the new painting, the opening sentence of which, no matter how familiar, demands repetition here because of its decisive importance for Art Nouveau as well: "Remember that a painting, before being a war-horse, a naked woman, or an anecdote of some kind, is essentially a flat surface covered with colours assembled in a certain order." Probably there was no real break in fact, for this was the very message that Gauguin had passed on to the young Paul Sérusier in Brittany, at Pont-Aven in 1888, as reported faithfully and promptly to Sérusier's young friends at the Académie Julian in Paris, Denis, Bonnard, Ranson and Ibels. But in contrast to the slow, groping experimentation that the painters of the previous generation had charily confided to their private correspondence, the message now hit young artists with the force of a revelation, which Maurice Denis still remembered in 1903 as having been "paradoxical, unforgettable." It led to an immediate radicalization, visible in the earliest paintings of Denis, which carried even further the abstract tendency of *On the Edge of the Abyss: Patches of Sunlight on the Terrace* (1890). At the same time it stimulated a desire to theorize such as their predecessors had never known. This time it was very much a question of young men consciously launching a new art. Without it being possible to speak of a sudden, unaccountable explosion, this fundamental change of attitude nevertheless marks the transition to a new period—the daybreak following the dawn.

The exhibition of Gauguin's works at the Café Volpini in 1889 added to the powerful impression produced by *The Talisman*, which Sérusier had painted under Gauguin's guidance the year before. In 1890 the Nabis, the lucid "prophets" of the coming era, decided that their meetings in Ranson's Paris studio, now dubbed the "Temple," should become weekly events. Denis published his manifesto, and in 1891 the group held its first exhibition in the gallery of the dealer Le Barc de Boutteville. The thirteenth and last show there took place in 1896, a year after Samuel Bing had opened a gallery expressly devoted to Art Nouveau and Denis had published the last important statement of this heroic period, the preface to the Nabi group's ninth exhibition (1895), which echoed the founding sentence of 1890 in an even more telling form: "Before being a representation of anything, a painting is a flat surface covered with colours assembled in a certain order for the delight of the eye." This sets very precise limits to the crucial period in which the new painting took up its position. As Denis himself said in 1934, recalling the originality and powerful coherence of the new movement: "The years 1889-1895 were the decisive years of work, theorizing, and bubbling excitement."

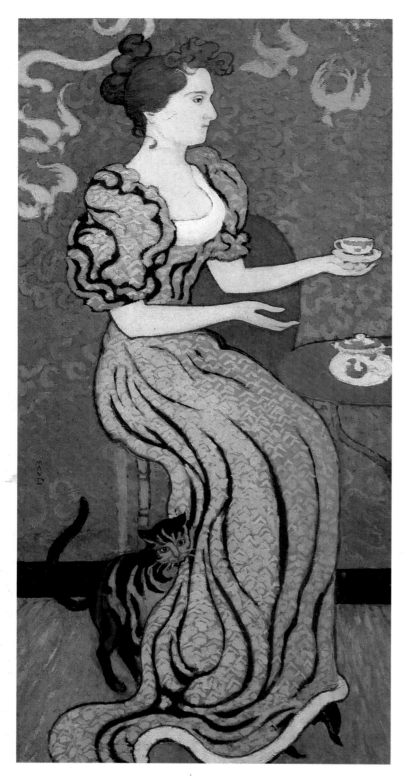

Maurice Denis (1870-1943):
Madame Paul Ranson with a Cat, c. 1892. Oil.

Here we touch on a key point as regards the definition of Art Nouveau and in particular the capital distinction that must be made between it and the Symbolist trend that developed in parallel with it at the prompting of the literary men. Interaction there no doubt was; however, the new painting sought first of all to *establish itself as an independent practice*. Hence the urgent necessity for theoretical work *by painters* and for the constitution of a coherent group. It was a question of proceeding collectively, in this world and outside any kind of transcendence, to build a *new order*, the "new classical order" of which Denis was to speak in later years. And what better indication could there be of their desire to make a stand against the *fin-de-siècle* decadence of spirit with which the bulk of Art Nouveau is too often confused even today?

The "Temple" that was Ranson's studio, its "light" in the person of his wife, the Nabis who frequented it, even Symbolism itself (a mere synonym for Gauguin's Synthetism, said Denis, who preferred to speak of Neo-Traditionism)—all these terms can be misleading with their echoes of the mystical Symbolism of Sâr Péladan and the Rose Croix Salons or even of Emile Bernard. Unlike that of the Pre-Raphaelites, for example, the "brotherhood" of the Nabis was primarily an association of art workmen employing shapes. If a work was to have a spiritual dimension, its only way of achieving that goal was through the rigour and logic of its organization of shapes, not through a hidden meaning that its images were expected to convey. Moreover the notion of the "pictorial equivalent"—as defined in Denis' 1895 summary of his friends' achievements—played a central, decisive role here: "In

Paul Ranson (1864-1909):
Woman with Flowers.
Gouache.

Whatever the interest of their later works, it was to the painters of the Nabi group that it fell to take the main weight of this historic moment, when the artistic avant-garde found itself faced with the task of organizing a new structure—in plastic terms, forming a style.

The point to remember about the 1890 formula, particularly as condensed in 1895, is the twofold affirmation of flatness and organization. Or, better still, an "organization of flatness for the delight of the eyes," for that is probably the most concise and the most apposite definition of the "pictorial" at its most specific. As far as painting is concerned, then, here was the end point and logical culmination of the rationalist movement in France. The paradox is only apparent, and it was not by chance that Maurice Denis spoke in 1903 of the "scientific doctrine" perfected by Sérusier on the basis of Gauguin's suggestions.

Edouard Vuillard (1868-1940):
Public Gardens: Girls Playing and Questioning, 1894.
Decorative panels. Oil.

their works they preferred expression through decoration, through harmony of shape and colour, and through the material employed, to expression through subject matter. They believed that for every emotion, every human thought, there existed a decorative pictorial equivalent, a corresponding beauty."

The portrait Denis painted of *Madame Paul Ranson with a Cat* around 1892—which could likewise serve as an emblematic overture to the period—is thus in no way a Symbolist celebration of the high priestess of the "Temple" any more than it is a piece of naturalism. (Jan Verkade recalls in his memoirs that Ranson's wife, "a cheerful, pleasant Frenchwoman," usually served the Nabis "beer and sandwiches"!) In looking once again at the example of Japan, and rejecting all preoccupation with expression or psychology, Denis in this portrait was aiming systematically at a purely decorative homogeneity. The arabesque is a *necessary* element here because it alone enables the tail and markings of the cat to blend smoothly with the folds of the dress, the swirls of hair to link up with the birds in flight on the tapestry, and the curved leg of the table to echo the double curve of the hands and forearms.

It would be equally erroneous to examine the tapestry cartoons that Paul Ranson was producing during this period for evidence of the painter's theosophical concerns. His *Woman with Flowers* resembles *Madame Ranson with a Cat* in that it is organized in accordance with comparable principles, if rather more hesitantly. But from the way in which the winding stems of shrubs and flowers seek to fill the entire perpendicular surface and deny with their two-dimensionality what is essentially a naturalist perspective, we are perhaps more aware, as we are in the insistent border of the painting, of the endeavour to convert a given reality into pure decoration.

Pierre Bonnard
(1867-1947):
Women in
the Garden,
1890-1891.
Decorative panel.
Pencil and
white chalk.

45

Maurice Denis
(1870-1943):
Procession Under
the Trees,
1892. Oil.

Consequently it would also be a futile exercise, from this point of view, to try to distinguish individual styles and personalities, for at this stage at least it was the joint nature of the new approach that constituted its true significance. In the decorative panels painted by Bonnard and Vuillard we find the same interest in the advantage that can be drawn from a narrow vertical format suggestive of a wall (Bonnard, dismantling what had originally been a screen, explained to his mother in March 1891 that the panels would "look much better against a wall") and the subtle variations that may result in terms of motif. The vertical stripes of Vuillard's dresses and Bonnard's bold use of strictly orthogonal chequerwork, found in several of their pictures of this period, permit an almost perfect integration of figure and decoration—a lesson Klimt was to recall at the end of the century.

With this determined advance in the direction of decoration they were at the same time moving away from Gauguin and traditional easel painting as well as from Puvis de Chavannes, whose murals were also at the back of their minds. In Denis' impressive *Procession Under the Trees*, painted in 1892, the shadow thrown by the leaves provides the excuse for a curious unifying motif reminiscent of a piece of wrought-iron work by Gaudí or Horta, and quite as arbitrary as the bizarre shapes found in the foreground of Gauguin's extremely ambitious *Day of the God*. In the latter painting, however, in which "literature" tends to dominate once again, the central figure of the idol ultimately imposes the idea of a mystery that goes beyond the decorative reality of the painting and surpasses it and all earthly reality in terms of transcendency. Held between the underside of the foliage and the trains of their dresses, which actually (it is one of Denis' favourite motifs) "root" them to the earth, the veiled figures of the *Procession Under the Trees* are organized primarily according to the slow rhythm of their flat

I think that before all else a painting should adorn. The choice of subjects and scenes is nothing. It is by the coloured surface, the tonal values and the harmony of lines that I mean to reach the mind and arouse emotion.

Maurice Denis, interview in
L'Echo de Paris, 28 December 1891.

white surfaces, to which the vermiculated shadows of the leaves form a counterpoint. The symbol, if such there is, is of a purely pictorial and natural order. To quote Denis once again, writing in 1890, art is here no more than "the sanctification of nature, of that universal nature that is content to live."

This being so, it is not really pertinent to reproach the Nabis for having "drained" the painting of Gauguin and Van Gogh of its subversive strength as an "imaginary fulfilment of desire" (Robert L. Delevoy). It makes more sense, pursuing the analyses of Meyer Schapiro, to note a change of aim as well as of the social status of works of art. The effort of structuration that appeared in the work of Gauguin and Van Gogh around 1888-1890 doubtless corresponded to a "thirst for salvation," a deeply felt "demand for order" which, however, failed to lead into the kind of social project that alone could have satisfied them, and which the Neo-Traditionism of Denis posited from the outset. The primitivism of Gauguin, rejecting the West, opted for "idols"; that of Denis and the Nabis, starting from the same pictorial aims, sought on the other hand to regenerate Western art by going back to a higher tradition: this was the true ambition of Art Nouveau.

Paul Gauguin (1848-1903):
The Day of the God (Mahana no atua), 1894. Oil.

God is said to have taken a handful of clay and made all that you know about.
The artist in turn (if he really wants to do the divine work of creation) should
not copy nature but take the elements of nature and create a new element.

Paul Gauguin, Cahier pour Aline, Tahiti, *1893.*

The Nabis were widely exhibited in Paris in the 1890s, and Maurice Denis at least was well represented in Belgium with some important paintings: *Trinitarian Evening* at the Salon des Vingt in 1892, *Procession Under the Trees* and *Jacob Wrestling with the Angel* at the Libre Esthétique in 1894. Henry Van de Velde was certainly not unaffected by Denis, nor was he by Ranson, and it is hardly surprising to find the two of them rubbing shoulders later on in the house of Count Kessler in Weimar (together with Maillol and Bonnard). Félix Vallotton, who had come to Paris from Lausanne in 1882 and flirted for a while with the Rose-Croix group, was moving closer to the Denis group from 1892 onwards and eventually joined it. The shredded tufts of cloud in his *Moonlight* of 1895 employ the same cutout technique as in Gauguin's *Day of the God* and Denis' *Procession*, but on this occasion it is justified by a frankly realistic subject. Moreover the boldness of Vallotton's simplifications and of the curious mirror effect he employs here is similarly imbued with this artist's characteristic humour in what remains a virtuoso but also a more superficial performance. Beyond anecdote and the network of direct influences, Lautrec and Maillol (who frequented the group from 1893 onwards) enjoyed what were probably deeper relationships with the Nabis.

Outside France, things developed more slowly and less clearly, the ambiguity of Symbolism being harder to remove. While the notion of "linear Symbolism" (S.T. Madsen) remains inadequate to take account of the French movement, it is true that what characterizes and indeed draws together artists as different as Segantini, Munch (in Paris between 1885 and 1892), and even

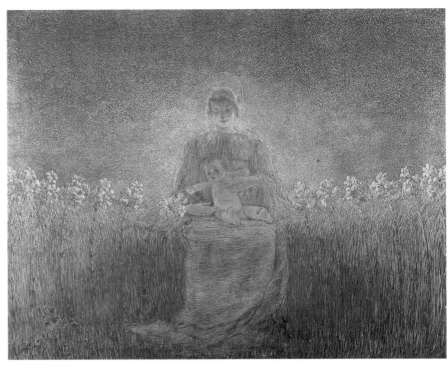

Gaetano Previati (1852-1920): Madonna of the Lilies, 1894. Oil.

Félix Vallotton (1865-1925): Moonlight, 1895. Oil.

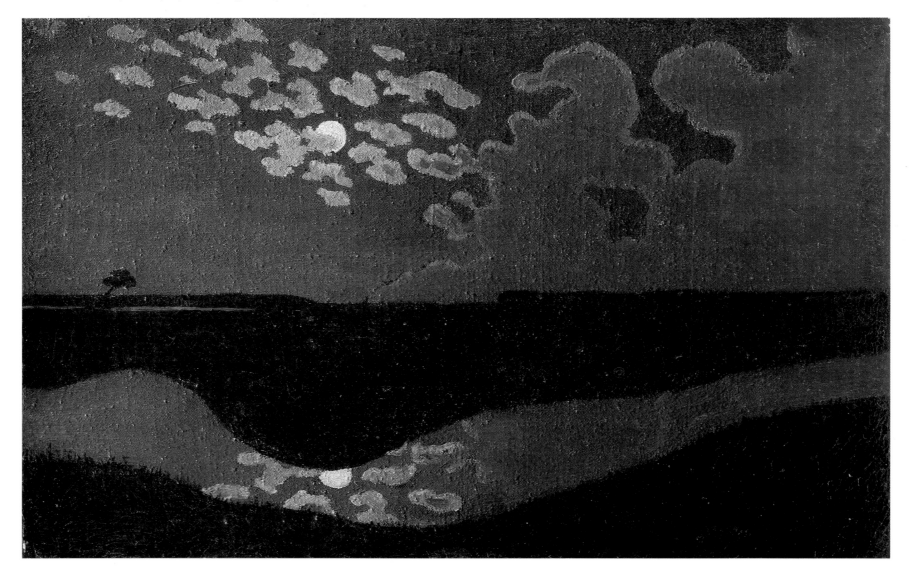

Hodler (who visited Paris in 1891 and 1892), to mention only three major painters of the period outside the French avant-garde, is the persistence of a symbolic content that is clothed in rather than signified by an essentially linear form, certainly, but one that above all shows a lively awareness of new discoveries.

A picture that invites comparison with Denis' *Procession* is the *Madonna of the Lilies* by Gaetano Previati (who exhibited in Paris at the Rose-Croix Salon in 1892 and was at that time one of the most advanced painters working in Italy). At the beginning of the 1890s his break with Naturalism left him undecided as between an avant-garde technique (the Italian version of Divisionism, which made its first appearance at the Milan Triennale in 1891) and a highly traditional iconography, in which the choice of the lily also goes back to Pre-Raphaelite painting. Similarly Giovanni Segantini (exhibited in Brussels by Les Vingt before being shown in Vienna by the Secession) was just beginning, also under the influence of Divisionism, to "formalize" his painting: it is significant that the windings of the intriguing red veil worn by his *Dea d'Amore* (*Goddess of Love*), which he painted in 1894, and the oval frame that is also intended to reinforce her plastic autonomy are the product of later modifications (1897).

Giovanni Segantini (1858-1899): Dea d'Amore (Love Goddess), 1894-1897. Oil.

Johan Thorn Prikker (1868-1932):
The Bride, 1892. Oil.

Ferdinand Hodler (1853-1918): Eurhythmy, 1895. Oil.

I aim at a powerful unity and religious harmony. What I want to express and bring out is what is within us, what makes us fellow men: the likeness between human beings... I brush aside accidental reality, small effects, witty strokes, little sparks. The manner of painting is subordinated to form. Whatever may distract the spectator from the whole, I suppress.

Ferdinand Hodler, "My Present Tendencies," winter 1891-1892.

In Northern Europe the characteristic example of Johan Thorn Prikker, who arrived in Belgium from Holland in 1893, shows the same difficulties in resolving these contradictions in the absence of the key notion of the "pictorial equivalent." His *Bride*, exhibited in Brussels by The Twenty, is baffling in its abstraction, precisely because it lacks the essential: the organization of the surface by means of "colours assembled in a certain order." Abstract but isolated, spiralling in a space that remains three-dimensional, the line, in order to be understood, can relate only to the multiple symbols—and how figurative and suggestive they are! —in the foreground and background of the picture (turgescent buds, the bride's veil and garland, the crown of thorns of the crucified Christ, candles, columns). Only a switch to the applied arts and complete decorative abstraction, particularly in contact with Van de Velde, enabled Thorn Prikker to extract from this erotico-mystical hotchpotch the wealth of ornamental material it so chaotically contained (the arabesque, the two-dimensional stylized flowers, the stippled mosaic background). With the "linear Symbolism" that we also find in his fellow Dutchman Jan Toorop, the field of the painting, whatever the strength and interest of the impulses informing it, has yet to be brought completely under control.

In this direction it was possibly the "Parallelist" aesthetics of Ferdinand Hodler that represented the most notable advance around this time, outside France. When his *Eurhythmy* was shown at the Paris Salon in 1895, it attracted less attention than his *Night* had done when exhibited in the same place in 1891. Working in the tradition of Puvis, Hodler had so far been closer to the "international Symbolism" of the Rose-Croix Salons (in the first of which he too participated in 1892): it was not in Paris but in Munich that he was to receive recognition in 1897 for the two paintings just mentioned. Nevertheless, if *Eurhythmy* represents "mankind's march towards death," the elimination of anecdotal content, the simplified shapes, the reduction of depth, and above all the rhythmic repetition that now formed the basis of this painter's compositions—and was what determined the title of the work in this case—are not unrelated to Denis' *Procession Under the Trees*, from which the only thing that separates us is the insistent realism of the details, particularly of the figures. A replica of Hodler's *Chosen One*, completed in the previous year, was to fit without difficulty into the Art Nouveau décor of the Hohenhof, which Van de Velde built at Hagen for Karl Ernst Osthaus in 1906-1907. And Hodler needed only to abandon his realistic old men, doubly turned towards the past, in order to participate fully in the art of the future. This he accomplished with *Day*, which was shown with *Eurhythmy* and *Night* at the Paris World's Fair in 1900 and rewarded with a gold medal, thus taking on a threefold symbolic value on the threshold of the new century.

Robert Burns (1869-1926):
Illustration for the book *Natura naturans*, 1891.
Published in *The Evergreen*, Edinburgh, spring, 1895.

Books,
Prints
and Posters

HAT the very extensive domain of works on paper should have become a favourite area of experimentation for the new art during this period, comes as no surprise. There are many reasons—the more obvious flatness of the support, the more direct way in which the artist's drawing relates to it, in the case of prints the very technique of printmaking, which by definition imposes flat tints and linear shapes, and in the case of books and posters the connection with the text and more generally with the setting of life —why books, prints and posters, which from the beginning were closely associated, provided the earliest homogeneous field of application for the new aesthetics.

The example of Maurice Denis is wholly typical in this respect. As early as 1890 his seminal essay on Neo-Traditionism came to grips with the problems of illustration. In the case of the book, the presence of a text makes it possible to tackle the crucial question of the relationship between ornament and content head-on. Denis' answer was unequivocal, as it was for painting: an illustration must be conceived independently of the text, as a purely decorative "pictorial equivalent." Here, too, this manifesto of the book of the future clearly indicated that a new era had begun.

Denis supplied the earliest examples with his illustrations for Verlaine's *Sagesse*; these drawings were exhibited as early as 1891 but Vollard did not publish them until 1911. "One is aware of the expressive intensity of the drawings of shapes and patterns—and of the feebleness, on the other hand, of those into which the literary mind has introduced disparate elements," was the painter's comment. He followed this up by illustrating *Le Voyage d'Urien* (1893), one of the incunabula of Art Nouveau publishing, produced in close collaboration with its author, André Gide. In "decorating" two musical works by Claude Terrasse (*Petites scènes familières* and *Petit solfège illustré* in 1892 and 1893), Bonnard similarly asserted his desire to keep art independent of literature, as did Denis once again with his famous lithographed cover for *La Demoiselle élue* (1893), a cantata by Debussy based on Dante Gabriel Rossetti's "The Blessed Damozel."

It is not entirely by chance that this last example leads us to one of the inspirers of the Aesthetic Movement in Britain. Across the English Channel it was in fact the book that was to provide the medium for the few works of this period directly dependent on Art Nouveau. One was the curious *Natura naturans* of Robert Burns, drawn in 1891 and published in the Scottish review *Evergreen* in 1895, in which the fishes, swans, and waves reminiscent of Japanese prints and the still Pre-Raphaelite female figure are probably less important than the way in which the artist filled the page and the new relationship established here between figure and background (which is the drawing and which the blank field of the

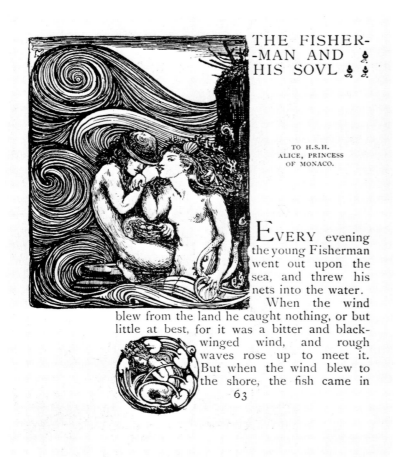

Charles Ricketts (1866-1931):
Vignette for Oscar Wilde's
A House of Pomegranates, London, 1891.

Aubrey Beardsley (1872-1898):
Illustration for Sir Thomas Malory's
Le Morte Darthur, London, 1893.

sheet?). And does not the title also have the sense of indicating the "genesis" of the work on the basis of its pictorial components alone, the white of the paper, the black of the ink, the line organizing them into homogeneous surfaces?

The same might be said of *A House of Pomegranates* by Oscar Wilde (another significant connection, repeated in 1894 with *The Sphinx*), which was illustrated in 1891 by Charles Ricketts, founder of *The Dial*, and which seems to meet every one of the demands formulated by Denis in the previous year with its scattering of asymmetrical vignettes and the quasi-abstract "embroidery of arabesques" of their motif—particularly when it comes to the waves in the story of the fisherman. The books that Ricketts subsequently published, from 1893 on, heralded the launching of his Vale Press in 1896. This private press developed the concept of the "total" book—paper, typography, page design, illustration, decoration, and binding—which Morris too had begun to put into effect with his Kelmscott Press, founded in 1891. But while the father of the Arts and Crafts movement remained faithful to his medievalist conception, which required the page to be crammed so full that the support was eventually forgotten, Ricketts usually took his cue from Blake and from Venetian incunabula to produce airy compositions with generous interplay between blacks and whites.

This was the course pursued even more radically by the young Aubrey Beardsley, the revelation of the years 1893-1894 with his illustrations for *Le Morte Darthur* and Oscar Wilde's *Salome* (he had met Wilde at Burne-Jones's house in 1891), before he turned after 1895 to a less curvilinear style of drawing that owed more to the often calculated "decadence" of his subjects. Beardsley took what he had inherited from the Pre-Raphaelites, from Morris, from Mackmurdo, from the Japanese, and above all from Whistler, and recast it in terms of a determinedly modern vision: the lovely Isolde at her writing-desk no longer owes anything to Malory's medieval text (which Beardsley boasted that he had never read), and even the Aesthetic Movement sunflowers that serve as a border for this sheet are overshadowed by the powerful contrast of black and white that gives the page its homogeneity and affirms its two-dimensionality by linking up the shapes and denying the very perspective of the room represented. *The Studio*, a London art magazine founded in 1893, began immediately to spread Beardsley's fame and at the same time propagate this purely decorative concept, later found throughout Europe.

With this new type of illustration, the book as medium retained the social scope that Morris for his part was trying to restore to it. The book retained it in so far as it henceforth constituted an object that could in turn be integrated into a decor, as witness the part the latter played in Huysmans' novel *A Rebours* (1884) or in Oscar Wilde's *Picture of Dorian Gray* (1891), which gave fresh impetus to book illustration in the 1890s. And it fell to the artistic press, then enjoying a boom, to propagate this new decor beyond the narrow circle of collectors—in particular to *The Studio* (1893), the most important of the international art reviews, but also to *The Yellow Book* (1894, with Beardsley as its art editor for the first year) and *Evergreen* (1895) in Great Britain, *The Chap Book* (1894) in the United States, *Van Nu en Straks* (1892) in Belgium, and in France *La Revue Blanche* (founded by the Natanson brothers in 1891, with Félix Fénéon as editor from 1894) and to a lesser extent Octave Uzanne's *L'Art et l'Idée* (1892).

Like books and art magazines, printmaking and posters were also enjoying a spectacular development. Following a prolonged period of lethargy, they too now experienced an awakening that was at the same time a transition to a new decorative conception, coupled with the introduction of new techniques and in particular with widespread use of colour lithography, which really "took off" in the 1890s.

In 1891 Fénéon hailed the bold use of colour in the posters of Jules Chéret, an artist to whom Seurat had already acknowledged

a debt. It was thanks to Chéret that poster design had thrown off every stylistic preconception and won freedom of colour by making simple, rational use of three-colour printing (1869). Here, then, was a particularly favourable terrain for the new aesthetics. Bonnard paved the way with his *France-Champagne* poster of 1891. But it fell to Toulouse-Lautrec, whose career, thanks to posters, really began at this date, to exploit the full possibilities of the medium by systematizing and structuring what in Chéret's work remains empirical and dependent on historical models from Watteau to Tiepolo. Toulouse-Lautrec's most famous prints, such as his first poster, *La Goulue au Moulin Rouge* (1891), date from this same period. As in *Le Divan japonais* (1892) and *Jane Avril* (1893) and in an even more concentrated form in *May Milton* (1895), the Japanese-influenced framing, the silhouette effects, the strong outlines, and the isolated, intense colours are all acquisitions of the new painting, with the addition in this case of integrated lettering. And with this new design, with this new decorative scheme in which, beyond the terms of the message, an exchange takes place between the product to be advertised and the consumer of that product, we are already in a very different world from that of Eugène Grasset, a more accessible, more famous, and (especially in the United States) more directly influential poster artist. The poster for Grasset's own exhibition, organized by the review *La Plume* in 1894 as part of the Salon des Cent, was more a prisoner of line and more timid typographically, primarily imposing an image—that of the turn-of-the-century *Parisienne*—rather than, as with Lautrec, revealing a new way of treating surfaces.

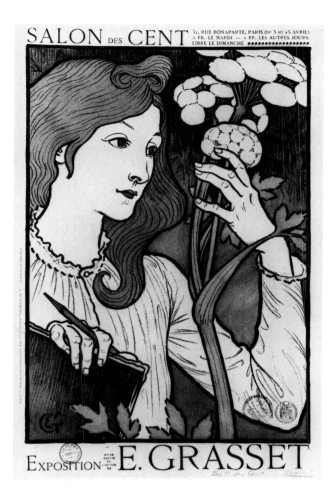

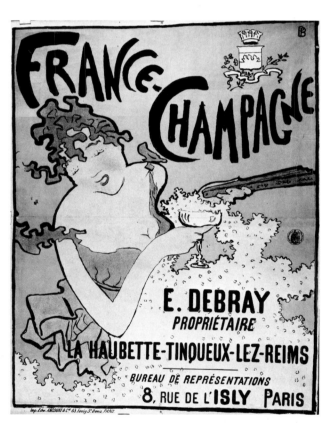

△△ **Eugène Grasset** (1845-1917):
Salon des Cent, Paris: Grasset Exhibition, 1894. Poster.

△ **Pierre Bonnard** (1867-1947):
France Champagne, 1891. Poster.

◁ **Henri de Toulouse-Lautrec** (1864-1901):
May Milton, 1895. Poster.

Equally characteristic in this respect was the appearance of the "mural print," an example being Chéret's four large decorative placards of 1891, which bore no text and really were meant for hanging up in interiors (they could be seen in Paris at the Chat Noir cabaret). Or, stemming inversely from the traditional print, the "decorative prints" of Henri Rivière (1896), intended from the outset to be hung on the wall. Similarly in the *Bois frissonnants* (Rustling Woods) by Georges Auriol, a six-colour lithograph published in 1893, it is a question not so much of elaborating a Symbolist composition as of placing the Charles Cros poem on the page, locating it in space. The concern with typography on the one hand (like Grasset, Auriol was to invent a new typeface, and its freedom of line and rhythm are already visible here) and on the other the stylized floral motif that frames the image and is at the same time projected on the dress of the woman who appears in it (as in Denis' print, *Magdalen*, published in 1892 and acknowledging a clearer debt to Gauguin) represent two ways of going beyond traditional genres to create a two-dimensional decorative scheme owing something to books, posters, prints and wallpaper.

In an equally subtle way it is sometimes an aspect of everyday life that is recast by the formalized design of the new print. In Vallotton's *Bath* (1894), a wood engraving published, like the last two, by *L'Estampe Originale*, which between 1893 and 1895 brought together all the different avant-gardes, regardless of technique, the delicate interplay of whites and blacks and the geometrical division of the floor and wall (contrasting with the arabesques of the wallpaper as the curves of clothing, body and bathtub contrast with this dense network of orthogonals) are two decorative suggestions that we find certain Viennese artists (Olbrich, for example, or Josef Hoffmann) using very effectively at a

Georges Auriol (1863-1938): Rustling Woods, 1893. Six-colour lithograph with a Charles Cros poem, published in *L'Estampe Originale*, Paris.

Félix Vallotton (1865-1925): The Bath, 1894. Woodcut published in *L'Estampe Originale*, Paris.

Will H. Bradley (1868-1962):
Cover for *The Inland Printer*, March 1895.

▷ **Charles-Marie Dulac** (1865-1898):
Canal Bank, 1892. Lithograph.

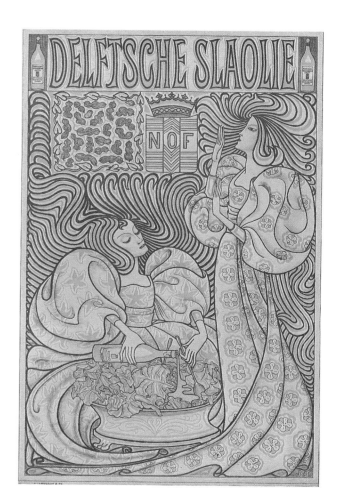

Jan Toorop
(1858-1928):
Salad dressing
poster, 1895.

later date. Vallotton's graphic work, here represented at its zenith, was widely disseminated by reviews both in Europe and the United States and exerted an influence far beyond printmaking.

In this field too, then, any Symbolist intention is to be ruled out or relegated to the background. For proof we need only compare the shapes—so similar and yet so different in inspiration and purpose—to be found in the prints of someone like Charles Dulac (a recent convert from Symbolism whom Huysmans in 1899 extolled for his "Franciscanism" and his "vegetation of souls in flower, quivering beneath an infinite sky") with the contemporary illustrations of Will H. Bradley, a prolific American poster-artist and designer whose early work was much influenced by Beardsley. Likewise in Jan Toorop's *Delftsche Slaolie* salad dressing poster we look in vain for any trace of the Symbolism of Maeterlinck or the Rosicrucians with which the artist was also associated and to which he sought to give expression in his paintings. The important thing here is the systematic use of the all-over design, which seeks to ensure homogeneity while leaving the surface of the paper quite visible. It is reinforced by the two-dimensional distribution of two complementary colours, violet and yellow, resulting in a simplicity and effectiveness that Toorop failed to achieve in his painting and that in this case arise out of the nature of the support used, the goal to be attained, and the technical adventurousness that this requires.

Photograph of the American dancer Loie Fuller
in her Serpentine Dance in the 1890s.

*And the depth of our emotion comes from the sufficient power of these
lines and colours to explain themselves, as simply beautiful and divine
in their beauty.*

Maurice Denis, *"Définition du néo-traditionnisme,"*
in Art et Critique, Paris, 23 and 30 August 1890.

Henri de Toulouse-Lautrec (1864-1901):
Miss Loie Fuller, 1892. Colour lithograph.

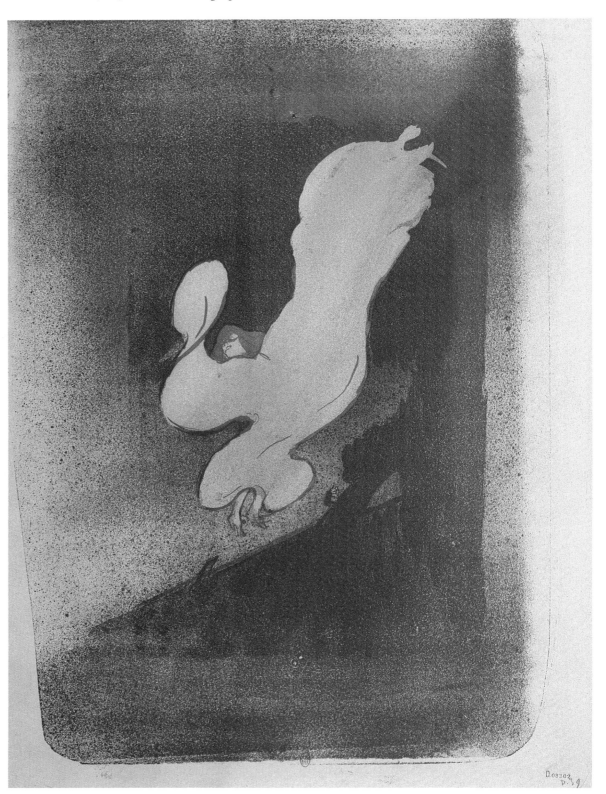

Will H. Bradley (1868-1962):
The Serpentine Dancer, 1894.
Published in *The Studio*, London,
and *The Chap Book*, Chicago.

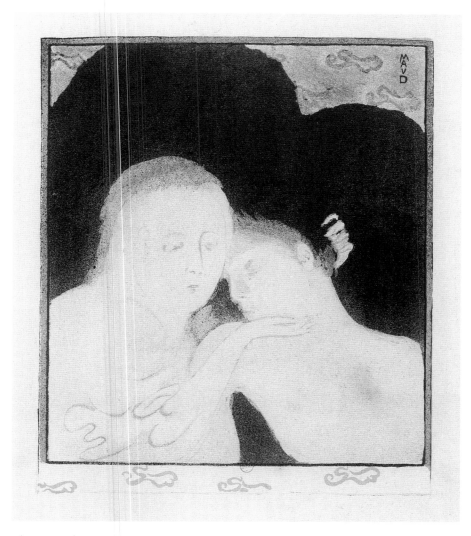

Maurice Denis (1870-1943):
Magdalen (Two Heads), 1893.
Colour lithograph published
in *L'Estampe Originale*, Paris.

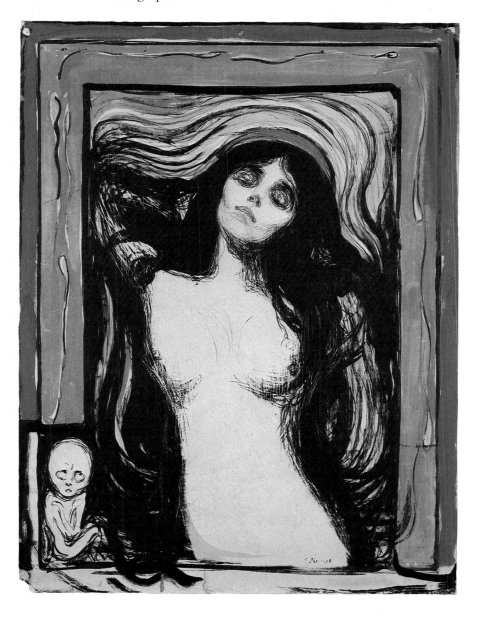

Edvard Munch (1863-1944):
Madonna, 1895-1902.
Hand-coloured lithograph.

This is the sense in which we should interpret the first wave of works inspired by the American dancer Loïe Fuller, who began performing in Paris with great success in the 1890s. These works appeared almost simultaneously from Lautrec and Bradley before the high-point of 1900 and shortly afterwards from Chéret. Doubtless the "figura serpentina" is important in itself, but it has less to do with any sort of decadent mannerism than with a concern to find some correspondence for the deployment of ornament within reality itself, the pledge of its most solid foundations.

Beyond its introversion and the dramatic sufferings that it reflects, Munch's extraordinary *Madonna*—in its lithographed version, the most satisfying and most beautiful because it is also the one most in tune with its technique and its support—does not possess any deeper significance, paradoxical though the comparison may seem at first. The astonishing discharge of spermatozoa that forms a Beardsley-style border around her also echo the waves that spread outwards from her body and from her enormous head of hair, falling naturally into the undulating shapes of the veil shown swirling round the body of Loïe Fuller. In terms of conception, the *Madonna* thus goes back—but how much more powerfully!—to the meaning of the *Natura naturans* of Robert Burns. And if Maurice Denis' *Magdalen*, a work that inhabits a quite different psychological climate, seems to us to attain the same universal value, it is because its arabesque in relation to its design and colour and the "tenderness" (the work's alternative title) connect-

ing them play the same key role in the immediate expression of a content that finds itself wholly displayed there. The same applies to Lautrec's *Loïe Fuller*, an even more abstract work than the foregoing and a long way from the sarcastic realism—as will come as no surprise now—to which the painter was condemned by other media. In these three seminal masterpieces, born of the surface of the paper and so passionately manifesting their loyalty to it, it is the very essence of Art Nouveau that stands revealed.

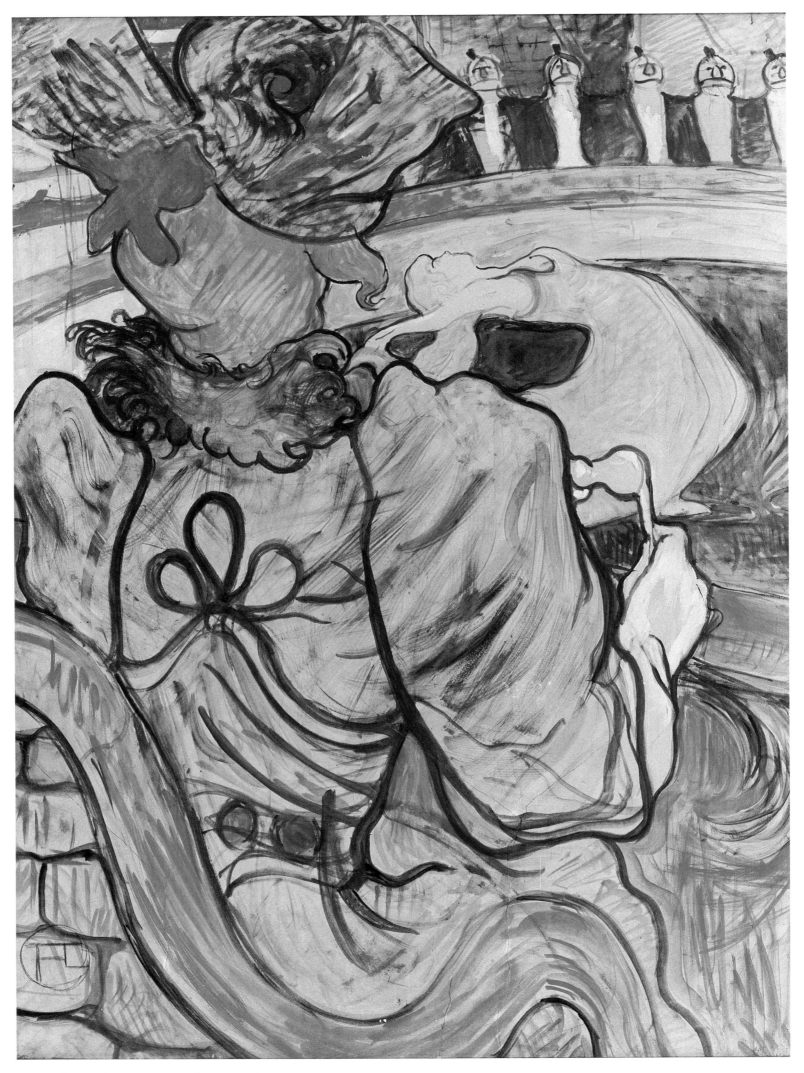

Henri de Toulouse-Lautrec (1864-1901):
At the Nouveau Cirque: The Dancer and the Five Stiff Shirts, 1891.
Oil.

The Expansion
of
Ornament

ITH the solid support of Art Nouveau to organize and ornament the picture surface and the sheet of paper, modern decoration was able to strike out to conquer the field of decorative arts proper—in an aesthetic perspective, therefore substantially different from that of the artisans of Arts and Crafts.

Here once more the example of the Nabis was decisive. Was it by chance if in the *Portrait of Madame Ranson*, as in the *Cup of Tea* exhibited in 1892 at the gallery of Le Barc de Boutteville and in many works by Maurice Denis of that date, the decorative elements (tapestry, dress fabric, form and tea-service decoration) take up so large a place? On this plane Gauguin had remained at the stage of a transient individual attempt, fundamentally divided between what should have been the logical culmination of his formal work and an ideology of revolt by definition incompatible with a truly social practice: "To think that I was born to create an art industry and that I can't bring it off. Stained glass, furnishings, faience, etc. That is where my abilities basically lie, much more than in painting proper" (Gauguin to Daniel de Monfreid, from Tahiti, August 1892). It was the Nabis who went on to implement this programme. Vuillard, Bonnard and Denis took up wall decoration from 1891-1892; Denis exhibited wallpaper designs in 1893; Ranson and Maillol devoted themselves to tapestry; Bonnard, together with Lautrec as we have seen, created the first new poster and designed furniture. All (as well as Signac, Auriol, Charpentier, Rivière and others) were very soon working for the theatre: the Théâtre-Libre of Antoine in particular (until 1894), then the Théâtre de l'Œuvre of Lugné-Poe. And it is characteristic to see this smooth transition to what was ordinarily considered, on the level of content, as the Symbolist reaction to Naturalistic theatre.

Most typical, however, is undoubtedly the move into stained glass. Actually, it marks the convergence of the aesthetic approach of the painters and the effort of the craft workers to get the maximum benefit out of techniques. Maurice Denis designed several fine cartoons in 1894, and we still have his large stained-glass window executed the following year for the Paris town house of Baron Denys Cochin. But it fell to the American, Tiffany, whose Tiffany Glass and Decorating Company was reorganized in New York in 1892, to carry out the commission given by the dealer Samuel Bing to nine artists of the French avant-garde (Denis, Ibels, Ranson, Sérusier, Vallotton, Vuillard, Toulouse-Lautrec and Grasset). The resulting stained-glass windows (since lost) were shown in Paris at the Salon of the Société Nationale des Beaux-Arts in 1895 before their exhibition at Samuel Bing's Salon de l'Art Nouveau at the end of the year.

The cartoon supposedly drawn for the occasion by Lautrec, *Au Nouveau Cirque* (At the New Circus), well conveys the intention behind this work. There we find the typical heavy outlining of Gauguin's disciples (and, taken over from ceramic "partitioning," the bruise-blue outline would thereby revert, with the cutting-out of these pieces to be "mounted," to its original vocation). The equalization of values and the reduction to six colours, whose thinning with spirits stresses their lightness, makes the reading of the forms difficult but answers to the decorative necessity. And the exaggerated back-arch of the dancer placed in the arena provides the core of a roll of arabesques that spread in the continuous intertwining of the hat, the hair, the pleats of the dress and the spectator's stall seat: a daring ornamental plan bordering on abstraction and going one better than the whiplash of Seurat's *Circus*.

Thus was resolved, through the natural embodiment of *style* in specific material, the major antinomy of the nineteenth-century stained glass: the stained-glass window-picture (the simple reproduction of a painting) or the archaeological stained-glass window (copying medieval windows). And we are already far from Grasset; from his famous *Spring* of 1894, whose colour mastery makes its decorative value, but which first displays motifs (Japanese-style irises, women draped in the Burne-Jones manner) in a simplified but still naturalistic composition. "Art Nouveau" faced by the first manifestations of "1900 Art": it was Grasset, who, with his fifty storiated stained-glass installations, was capable of answering the requirements of traditional iconographic programmes that, on the contrary, were excluded at that time by the ornamental abstraction of the Nabis and their friends.

The renewal of interest in applied arts then came to meet the expansion of the art of ornamenting. In 1891 the newly formed Société Nationale des Beaux-Arts (of which Bracquemond, with Rodin, was one of the founding members) for the first time accepted art objects (notably by Gallé) at its Salon du Champ de Mars. And the official Salon on the Champs-Elysées soon followed suit. The idea was now accepted, as Henri Rivière stated in 1895, that "a beautiful table was every bit as interesting as a statue or a painting." It was in this new context that the future School of Nancy began to appear as a coherent group. As in the case of Grasset, in 1894 and, soon after, Rops, Ensor and Mucha, the highly literary review *La Plume* devoted a special issue to the "Lorrain School of Decorative Art" (November 1895), which had held a group exhibition at Nancy the previous year.

The place of publication and the groupings are not fortuitous: Gallé's glasswork continued also to be divided between conflicting aspirations. It began at the start of the 1890s to free itself from traditional schematic conceptions—from the horizontal banding of vases, for example—in favour of organic forms more in keeping with its motifs. And its three main technical innovations ("wheel-engraving," which leaves the decoration to the relief, "acid-engraving," which permits the opposition of matt and glossy surfaces, and "lined glass," which enriches the colours from the material itself) indeed correspond to a rational and true utilization of process. But on the other hand, Gallé did not give up literary allusion and symbolism (that of Rodenbach and Rollinat, in particular, as Jacques-Emile Blanche rightly points out), which then shows itself in his writings (published in the *Revue des Arts Décoratifs* in 1892 and *La Plume* in 1895) and imposes restrictions alien to the nature of the work.

Eugène Grasset (1845-1917):
Spring, 1894. Stained-glass window.

The portrait made by Victor Prouvé of his friend Gallé in 1892 gives a good account, by its very form, of the limits placed on decorative invention by this ardent quest for the poetic. A far cry from the research of the Nabis (modelling, perspective, colours), here everything is based on the apt description of the man portrayed: the gesture of a demiurge (with a conspicuously magnified hand), his intent and inspired gaze, the luminous halo that is there to render him holy more than to seek an accommodation with the arabesque of the plants.

And yet the Parisian movements could not leave the artists of Nancy unmoved. In the binding executed by René Wiener in 1894 for *L'Estampe Originale* from a lithograph by Camille Martin that was published in it, there is a rigorous division into flat tints corresponding to the material and to the place for which the object is destined. But this fine avant-garde work—its ornamental transposition of motif, the outlining and the simplification of line, the quite intentional asymmetry and even the handling of the letters of the title—has its direct origin in the famous lithographed cover made by Lautrec in 1893 for the first volume of *L'Estampe Originale*: the printing press of Père Cotelle and the hat of Jane Avril there formed a similar decorative arrangement.

The decorative artist has a mission to fulfil, a higher one, it may be, than bringing joy. He holds illusion in his hands, but also realities, promises and consolation, mirage and balm... It is not enough for the music to lull me for a moment, as David with Saul. The decorated object has to console me with smiling enchantments, with colours and rainbows, with forgotten words blended into the shading which makes me glimpse and believe in a forward turn of the road and access to promised lands "where not death nor grief shall be..." What matters the painter to me? I want the decorator...

Emile Gallé, "Les Salons de 1897,"
in Gazette des Beaux-Arts, Paris, September 1897.

Victor Prouvé (1858-1943):
Portrait of Emile Gallé, 1892. Oil.

René Wiener (1856-1939):
Binding for a portfolio of issues
of *L'Estampe Originale*, 1894,
from a lithograph design by
Camille Martin.

Outside France, object and decoration were in a comparably ambiguous situation. The fact that on the sides of Charles Ashbee's bowl (executed in 1893 by his Guild of Handicrafts) there is a waviness of lines close to that which animates the dress of Lautrec's female spectator does not justify speaking here of the same use of ornament. Despite the refinement of the triple arabesque uniting the feet of the bowl with its crosspiece and the incision of the cup, the persistent symmetry of the design shown in the decorator's remarkable pieces of jewellery, their precious elegance in the restrained use of the material and in particular those embossed silver leaves that both catch the light and stress the craft-industry character of the product, all refer back to an aristocratic version of Arts and Crafts, as well as to the great classical works in precious metals, more than they do to the recent conquests of Art Nouveau.

The same is true of Voysey's famous wallpaper with the *Water Snake* pattern (published in *The Studio* in 1896 but no doubt executed about 1893). Lighter and suppler, like those of Mackmurdo as compared with Morris, but also restrained in its expansion and moderate in its stylization, it had in fact but little future in England, even though it made an impression on the Continent. Voysey himself stated in *The Studio* (1893) that his wallpapers were only a palliative for the poverty of contemporary furniture and that, for his part, he preferred the absence of all ornament, as indeed appears in his own domestic architecture, on the fringe of Art Nouveau.

Jan Toorop (1858-1928):
Design for a mirror, c. 1893.

Charles F.A. Voysey (1857-1941):
Water Snake wallpaper, c. 1893.
Published in *The Studio*, London, 1896.

Hermann Obrist (1863-1927): Cyclamen Embroidery, 1895.

Charles R. Ashbee (1863-1942): Silver Bowl, 1893.

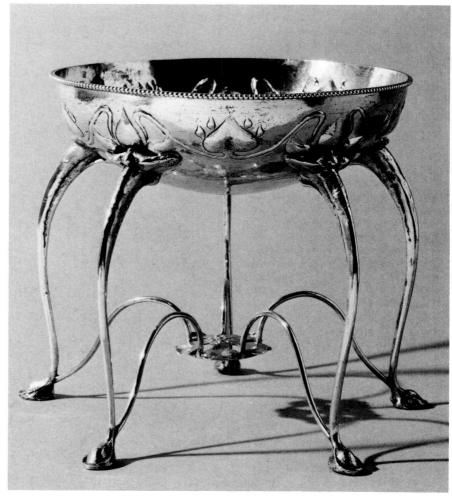

And despite opting for asymmetry, Jan Toorop found it harder than in his posters to transcend the symbolist overtones of his Anglo-Balinese motifs in the mirror which gave the final touch to the room designed by Gerrit Willem Dijsselhof for a private patron in Amsterdam: the one outstanding achievement of Art Nouveau in Holland at that time (1890-1892). This "Peacock Room in miniature" (Robert Schmutzler) is more in keeping with the spirit of Arts and Crafts than with the Aesthetic Movement.

It is quite a different matter, however, when we come to the embroideries of Hermann Obrist, which serve on the contrary as the prelude to a much more radical expansion of ornament in the Germany of the later 1890s. In these pieces executed in the workshop which Obrist founded in Florence in 1892 and transferred to Munich in 1894, ornament in a way generated itself and created its own space. And contrary to the glasswork of Gallé, the motif, although it still confessed to its plant-life origin (from the root to the bud and the flower), nevertheless turned its back on Nature. The fact that Obrist's famous *Cyclamen* was afterwards christened "whiplash" (*Peitschenhieb*) by the art critic writing in *Pan*, Georg Fuchs (1896), is entirely revealing in this respect: its unfolding line no longer owes practically anything to the plant which inspired it —and whose cross-shaped stem is nevertheless, in itself, far more promising than Mackmurdo's tulips are—, and Obrist's cyclamen thus fulfils completely the ornamental potential of the flower held by Félix Fénéon in Signac's 1890 portrait of him.

Louis Sullivan (1856-1924):
Guaranty (Prudential) Building, Buffalo,
New York, 1894-1895: detail
of entrance ornament.

Thus we are led to the last area into which ornament expanded, to its supreme goal: architecture, and the singular place given to it by Louis Sullivan in his buildings. It is an obvious and often emphasized paradox, in fact, to see those great commercial buildings of the 1890s, whose rational, simple and monumental structure corresponds to function and exposes the interior layouts, covered with a proliferating ornamentation! And yet the association of ornament with a rational structure follows directly from Viollet-le-Duc, whose faithful disciple Sullivan set out to be.

The American architect's ornamentation has been objected to for its symmetry and its "Celtic" packing, a sign of addiction to the past; and it is quite possible that on this point Sullivan has debts to Morris. The Golden Door of Sullivan's Transportation Building at the World's Columbian Exposition of Chicago in 1893 (admired by the French and afterwards presented at Paris with photographs and casts) provides an extreme example, not exempt from contradictions besides (the phylacteries in the corner piers, the lateral kiosks). But we need only consider, in 1894-1895, the admirable detail of the Guaranty Building in Buffalo, one of the

masterpieces of the Chicago school, with its metal skeleton and the terracotta sheath (it, too, manufactured industrially) which makes no claim to conceal the skeleton and whose lightness is in accord with its single function of insulation and filling, to see how ornament can be born organically from matter without contradicting its rational organization. In this masterly alliance there is indeed, before Guimard (more than one of whose ornamental designs is prefigured here) and at the same time as Horta, one of the most original and solidly based creations of Art Nouveau. According to Sullivan's celebrated formula (1895), "the form follows the function" in the biological sense of the terms; and it may be said, perhaps still more clearly, that in its very ornamentation it "fulfils its structure" (François Loyer).

In 1893 Samuel Bing was on a mission to the United States. In Bing's remarkable report on what he saw (*Artistic Culture in America*, published in 1896), Sullivan has his place alongside Tiffany. Both would be no strangers to the Salon de l'Art Nouveau which Bing opened in Paris at the end of 1895, and which proved to be the culminating point of this expansion of ornament.

Louis Sullivan (1856-1924):
The Golden Door, entrance of the Transportation Building,
World's Columbian Exposition, Chicago, 1893.

*There exists a peculiar sympathy between the ornament and the structure...
Both structure and ornament obviously benefit by this sympathy; each
enhancing the value of the other. And this, I take it, is the preparatory basis
of what may be called an organic system of ornamentation.*

Louis Sullivan, "Ornament in Architecture,"
in *The Engineering Magazine*, August 1892.

Henry van de Velde (1863-1957):
Garden at Kalmthout, c. 1892. Oil.

Clearing Up
Art in
Belgium

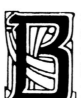RUSSELS, on neutral ground, halfway between English aestheticism and French rationalism, proceeded to make a synthesis of the preceding elements and provide the decisive send-off. And yet the rise of Brussels as a modern centre of innovation had quite modest origins: a magazine, *L'Art Moderne*, and an artistic circle, the Salon des Vingt (better known as "Les XX"), taken over in 1894 and continued by the Libre Esthétique.

Alongside *L'Emulation*, the architect's journal founded in Brussels in 1874 which defended the rationalist point of view, *L'Art Moderne*, started in 1881, supported the pictorial avant-garde. Félix Fénéon, for example, published in it his seminal article on Neo-Impressionism in 1887. Its founders, Octave Maus and Edmond Picard, two art-collecting lawyers, had as their only goal the rejection of conformism and the quest for novelty, the "free aesthetic" that would at first characterize the Belgian movement: "Art for us signifies the opposite of every recipe and every formula. Art is the eternally spontaneous and free action of man on his milieu, in order to transform and adapt it to a new reality" (*L'Art Moderne*, No. 1, 1881).

From the magazine was derived, in 1884, the group of The Twenty ("Les Vingt," from the number of its founders) and the establishment of an annual Salon in Brussels which, until 1893, would exhibit the work of the most important painters and sculptors of the European avant-gardes. That was the main point: while in London and Paris (in the Salons, for example), the novelty of the works tended to vanish behind the number of productions exhibited and the conflicting tendencies, The Twenty would give, so to speak, only the quintessence of them, which made the convergence of aesthetics easier to observe. They had available for that purpose attentive observers like Fénéon, who found there another platform from which to defend the Divisionists, or the poet Emile Verhaeren, the editor of *L'Art Moderne*, who as early as 1886 was himself among the first admirers of Seurat.

Rodin was thus exhibited at the first Salon of The Twenty. Then came the Impressionists: Cézanne, Redon, Toorop, Segantini. But the accumulation of names is less significant than the simultaneous presence in that place of the French and English avant-gardes; it was their conjunction that was decisive in the formation of Art Nouveau. For on one hand there was Whistler among the exhibitors, every year from 1884 to 1894, and from 1892 the men from Arts and Crafts: Morris, Ashbee, Image, Sumner —and in 1894 Beardsley, with the drawings for *Salome* and *Le Morte Darthur*. On the other hand, the big Seurats, including the *Grande Jatte* in February 1887 (with the expected outcry: Van de Velde reports that on the day of the private view the painting was assaulted with blows from an umbrella), and finally seventeen

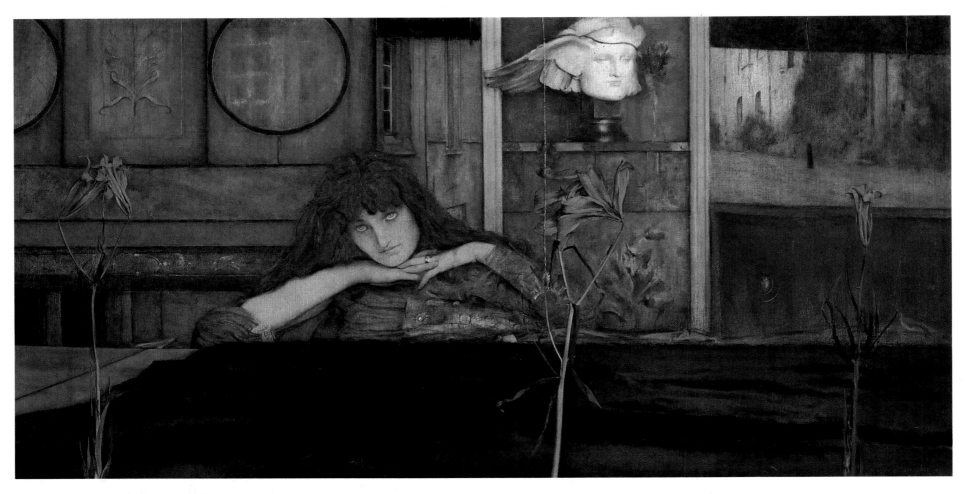

Fernand Khnopff (1858-1921):
I lock my door upon myself, 1891. Oil.

Georges Lemmen (1865-1916):
Catalogue cover for the exhibition
of The Twenty, Brussels, 1891.

smaller Seurats in 1892 (including *Circus* and *Woman Powdering Herself*), Signac's *Portrait of Fénéon* the same year; and in addition Gauguin in 1889 (with his *Vision After the Sermon*) and 1891, Van Gogh in 1890 and 1891 (a retrospective show), Maurice Denis in 1892, Toulouse-Lautrec once more in 1892 and 1893, and so on.

La Libre Esthétique, founded in Brussels in 1894 by Octave Maus alone, took over from The Twenty, with a more revealing name which assumed a symbolic value. But it came out still more doggedly in favour of the decorative arts which The Twenty had been the first in 1891 (at the same time as the Société Nationale des Beaux-Arts in Paris) to exhibit together with paintings (that year it was ceramics by Finch and by Gauguin and books by Crane, including *Flora's Feast*). The Libre Esthétique programme by Maus states this clearly, announcing an "annual Salon which will combine all the expressions of Art: painting, sculpture, graphic arts, applied arts." And starting in 1894 it exhibited Ashbee's silverware alongside wallpapers and books by Morris and the first suite of furniture by a Belgian artist: Gustave Serrurier-Bovy. Other exhibiting societies were founded in Brussels the same year with the same goal: the Association pour le Progrès des Arts Décoratifs, for example, and Pour l'Art, which welcomed artists from Nancy.

These events developed in a hostile climate. After the scornful reception given by the Brussels public to the *Grande Jatte* in 1887, Gauguin in 1891 was termed a "pornographic image-maker," an "infamous dilettante"; Seurat was still classed among the "mad masters." But that was precisely the point. The avant-garde, which had long since gone on the warpath against what Verhaeren in 1886 had called the "excrements of folly" and "Belgian bourgeois stupidity," found in this crass hostility the justification of its efforts, and it was *L'Art Moderne* itself which, in 1891, published the anthology of these insults. The conversion of young artists was thereby all the more rapid, especially to Divisionism, which

seemed the newest and most firmly structured: it was very quickly taken up by Van Rysselberghe, Lemmen, Finch and Van de Velde.

The essential point, however, lay elsewhere. From the simultaneous observation of so many works of such different inspiration, techniques and personalities, the Brussels art world became conscious, more acutely than in Paris, of their decorative scope, their ornamental value, their organizing function, their irresistible expansion outside the framework and conception of traditional painting. In 1891 Verhaeren reached the conclusion that the work of Seurat, at his death, "by its investigations of line was achieving arrangement and composition, a broad and ideal decoration" (*Société Nouvelle*, April 1891). From Gauguin and Van Gogh, Lemmen and Van de Velde (accepted together into The Twenty in 1888) took over only their line and vermiculation, which unified surfaces and ensured the cohesion of the design—and soon, for Van de Velde, the coherence of the reflected life-experience. As for the English movement, the showings in Brussels, especially after 1892, of Whistler, Morris and Beardsley, favoured the formation of the project at once aesthetic and decorative, as well as ethical and social, which was to be the lifework of Van de Velde.

In conjunction with the political consciousness of these enlightened intellectuals and patrons, in a Belgium on the point of Continental industrialization and aspiring more strongly than London and Paris to build a new world, the absence of artistic ideology in The Twenty, their "eclecticism," and even more that of the Free Aesthetic group, explain why the true birth of Art Nouveau would happen in that particular place and why it was in Brussels that forms were first able to try to seize power.

From the crossroads of this dual French and English contribution two opposed currents could spring: that of a symbolist painting tucked into its shell and violently anti-realist, and that of Art Nouveau, converted to the reorganization of the real world. Fernand Khnopff (founding member of The Twenty and participant in La Libre Esthétique) was without doubt the best representative of the former. And in his painting *I lock my door upon myself*, one of the most accomplished, in so far as its introspective theme least contradicts the necessary autonomy of the form, the Pre-Raphaelite and Symbolist reference is sufficiently indicated in the title to explain the painter's success in Paris with Péladan and his Rosicrucian followers. But it is also worth looking at for its stripped-down and linear interior, its flowers of a delicate metallic tincture heralding also the stained-glass windows of Koepping, its pale colours, and that network of rectangles in frontal view which in its way integrates it into the décor: Art Nouveau represented, if not truly created and experienced.

It was four Belgian masters who would give Art Nouveau its wings: Serrurier-Bovy (with his room for La Libre Esthétique in 1894), Hankar (with his wrought-iron decorations for it), Van de Velde, and the early Horta, whose Tassel House (then at 12 Rue de Turin, Brussels, now 6 Rue P.E. Janson), in 1893, is generally considered to be the movement's founding work.

On the outside, however, with that classic symmetrical scheme in which there is again found the typical bow-window of the Brussels streets, the Tassel House seems at first only to proclaim the truth of its composite materials: stone, wood, glass, iron (with the beam-rivets left exposed). But the closely-knit composition insists too on the unity of the volume, by the details of the ornamentation (the scrolls, for example) and that scaled-down relief which fits the projection into the smooth wall of the façade. Nor does the symmetry allow anything to be overlooked (notably with the mezzanine, and unusual unequal openings) in the nonconformism of the interior layout.

Henry van de Velde (1863-1957): Cover for Max Elskamp's *Dominical*, 1892.

Van de Velde thus moved away from his friend Georges Lemmen who, from his abstract design for the exhibition catalogue of The Twenty in 1891, now seemed, as his cover for *L'Art Moderne* testified, to wish to proceed the wrong way round and suck into the page, where their mystical impulse became tangled confusion, the twistings of Horta's ironwork. And these features were further intensified in the title of *Van Nu en Straks* (From Now to Tomorrow), the Flemish avant-garde review launched in 1893.

But the English example, of William Morris especially, led Van de Velde to place the problems on a more general theoretical plane. Horta built; he, Van de Velde, explained himself, in *L'Art Moderne* in 1893 (notably with a "First Sermon on Art," a most revealing title) and in his Libre Esthétique lectures in 1894. This "clearing up of art" (*Déblaiement d'art*, as he called the most significant of these lectures, published the same year in a booklet) would acquire an importance comparable to that of Maurice Denis' writings, of which it provides the prophetic and exalted counterpart. Here Van de Velde definitively rejected historicism, condemned with unusual force the cult of individual arts founded by the Re-

Victor Horta (1861-1947): Tassel House, Brussels, 1893. Staircase.

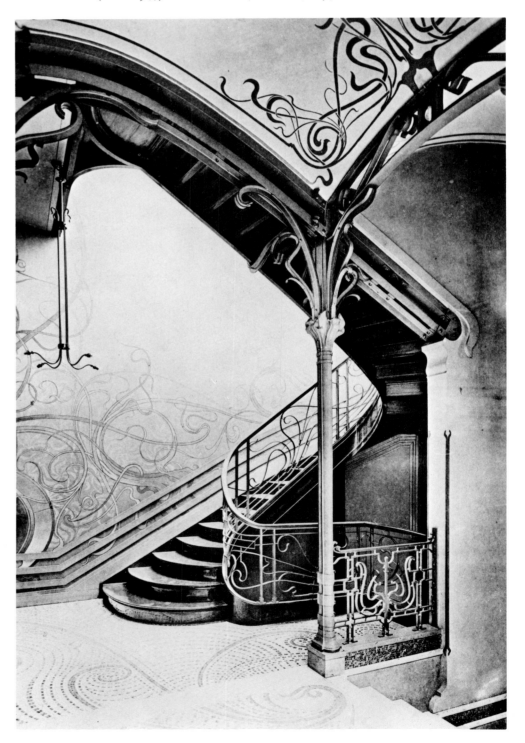

On the contrary, the interior of the Tassel House, at the outlet of the entrance staircase, seems at first dedicated to the expansion of the ornament. But if the proliferating line refers back to that of the painters, it is in fact really a case of the tectonic ornament of Viollet-le-Duc, which brings out the structures without dissimulation (cast-iron columns and small iron girders, with the daring to expose them thus naked in a private house). Still more, the unchanging arabesques which, from those structural elements, spread over the mosaic flooring and accompany on the wall the rise of the staircase, display the spatial continuity which is indeed the primary intention of the architect, whose "flexible plan" is entirely justified by the functions, and who derives maximum advantage from the narrow building lot, its space without partitions punctuated rhythmically only by the differences in levels, and precisely that transparent metallic ornamentation, its original light wells (the glass roof of the greenhouse and that of the stairwell). Nor does the strange suspension of the entrance landing, with its unshaded bulbs, have other meanings: it develops in three dimensions what is stated in two on the wall placed behind it.

After this exemplary display of Art Nouveau by Horta, it was left to Van de Velde, however, to give the movement a theoretical foundation. Still more than Horta's, Van de Velde's career was then highly significant: academic training in Paris as a painter (with Carolus-Duran in 1884-1885), conversion to the Pointillist technique of Seurat (1887) and founding of a group which in *L'Art Moderne* gave rise to that precursory title coined by Edmond Picard, "Art Nouveau"; then came Van de Velde's almost simultaneous discovery of Van Gogh and the Arts and Crafts movement. One common theme: the revelation that form, in particular the line, has first an organizing and unifying function—as in fact it appears in Van de Velde's paintings of the early 1890s and again in the cover of *Dominical* by his friend Max Elskamp, in 1892, where the leaves of Gauguin's *Man With an Axe* become in turn the outgoing tide on the beach, the setting sun, clouds in the sky and finally typography, playing down the naturalistic origin of the motifs in favour of the decorative unity of the whole.

naissance ("that impious disintegration") and makes the synthesis of recent contributions from France (from Chéret to Gallé and Wiener) and from England (from Morris to Crane and Voysey), finally placing his hopes in the United States ("Art Nouveau will be stammered out by an innocent and delighted people"). He also drew the logical conclusions: easel painting had to be abandoned for the arts of decoration; art would be regenerated by its contact with the people ("And for that it must surrender every form that would destine it for only one among us"), by the stirring appeal for an "ornamental concept, single and commanding."

Van de Velde himself practised what he preached, distributing in his booklet an ornamentation by now totally abstract, and above all renouncing his career as a painter. One of his last mural works, *The Angels' Vigil*, was composed of appliqué fabrics on canvas: the cartoon was put on show at the Salon of The Twenty in 1892, and the tapestry was woven the following year. It did not conceal what it owed to the Pont-Aven School (for its uniform flat tints and its colours), to Maurice Denis (for the rejection of symbolism, the search for pictorial equivalents and the Neo-Traditionist association of dresses and tree-trunks), to Van Gogh, not to mention Toorop (for the even lines that furrow its path). But this angels' vigil was also the eve of combat, and the newborn sleeping Infant a promise of a new Gospel, that of Art Nouveau: with Van de Velde the search for a free aesthetic ended in the advent of a militant art.

Ornamentality struck them therewith as the unsuspected womb which fed with blood all the works which men have tried to classify under justificatory names, but to which one name alone applies, a name intimating and magnifying the return of the prodigal sons: decoration!

Henry van de Velde, Déblaiement d'Art, *Brussels, 1894.*

Georges Lemmen (1865-1916):
Cover for *L'Art Moderne*, Brussels, 1894.

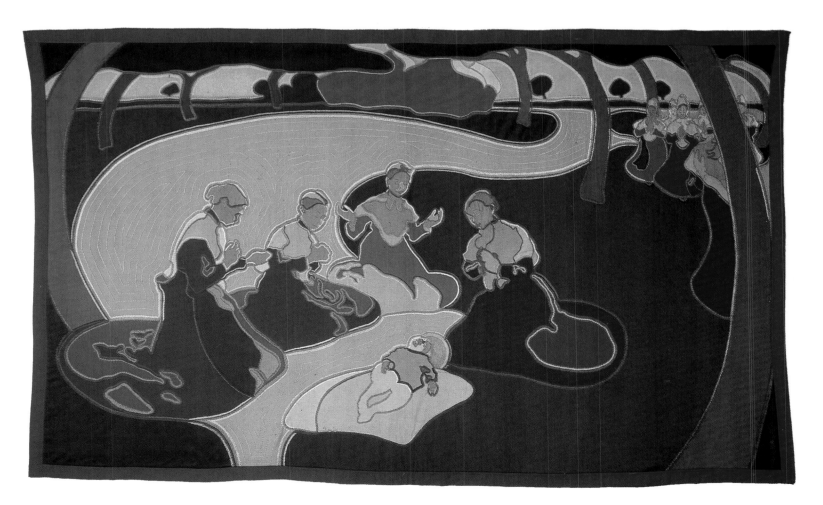

Henry van de Velde
(1863-1957):
The Angels' Vigil, 1893.
Embroidered
wall hanging.

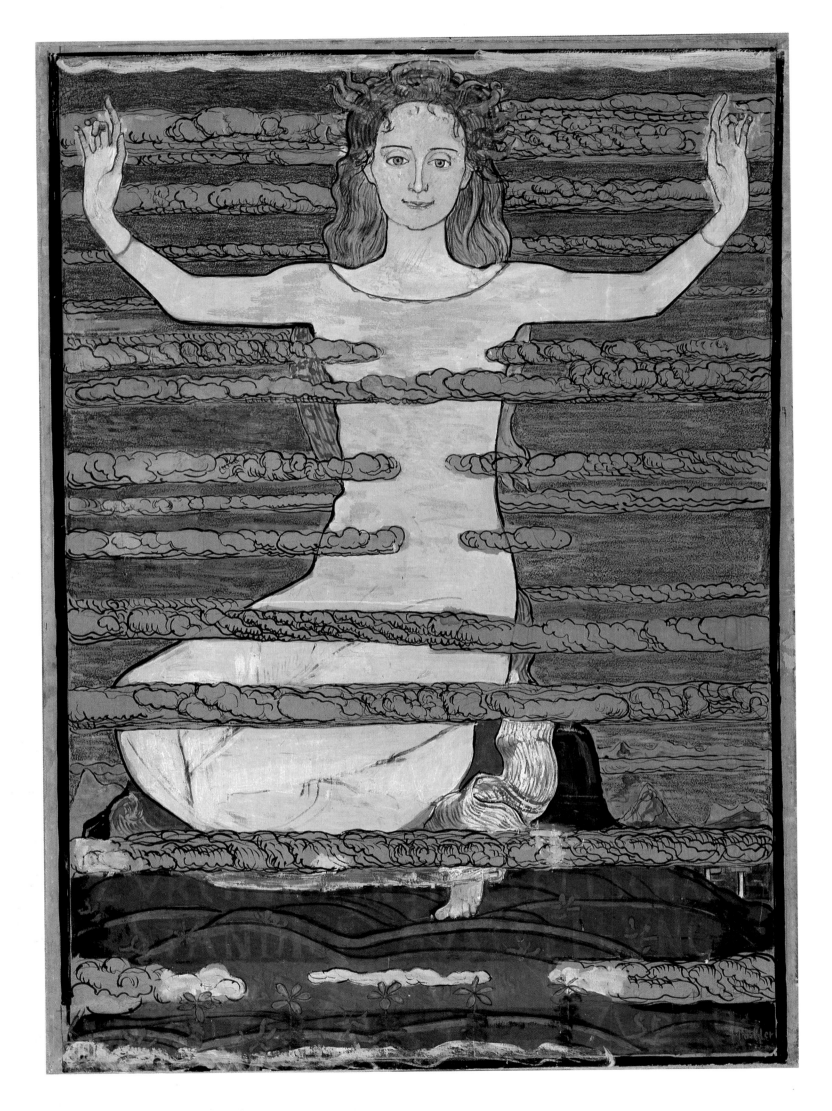

Ferdinand Hodler (1853-1918): Poetry, 1897.
Black and colour crayons, ink, watercolour, gouache, oil.

Spring

"What we experienced around 1894 can only be compared to the relief we feel at the first signs of spring," Van de Velde was to write in 1929 in one of his many retrospective reviews of this decisive period. First Belgium, then France following its example, took the lead in deliberately and systematically developing principles put forward previously by independent artists working outside the establishment or in open rebellion against it. Economic and social-cultural factors help to explain these oscillations from centre to centre, in particular this unexpected spring in Belgium, the only country at that time, to quote Van de Velde again, where the movement "was directed towards the future and towards a bolder and more adventurous goal, namely a new style."

The leading role was, however, taken by individual artists, and these have to be chosen as guides—without confusing what is due to the artists themselves and what stems from the moment they most effectively embody: "a universal style can be born of strong conviction and imperious resolutions," as Van de Velde was later to recall. In Belgium, Van de Velde himself and Horta, brother artists and opponents, immediately introduced their highest ambitions and finest achievements into the very heart of Art Nouveau. In France, in a more uncertain context, the architect Guimard made a parallel effort, and the dealer Bing, a naturalized German, raised at once on the commercial level the complex problem of the relations of art with the society it sets out to reform, which imposes its own conditions on it in return. Through the breach thus opened rushed "a swarm of individuals who, carried away in a frenzy of recovered freedom, the joy of having shaken off the nightmare imitation of styles, were for some time no longer going to take account of anything remotely resembling discipline, any measure, or anything whatever that might look like interfering with this freedom" (Van de Velde)—with, it should be added, unequal success.

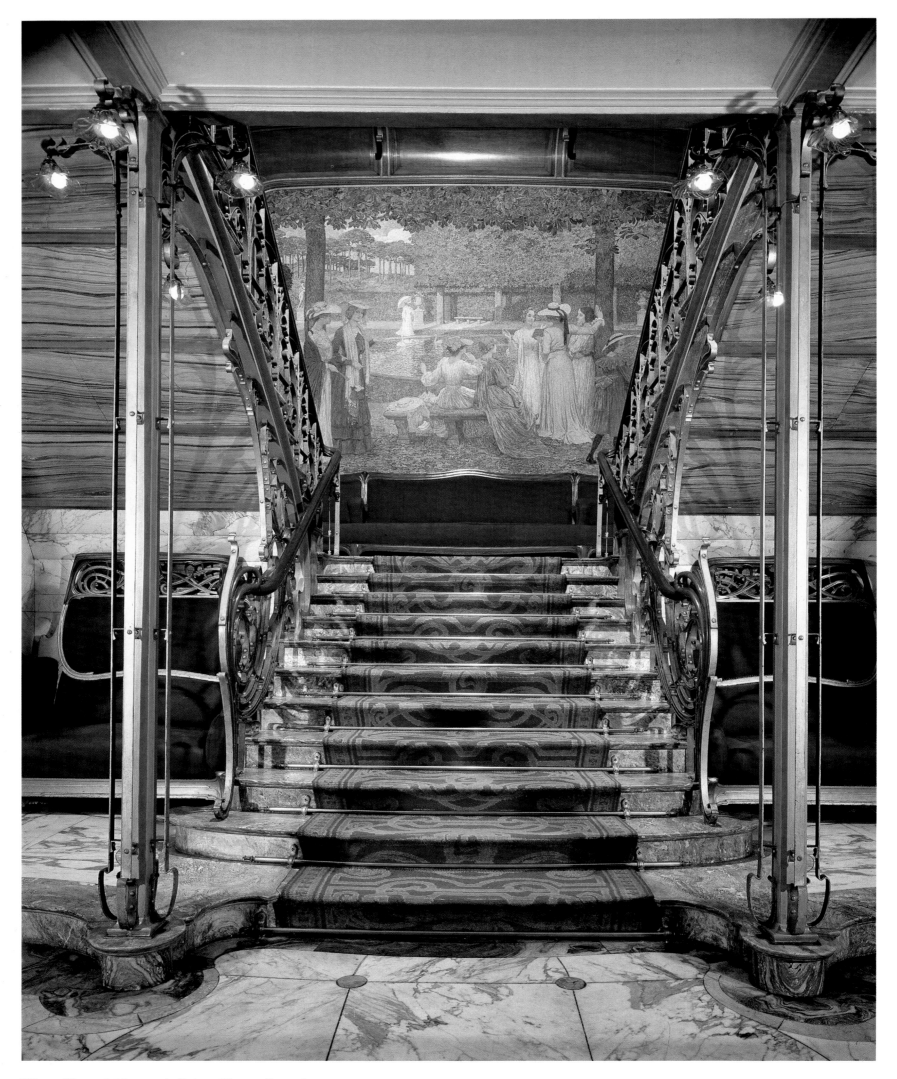

Victor Horta (1861-1947): Solvay House, Brussels,
1894-1898. Grand staircase.
At the top: oil painting of 1902 by Theo van Rysselberghe.

MILITANT ART NOUVEAU
IN FRANCE AND BELGIUM
1895-1900

3

Horta and the New Architecture

BUILT for a friend who, in the end, had left the architect a free hand, the Tassel House in Brussels appears as a pioneering construction, a manifesto of Art Nouveau architecture. The paradox lies in the burst of commissions to which it immediately gave rise. Between 1895 and 1900, in other words, up to the project for the Brussels department store *A L'Innovation*, which may be considered his last great Art Nouveau creation, Horta, with some fifteen major building projects completed, became the leader of the new architecture in Belgium.

This unlooked-for success actually rested on well-defined socio-economic foundations which, in an exemplary manner, make it possible to understand why Art Nouveau developed rapidly at that time and in that place.

Belgium was then in fact a country in the full swing of expansion, with substantially increasing prosperity. At the Berlin Conference on African Affairs, held in the winter of 1884-1885, King Leopold II of Belgium made the great aim of his reign a reality: he became the sole master of the Congo Free State, whose fabulous wealth in natural resources (ivory, timber, rubber), intensively exploited, was by 1895 beginning to make its effects felt on the Belgian economy. Concurrently, industrialization (iron and steel manufacture, glassworks) led in 1885 to the founding of the Belgian Labour Party (reformist), which made its entry into the parliament in 1894.

Following a classic scenario in the history of avant-garde art, a dual movement was then observed: the new upper middle classes made their liberalism a mark of their social rise by turning towards "what was new," particularly in art; the Labour Party adopted a progressive stand in the sphere of art and ideas, leaving it up to sympathetic bourgeois intellectuals to carry on the cultural battle. There were thus two converging causes for the appearance of a militant new art.

Horta's clients, the Aubecqs, the Tassels, the Solvays, the Van Eetveldes, belonged to that new prejudice-free social class which affirmed its stubborn faith in progress in every field. Horta was to make just that observation in his *Memoirs* (written in 1940): "The daring of doing things my way, a sign of energy and independence, was a continuation in another form of the energy the Solvay brothers needed to invent their soda-making process."

And that indeed is what is admirably expressed in the Solvay mansion, commissioned in 1894 and completed in its essentials in 1898: one of the key works of Art Nouveau. There, expanded and streamlined, is to be found the road taken for the Tassel House: spatial continuity and fluidity, openness in the utilization of modern materials. Iron, above all, is exposed there with a boldness

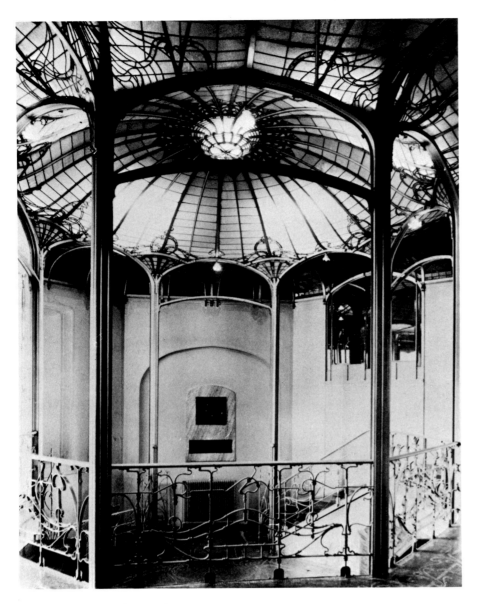

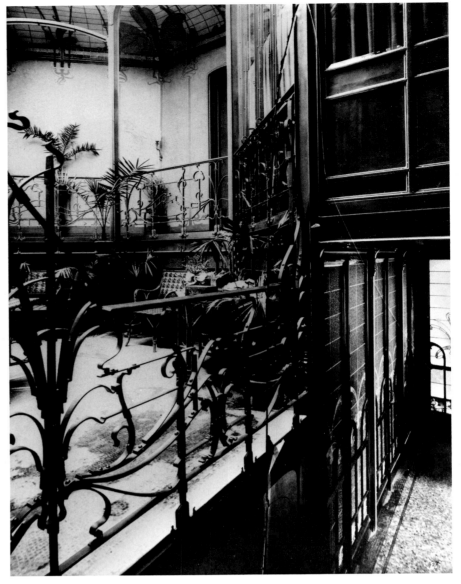

Victor Horta (1861-1947):
Van Eetvelde House, Brussels, 1897. Glass roof of the winter garden.

Victor Horta (1861-1947):
Van Eetvelde House, Brussels, 1897. Entrance hall and winter garden.

rare in so sumptuous a middle-class dwelling, particularly in the stairwell, where it ensures the spatial homogeneity while attesting to the quality proper to itself: ductility. The prodigious whorls at the start of the staircase banister, with its rivets left showing, continue in the long arabesque that accompanies the twisting flights; the supporting columns are repeated by an ornamental strip emphasizing the bearing structure but also playing its part in carving out a "transparent" space.

Thus there was implemented in Brussels, in a masterly way, the programme fixed by Viollet-le-Duc (in particular in the thirteenth *Entretien*). Conversely, its break must be stressed with the position adopted at the same time by Grasset in Paris: "This iron architecture is horrible... Art is born precisely of the need to *provide a dress for the purely useful*, which is always repugnant and horrible. That is what our modern iron-lovers do not realize" (*L'Emulation*, 1896). That is why, too, the large painting by Theo van Rysselberghe which adorns the landing of the Solvay House and may seem rather tame to us today was itself also a *modernist* work. The Divisionist technique, which the painter borrowed from Seurat as early as 1888, counted here more heavily than its Denis-type subject and its Puvis-like composition, which for its part permitted a

skilful integration with the decor; it expressed there, beyond the motif, the same spatial and ornamental conception.

And yet this architecture of transparency and rationality was also an architecture of display. The pomp of the Solvay staircase, with the precious materials placed next to the iron largely compensating its proletarian connotations, would be enough to indicate the fact. And above all, that open and fluid space (which it would be going too far to call the simple metaphor for the free circulation of capital) is a stage space, whose theatrical function Horta himself pointed out clearly in his *Memoirs*: "A dwelling like any other... but with an interior characterized by an exposed metallic structure and a series of glass screens giving an extended perspective and view for evening receptions."

That same theatricality is again found in the dazzling winter garden placed in the centre of the Van Eetvelde mansion, begun in 1895: once again a light well, but whose split level, octagonal form and sumptuous glass roof linking up without a break, through the motif itself of the stained-glass pane, with the metal supports, further enhance the dematerialization of this spectacular space, into whose full light one emerges out of an unlit and queerly diagonal passageway (at ground-floor level).

In his own house in Brussels, in 1898, Horta once again would crown the staircase spiral, also conceived as an interior light well, by a double glass roof framed by mirrors which expanded this space, restricted, but also unified by the link-up between the mural painting, the iron tie-beams and the stained-glass window design.

All this, which is inadequately represented by space-negating photographic reproduction, would be answer enough to the often posed question: is there a true Art Nouveau architecture that goes beyond ornamentation? For what is here involved is indeed the organization of volumes and spaces, of which the ornament entrusted with making them manifest is also a constituent part: syntax and not just vocabulary.

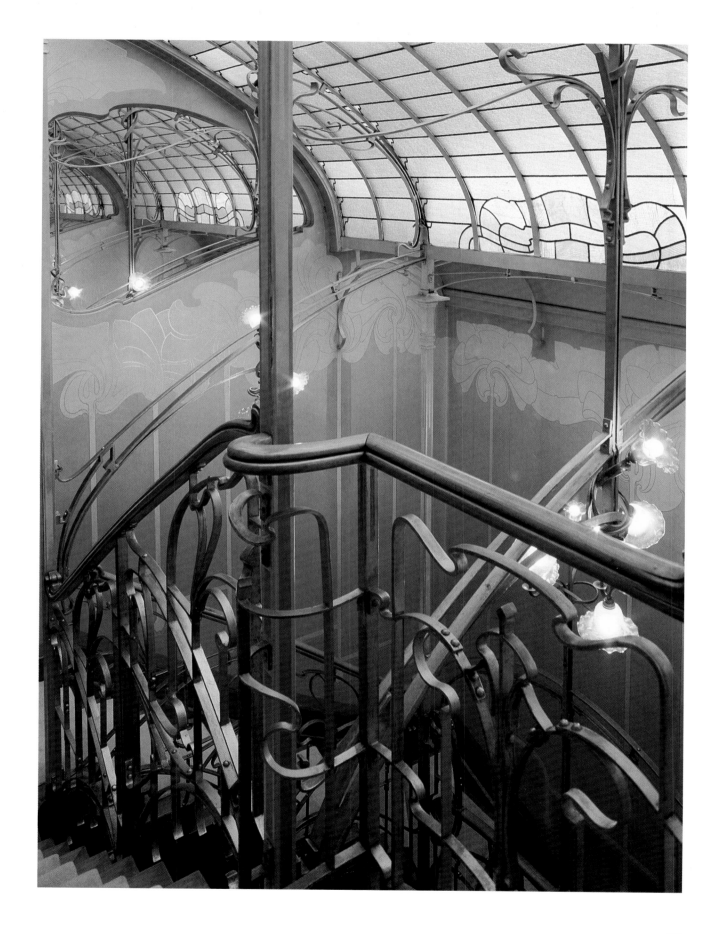

Victor Horta (1861-1947):
Horta House, Brussels, 1898. Glass roof.

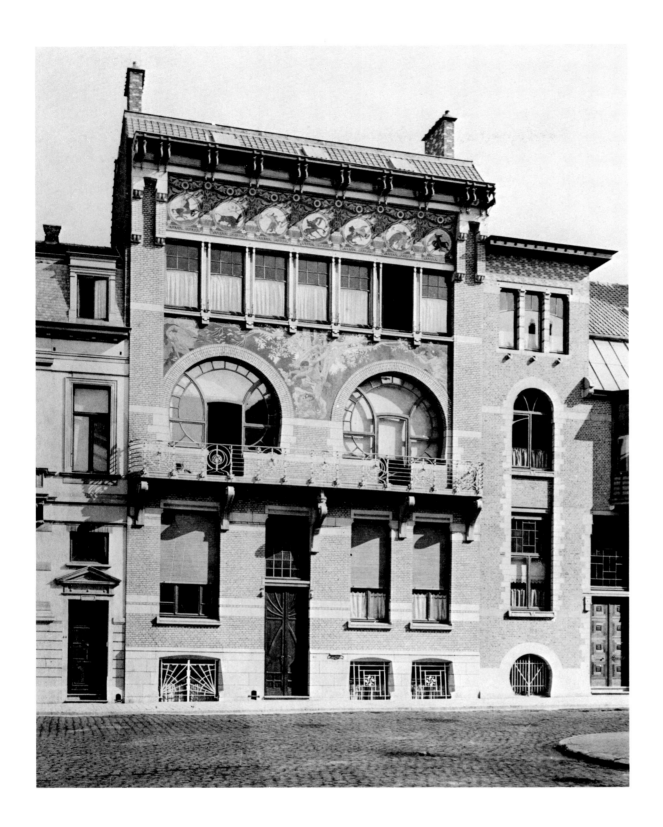

Paul Hankar (1859-1901):
House of the Painter Ciamberlani, Brussels, 1897.

On this point Horta may perhaps be distinguished from Paul Hankar, the other great Belgian architect of the period. The latter displayed an unparalleled virtuosity in the decorative handling of surfaces (by more variety in the use of materials; by the integration of autonomous motifs, such as the horseshoe-shaped windows which are his hallmark; by polychromy and by the great graffito decoration, for instance, inscribed in the centre of the painter Ciamberlani's house in 1897); but Hankar expressed himself first of all in the original design of his screen-façades, and only secondarily raised the problem of internal arrangements.

By contrast, it was in the façade that Horta seems to have had trouble in proposing a modernist solution breaking with classical, symmetrical and monumental composition. The original solutions would come only when the expression of functions would be able, there too, to take precedence over the concern for representation. Witness Horta's own house in the Rue Americaine, in Brussels, this time resolutely asymmetrical, with the living quarters on the left, for which is reserved the balcony hung from iron ties standing

out boldly in front, and the monastic simplicity of his architect's studio on the right, with the great continuous industrial-style window lighting the workroom.

Witness further, and above all, the Maison du Peuple or People's House (inaugurated in 1899, demolished in 1965), whose façade combines in superior fashion the adaptation to a difficult site affected by rights of way (the circular esplanade), the forthright emphasis on structures (the bearing elements in brick and stone; the staircase), functionalism (the large windows lighting the interior rooms), the use of modern material in association with wood and stone (one of the first affirmations of the glass wall in the heart of Brussels). For here, programme and function can assert themselves in full independence: "To build a palace that would not be a palace, but a 'house' where air and light would be the luxury so long excluded from working-class slums: oh, what a beautiful programme!" noted Horta further in his *Memoirs*.

Horta thereby participated—but, as we can see, without committing himself any further ideologically and without seeming to

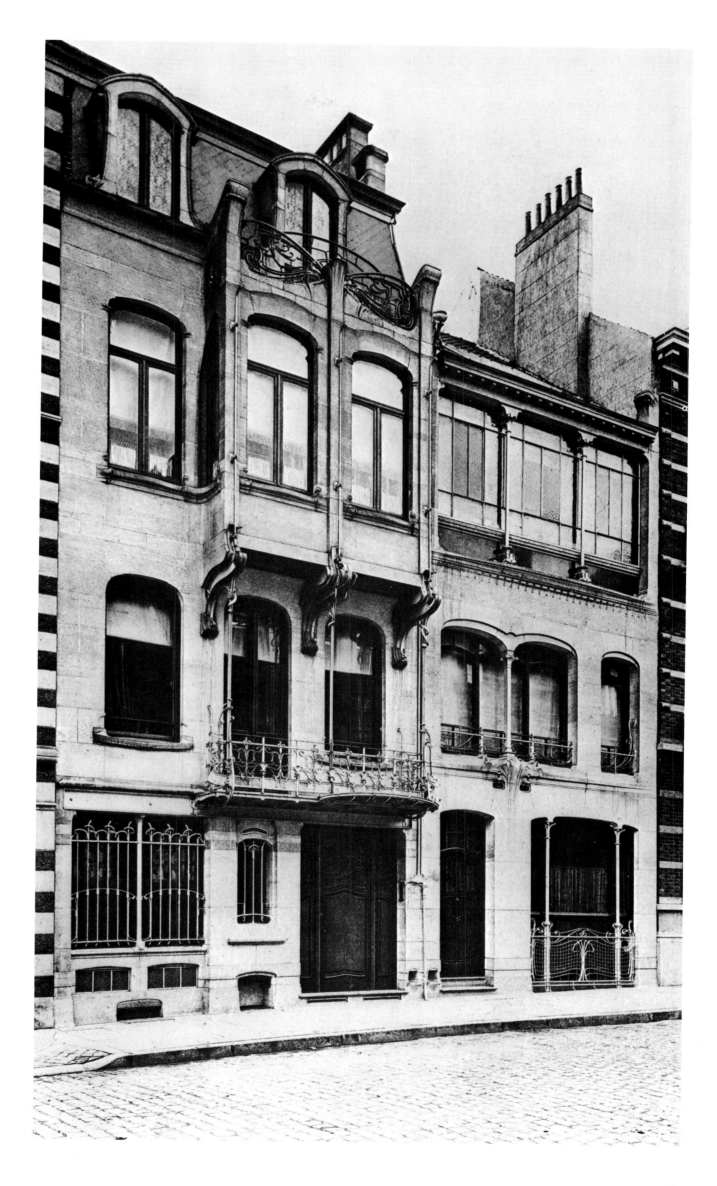

Victor Horta (1861-1947):
Horta House and Atelier, Brussels, 1898.

be bothered by the fact of pursuing these works at the same time as those of the Solvay mansion—in that great idealistic and messianic movement of "People's Houses" managed by socialist cooperatives, which was then spreading all over Belgium, and of which Emile van Averbeke furnished in 1898 in Antwerp a more timid but refined and instructive example by its very borrowings (chiefly from Horta's People's House and Hankar's Ciamberlani House, and from Mackintosh in a general way). But here again, in his People's House in Brussels, Horta followed first of all his "beautiful programme," which found its fulfilment in the auditorium placed on the top floor. The light slender girders of the structure, which made it possible to keep all the interior space free, are left showing there, and lean so as to resist the wind; the ceiling curves also have their rationale in acoustical considerations; and the arabesque of the balcony is consequently no more than the wholly natural echo of both of these: a fresh masterly example, in its sober integration of structure and ornament, which marks this high period of true Art Nouveau architecture.

Horta's work, however, rested on a narrow and fragile base. Closely dependent on his clientele, he was by the same token subject to the whims of fashion. When the outlying districts of Brussels developed in after years, the town houses of the centre would be abandoned by proprietors for whom they had often been no more than passing fancies. (Horta recounted that Madame Van Eetvelde, in her mansion, "regarded glasshouse and drawing-room with the amused eye of a connoisseur of the Louis XVI style which it was good form to admire in the society she frequented.") His other support was no more secure. The leaders of the Labour Party backed the People's House on the recommendation of Horta's friends, in the name of a militant socialism, but at face value, without understanding its deeper justifications; and Camille Huysmans, the prominent Antwerp socialist, did not hesitate later to describe it as a "lamentable construction!"

On a deeper level, Horta always proceeded empirically, without theoretical support, resourcefully combining the techniques of

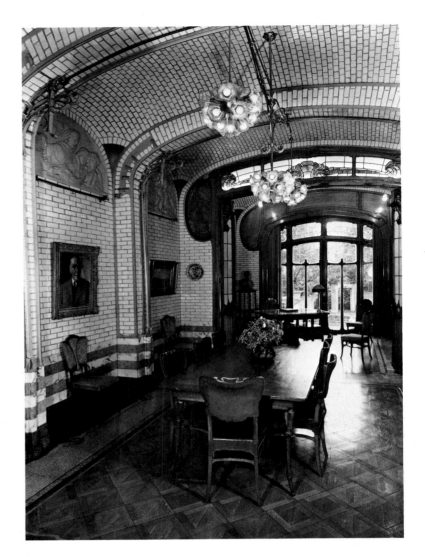

Victor Horta (1861-1947):
Horta House, Brussels, 1898. Dining room.

Emile van Averbeke (1876-1946):
Liberal Party People's House (Liberaal Volkshuis), Antwerp, 1898.

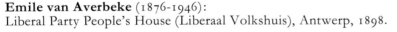

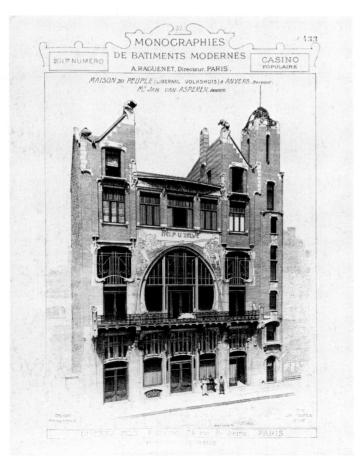

engineering (which he had been able to appreciate at the Paris World's Fair of 1889 and which his master, Balat, who designed the Laeken Palace glasshouses, had taught him) with the aesthetic remodelling of private houses exemplified by the English. But his sole guide in this work was the concern to adapt himself as faithfully as possible to demand and to the personality of the financial backer: "It was the period when, making a synthesis of my ideas, I proclaimed that the house ought to be not only in the image of the owner's life, but that it should be a portrait of him." Such personalization went beyond functionalist concerns and limited their impact; it also accounts for the craft-industry aspect, and the slowness, of "the most expensive architect in Brussels." Despite his use of modern materials Horta remains in this respect close to William Morris (whose wallpapers he liked and used): "All my houses, because of their exceptional method of construction, required endless details both in their furnishing and decoration." The dining-room of his own home, with its enamelled white bricks, its ashwood arcades, its copper bars for hanging paintings, its furniture designed for a precise position, its flooring set in a triple border of ashwood, copper and mosaic and a thousand other details, preserves for us today a particularly eloquent example of this. Horta stands at the opposite extreme from standardization and the semi-industrialization advocated by Van de Velde. And despite the deep reverberation which this work had abroad (Guimard's visit to Brussels in 1895, Ludwig Hevesi's article of 1898 in the *Wiener Tagblatt* hailing him as "the most inspired of modern architects"), Horta was thereby condemning himself to a dead end and a return to neo-academicism, with effect after 1903, albeit still springing from a superior talent. Contrary to Van de Velde, the new architecture of Horta embodied in a superior manner an exceptional moment, but remained without a future.

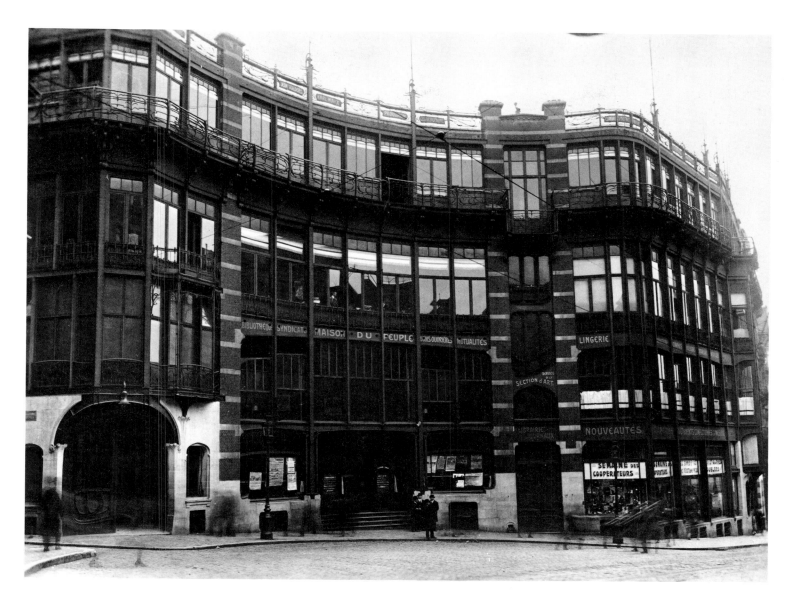

Victor Horta (1861-1947):
People's House
(Maison du Peuple),
Brussels, 1895-1899
(demolished in 1965).
◁ Front.
▽ Auditorium.

Photograph of Victor Horta
in his Brussels house
(Hôtel Horta, Rue Américaine), c. 1903.

Henry van de Velde (1863-1957):
Binding for W.Y. Fletcher's *English
Bookbinding in the British Museum*, London, 1895.

Van de Velde
and the Synthesis
of Art

HE way Van de Velde went about things was exactly the opposite: where Horta built, Van de Velde laid down principles and constructed a theoretical scheme, seeking first to adapt the mould of his "shells" rationally to the "molluscs" they had to contain, as Ludwig Hevesi whimsically wrote in 1898. While Horta masterfully enclosed his conquests in a narrow historical and geographical setting; while he strove to mark out and fill his social space—that of the Brussels plot of land—without trying to burst its bounds, Van de Velde proceeded on the contrary by expansion, starting from his own self and a profound moral crisis, which he discovered finally was that of society as a whole. In 1894 his book *Déblaiement d'Art* (Clearing Up Art) prepared the ground and rejected a sterile past, as Van de Velde had rejected painting. The following year his essays *L'Art futur* (The Art of the Future) and *Aperçus en vue d'une synthèse d'art* (Ideas with a View to a Synthesis of Art) proclaimed their forward-looking sense of purpose.

This synthesis was at first the bringing together of the most useful contributions of his immediate predecessors for the formation of a "new style," to use the favourite expression of Van de Velde; that is, of a new social "form" in the full sense of the term: moral demands, faith, the fierce passion of Ruskin and Morris and the rigour and sobriety of the Arts and Crafts men on one hand, with the rationality, modernity, purposefulness and clear mind of the French movement on the other.

The moral demands and passion received full expression in that act of faith which consisted in the construction, after his marriage, of his own house, Villa Bloemenwerf, at Uccle, near Brussels (1895). At that time Van de Velde had no experience of building but it was for him a vital, existential necessity: "I told myself that I would never allow my wife and family to find themselves in 'immoral' surroundings," he would later confide to Sigfried Giedion, meaning by that the "lie" of borrowed and tacked-on forms of historicism. There was nothing of Art Nouveau in the house itself: it owed much to Morris, to the example of his Red House of 1859. And yet the simplicity and functional character of the ground-plan and interior layouts also spring from a fundamentally different line of thought. On the walls hung Seurat's *Sunday at Port-en-Bessin*, a pen and ink sketch by Van Gogh and the portrait of Van de Velde's wife, Maria Sèthe, by her brother-in-law Theo van Rysselberghe—one of the painter's most accomplished Neo-Impressionist works. The intention was thus clearly to stick to the present and not to seek refuge in the medieval world of the English. And the furniture, in its monastic austerity, differed radically too from the rustic traditionalism of Morris's: its curves, simple but favouring convex and centrifugal forms, boldly aim at con-

Photograph of Henry van de Velde
in his Bloemenwerf villa, Uccle, Brussels, c. 1897.

To arrest the decadence and erring ways into which in the course of centuries the quest for Beauty had led the taste of the public, it was necessary to impose upon Beauty a "new discipline" which, beyond that fallacious and tempting promise of a beauty consisting in this travesty of all forms and all aspects, would call forth the instinctive and primordial faculties of conception and would bring back an age of the rational and consistent conception of all things, the notion of adequate, exact and pure form.

Henry van de Velde, La Triple Offense à la Beauté,
Zurich, 1917-1918.

Henry van de Velde
(1863-1957):
Tropon,
"Protein Nutriment,"
1898. Poster.

quering all the space outside. On their visits to Bloemenwerf, Samuel Bing and Julius Meier-Graefe in 1895, Count Kessler and Eduard von Bodenhausen in 1897 and Karl Ernst Osthaus in 1900, would make no mistake: they were responsible for the international influence of Van de Velde, whom Meier-Graefe's Berlin periodical *Pan*, launched in that year 1895, immediately took charge of making known.

The moral fervour springing from the same "feeling of revolt" as that of Ruskin and Morris, was thus very quickly corrected in Van de Velde by a keen sense of modernity and reliance on Reason, to make the idea of "the adequate, exact and pure form" prevail against the "debasement that lay in conceiving objects, buildings and everything connected with aspect and form, in defiance of logic and the essential requirements of their use and purpose," as he was to write in his "Triple Offence to Beauty" (*Triple Offense à la Beauté*, 1917-1918), one of the many essays in which he tirelessly harked back to the history of this decisive period.

Henry van de Velde (1863-1957):
Belt buckle, c. 1898. Silver and amethyst.

Impassioned rationalism, then, resting on the conviction (destined to become the "great utopia" of the modern movement) that the world would be regenerated by the sole logic of forms, made effective by the draughtsmanship of the engineer-artist. And even the First World War would not suffice to shake this formalist faith in which lay all the grandeur of true Art Nouveau and of Van de Velde in particular.

For him, that meant first of all a systematic and practically exclusive use of line, the complete theory of which would not be worked out until 1902 (in his essay "Die Linie," in the review *Die Zukunft*) but was sketched out as early as 1894-1895, at the time when, he wrote later, he was trying to "fix the relations that existed between his own dynamic nature and the nature and function of ornament." Abstract line, the purest and most rational; "organic and living" line, capable of perpetuating in the work at one and the same time "the moment and our being"; forceful line, indebted to the example of Van Gogh and before him of Millet, in whom Van de Velde discovered its universal value; continuous line, distinguished from the "whiplash" of Horta and Obrist, an interrupted and therefore arbitrary and useless gesture; dynamic line, in short, whose life-force insures the homogeneity of forms and which creates space from objects and their use; not, as with Horta, from the organization of objects and masses.

This is already admirably encapsulated in Van de Velde's only poster, made in 1898 for the Tropon food company. In the upper half are found the parallel ruts of the road in the *Angels' Vigil*, but

Henry van de Velde (1863-1957):
Evening gowns, c. 1898.
Photographed in Berlin, 1901.

What differentiates the movement which arose on the Continent in the 1890s from the movement beyond the Channel set going by Ruskin and Morris, some twenty or twenty-five years before, is this: Keeping fanatically to the principle of rational conception, and moved by the idea that it was necessary to return to the truthful and moral aspect of all things, we revised—without indulgence—all our opinions about style, forms and ornaments, and after that scrutiny we declared that we were turning our back on the past. This did not exclude our feeling, at that point, that we were the ones who would restore the links of the present with the past, that we would rediscover the source of the great tradition.

Henry van de Velde, Le Nouveau, son apport
à l'architecture et aux industries d'art, *Brussels, 1929.*

this time at the service of "the most concentrated food," as the French version of the poster put it! And this "concentration" is above all that of form: of those closed lines whose downstrokes and upstrokes arranged in an ascending asymmetrical composition express, without any figures, the irresistible vitality of the advertised product; of that surface whose rhythmic animation forms its unity and where a drawing and a "foundation," a line on a support, are no longer distinguishable. And if Toorop, whom Van de Velde admired, stands in the background, the comparison with *Delftsche Slaolie* is sufficient to show how the abstraction and exploitation of the properties of the line alone makes it possible to extract its quintessence and multiply its effect tenfold.

In the same way in Van de Velde's famous contemporary silver buckle, also showing well enough the secondary role of material as compared with design, there is no longer any adding of ornamentation around the amethyst, but the ornament alone is the object, and the line all the ornament, creating by its continuous intertwining, in the manner of some Möbius strip, its own space. An organic form, abstract and autonomous, like the inkstand designed at the same time, it yet also reveals to us the universal meaning of the motion and use that justify it: testimony to the regained unity of the individual and the world; of art and life, as in those dresses designed for Madame Van de Velde which unite the rhythm of the body with that of the garment but also with the

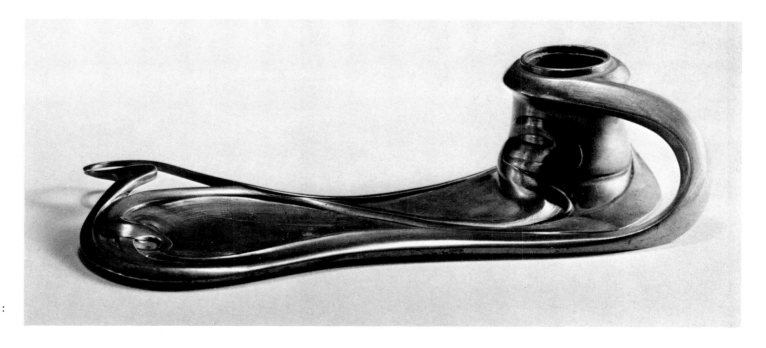

Henry van de Velde (1863-1957):
Brass inkstand, 1898.

space surrounding it, which it literally brings to life. Or again, as in that admirable binding of a book about English bookbinding, which is in effect, with the line of fine gold threads creating the colour-planes of the mosaic decoration, the manifestation of the very essence of its object: bookbinding.

Necessary "harmony and kinship" which make the meaning of this "synthesis of art" complete: ornament, as with the French rationalists, triumphs over ornamentation and prepares "the awakening of the feeling which perceives in a building, interior, object, flower or human body, a supreme ornament, created by the varied play of proportions and volumes animated by a rhythm that sweeps it along like a musical phrase or a line of verse" (Van de Velde, *Le Nouveau*, 1929).

Contrary to Morris and the Arts and Crafts movement, whose fine products, elaborated by handicraft techniques, presupposed, despite declared intentions, a restricted production reserved for a moneyed aristocracy; contrary also to Horta, who asked industry

Henry van de Velde (1863-1957):
Writing-desk chair, 1896.
Upholstery by Johan Thorn Prikker.

Henry van de Velde (1863-1957):
Advertisement for his Interior Decoration and Applied
Art workshop, Uccle, Brussels, published in *Art et Décoration*, Paris, 1897.

to make him custom-built components, complicated and costly, this conception of form and its function necessarily implies the purpose of a wider dissemination, beyond the narrow bounds of patronage. Before the Weimar workshops in 1902 and the Deutscher Werkbund founded in 1907, Van de Velde opened an applied arts workshop of his own at Uccle in 1898; it was the first attempt at a total planning of production and distribution of objects which in fact found outlets, starting from the original nucleus of Bloemenwerf, outside Brussels and beyond national boundaries. In 1895 Bing commissioned him to fit out four rooms in his Art Nouveau gallery in Paris. In 1897 his success at the Dresden Exhibition of Applied Arts (a room commissioned by Waldemar von Seydlitz, director of the Dresden Museum, after seeing Bing's gallery) won Van de Velde several commissions in Germany (fitting up of the Keller and Reiner Art Gallery in 1897, of the Havana Tobacco Co. in 1898-1899, of the Haby hairdressing saloon in 1901, all in Berlin). In Paris in 1898 he had been commissioned to do the interior decoration for the Maison Moderne, the art shop founded there by Julius Meier-Graefe.

The desk he then designed for Meier-Graefe was perhaps the finest of the series of similar pieces of furniture executed during this period, with its simple and functional organic structure, in which all the curves harmonize with the sweep of the desk around the occupant: one of the pinnacles of Art Nouveau furniture, in which the contradiction between function and decoration is resolved in the organic expansion of ornament, and which also went beyond the English and Japanese influences which, in Serrurier-Bovy for example, dominated the furniture of the middle 1890s.

Other pieces of furniture were no less remarkable, such as the armchair upholstered with fabric designed by Thorn Prikker, in which the curves of the wood correspond to those of the material and were but so many inducements to the comfortable occupation of the seat. And if the protrusion of the slats of the back and arms has sometimes been criticized, they also clearly show that it is the material here that must bend and adapt to the ideal lines which make the continuity with the surrounding space: a logical, but more luxurious and sophisticated development of the chairs designed for Bloemenwerf.

It is striking to see Meier-Graefe's desk placed beneath Hodler's *Day* (in the second of its three versions, painted a little later than, but very like, the version shown at the Paris World's Fair of 1900), a major work by the Swiss painter conceived just at that time. The convergence of forms is startling, especially in the curve of the ground and the rhythmic spreading of feminine curves around the central axis, closed and outlined forms, so many echoes of the general scheme of the composition. Hodler's *Day* is still indebted to Gauguin, and its frieze layout, its interlocking arabesques, its upright perspective, make it comparable, for example, to *Manao Tupapau (She thinks of the spirit of the dead)*, one of the purest woodcuts of the years 1893-1894. The foetus-woman seen in Gauguin's woodcut was plunged in the darkness of death and the past, dreaming of the bright and harmonious world above her—of day.

From Gauguin to Hodler and Van de Velde: continuity and expansion of forms, conquest of three dimensions and social space. From individual withdrawal into myth and thinking of the dead to the luminous, peaceful and solemn breaking of the "new dawn." Need one add that Van de Velde was a passionate reader of Nietzsche? Van de Velde would "put into forms," in the same manner and in the same spirit, his own superb *Zarathustra*, the project for which was launched by his friend Count Kessler in 1898.

Photograph of Julius Meier-Graefe's Munich office.
Furniture by Van de Velde, c. 1899.
Oil painting by Hodler: Day, second version, 1904-1907.

Paul Gauguin (1848-1903):
Manao Tupapau (She thinks of the spirit of the dead),
c. 1893-1894. Woodcut.

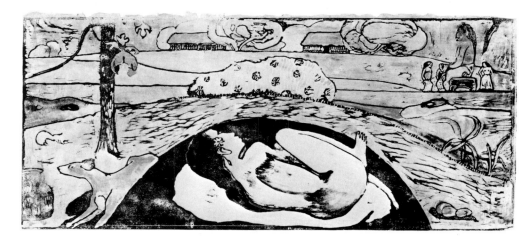

Ferdinand Hodler (1853-1918):
Day, first version, 1899-1900. Oil.

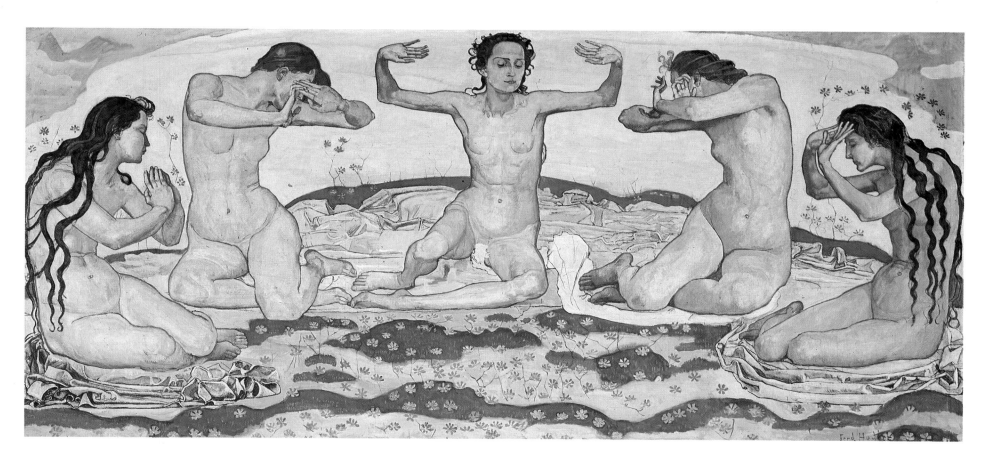

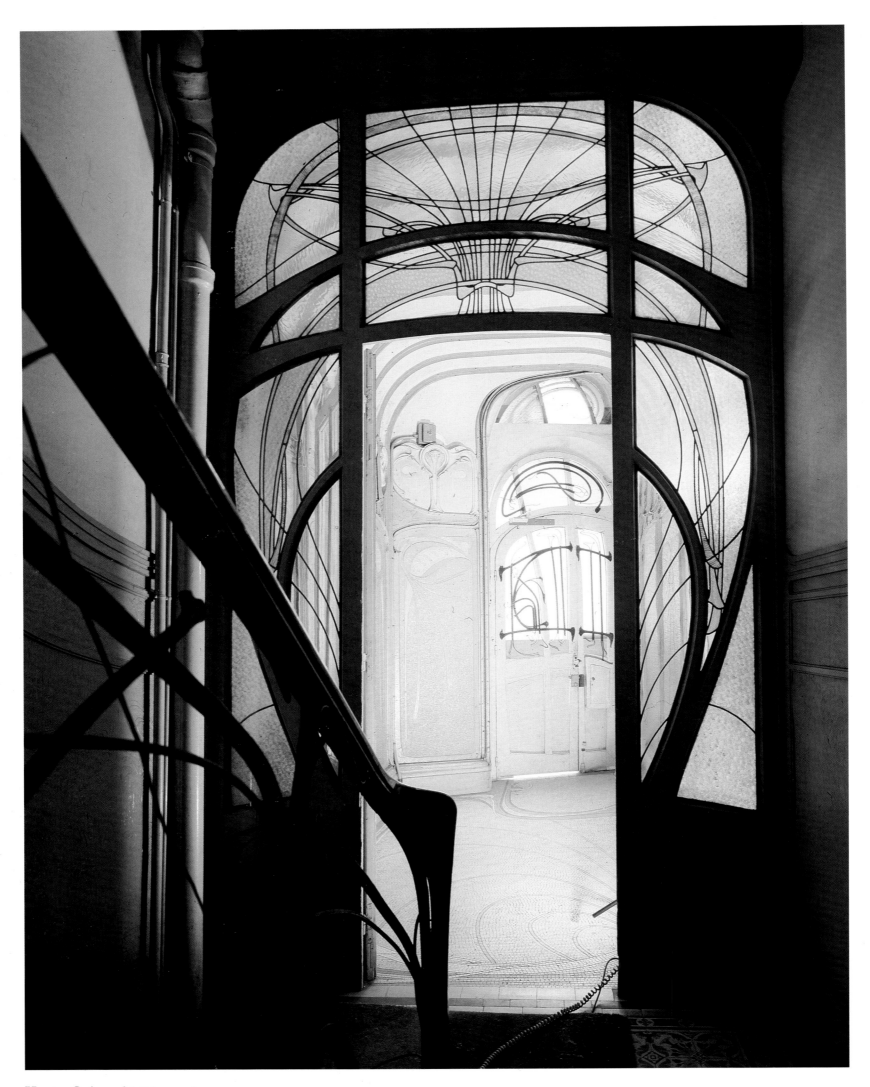

Hector Guimard (1867-1942):
Coilliot House, Lille,
1898-1900. Entrance.

Guimard
and the
Ornament Compromise

HE news of the orders Samuel Bing gave to Henry Van de Velde was very poorly received in Paris. This showed no doubt that the time had not yet come, despite the lessons of Viollet-le-Duc and the polemical writings of Bracquemond, for the ready acceptance of a purely decorative utilization of the applied arts as part of an ornamental concept of decoration taken as a whole. Belgium was none the less the country from which the new architecture was to come, and Horta—his ornamentation in particular rather than the space justifying it—the source from which it was borrowed.

Credit for this "importation" into France has to be given to Hector Guimard, but the circumstances in which it took place are unclear and this helps to explain the contradictory views that are still, even today, held concerning him. For the French, Guimard is a typical, now almost popular representative of Art Nouveau, whereas for most foreign historians he is a secondary if not a minor figure.

This French style Art Nouveau architecture was the result of a relatively sudden conversion, which took place in the same year, 1895, that Bing opened his Salon de l'Art Nouveau in Paris, and here again the chronological break is marked with astonishing precision. Prior to that date, Guimard's career had been that of a rationalist trained in the school of Viollet-le-Duc. The Sacré-Cœur school in Paris, completed in 1895, shows this very explicitly, with its bold wrought-iron columns placed obliquely like piles, at ground level, in order to open up a large courtyard; the layout is indeed the direct reproduction of a plate in Viollet-le-Duc's twelfth *Entretien*.

In 1894 Guimard had been to England where he became especially interested in the picturesque and practical native architecture, which left its mark on his own villas and country houses. His Castel Béranger, an apartment house in Paris, in the sixteenth arrondissement, was built at this time after the same manner as the Sacré-Cœur school; but the desire to differentiate—as an expression of rational and individualistic principles—the façade of each of the thirty-six apartments of this big block is manifested in the variety of openings and many broken volumes, underscored by bold asymmetry in the arrangement of the gables, balconies and projecting parts, as well as by the use of strongly contrasted materials (masonry, freestone, brick, iron and cast-iron). On the other hand, as regards the style and details of the ornamentation, the gables, the proportions of the cornice, and the strictly geometrical and bare design of the metal parts of the Castel Béranger remained originally in the direct Neo-Gothic line of Viollet-le-Duc, which was stressed again by the name of the building.

Hector Guimard in his Paris workroom, 1903.
Postcard illustrating the "Guimard Style."

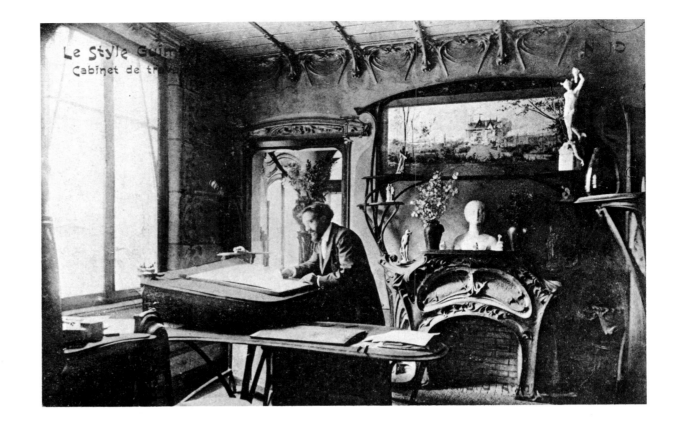

Hector Guimard (1867-1942):

▽ Invitation for the exhibition of the Castel
Béranger in the private rooms
of the *Figaro*, Paris, 1899.

▽ Motif for a balcony, 1898-1900.
▽ Pencil and Indian ink.

EXPOSITION
SALON DU
FIGARO

LE CASTEL BÉRANGER
Œuvre de
HECTOR GUIMARD
Architecte, Professeur à l'École nationale des Arts décoratifs

COMPOSITIONS DANS UN STYLE NOUVEAU
Architecture, Sculpture
Décoration, Ameublement et Objets d'Art

Du 5 Avril au 5 Mai

De la part de M. _____

INVITATION

The year 1895 was also the year of Guimard's trip to Brussels, where Horta's Tassel House came like a revelation to him. The Castel Béranger project was revised throughout, although the basic structures were not affected; as a result, the Horta ornamentation is applied to a space deriving from a different rationale (the solidity of the material and textures as opposed to the fluidity of an abstract linear space). The whole problem of Guimard is summarized in the Castel Béranger building and the difficult transitional phase covering the next three or four years, namely the problems of making a synthesis of these so obviously borrowed decorative elements and a rational approach doubtless having the same origin (Viollet-le-Duc) but taking its inspiration from such a different personality and different context.

In Castel Béranger, it was impossible to change the extreme fragmentation of the volumes, as opposed to the continuous space of the Brussels mansions in which ornamentation had precisely the function of emphasizing its continuity. With the same forms, and first of all the "whiplash" line, the decoration had to have the contrary function of unifying that which in the original conception had been based on the principle of division and contrast. In the interior above all, Guimard seems to have been determined to introduce a veritable "retreat forwards" with a proliferation of unifying ornamentation—besides reproaching Horta for not having been radical and coherent enough on this point (using, for example, English painted wallpapers).

In this respect, the hall is even today the most typical example, with its spectacular wrought iron door contrasting with the symmetry of the pillars framing it and the neo-Romanesque design of the original porch; the exuberance of the Bigot freestone slabs, as though made of matter in process of fusion, but restrained by the regular grill of the metallic framework, and the whiplash thrown from the ceiling painting to the floor mosaic taking in the iron uprights parallel to the curve of the door. The aim is clearly to create, within a very square conception of geometric volume, the fluid space of the ornamentation.

This is the reason for the superabundance in the interior of decorative inventiveness heightened by the profusion of the material which this time covers the walls and tends to overshadow the structure: wallpapers and embossed papers, stained glass, carpets,

paintings, mosaics, all shot through with the same nervous undulations, and the astonishing glass wall of the staircase, no doubt justified by the search for rational lighting but having also, as the shape of the moulded glass bricks shows, the same destabilizing value. This explains above all the deliberate exaggeration of the twisted lines, often considered "nightmarish" and far removed from the restraint of Horta and the purity of the Van de Velde arabesques. In Guimard's own workroom, as can be seen from the picture he printed and distributed in 1903, the furniture teems with asymmetrical excesses and painful overhangs designed to create at all costs an organic space, once again contrary to the contemporary creations of Van de Velde.

Thus a number of basic contradictions are laid bare, which subsequent works represent an attempt to resolve. That of struc-

ture as opposed to ornament, appearing here as it were by a graft and destined for picturesque exasperation; that of abstraction versus representation, which was responsible for the placing of sea horses alongside the flexible line of the Castel Béranger façade; and that of rational creation in relation to natural forms, the only model however that could be invoked to defend the unity of this exuberant universe. Of capital importance as regards this last point is the fact that Guimard rallies to Horta, not Gallé or Majorelle, and follows Horta's advice to take the stem and leave the flower and the leaf as the only means of avoiding descriptive decoration and attaining the organic principle.

The Humbert de Romans Hall in Paris, begun in 1897, which was Guimard's most ambitious achievement, was an attempt at a reply to the auditorium of Horta's Maison du Peuple in Brussels.

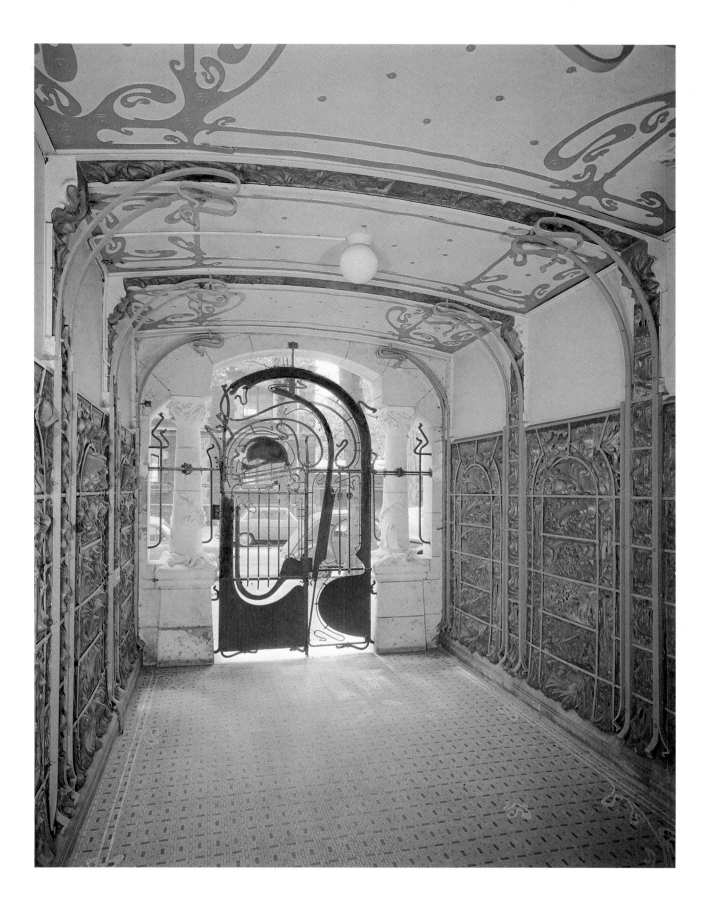

Hector Guimard (1867-1942):
Castel Béranger apartment house, Paris, 1899.
Entrance hall and door.

It does not, however, attain the simple and calm strength of the latter. On a remarkable metallic structure, which amplifies by recourse to steel a model proposed by Viollet-le-Duc, figurative decoration mingles with the linear design, more capricious and loaded with ornament than that of the Belgians, and mahogany posts cover the framework. The Coilliot House in Lille (1898-1900), a more coherent repetition on a smaller scale of Castel Béranger, presents in its façade a curious interlocking of a Neo-Gothic structure (reflected in the distribution and showing also in the double pitched porch roof and ogival arch its relation to the French tradition) and a very deliberate asymmetrical plan parading Art Nouveau but exploiting above all the material and brilliant contrasts of colour and texture. When Henri Sauvage came later to make a comparable design for the Majorelle villa at Nancy, he followed the model only in respect of the interior distribution, and therefore with more naturally organic asymmetry and more discreet decoration depending entirely on the structures.

Guimard's attitude itself condemns him to a "totalitarian" conception of architecture and at the same time to highly individualized production (in which more than in anything else he approaches Gaudí). It is indeed significant that he should himself have been led to speak of the "Guimard style" and not of Art Nouveau, and that he should have done his utmost to ensure for himself the monopoly of promoting it. His Castel Béranger was the subject of a de luxe publication in 1898 and an exhibition and lecture the year after. In this way, by a kind of publicity stunt, Guimard tried to force his "new style" on society, whereas at the same time Van de Velde, for example, was content to propose products of "art and industry, construction and ornamentation."

That was the reason why Guimard's bold and courageous industrialization effort was doomed to fail. The idea of large-scale dissemination of forms so clearly marked "pictorially" by the personality of their creator was by definition self-defeating. Yet Gui-

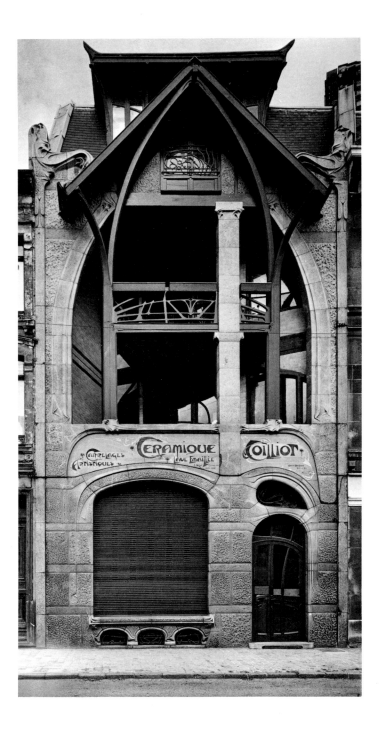

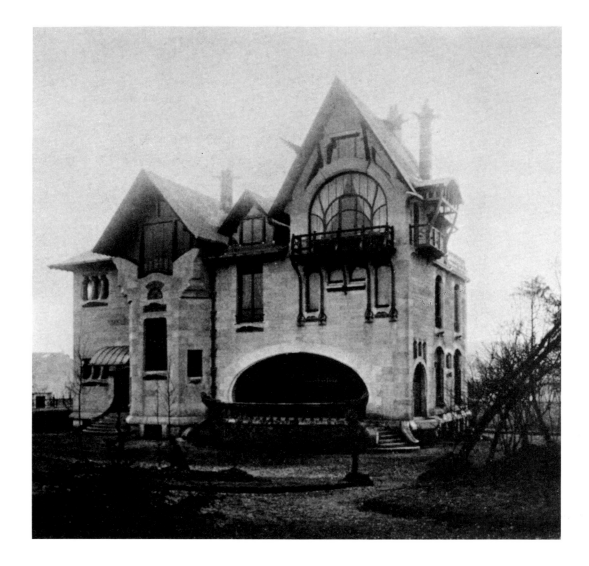

Viollet-le-Duc is well known. In his remarkable lectures on architecture he said: "Arts which cease to express the need they are meant to satisfy, the nature of the material employed, and the means of shaping that material, cease to have style." Here perhaps is why I have often heard it said, in speaking of the Castel Béranger: but what is this "new style"? Well, such are the ideas to which I appeal, even from the emotional point of view.

Hector Guimard, "La renaissance de l'Art dans l'architecture moderne," in Le Moniteur des Arts, Paris, 7 July 1899.

Hector Guimard (1867-1942):
△ Coilliot House, Lille, 1898-1900.

Henri Sauvage (1873-1932):
◁ Villa Majorelle, Nancy, 1898-1900.
Period photograph.

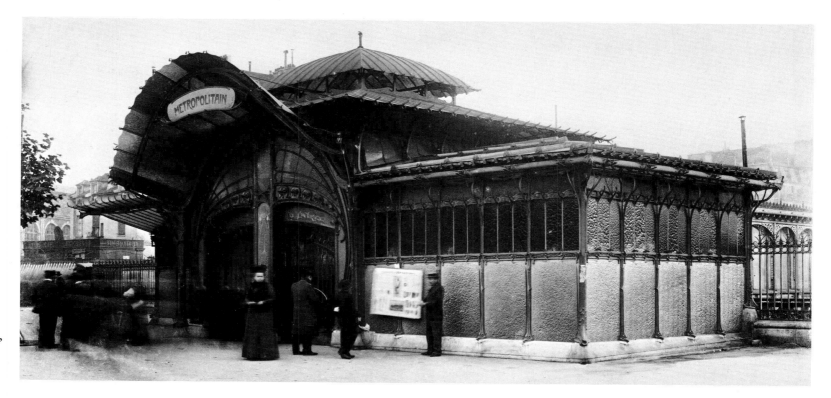

Hector Guimard
(1867-1942):
Bastille Métro station,
Paris, 1898-1900
(demolished).
Period photograph.

mard had a real success with the Paris Metro stations ordered from him from 1899 onwards on the personal initiative of the chairman of the City Council, Adrien Bénard. In these utilitarian and modest structures the contradictions resolved themselves. The system of standardization, with moulded castings attached to profiled guard-rails, the slabs of freestone and the glass roofs were fully justified since they were multiple objects and Guimard's inventive talents were admirably suited to the combination of simple elements. The material, left bare, was appropriate and functional and the same was true of the arrangement of the volumes in the "C type" pavilions (today all demolished). The ornamentation was wholly integrated in the structure, which remained visible. And the organic form (the stem of the plant) was also warranted by its symbolic function (indicating the entrances) and its perfect aptness for specific uses (the globes in the grouped lights over the doorways, gutters draining down cast-iron columns). In spite of the signature proudly displayed on special name plates, in this case Guimard succeeded in going beyond a mere personal creation, and it is significant that for a time the "Metro style," not "Guimard style," was a recognized term.

In some of the Metro stations there were striking similarities with certain details in Mucha posters. In Mucha's work women's hair tended to be depicted in firmly outlined areas of flat colour with curves so extremely rounded that they come near to the design of moulded castings. In the draft poster for Lefèvre-Utile biscuits, in 1896, the abstract geometrical pattern of the lower part strangely heralds the deployment of the Metro roofs, the one at the Bastille station, for example. In Mucha, a master of "1900 Art," these ornamental additions are meaningless apart from their supporting image, the feminine figure idealized according to the canons of the most academic tradition. The excesses and uncertainties of the architect during this period led him sometimes to run the risk of this "1900 fashion," and his ephemeral success is likewise significant: the Castel Béranger was awarded a prize in 1899 in the City of Paris Housefront Competition, but the Opera Metro station was to be rejected in 1904 and the Humbert de Romans Hall destroyed the year after. If the suddenness of his conversion and impetuous romantic bent of his rationalism prevented Guimard from obtaining the universal fame and international influence of foreign masters, this comparison is enough also to recall all that separated him from the mere trade in Art Nouveau products and designs which developed during the same period.

I have an unfortunate passion; I call it unfortunate because it is not much shared. I love architecture, and if I do, it is because architecture in its essence, in its formula, in its function and all its manifestations, includes all the other arts, without exception.

Hector Guimard, "La renaissance de l'Art
dans l'architecture moderne,"
in Le Moniteur des Arts, Paris, 7 July 1899.

Alphonse Mucha (1860-1939):
Calendar design for Lefèvre-Utile
biscuits, 1896. Watercolour.

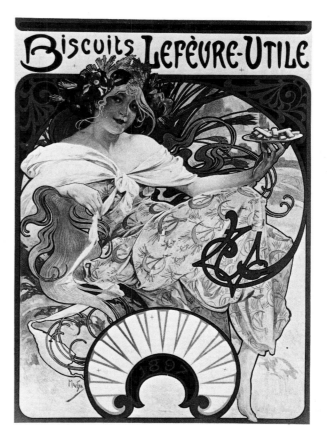

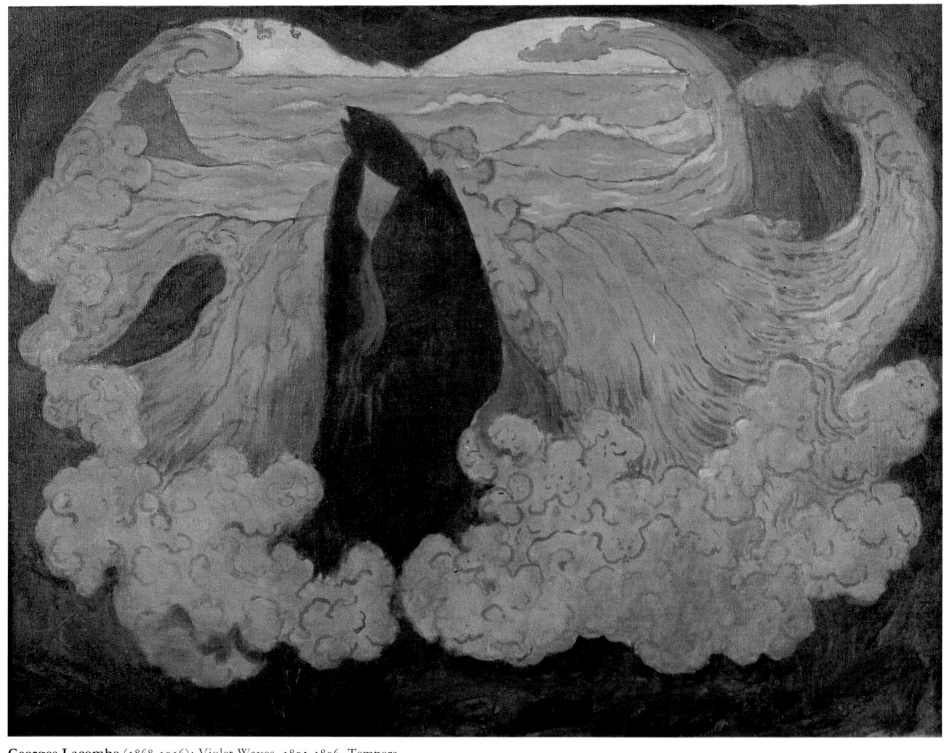

Georges Lacombe (1868-1916): Violet Waves, 1895-1896. Tempera.

Bing
and the Spread
of Modern Style

HE wider popularity of Modern Style began with the opening in Paris in December 1895 of Samuel Bing's Salon de l'Art Nouveau. The name given to this art gallery, shortly to become that of the entire movement, was already enough to indicate both its commercial role and its militant vocation. This venture cannot, however, be regarded as the launching of a style that would in the normal course of events grow to maturity. The problems raised by Bing's gallery were more complex. By this way of gaining larger access to the market, Art Nouveau also called its origins in question, those of plastic thought issuing from artists' studios in often highly individualized form. The popularization of this art quickly raised all the problems of the relations of the style to its vogue. Notwithstanding the enthusiastic support of the international movement, Bing worked in Paris in a very special context, which was soon to have its repercussions on his activity.

Born in Germany but living in Paris since 1871 and naturalized French, Samuel Bing had a business in Far Eastern art objects, supported from 1888 to 1891 by his important monthly publication, *Le Japon Artistique*. He was a shrewd dealer and in 1895 converted his shop at 22 Rue de Provence to Art Nouveau, in so doing recalling very significantly that one of the main sources of inspiration of the new style was Japanese art. In the meantime, he had been to the United States, and La Farge, Tiffany and Sullivan have a prominent place in his report on artistic culture in America (*La culture artistique en Amérique*), which he completed at that time. In 1895 again, Bing visited Van de Velde's newly built Villa Bloemenwerf and the Brussels shop "A la Toison d'Or," opened in March 1894, just before his own art gallery.

The opening of Bing's Salon de l'Art Nouveau thus coincided with the appearance of the most modern elements of the international movement, now taking shape in the principles laid down in Belgium (Van de Velde had used the term Art Nouveau, appropriately capitalized, in his *Déblaiement d'Art* of 1894), in the model for an "art industry" in the firm of Tiffany in New York, and in France the Nabis' recent stylistic interpretation of the art of Gauguin and the Japanese. This is succinctly reflected in the first orders placed by Bing: on the one hand, stained glass made by Tiffany after cartoons by French painters and, on the other hand, sets of furniture ordered from Van de Velde and Georges Lemmen.

At that time, the expression Art Nouveau had no other meaning for Bing, as he was to reiterate quite clearly in 1902: "Art Nouveau, at the time of its creation, did not aspire in any way to the honour of becoming a generic term. It was simply the name of an art firm opened as a meeting place for all ardent young spirits anxious to manifest the modernness of their tendencies, and open

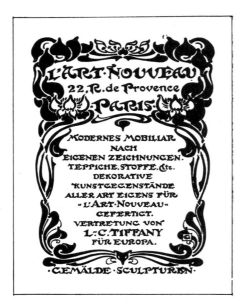

Georges Lemmen (1865-1916):
Advertisement for Samuel Bing's
Art Nouveau shop, at 22 Rue de Provence,
Paris, published in
Dekorative Kunst, Munich, 1898.

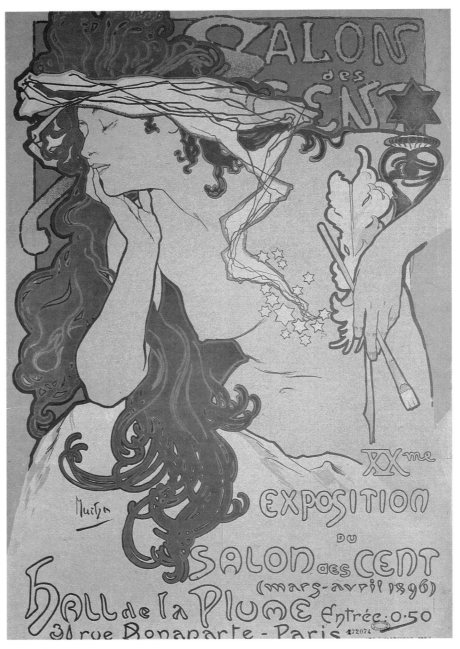

Alphonse Mucha (1860-1939):
Poster for the 20th exhibition of the Salon des Cent, Paris, 1896.

also to all lovers of art who desired to see the work of the hitherto unrevealed forces of our day." This was confirmed by Bing's choice of artists to exhibit in his gallery: the Nabis, Seurat, Signac, Toulouse-Lautrec and Carrière for painting, Rodin among others for sculpture, and for stained glass Tiffany and Gallé, Lalique for jewellery, and posters by Beardsley, Bradley and Mackintosh. At the beginning, even architecture was included with the remodelling of the gallery by Louis Bonnier, whose metal ornamentation showed the influence of both Horta and the English school. From the first, therefore, two basic tenets were established: internationalism and the presentation of "major" and "applied" arts on the same footing.

Aristide Maillol (1861-1944):
The Wave, 1898. Woodcut.

It was precisely this attitude that provoked a heated reaction from a wide sector of the public and critics, who saw it as a direct threat to the quality of the French tradition. Writing in the *Figaro* on the occasion of the opening of Bing's gallery in 1895, Arsène Alexandre said: "All this smacks of English viciousness, Jewish morphinomania or Belgian cunning, or an agreeable mixture of these three poisons." At the same time Edmond de Goncourt railed in his *Diary* against this "delirium of ugliness," this invasion of "Anglo-Saxon and Dutch furniture," this "conquest worse than the conquest of war." Shortly afterwards, Goncourt in his irritation returned to the subject, quoting the painter J.F. Raffaelli as speaking of "the moral perversion generated by these Anglo-Saxon pieces of furniture and the spread of sodomy encouraged by Liberty fabrics"! Octave Mirbeau, one of the most prominent French critics, was no less aggressive.

This violent reaction of French chauvinism, with its show of offended morals, could hardly leave Bing unmoved. He went ahead nevertheless, courageously exhibiting in 1896 the paintings of Munch (and Strindberg wrote an important article on them for the *Revue Blanche*), but the year after he turned to Germany and sent Van de Velde's furniture to Dresden for exhibition. In 1898 it was the German art review *Kunst und Kunsthandwerk* that printed Bing's fine article on Tiffany (translated into English in 1899). Paradoxic-

Félix Vallotton (1865-1925):
Poster for Samuel Bing's Art Nouveau
shop and gallery, Paris, 1895.

ally again, Georges Lemmen's attractive publicity for the shop in the Rue de Provence appeared in 1898 in *Dekorative Kunst*, Munich.

This change of direction was important and was to give new significance to the militant attitude of Parisian Art Nouveau. From then on, in the context of Art Nouveau, painting and architecture lost ground. In 1903 Bing stated oddly that architecture had failed to benefit from the progress of other art forms and had shown itself to be "incapable of guiding them by a bold initiative"! As regards painting, he considered in 1902 that its normal and regular development "called for no renewal." This surprising statement was, however, understandable since the founders were in reality developing principles posited before 1895, and works that seemed to be a pale reflection of those principles were abounding in ever greater numbers: Maillol's *Wave*, for example, in its different versions deriving from Gauguin's *Undines*, or the Breton landscapes of Georges Lacombe, the "Nabi sculptor," which repeat, in more decorative style and without the same areas of flat colour, Gauguin's *Over the Abyss*. In painting also, the theme tended to determine the form, and the innumerable variations, with more or less symbolist overtones on the themes of woman, hair, the snake and the sea, led progressively from Art Nouveau to 1900 Art, from Gauguin to Clairin, from Denis to Lévy-Dhurmer—even if the last named painted some fine pictures, such as the *Eve* of 1896, in which a leaf pattern after the manner of William Morris is combined with the Voysey snake and the red locks of Henner's nymphs.

Lucien Lévy-Dhurmer (1865-1953):
Eve, 1896. Pastel and gouache.

Edvard Munch (1863-1944):
Meeting in Space, 1899.
Three-colour woodcut.

Eugène Carrière (1849-1906):
Poster for the Paris newspaper *L'Aurore*, 1897.

On the other hand, the productions that showed independence and maturity were more marginal works, such as the lithographic art of Carrière, which attained an astonishing, almost abstract coherence in black and white sheets that deserve even now to be better known. Committed, like the Belgians, to socialist ideas, this painter clearly belongs among those who thought that the confrontation of shadow and light through sinuous lines heralded a new dawn for mankind. Bing held a one-man show for Carrière in 1896, the same year as his Munch exhibition, and this was more than a coincidence. Through his mastery of his medium, Carrière had grown and revealed himself as more than the "painter for literary men" which Fénéon had called him, dismissively, in 1891.

For Bing, the upshot was a self-imposed restriction to the decorative arts. The tide of modernity turned in favour of more marked reference to tradition, particularly French tradition, as Bing was to make a point of announcing very explicitly in 1902 in one of his two major essays on the movement: "Let us steep ourselves anew in the old French tradition, try to pick up the thread of that tradition with all its grace, elegance, sound logic and purity, and give it new developments." These are the features we find in three of his favourite collaborators: De Feure, Gaillard and Colonna. Hence, finally, the increasing importance of Bing's managerial role: in 1898-1899 his original gallery became a shop with its own workrooms.

Nor was Bing prepared to give way all round. Nobody criticized more harshly the practitioners of 1900 Kitsch: "All those crude imitations, shaped without regard to the most elementary rules of logic and given the name of Art Nouveau." The decisive turn Bing gave to the movement during these five years (1895-1900) culminated in an unexpected result, the creation of a typically French Art Nouveau, chiefly in furniture and ceramics, which revived the eighteenth century grace and refinement that had been regretted by Goncourt! Bing's Salon de l'Art Nouveau of 1895 was succeeded, significantly enough, by his "Art Nouveau Bing" pavilion at the Paris World's Fair of 1900; and "Art Nouveau Bing" became from then on his trade mark.

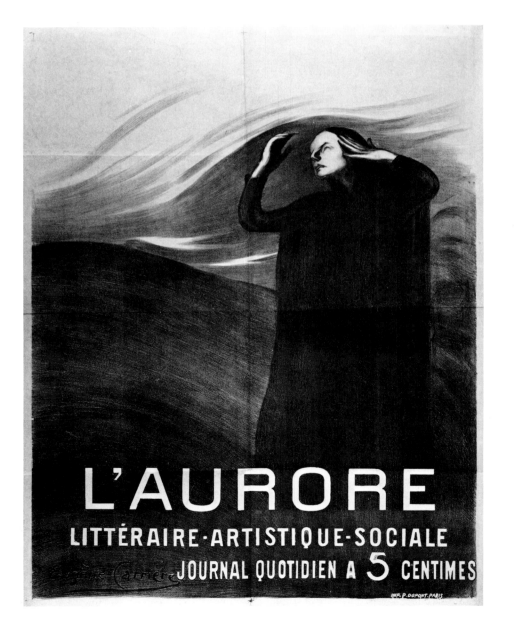

Eugène Grasset (1845-1917):
Buttercup illustration for his book *La Plante
et ses Applications Ornementales*, 1897.

The Art Nouveau sponsored by Samuel Bing was therefore
very different from the Art Nouveau of the architects and as dif-
ferent again from that of an artist like Eugène Grasset, who con-
tinued to advocate the undifferentiated application of stylized de-
coration, for example in his essay of 1896 on "Plants and their
Ornamental Applications," in which the powerful vitality of Van
Gogh's irises is lost in the dry medium of graphic design. Grasset
and Mucha did indeed "stylize" and "apply" with remarkable
skill, while the School of Nancy (and also Philippe Wolfers, the
Belgian counterpart of Gallé and Lalique) copied the floral motifs
and were at their best inspired by them to develop new forms.

Philippe Wolfers (1858-1929):
Gilt bronze inkstand, 1895-1900.
Made for Armand Solvay, Brussels.

PL. 65

BUTTER-CUP BOUTON D'OR Die GOLDBLUME

René Lalique (1860-1945):
Naiad diadem, c. 1897-1898.
Bronze, opal, gold mount and emerald.

els and Paris. And Gallé, triumphant in 1900 with his glassworks and its nearly 300 employees, was not the last who would go to war against "the partisans of meretricious decoration... cashing in on fashion snobbery and seeking to saddle the French, after the Belgians and the Germans, with a cosmopolitan modernism and a half-baked art, if the name of art can be given to a deformation of themes taken from nature, to the misguided outbreaks of the roughing chisel" (*Revue des Arts Décoratifs*, November-December 1900). Significant words indicating the profound crisis and fierce battles engaged in the French movement. It is indeed beyond the brilliant successes of the "decorators" and "stylists" that the vital forces of Art Nouveau have now to be sought.

The same could not be said of the Maison Moderne founded in Paris by Julius Meier-Graefe in 1897; nor of the Galerie des Artistes Modernes and the group of The Five (Charpentier, Dampt, Aubert, Tony Selmersheim, Moreau-Nélaton) who exhibited first in 1895, then in 1896 became The Six with Charles Plumet; nor of L'Art dans Tout ("Art in Everything"), another significant title, founded in 1897 by Henri Nock and Henri Sauvage. For all these artists, rationalist considerations came first, the question of form being only secondary. During this period, moreover, everything combined to favour the success in Paris of this new (decorative) art after the French manner, an art aiming once again at the creation of a style using traditional materials in a limited sector of production, which could in some respects even seem like a last and brilliant reincarnation of the historical past. Magazines like *Art et Décoration* (1897) and *L'Art Décoratif* (1898) undertook to make it widely known, and if the second featured a Van de Velde cover, that was only because it was a special number of the Meier-Graefe review devoted to the artist. The founding principles of the early nineties were in reality left far behind, together with English moralizing and the painters' and architects' concern with space.

"The creations of the School of Nancy, the jewellery of Lalique, were regarded at that time as examples of a new style that was spreading to Belgium and manifested in hybrid architectural conceptions in which the clear and sincere principle of the construction was tricked out in riotous ornamentation. Wigs on skeletons." Such was Van de Velde's harsh criticism in 1933, in *La Voie Sacrée*, as he recalled those who had blocked his way in Bruss-

Emile Gallé (1846-1906):
Iris, 1898. Polychrome glass
vase mounted in bronze.

Cover of *L'Art Décoratif*, special issue
devoted to Henry van de Velde, Paris, October 1898.

Cover of *Art et Décoration*,
Paris, January 1897.

◁ **Alphonse Mucha** (1860-1939):
The Daisy Woman, 1898-1899.
Decorative panel in printed velvet

Philippe Wolfers (1858-1929):
Flower vase, 1896. Silver mounted cut glass.

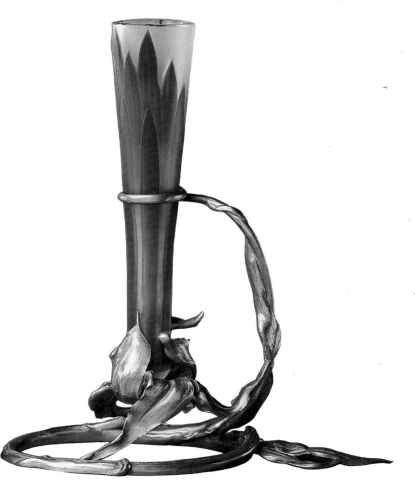

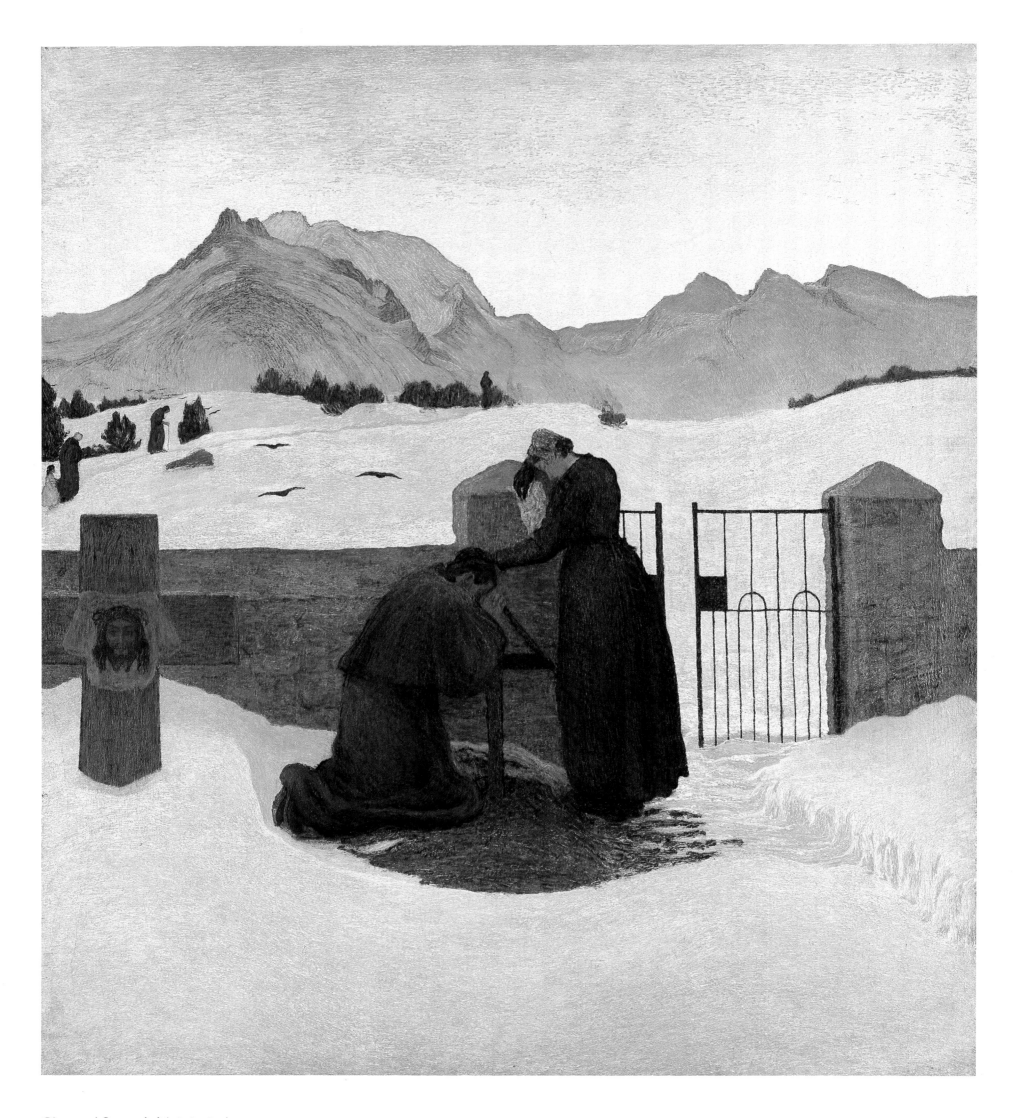

Giovanni Segantini (1858-1899):
Sorrow Comforted by Faith, 1896.

The Consolation of Faith

Living since 1894 at Maloja in the Upper Engadine, Segantini moved in 1899 to the Schafberg above Pontresina. His deliberate withdrawal into the Alps of eastern Switzerland may have seemed to cut him off from the great centres of artistic activity. And yet he was exhibited by The Twenty in Brussels from 1890 on, he was acclaimed in Munich in 1896, and he was one of the few outsiders invited to exhibit with the Vienna Secession, which published his work and quoted him in its magazine *Ver Sacrum* in 1899.

Painted at the beginning of this new phase, his *Sorrow Comforted by Faith* shows all the characteristics of Segantini's final manner and accounts for his growing influence in the 1890s. No more floating draperies here, no more pretty but pointless arabesques. The setting is the small country graveyard at Maloja (where Segantini himself was buried in October 1899). Organized around it is a controlled, homogeneous composition in which forms fit together on the picture surface, in parallel planes and bands creating an alternation of brighter and darker values. The human figure hides its features and assumes attitudes which favour its integration into the natural setting. For all the expressiveness of the subject, Segantini had never departed so far from the imagery of international Symbolism, such as still dominated his *Dea d'amore* of 1894, in order to work out those "pictorial equivalents" typical of the ornamental conception of painting advocated by Maurice Denis. As for the powerful contrast of black and white distinctive of this picture, it refers back both to the new English book design and to the interior decorations of the Glasgow School and the Vienna Secession—two movements gradually growing together and due to meet at the end of the century. Decoration in the typically Hoffmannesque manner is suggested at once by the cemetery gate with its sober pattern of black on white, its square expanse of flat colour, its geometric combination of straight lines and curves.

This masterly synthesis, carried out in the solitude of his mountain retreat, but linking up with the avant-garde of both Eastern and Western Europe, fulfils one of the chief ambitions of Art Nouveau. Segantini had met with incomprehension in his native Italy and gone into exile. There his keen questing spirit sought and found fulfilment in the faith that animated his art; and it was that faith which, paradoxically, enabled him to assume his international vocation.

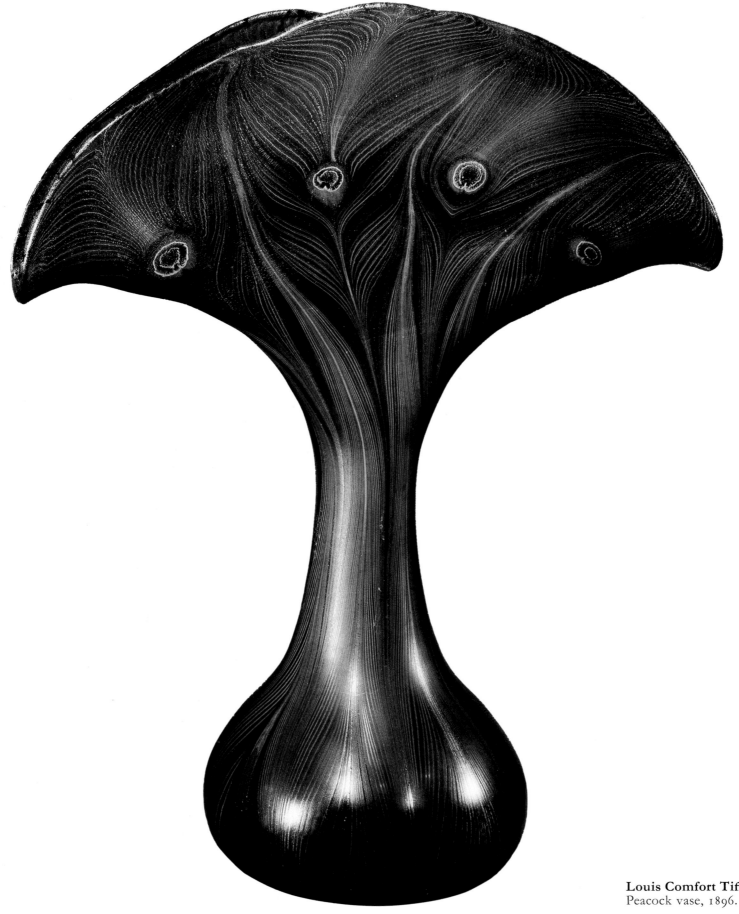

Louis Comfort Tiffany (1848-1933):
Peacock vase, 1896. Favrile glass.

MILITANT ART NOUVEAU
IN ENGLAND, SCOTLAND, THE UNITED STATES, GERMANY AND AUSTRIA
1895-1900

The Contradictions of the Anglo-Saxon World

THE same year he died (1896), the Kelmscott Press of William Morris brought out what was without doubt his most perfect book: the *Chaucer* illustrated by Burne-Jones, with borders and initial letters designed by Morris himself. With this major achievement in the history of the nineteenth century art book, but also with the death of its inspirer and soon afterwards the closing down of his publishing firm, an epoch came to an end. One has only to set these compact pages against the bold binding designed by Beardsley at the same time for the *Verses* of the Symbolist poet Ernest Dowson to see once more everything that divides the initiator of Arts and Crafts from the man whose career owed everything in fact to Burne-Jones. Just as the mechanical reproduction of Beardsley's illustrations is contrary to the wood engraving used by Morris; just as the medievalesque lettering of Morris (of which the "Chaucer type," derived directly from the Gothic, is perhaps the finest) turns its back on the new typography just then devised by Grasset in France (1897) or by Eckmann in Germany (around 1896); so Morris's foliated scrolls, despite their admirable suppleness and the unbroken linking of their lively and spirited coilings, depend here on a conception wholly different from that abstract, denuded line, content to denote its territory and material by a few ironic curves, with all the superior detachment of the aesthete. And with a casual individualism as well, distinguishing it from the solid, rational construction of Van de Velde's bindings.

But in England this arrival point also marked a roadblock. Beardsley, like Wilde and Whistler, was cause for scandal. After his expulsion from *The Yellow Book*, the founding of a new, more private review, *The Savoy*, began in 1896 what became for the two remaining years of Beardsley's life a growing eroticism and mannerism accompanied by a marked reference to eighteenth century art. And the Arts and Crafts movement simultaneously gave a sharp "puritan" check, so to speak, to the expansion of English Art Nouveau. Ashbee's silverware offers a good example. Its simplicity, its ease of use, its "truthfulness" in the use of materials were so many recent conquests that, like Voysey's architecture, made possible the smooth transition, after the parenthesis of continental Art Nouveau, to the industrial object of the Werkbund and subsequently of the Bauhaus. But at the time Ashbee himself remained attached solely to the virtues, honest and sincere, of craft production, and gave scarcely a thought to the search for a style for the coming era. If he happened to come close to Art Nouveau, as in the sinuosity of that strange spoon he designed around 1900, it was, as it were, by accident: the strict symmetry of the mustard pot which accompanied it, the classicism of its form, the restraint of its decorative motif show substantially that the success depends more

on the mastery of a superior craftsmanship than on the "will to art" that might have guided its conception.

As much might be said for the eclectic productions of the London firm of Arthur Lasenby Liberty, whose fabrics, often of Far Eastern inspiration, were then invading Europe, and whose name would serve to christen the Italian movement. When the Liberty firm became interested in objects, beginning in 1894, it was in the same spirit, seeking neither unity nor complete originality: the beautiful silver plate by Archibald Knox, for example, with its embossed enamels, owed a great deal of its decoration to Celtic interlace motifs, and prided itself in the reference to a remote national past.

Charles R. Ashbee
(1863-1942):
Mustard pot
and spoon, c. 1900.
Silverware.

Aubrey Beardsley (1872-1898):
Binding design for Ernest Dowson's *Verses*, London, 1896.

William Morris
(1834-1896):
Two pages from
*The Works of
Geoffrey Chaucer*,
Kelmscott Press, 1896.
Woodcut illustrations
by Burne-Jones, borders
and initials by Morris.

Charles Harrison Townsend (1851-1928):
Design for the Whitechapel Art Gallery, London, 1895-1899.

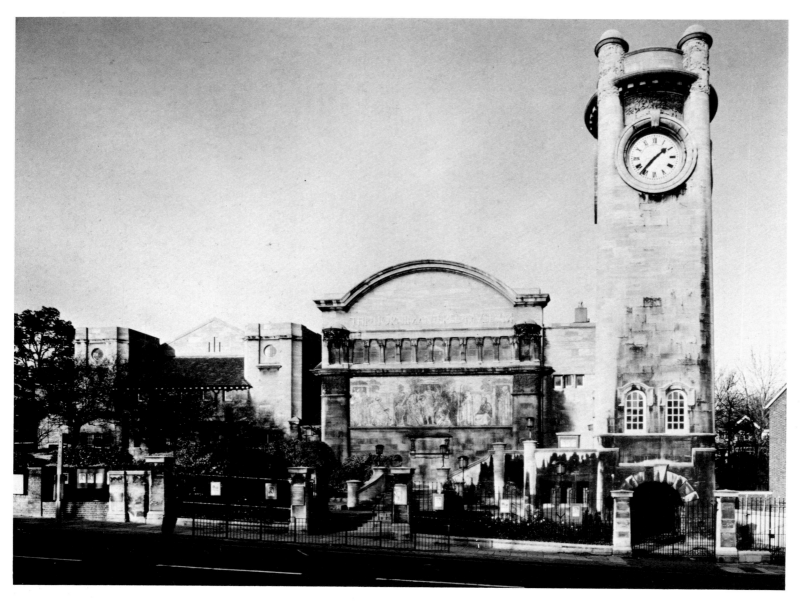

Charles Harrison Townsend (1851-1928):
The Horniman Museum, London, 1896-1901.

Among the rare examples of true English Art Nouveau, the architecture of Charles Harrison Townsend stands out as a special case. The astonishing design for the Whitechapel Art Gallery, remodelled between 1895 and 1899 (and unfortunately followed by an execution that fell far short of it) asserted against the austere utilitarianism of Arts and Crafts the primacy of a pictorial composition with provocative asymmetry, in which the rounding and hollowing of the volumes are brought out by a strong contrast of light to match the varied handling of the surfaces. The central mosaic design (not carried out), less well integrated and advanced than the graffito technique of the Ciamberlani House in Brussels, bears eloquent witness, with its peacocks and lilies, to the influence of the Aesthetic Movement, as does the densely packed greenery at the base of the towers, somewhere between English wallpaper and the foliage of Vuillard's *Public Gardens*. Begun in 1896, the Horniman Museum, also indebted to the neo-Romanesque of the American architect Henry Hobson Richardson, gave a less provoking version, compromised by a certain heaviness and the return of historicist elements, in particular in the blind façade.

But it is only necessary to compare these two unorthodox buildings (which for all that do not call into question structures or materials) with the Glasgow School of Art designed by Charles Rennie Mackintosh at the same time (1896) to see, beyond the superficial analogy of the central arches of the fronts, what differentiates an original decorative composition from one of the finest achievements of genuine Art Nouveau. Here, in the Glasgow School of Art, are to be found joined once more the two major components already seen at work in Horta and Van de

Velde, and to a lesser degree in Guimard: a frank rationalism and, as has been said, an intention even as powerful to create a style, but without tacking on ornament and without contradicting function.

Rationality is expressed first in the organization of the main front: pure structure in which the great windows in metal frames correspond to the north-facing studios, which they amply light beneath the shelter of a continuous penthouse roof. But rationality is equally asserted in the central part, the asymmetry of which results, this time, first from the interior arrangements: door, vestibule and first flight of the interior staircase, placed exactly in the central axis of the building, and on the left of this axis, the concierge's lodge and the second staircase, housed in the turret, to link the two rooms assigned to the director on the first floor and the mezzanine. Hence a subtle counterpoint, based on the *necessity* of the asymmetry, on the *aesthetic* advantage that may be gained from it: the entrance door and the office window are in the centre of the main front, as the severely symmetrical street railings emphasize; but the solid mass of the stonework is shifted to the left, and on the far right two narrower windows instead of one fill the larger space thereby left available. The breaking up of the other volumes follows the same principles, and in particular the main staircase leading to the museum room on the first floor, lit by one big window and serving as a light well, as with Horta.

Mackintosh's aesthetic concern, in the Glasgow School of Art, comes out in the ornamental design which (as distinguished from Townsend) emphasizes the structure, and also in the metal decoration which takes full advantage, again as with Horta, of the properties of the material. This is well summed up in the famous "brack-

Charles Rennie Mackintosh (1868-1928):
The Glasgow School of Art,
main front, 1896-1899.

ets" placed at first-floor level in front of the studio windows: at one and the same time, a projection of the metal skeleton into exterior space, an aesthetic motif calling attention to the artistic purpose of the building by the abstract "flowers" in which the brackets terminate, and a point of support from which to clean the windows.

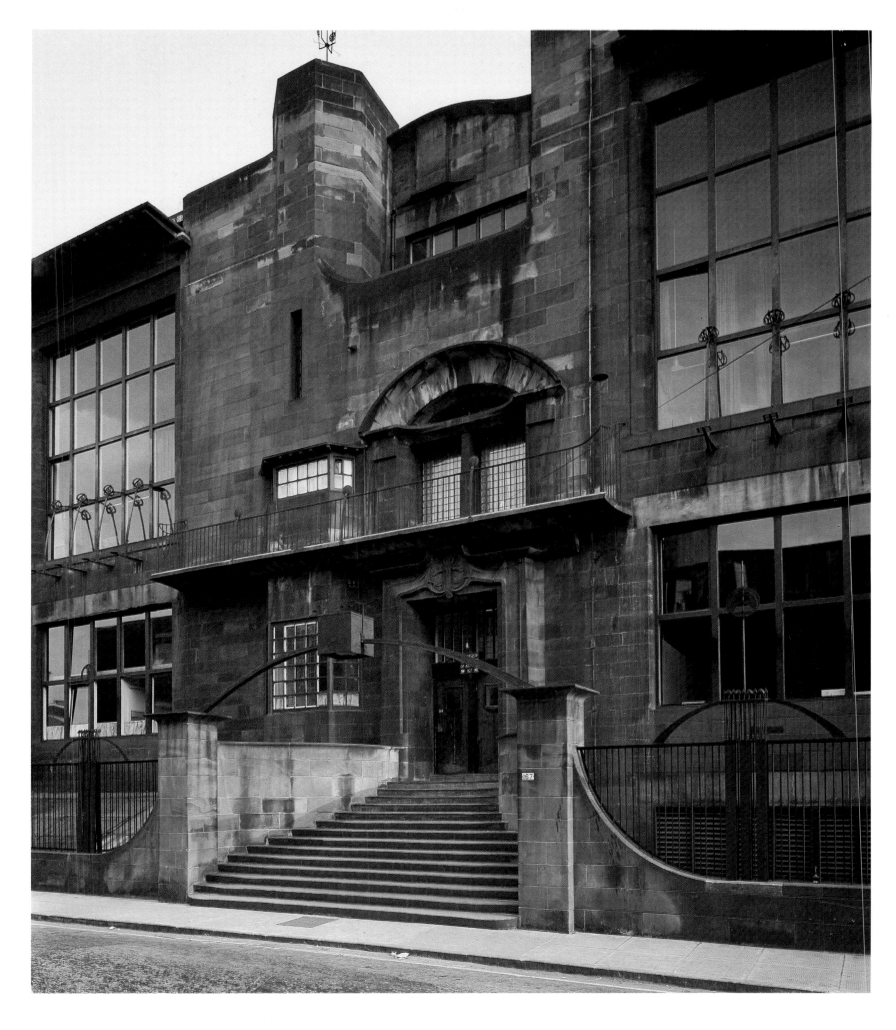

Thus the Glasgow School of Art represents a masterly synthesis, and a major success of Art Nouveau in which design remains in command without being false or gratuitous—the total expression of a project fully responding to a definite programme.

After having absorbed the lessons of neo-Gothic rationalism, Mackintosh in fact discovered in Whistler and at the same time in Japanese art (then very much in vogue in Glasgow) the value of empty areas, of surface contrasts, of linear cutouts. The dynamic power of line had also been revealed to Mackintosh through *The Studio* and its reproductions of Beardsley and Toorop. These two artists were the inspiration behind the graphic works of the group known as "The Four" (Herbert McNair, who worked in the same architectural firm as Mackintosh, and the sisters Margaret and Frances Macdonald, who ultimately became their wives). Their posters, in particular, freed of all "decadent" symbolism, held the balance, as with Lautrec and the Nabis, between representation and the full use of pictorial resources. Their mark may be found in the single carved ornament above the door of the Glasgow School of Art, and Mackintosh would later transpose them into the decoration of Miss Cranston's Buchanan Street tearooms: pure rhythmic animation of the wall, strictly in flat colour, with great empty areas respecting its integrity.

But this also explains the violent rejection expressed in London at the 1896 show of the Arts and Crafts Exhibition Society: The Four were lumped together with Beardsley and, with Oscar Wilde's trial then proceeding at the Old Bailey, considered as perverted aesthetes. In Glasgow itself Mackintosh was supported only by a handful of friends and patrons (including Francis Newbery, the director of the School). Abroad, on the other hand, his revolutionary ordering of forms was seen and appreciated: the favourable articles published in *The Studio* in 1897 and those which followed in Germany (in *Dekorative Kunst* beginning in 1898) heralded Mackintosh's surprising conjunction with the Vienna Secession, which he was to visit in 1900.

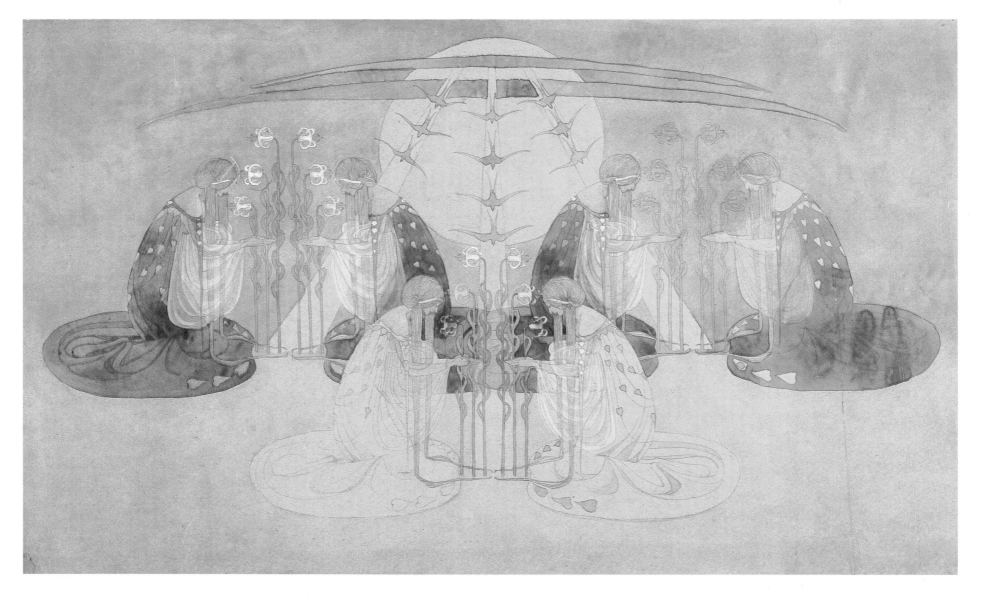

Frances Macdonald McNair (1874-1921):
The Moonlit Garden, c. 1895-1897.
Watercolour.

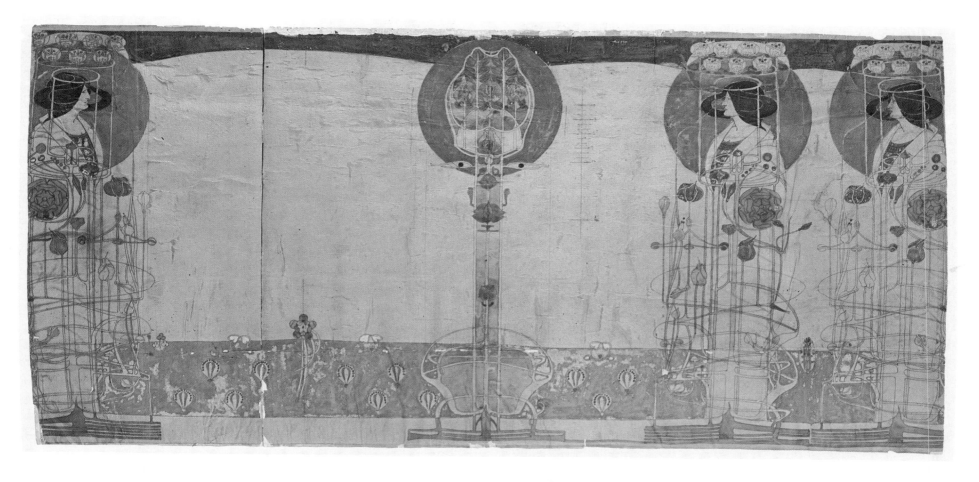

Charles Rennie Mackintosh (1868-1928):
△ Preliminary design for the mural decoration in
Miss Cranston's Buchanan Street Tearooms, Glasgow.
Watercolour over pencil, 1896-1897.

▽ Photograph of Miss Cranston's Buchanan
Street Tearooms, Glasgow, with Mackintosh's decorations
and furniture by George Walton.

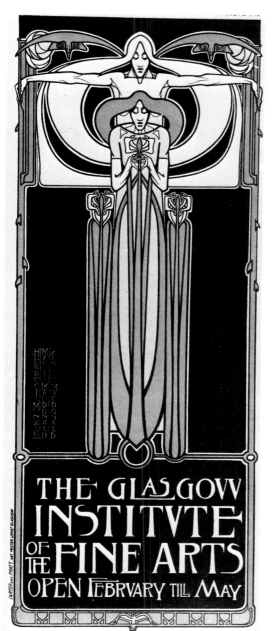

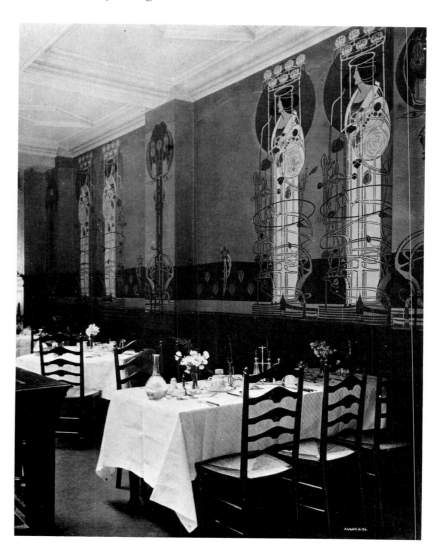

Margaret Macdonald Mackintosh
(1865-1933),
Frances Macdonald McNair
(1874-1921),
Herbert McNair
(1868-1955):
Poster for the Glasgow Institute
of the Fine Arts, c. 1896.
Colour lithograph.

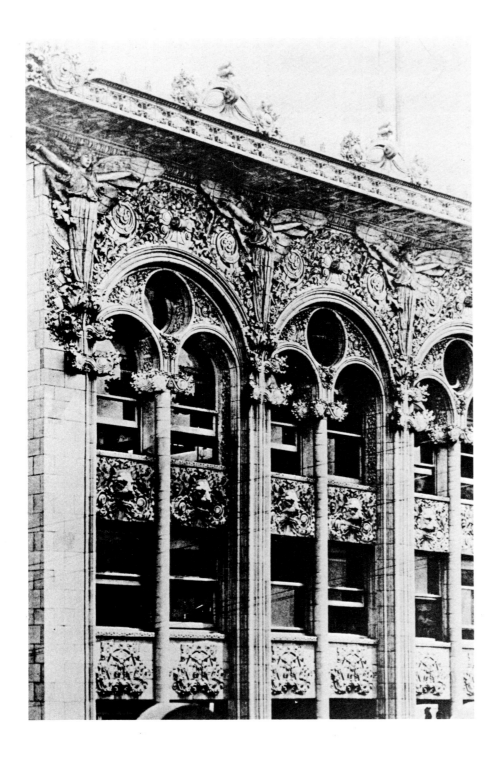

Again in a comparable way, Tiffany, then at the height of his production, inimitably combined ornament and rationality. The analogy that may be detected between the drawn-out forms of many of his vases and those of the Scots, for instance, is in reality only secondary. What is important is that they derive from process alone and from material alone, as Bing strongly and quite rightly emphasized in his article on Tiffany published in 1898 in *Kunst und Kunsthandwerk*. The colours of his Favrile ("hand-made") glass in particular are the result, as with Gallé, of superimposed layers; their unique iridescences come from the vapours of molten metals projected onto the hot glass; the stretchings are due to the way the glass is blown, a process at its peak during the years 1896-1900. In the majority of Tiffany's vases (for there are also borrowed forms) the result is a completely homogeneous object which owes no more to the copy of a floral pattern (as with Gallé) than to intervention after the fabrication itself, by engraving, for instance. And in

Louis Sullivan (1856-1924):

◁ Bayard Building, 65 Bleecker Street, New York, 1897-1898. Cornice detail. In collaboration with L.P. Smith.

Carson, Pirie and Scott Department Store, Chicago, 1899-1904.
▽ Round corner element with entrance.
▷ Ornament detail of the round corner element (page 115).

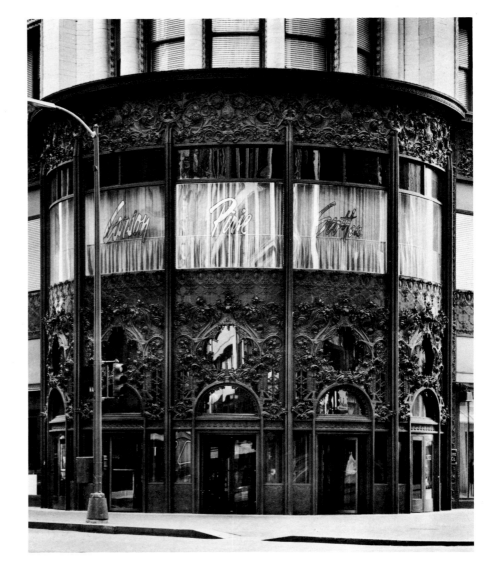

That is why, too, the parallel with the American movement, however distant from Europe, is in no sense paradoxical. The personal, unacademic way in which Sullivan used ornament by associating it with a rational structure was as frowned on in New York, where it ran counter to all the cherished principles of the French Beaux-Arts style, as the work of Mackintosh was in London. Relegated to the shadow of a sharply projecting cornice, the caryatids of the Bayard Building, Sullivan's only New York construction, prolong the upspring of the colonnettes and their outspread arms logically close, as in the Glasgow Institute poster, the verticality of the form. In the Chicago department store of Carson, Pirie and Scott, begun in 1899 and finished in 1904, which stands as Sullivan's greatest achievement, the ornamentation may seem to reach its peak of "extravagance." But, still following a clear outline, it is concentrated in fact on the powerful rotunda that marks the corner of the building, leaving the upper storeys bare, and its signalizing function is repeated by a reference to the inflow of potential buyers, whose trajectories interweave in a comparable way in this particularly busy city square; an inducement to pursue these crisscrossed routes inside the building.

this maximum integration, Tiffany doubtless stands closer to the proceeding followed by Chaplet in his flamed stoneware than to that of Gallé, his rival from Nancy.

The vases blown in the shape of a peacock's feather (all different, and of which an example was given in 1896 to the Metropolitan Museum in New York by H. O. Havemeyer) represent an amazing feat as well as one of Tiffany's most accomplished achievements. It was not by chance that it was the emblem of the Aesthetic Movement, which was thus not copied, drawn and stuck onto a form, but organically recreated, by human industry, in the image of natural creation—between Whistler's Peacock Room and the spin-off of the peacock motif in the stylized imagery of Art Deco. There once again Art Nouveau was seen at its best, not only in the beauty of achieved works but in the perfect fulfilment of its principles : total novelty of form due to the close union of universal reason and the act of individual creation.

Louis Comfort Tiffany (1848-1933):
Two tulip vases, c. 1897.
Favrile glass.

If we are called upon to declare the supreme characteristic of this glasswork, the essential trait that entitles it to be considered as making an evolution in the art, we would say it resides in the fact that the means employed for the purpose of ornamentation, even the richest and most complicated, are sought and found in the vitreous substance itself, without the use of either brush, wheel or acid. When cool, the article is finished.

*Samuel Bing, The Colored Glass of
Louis C. Tiffany, Paris, 1898.*

Joseph Sattler (1867-1931):
Cover for *Pan*, Berlin, 1895-1896. Colour lithograph.

Jugend:
The Awakening of Youth in Germany

ITH the sudden blossoming forth of Jugendstil in Germany in 1895-1896, all the ardour of militant Art Nouveau on its full upward swing is found again. In a few years the ideas propounded in Brussels, Paris and Glasgow would be so far radicalized and systematized here as to lead on, steadily and smoothly, to the new international avant-gardes in the opening years of the twentieth century.

"It is only for the last five or six years that we have been able to speak in Germany of a modern movement in the applied arts," a critic was to write in 1901, before adding significantly: "The will to reform the decorative arts was there, and will bring forth action." The suddenness of this tardy awakening and its eager intentness are in fact the hallmarks of the German movement, in complete contrast with the gradual loss of momentum in England and America.

Still more than in England and France a few years before, the new German periodicals—both in their articles and their illustrations—came to play a decisive role, for they were receptive to all forms of advanced art and they were international-minded. In three or four years an astonishing output of art and literary magazines occurred: in Berlin, *Pan* in 1895 and *Die Insel* in 1899; in Munich, *Jugend* and *Simplicissimus* in 1896 and *Dekorative Kunst* in 1897; in Darmstadt, *Deutsche Kunst und Dekoration* and *Kunst und Dekoration* in 1897 came to join the *Zeitschrift für Innendekoration* founded in 1889.

Pan and *Jugend* sum up well the spirit of the movement. The art critic Julius Meier-Graefe, together with the poet Otto Julius Bierbaum, was the founder of the first; thoroughly familiar with the Paris art world, he was friendly with Bing and Van de Velde, whose Bloemenwerf villa near Brussels he saw the same year he started his magazine. And its title (*pan* means "all" in Greek) was meant to convey its receptiveness to all European artistic currents. The poster for the magazine and Joseph Sattler's cover design are highly eloquent in that respect. This god, at once mocking and marvelling, who watches a strange flower blooming in a fallow field, a product of nature and of publishing at the same time, harks back to a typically Germanic mythological tradition of which Franz von Stuck provided at that time the latest version. But the scrolls of paper and the very sinuosity of the stamens point beyond the figurative pattern clearly to the kind of art in question: linear, floral, organic and abstract all at the same time, it was indeed the whole growth of Art Nouveau that was now being cultivated on German soil.

A satirical magazine like *Simplicissimus*, *Jugend* did not have exactly the same function, but there once more the symbolic value

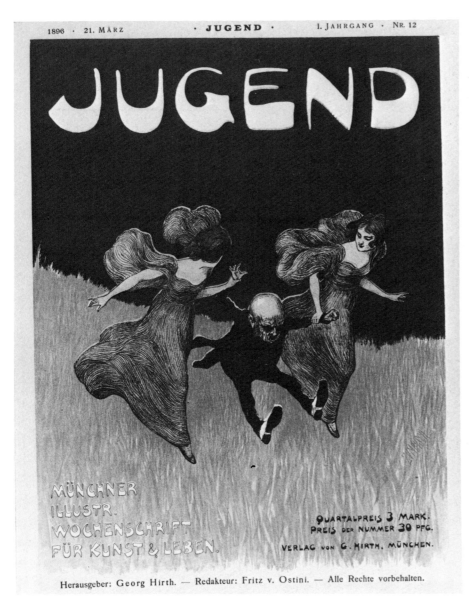

Ludwig von Zumbusch (1861-1927):
Two covers for *Jugend*, Munich, March 1896
and October 1897. Zinc engravings.

of the title and that of the illustrations were no less rich. "We want to call our new weekly *Youth*," declared the editorial of the first issue in January 1896, "and that says everything we have to say." The famous title and poster drawn that first year by Ludwig von Zumbusch are still more explicit, showing two young women dragging a reluctant little old man in a wild romp through open country: for "youth" violence had indeed to be done to a dreary academic past. The following year, again drawn by Zumbusch, the two girls, this time alone, would be able to celebrate in an exalted Fulleresque dance—but in which the swirling flight of the dresses takes good care to respect the composition in flat colour—the final conquest of aesthetic liberty. Jugendstil, which took its name from the Munich weekly, thereafter asserted itself as the distinctive style of Art Nouveau in Germany.

This appeal to national renewal based on the living forces of the outside world was felt all the more strongly in that it came at a moment when a crushing historicism prevailed, fostered by Germany's economic prosperity and the standfast conservatism of its Academies. It explains the lifting of the nationalist barrier. Munch caused a scandal with his one-man show in Berlin in 1892, but he continued to live there, and the first book on his work was published in 1894 in German; Toorop was exhibited at Munich in 1893;

Mackintosh's Glasgow School of Art was illustrated in 1898 in *Dekorative Kunst* for the first time on the Continent; Van de Velde worked in Berlin in 1899, and that same year the Austrian architect Olbrich left Vienna for Darmstadt.

The pictorial tradition nevertheless continued to have a strong braking effect. Even the German Secessions, those dissident movements created on the fringe of the Academies in 1892 in Munich and in 1898 in Berlin, did not open the way to an avant-garde painting. With their heavily symbolic subjects and a strange indifference to any innovative research into form and design, a Max Klinger, a Franz von Stuck or a Ludwig von Hofmann remained well short of Munch, Hodler or Segantini, to say nothing of the Nabis and Post-Impressionists in France.

But at the same time there was a stampede and a leap forward in the field of graphic and then of applied arts. Nearly all of the great names of Jugendstil repeated the career movement of a William Morris or a Van de Velde by giving up painting for *Flächenkunst*, the art of decorating surfaces. That, for example, was the case of Otto Eckmann, who sold or burned his paintings in 1894 to become in the following year the most remarkable illustrator of *Pan*. But the same was true for Riemerschmid, Behrens, Endell, Pankok and Christiansen.

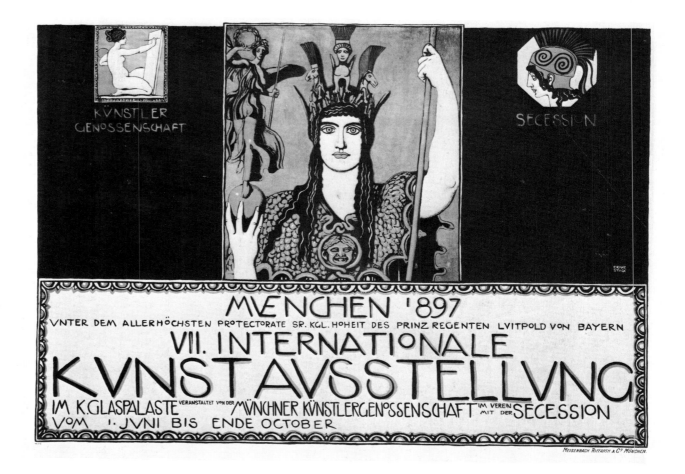

Franz von Stuck (1863-1928):
Poster for the Seventh International
Exhibition of the Munich Secession,
June-October 1897.

Otto Eckmann (1865-1902):
Frame and border decorations for a poem
by Hans Bruckner in *Pan*, Berlin, 1895-1896.

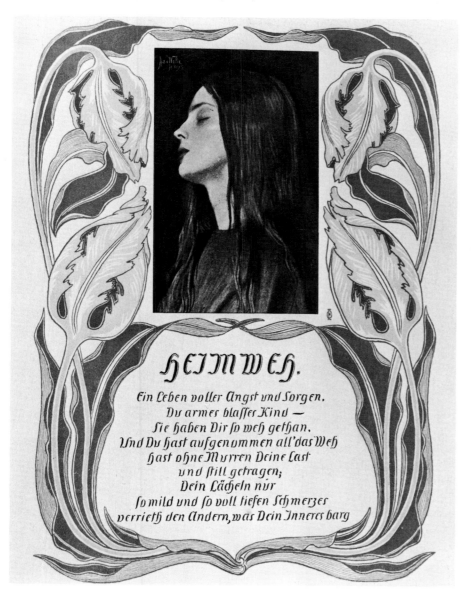

Otto Eckmann (1865-1902):
Title page for *Die Woche*, Berlin, 1899.

Bruno Paul (1874-1932):
Cover for *Jugend*, Munich, August 1896.

The outstanding welcome mat put out by the periodicals (*Jugend* employed no fewer than 175 illustrators in its first year) fostered that conversion, the more so in that the leading names of the international avant-garde figured in their pages—for example, Félix Vallotton in 1896, the first biography of whom was brought out by Meier-Graefe in 1898. Hence the frequent impression of a certain intoxication, not without superficiality, either, in the use of new procedures. In 1896 Bruno Paul's cover for the thirty-fifth issue of *Jugend* had a field day with sinuous linework: bends of the road, cant of bicycles, curve of handlebars and especially that warped wheel, which recalls the satirical intentions of the magazine but, with the heavily marked outlines, provides a curious aftermath of the experiments made in the 1880s by the Pont-Aven painters.

Otto Eckmann's work has solider foundations. The presence in it of the Japanese model is obvious, as is that of the English book, from Ricketts to Beardsley. But these influences are assimilated; and his attachment to the floral pattern, as with Gallé, does not prevent Eckmann from first taking into account the complete organization of the page and the balanced distribution of light values. For this reason also, from 1896 on, he worked out a revolutionary typography that would result, after 1900, in "Eckmann Schmuck," the most accomplished Art Nouveau fount along with that devised in France by Georges Auriol. The title page of the Berlin weekly *Die Woche* in 1899 gives the intermediate stage, with the recurrent loops of its letters, whose highly organic downstrokes and upstrokes occupy and animate the surface, and

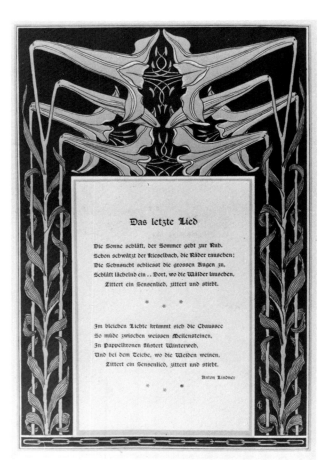

Otto Eckmann
(1865-1902):
Decorated page
from *Pan*, Berlin,
with a poem by
Anton Lindner, 1896.

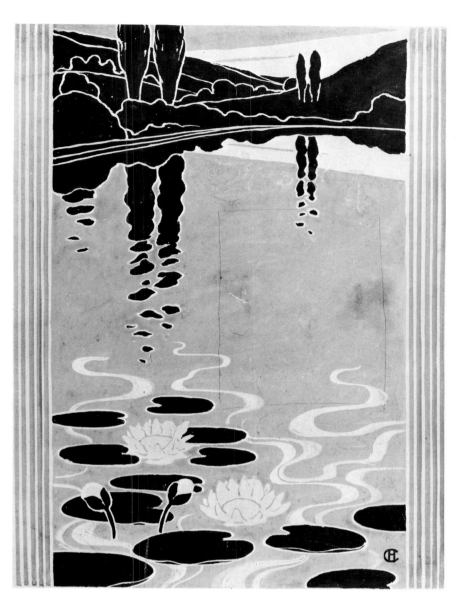

Hans Christiansen (1866-1945):
Water, 1896. Decorative design
for the cycle The Four Elements.

that "7" of the seven days of the week which has itself also absorbed the abstract line of Van de Velde in order to achieve a homogeneous interaction of white and black.

This reasoned passion for flat tones also explains the importance given to tapestry, the first craft technique generally taken up by defectors from painting like Van de Velde. Eckmann's *Swan*, the most famous of Jugendstil tapestries, with over twenty examples woven, gives its quintessence, as it were, with its subtle development in height, where the verticals (tree trunks and swans' necks) counterpoint the sinuous lines (the stream, the reflections); and it manages to replace in the spectator's mind a pattern nonetheless charged with symbolic overtones by a completely abstract rhythmic movement (shifting the swans to the right, then to the left, and downwards as against the rising movement of the trees). Every tapestry does not attain this refinement, and the comparable works by Hans Christiansen, for instance, mastering space less well, give only a weakened version of it. But that is enough to point out the intense activity of the Scherrebek tapestry works in North Schleswig, founded in 1896. With other artists like Walter Leistikow or Alfred Mohrbutter, Scherrebek was to turn out the most finished products of Art Nouveau weaving.

The painters thus answered the appeal addressed to them by Alexander Koch in May 1897 in the first issue of his *Deutsche Kunst und Dekoration* for an integration of all the arts and a return to handicraft industry. So did the Vereinigte Werkstätten für Kunst und Handwerk founded in 1897 in Munich (with Obrist, Pankok, Paul, Riemerschmid and Behrens as the moving spirits) and the

Otto Eckmann (1865-1902):
◁Swan Tapestry, 1897.

△German interior with
Eckmann's Swan Tapestry.
Photograph from *Deutsche Kunst und Dekoration*,
Darmstadt, August 1899.

Carl Strathmann (1866-1939):
The Cosmic Serpent, before 1900.
Watercolour over pen and ink.

Karl Koepping (1848-1914):
Two glass cups, 1895-1896.

Dresdener Werkstätte für Handwerkskunst starting the following year. And contrary to what happened in France, it was the applied and decorative arts in Germany that in return would act on the work of some painters, as on the *Cosmic Serpent* of Carl Strathmann, a Munich artist influenced by international symbolism, who here borrowed from mosaic, from Voysey's *Water Snake*, not to mention the thread-like wall decoration of the Glasgow School of Art, to affirm the universal calling of the serpentine line and the flat tint in a composition bordering on abstraction.

Even the beautiful glassware of an independent artist like Karl Koepping springs from this same linear conception (unlike Tiffany's work, which perhaps inspired it). The unintegrated ornament flows out of the principal form in fragile, hardly rational filaments which account for the success of Koepping's glass.

The outstanding symbolic work of Jugendstil design during this first phase was the Elvira Studio in Munich, a photographer's studio built in 1897-1898 by August Endell (destroyed in an air raid in 1944). A key work of architecture, but in a far different way from Horta's Tassel House, from which it borrows only superficially the most spectacular part of its highly theatrical decoration. If Horta's purely architectural features are not wanting in the Elvira Studio (the asymmetrical distribution of openings, the emphasis on wall), the essential concentrates in fact on decoration, and above all on the ornamental shape sweeping over the front, standing out in purple on a green background: dragon, cloud or shell according to the various interpretations that have been suggested, but above all an aesthetic provocation, throwing a challenge in the face of Munich academicians.

We stand at the threshold of an altogether new art, an art with forms which mean or represent nothing, recall nothing, yet which can stimulate our souls as deeply as only the tones of music have been able to do.

August Endell, 1898.

August Endell (1871-1925):
Elvira Photo Studio, Munich,
1897-1898 (destroyed 1944).
▷ Hall staircase.
▽ Main front.

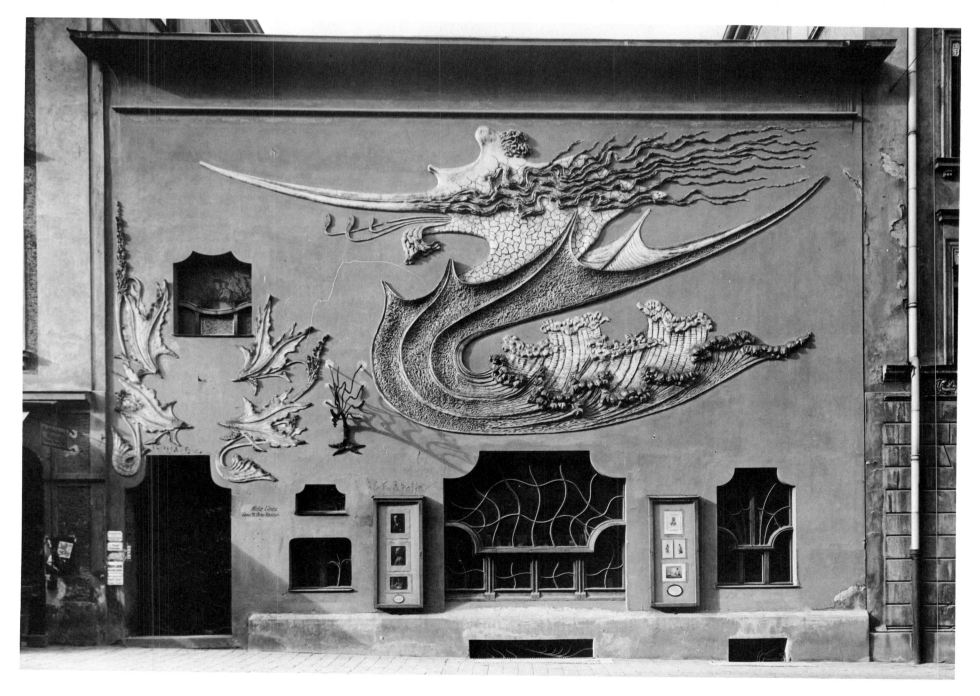

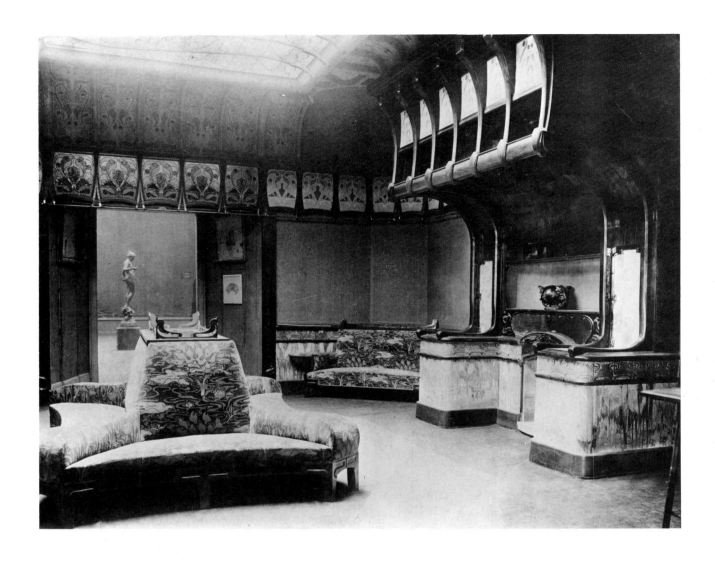

The 1897 Dresden exhibition of rooms furnished by Van de Velde marks the passage from this revolutionary practice of the art of surfaces to a reflection on volumes and structures which testifies to a deeper will to the rational renewal of social space. With the coherent doctrine that had up to then been lacking—and in particular the theory of "force-lines" opposing the gratuitousness of the simple arabesque line—his works were welcomed "with an enthusiasm that was rather excessive," as Van de Velde himself emphasized in 1933 in *La Voie Sacrée*. In his wake appear the works of the third dimension, and first of all the furniture from the Dresden and Munich workshops which, following his example, aimed both at functionality and at continuity with the surrounding space, as in the armchair designed by Endell in 1896.

Van de Velde's example stimulated German designers, like Richard Riemerschmid, who in 1896, like him, built his own house, near Munich, and placed on exhibit some rooms in which the homogeneity of the space and the rationality of the furniture took precedence over the ornamental detail; such was the Music Room shown in Munich in 1899. And above all there was the personality of Peter Behrens, who also began to pose the problem of semi-industrial production, as in the glass service he designed in 1898, the force and sobriety of which made a complete break with the precious and sophisticated work of Koepping. By the diversity of his activities and the unifying power of his design, Behrens would go on to appear as a kind of German Van de Velde. His interest in book design and illustration revived, stimulated by the work of Otto Eckmann and the ideas set forth in Van de Velde's *Déblaiement d'Art* ("Clearing Up Art") and in the Belgian

August Endell (1871-1925):
Elmwood office chair, 1896.
Cushion design by Richard Riemerschmid.

124

periodical *Van Nu En Straks*; witness Behrens' fine cover for *Der Bunte Vogel von 1899*, "a calendar book by Otto Julius Bierbaum," which he illustrated. And one of Behrens' major graphic achievements, *The Kiss*, a woodcut done for *Pan* in 1898, develops the same principles as the goldsmith's work done by Van de Velde at the same period. As in the latter's belt buckle, the ornament of Behrens' woodcut engenders its own space, and the kiss represented is only the embodiment, in terms of the human figure, of interwoven abstract lines which have no other justification, and no other desire, but the embrace of their interlaces. This work is as fascinating as Munch's contemporary and more famous *Kiss*, also a woodcut, which by its medium conveys a similar meaning.

Behrens' *Kiss* stands out as one of the most distinctive works of Art Nouveau. By then, in 1898, the provocative Jugendstil of 1896 was a thing of the past and, Van de Velde having shown the way, Germany was ready for the advent, through forms alone, of an all-embracing social project, whose architectural foundations were to be laid at Darmstadt in 1901.

Peter Behrens (1868-1940):
The Kiss, 1898. Six-colour woodcut
published in *Pan*, Berlin.

Edvard Munch (1863-1944):
The Kiss, 1902.
Woodcut, fourth version.

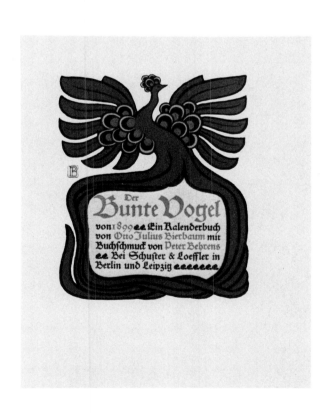

Peter Behrens (1868-1940):
Cover ornament, 1898, for *Der Bunte Vogel von 1899*,
"A Calendar Book by Otto Julius Bierbaum,"
Berlin and Leipzig, 1898.

125

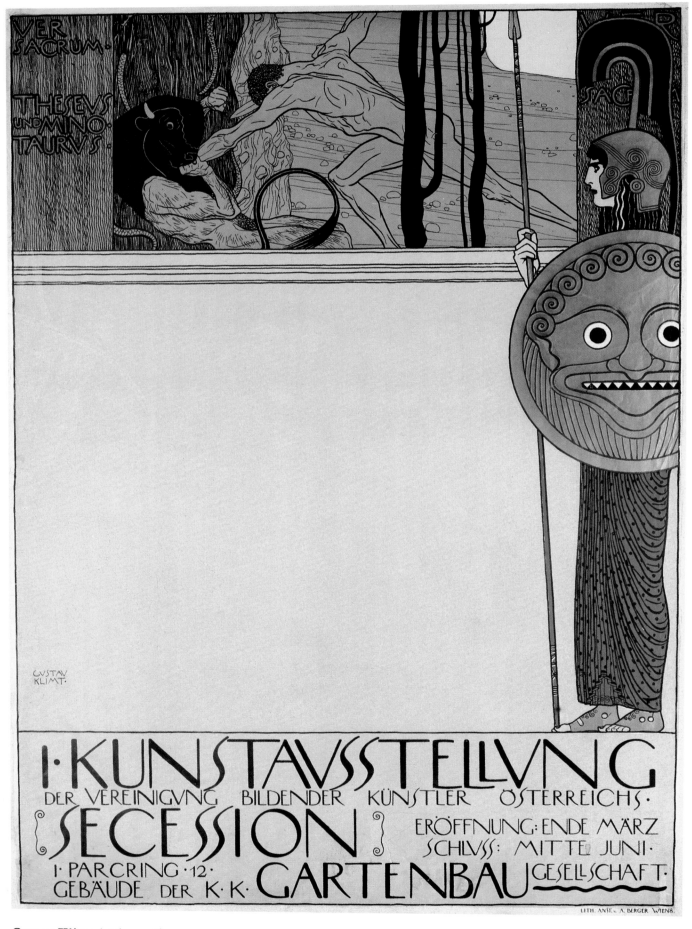

Gustav Klimt (1862-1918):
Theseus and the Minotaur, with Athena and her Gorgon shield.
Poster for the First Exhibition of the Vienna Secession, 1897.

Ver Sacrum:
The Spring of
the Vienna Secession

 OUNDED in 1897, the Vienna Secession was able to capitalize on the innovations made by each of the previous movements: the constructive rationalism of the French, the style-creating purposefulness of the Belgians, the sobriety and mastery of surface design of the Scots, the radicalism of the Germans and their desire to break with the past. To this the Austrians added the mark of their own culture, refinement and sensibility.

Here, too, things and events stand out with more clarity. One centre: Vienna. One group: the Secession. One magazine: *Ver Sacrum* (meaning "sacred spring"). Two leaders: Gustav Klimt for painting, Otto Wagner for architecture. Up to 1905 the Secession represents Austria's contribution to Art Nouveau. So true is this that Vienna coined the term Secessionsstil, as Munich coined the term Jugendstil.

The Secession was the dissident movement of a small group of painters rebelling against the conservatism and commercial compromises of the "Künstlerhaus." The date of its foundation is significant. 1897 saw the success of the reform party of Social Christians and the election of its leader, Dr Karl Lueger, as mayor of Vienna: his strong personality marked the life of the city till his death in 1910. Here, as in Brussels, Art Nouveau found its clientele in a narrow fringe of the well-to-do liberal bourgeoisie.

Unlike the Secession groups in Munich and Berlin, the Vienna Secession came very quickly to the forefront of the avant-garde, thanks in part to its open-minded attitude to the international movement, to the decorative arts in particular. Appointed director of the Österreichisches Museum für Kunst und Industrie in 1897, Arthur von Scala at once exhibited English furniture, and the magazine he founded in 1898, *Kunst und Kunsthandwerk*, published articles on Tiffany (by Bing), Voysey, Crane and Ashbee. At first, however, it was primarily a movement of designers and painters, and its chief innovations lay in the field of the graphic arts.

This point was made already in the poster which Klimt, its president, designed for the first exhibition of the Secession, which opened in March 1898. The mythological scenes of Franz von Stuck, much admired in Vienna, who had already invoked the tutelary figure of Athena for the Munich Secession, were here deflected and given those polemical and critical overtones expressive of the determination to break with the past. As in his large *Pallas Athena* of 1898, Klimt's Gorgon shield shows a grimacing face with nothing academic about it. And the accompanying Theseus, audaciously nude (so much so that the censorship insisted on the addition of shrubbery, as again on the cover of *Ver Sacrum* which took over the same motif), represents the champion of Art Nouveau thrusting the bastard monster of academicism into the

darkness of mediocrity, on the left or "sinister" side of the sheet. What matters even more than the imagery is the new organization of forms: profiles and flat colours, a telling void in the central part, an off-centre composition. The antique figure gives place to Art Nouveau, a new art of surface pattern.

Arising between tradition (as represented by Hans Makart, from whom he took over in the decorations done for the new Ring) and the blandishments of international Symbolism (as re-

Adolf Böhm (1861-1927):
Frame for a poem by Arno Holz
in *Ver Sacrum*, No. 11, Vienna, 1898.

Josef Hoffmann (1870-1956):
Frame for a Rilke poem in
Ver Sacrum, No. 9, Vienna, 1898.

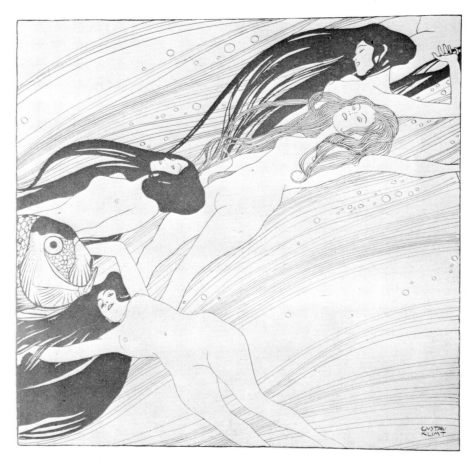

Gustav Klimt (1862-1918):
Fischblut, drawing published in
Ver Sacrum, No. 3, Vienna, 1898.

presented by Khnopff, who bequeathed to him his feminine figures with their siren gaze and square chin), Klimt's painting was not yet as advanced as his graphic work. Compare the two in 1898: the picture *Moving Waters*, still unsure in its contouring and its floating colours, aiming at evoking the lasciviousness of these new Rhine maidens, with the *Ver Sacrum* drawing *Fischblut*, which is its counterpart. From such a comparison, one sees how much the drawn form owes to the firm and supple line, to the telling contrast of black and white, to the negation of depth—in short, to the lesson of Aubrey Beardsley.

Like the German magazines, *Ver Sacrum* played a key part in art life. The Austrian equivalent of *Pan*? Yes, in its concern to join text and picture, and in its love of ornament. But with a still greater emphasis on their integration, on the overall visual impact of the page. *Pan* had illustrated Mallarmé by setting an unpublished sonnet (*A la nue accablante tu*, 1895) beside a much more old-fashioned picture by Khnopff. Three years later *Ver Sacrum* set a Rilke poem within the squares of an almost abstract ornamental design in which the forms and the letter are indistinguishable from the support. And while nothing is more remote stylistically from Hoffmannesque abstraction than the plant forms of Adolf Böhm, the

Josef Hoffmann (1870-1956):
Cover for *Ver Sacrum*, No. 7, Vienna, 1899.

conception of both artists, and the scope of the work, are essentially the same. Better than Hans Christiansen in tapestry, Böhm uses the reflection in the water to emphasize the flat area of colour and transpose the illusionism of the motif into a purely ornamental register.

Within a few months of its first issue in 1898, *Ver Sacrum* set forth the principles of a new decorative system in which the differences of manner from one artist to another (the vegetable curve as against geometric abstraction) count for less than the common inspiration behind them. From Klimt's "Minotaur" cover of 1898 to that of Hoffmann in 1899, there is a logical follow-up and deepening, in the sense of a deeper coherence of design. The same trend occurs in Klimt's own painting, and after 1900 it led on naturally to his collaboration with Hoffmann in the dining room of the Stoclet House, Brussels.

Lacking any wide social appeal, catering (rather as William Morris had done) to a public of artists and bibliophiles, and too exclusively aesthetic in its aims, *Ver Sacrum* found it hard to survive; from a monthly, it became a fortnightly in 1899 and ceased publication in 1903. But from the first its impact on Viennese art life was considerable.

The book illustrator follows the writer as the harp accompanies the song.

Wilhelm Schölermann, "Buchschmuck," in
Ver Sacrum, *Vienna, 1898.*

Take the spectacular front of Otto Wagner's Majolika-Haus of 1898 (40 Linke Wienzeile): what is it but the enlargement of a page from *Ver Sacrum*? The open, unframed windows, as set in the continuous ornament of the façade correspond to the poems placed on the page. This housefront is a manifesto, like that of Endell's Elvira Photo Studio in Munich, but one benefiting now from this overall conception of surface design.

Otto Wagner was fifty-seven in 1898 (twenty years older than Horta!) and there seemed nothing revolutionary about him. With a rich historicist production behind him, he had recently been appointed to a professorship at the Vienna Academy (1894). But his inaugural lecture there, published as *Moderne Architektur* (1896) and reprinted several times up to 1914, already set forth with vigorous conviction the rational principles of the international movement: the need to agree with the times, to adapt forms to function and renew them in keeping with new techniques and materials. Wagner was not exactly a radical and his later work is a

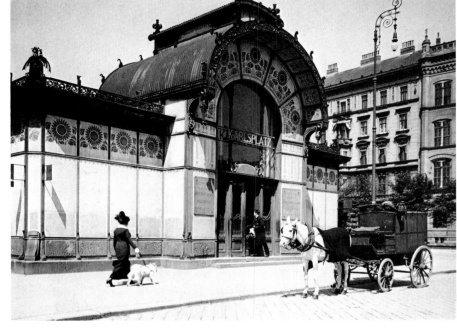

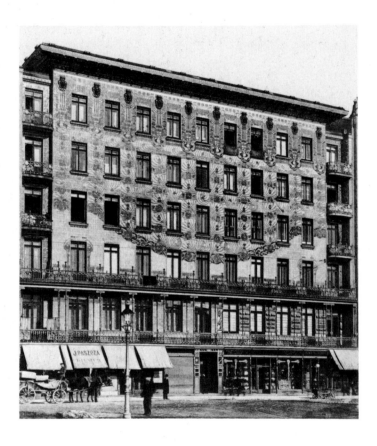

Otto Wagner (1841-1918):

△ Karlsplatz city railway station, Vienna, 1898-1899.
Period photograph.

◁ Majolika-Haus, Vienna, 1898.
Photograph published in *L'Architecte*, Paris, 1906.

▽ Hofpavillon city railway station, Vienna, 1894-1898.

Realism and idealism may be thought of as irreconcilable terms. This mistake is due to the false assumption that the useful parts company with the spiritual, and to the logical conclusion that mankind could live without art; whereas one might rather suppose that utility and realism come first, conditioning and preparing what art and spirit have to accomplish.

Otto Wagner, Moderne Architektur, *Vienna, 1895.*

subtle renewal of the traditional repertory to which he preferred to keep. But his Majolika-Haus, and the fact that he joined the Secession in 1899, show clearly enough that his sympathies were with youth. His ideas were diffused widely in the pages of the Viennese magazine *Der Architekt*, founded in 1895.

As in Glasgow, and unlike Germany at this period, architecture was the innovating art in Vienna, acting on principles which had already been seen at work in Brussels and Paris. In Majolika-Haus the conspicuous use of ceramic tiles (recalling the suggestions of Viollet-le-Duc) is accompanied by the specific use of metal in the balconies, lower galleries and stairway. Above all, the whole answers to a rational organization unprecedented in Vienna: large shop-windows on the ground floor and (instead of undue emphasis on the first floor) an equalization of the openings and decoration over the entire façade, up to the broad cornice, where the topmost frieze brings to mind Sullivan's manner of terminating the Bayard Building, New York (1897-1898). "Artis sola domina

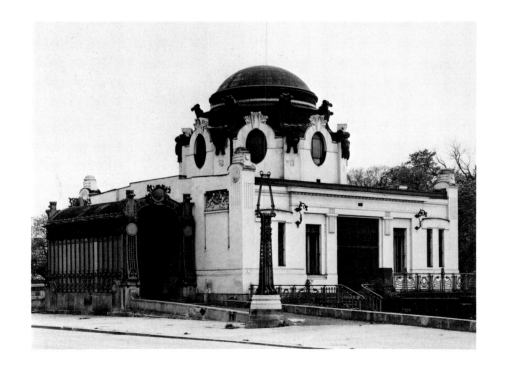

necessitas" (necessity sole mistress of art) was the motto adopted by Wagner in the early 1890s. And the decoration here is not "overlaid" as sometimes suggested. Allowing the structures to show through clearly, it sets off the continuity of the façade plane, while also asserting the necessity of a style, of a "Nutz-Stil" (useful style), in keeping with the fundamental concept of Art Nouveau as illustrated at the same period by Van de Velde.

As with Guimard, this concept is best expressed in a functional construction: the Vienna Stadtbahn, the elevated and underground railway system, Wagner's first important public commission, which from 1894 kept him busy for several years with a large staff of collaborators. The two best known stations of his own design were the "prestige stations" in the Karlsplatz (near Fischer von Erlach's Karlskirche) and the Hofpavillon (for the

exclusive service of the court at Schönbrunn), and they are representative of the whole: simple volumes, clearly articulated and functional; metal structure and ornamentation; outer walls covered with thin marble slabs, secured with angle irons which are left visible; decoration in broad simple areas, as in a Klimt poster. Nor does the neo-Baroque dome of the Hofpavillon, accounted for by the proximity of Schönbrunn castle and the central pavilion of its menagerie (1752), contradict these principles, which are aptly applied in the entrance hall.

Like Hoffmann, who was also a founding member of the Secession, Olbrich was a pupil of Otto Wagner, from 1894 to 1898. This is clear from the kinship between Wagner's Hofpavillon and Olbrich's exhibition building for the Secession (1898). Clear, too, from the motto inscribed on the pediment of the latter, which

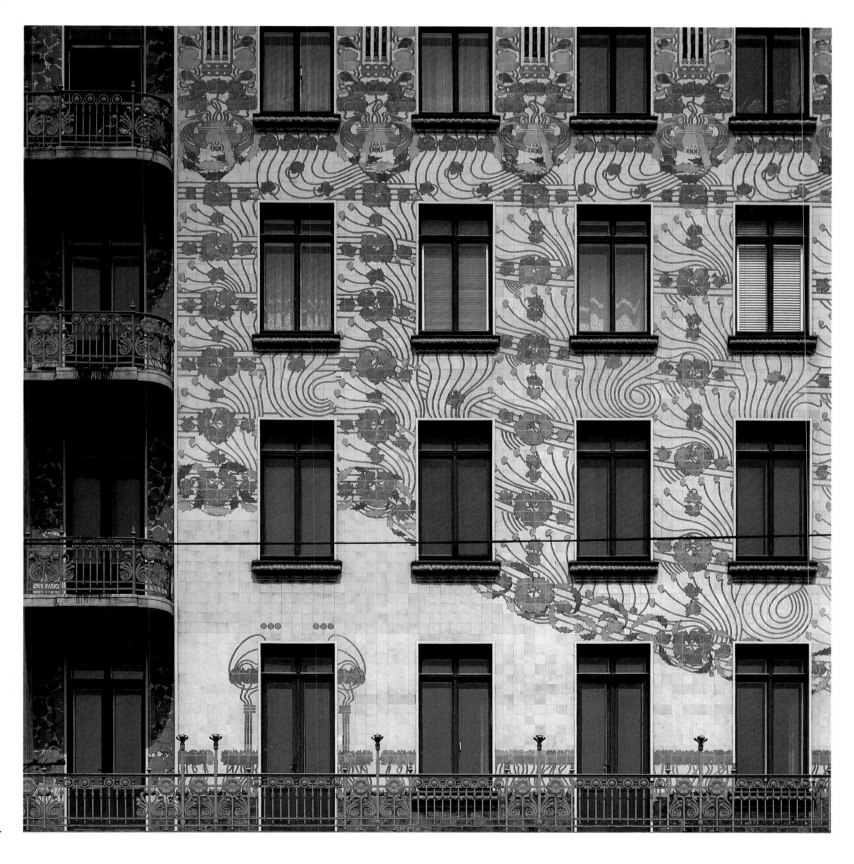

Otto Wagner
(1841-1918):
Majolika-Haus,
Vienna, 1898.
Detail of the front.

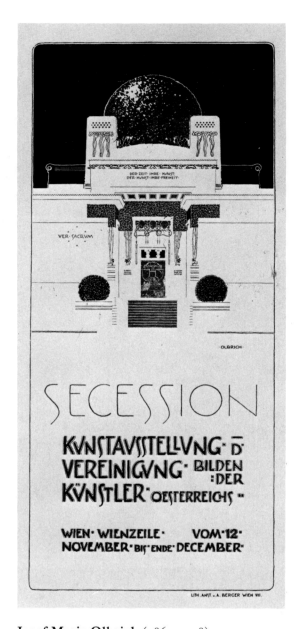

Josef Maria Olbrich (1867-1908):
Poster for the Secession Building,
Vienna, 1898.

Josef Hoffmann (1870-1956):
Design for a house entrance,
published in *Ver Sacrum*, Vienna, July 1898.

might have come from Wagner's *Moderne Architektur*: "Der Zeit Ihre Kunst, Der Kunst Ihre Freiheit" (To the time its art, to art its freedom)—a motto which would hold good for the entire "free aesthetic" of Art Nouveau. Olbrich's exhibition building may stand as a symbol of the Secession, but its symbolism must not be exaggerated: an openwork metal dome surmounted, presumably, by the tree of creation, but above all a firm and simple volume combined with elementary forms set off by the sober flat patterns of the ornamentation and the bold nudity of the surfaces. If on the one hand Sullivan comes to mind (his Wainwright Tomb in St. Louis, for example, of 1892), on the other one realizes that Mackintosh must have felt at home in this building when he visited the 1900 Secession exhibition.

Contemporary with it is Olbrich's Villa Friedmann, with its painted birch forest (done by Adolf Böhm) and the bed with the circle patterns dear to Olbrich: it confirms how wrong it is to see rectilinear decoration as typically Austrian, in contrast with arabesque decoration. Likewise with the early work of Josef Hoffmann. Looking in *Ver Sacrum* at his early designs for powerfully modelled house-entrances, one realizes that his later emphasis on unrelieved square or rectangular forms ("Quadrat-Hoffmann") is only a secondary stylistic feature. How well the two conceptions of line could be combined was shown again, after other projects, in the hall which Hoffmann presented at the Paris World's Fair of 1900.

What mattered most in Vienna was the idea of overall decoration, an extension into space of the *Ver Sacrum* page. The idea can already be seen in practice at the first Applied Arts exhibition in 1897, and further stimulus came with the reform of the Kunstgewerbeschule in 1899, when both Hoffmann and Koloman Moser joined the teaching staff. Moser too was a pupil of Otto Wagner and a founding member of the Vienna Secession. His racy caricature of Hoffmann in 1898, done in the Beardsley manner, indicates one of the sources of this art, and indicates how many people persisted in considering it a manifestation of decadence and perversity, in the English style.

Josef Maria Olbrich (1867-1908):
Bedroom in the Villa Friedmann,
Hinterbrühl, near Vienna, 1898.
Period photograph.

Josef Hoffmann (1870-1956):
Secretariat of the Secession Building, Vienna, 1898.
Period photograph.

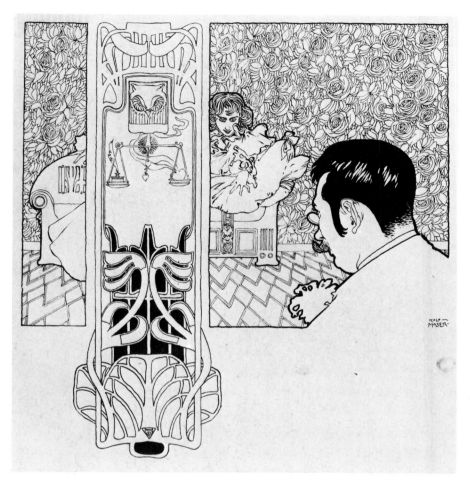

Koloman Moser (1868-1918):
Portrait of Josef Hoffmann, 1898.
Pen and ink illustration for
Meggendorfers Humoristische Blätter, Vienna.

Josef Hoffmann (1870-1956):
Design for a house entrance,
published in *Ver Sacrum*, Vienna, July 1898.

Beyond a limited circle, the art of the Secession was no more liked in Vienna than that of Mackintosh was in London. The historicist school (represented in architecture by Karl König and Ludwig Baumann) continued to hold the field, and it found support in the political reaction which saw in the defence of a national, conservative art one means of consolidating an endangered monarchy. Since his poster for the first Secession exhibition in 1898, Klimt had been an object of permanent scandal, culminating in 1903 with the final refusal of the University ceiling painting commissioned from him in 1894. Olbrich, in spite of Wagner's backing, failed to obtain a teaching post at the Kunstgewerbeschule and moved to Darmstadt in 1899, accepting an offer from the Grand Duke of Hesse. Wagner himself, attacked in a local pamphlet as "an adherent of the brutal Gallic architectural materialism," failed to overcome the opposition to his project for a Municipal Museum, the pivot of a large town-planning scheme. And Hoffmann's major work, the Stoclet House, was done in Brussels. By their achievements both at home and abroad, these Austrian artists contributed indispensably to the stylistic renewal and international vocation of Art Nouveau.

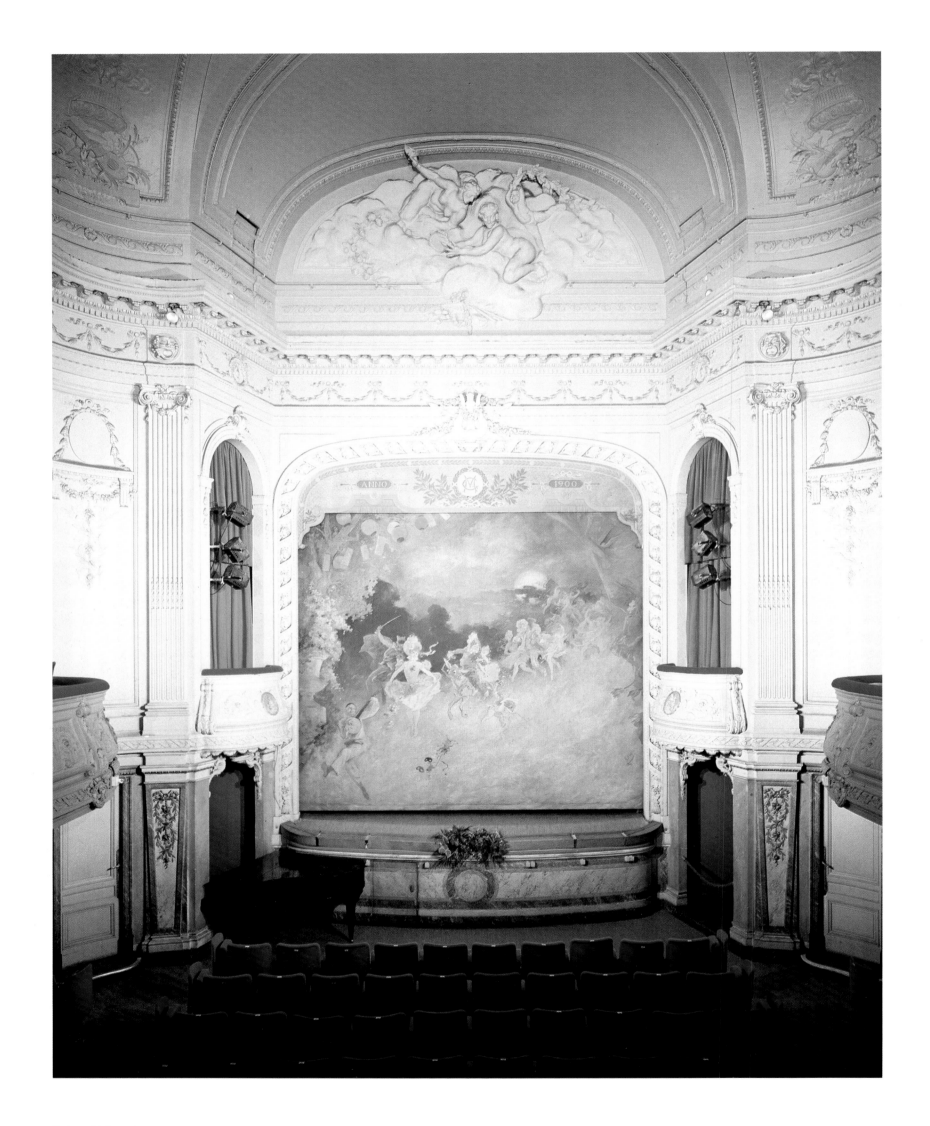

Jules Chéret (1836-1932):
Curtain painting in the Theatre of the Musée Grévin, Paris, 1900.

The Carnival of Paris

The year 1900 opened for Art Nouveau the period of great exhibitions, heralded in the late 1890s by the first showings of the Vienna Secession and those of applied art in Dresden and Munich in 1897. These were followed by the international exhibitions in Paris in 1900, Glasgow and Darmstadt in 1901, Turin in 1902, St Louis in 1904, Liège in 1905, Dresden and Milan in 1906, London and Munich in 1908. The new art was projected into the forefront of the international scene. But the time of its apparent triumph was also that of its greatest misgivings and of encroaching perils. In Europe, at the Paris World's Fair of 1900, the balance was tipped in favour of "Modern Style" in its Latin forms, predominantly French: there Art Nouveau *à la française* seemed to score a success and have a bright future before it. Then, paradoxically, at the Turin exhibition of 1902, the proportions were reversed and Art Nouveau gained fresh recognition in its northern and Germanic forms—a triumphal conjunction of Glasgow and Vienna.

In Paris, where fashion ruled supreme and market requirements could not be ignored, danger loomed more menacingly. There, owing to its spectacular excesses and superficial deviations at the 1900 Fair, Art Nouveau began to attract derision and pastiche in the press and literature. For one of its greatest painters, Segantini, who had just died, the triumph of the Paris World's Fair was also the victory of death: his final, unfinished masterpiece, the triptych *Life, Nature, and Death*, with its concluding scene of a winter bereavement, was exhibited in the Italian section with a knot of black mourning crape. In contrast, the smart little theatre at the Musée Grévin with Chéret's dazzling curtain painting seemed to mark the carnival culmination of Art Nouveau, later evoked as such by Van de Velde. But it was an illusion: in Paris the curtain was not rising but coming down.

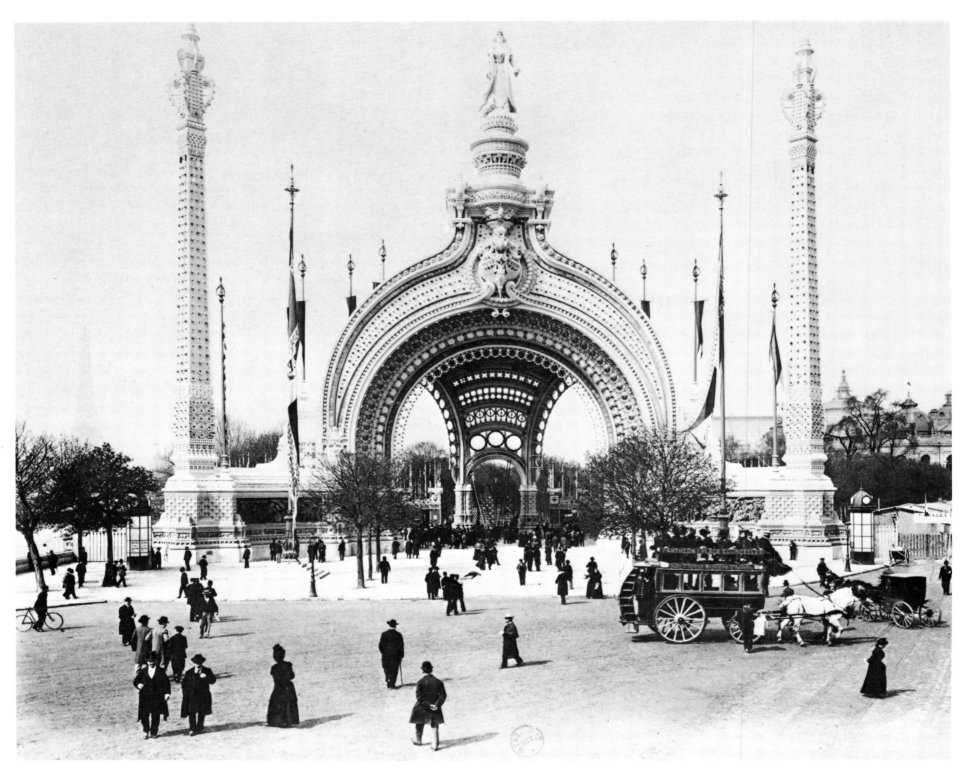

René Binet (1866-1911):
Gateway to the World's Fair, Place de la Concorde, Paris, 1900.
Period photograph.

TRIUMPHANT ART NOUVEAU
THE CHOSEN LAND
1900-1902

Paris 1900: The Ambiguities of the World's Fair

HE 1900 World's Fair—fulfilment of Art Nouveau? or heyday of that caricature of it known as 1900 Art? One hesitates for an answer; it has varied widely according to the historian and the time and place of writing. Just when Guimard's Metro stations were setting their distinctive mark on the streets of Paris, Art Nouveau was still far from being the dominant style on the grounds of the World's Fair: that much is certain. Nor is it matter for surprise. The Fair came as the final effort and last gasp of a century trying to convince itself of its own vitality. As such, it could hardly be expected to honour an avant-garde movement intent on breaking with the very past which the Fair wished to extol. Like the Columbian Exposition in Chicago in 1893, the Paris Fair set out to give a representative view of that past, and this meant the domination of historicist eclecticism, of that "miscellaneous heap of buildings in plaster, cardboard, papier mâché and fake sublime" which Frantz Jourdain objected to in the *Revue des Arts Décoratifs*. The surprising thing was to find so much of the New Art, only visible at scattered points, but here for the first time brought together on an international scale. If not fulfilment, this was at least a significant token of recognition.

But by its very pretension to be worldwide in scope, the Exposition Universelle, as it was called, had to stoop to more than one compromise, to impure mixtures and isolated or bastard propositions in which Art Nouveau also made its influence felt. For example, the monumental gateway which René Binet erected in the Place de la Concorde, at the entrance of the Cours-la-Reine. Its features were: the rational layout of its triangular plan; the set of wicket-gates orienting the flow of visitors from the central arch, an undisguised metal structure of simple form reminiscent of the Eiffel Tower and renewing the conception of the arch of triumph, and as typical in its way as Guimard's Metro stations; profuse ornamentation whose materials and colours play a conspicuous part, but without concealing the structure, this after the manner of Sullivan's Golden Door of his Transportation Building at the Chicago Exposition, so much admired in France. And yet Binet's gateway can hardly be described as Art Nouveau, for it lacks unity of style, as one is pointedly reminded by Moreau-Vauthier's statue dominating the whole, that *Parisienne* in the "1900 style" whose dated realism contradicts the futurist abstraction of the architecture. But in itself Binet's gateway is a masterly work bringing nineteenth century architectural design to an honourable and colourful close.

This ambivalence appears again in the Pont Alexandre-III, where the bold single arch is overlaid with a neo-Rococo not without a charm of its own, and in the Gare d'Orsay designed by

Louis Albert Louvet (1860-1936):
Main staircase of the Grand Palais, Paris, 1900.
Period photograph.

Victor Laloux, Binet's master, and completed that same year, 1900. But it is more typical still of the Grand Palais, which combines with unequal success what at the 1889 Fair had belonged to the still distinct fields of engineering and architecture: a vast iron skeleton, simple and rational (in which Binet apparently had a hand), and the historicist facing of massive stone by Deglane, Louvet and Thomas. To this were casually added some Art Nouveau elements: the supporting members of the grand staircase, where the iron is left visible, it is true, but (unlike Horta) keeps to the positions and even the forms of classical stone architecture, without any real necessity nor any organic connection with the surrounding structure and space. The only justification here was a symbolic one: "The supports are considered no longer as simple pillars, but as the stems and branches of a sturdy vegetation upholding the platforms" (*La Construction Moderne*, 1 January 1901).

Art Nouveau was excluded from the major architecture of the Fair, from the one field where its overall design could have found scope for expression. And apart from purely decorative applications it is only to be found in the smaller constructions, in those miniature "palaces of fancy" whose isolation and small scale al-

lowed of freer invention: the Majorelle pavilion by Sauvage, the Pavillon Bleu restaurant by Dulong and Serrurier-Bovy, the Belle Meunière restaurant by Tronchet, the theatre of Loie Fuller and Bing's Art Nouveau pavilion. To these may be added some scattered works, like Tiffany's stained-glass windows in the United States pavilion, and above all the "ensembles" of the French "Central Union of Decorative Arts" and those of the German and Austrian sections.

The Majorelle pavilion and the Pavillon Bleu restaurant are genuine works of architecture. In both we find the same bold projection of the structure into space and the same concern for an overall unity of style. (Add to this, inside the Pavillon Bleu, the forthright simplicity of the stencilled flower designs, the strutted furniture and the wrought iron lamps so characteristic of Serrurier-Bovy.) One may therefore doubt (the point is still unsettled) whether Sauvage had a great deal to do with the theatre of Loie Fuller. In his superb design for the Majorelle pavilion Sauvage had never been closer to the spirit of Guimard's "style C" Metro stations (as exemplified in the "Chinese" pavilions of the Etoile and Bastille stations). In Loie Fuller's theatre, on the contrary, we find

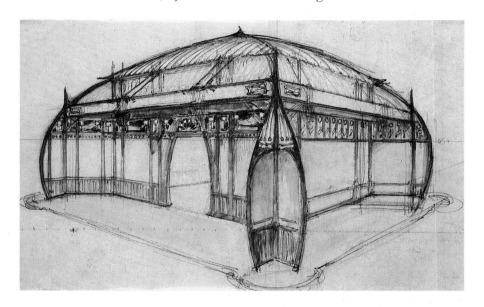

◁ **Gustave Serrurier-Bovy** (1856-1910)
in collaboration with R. Dulong:
The Pavillon Bleu Restaurant at the World's Fair, Paris, 1900.
Photograph from *Art et Décoration*, Paris, 1900.

Henri Sauvage (1873-1932):
Sketch for the pavilion of the Majorelle firm of Nancy
at the Paris World's Fair, 1900. Watercolour drawing.

Henri Sauvage (1873-1932)
in collaboration with Francis Jourdain and Pierre Roche:
Theatre of Loie Fuller at the World's Fair, Paris, 1900.
Photograph from *L'Art Décoratif*, Paris, November 1900.

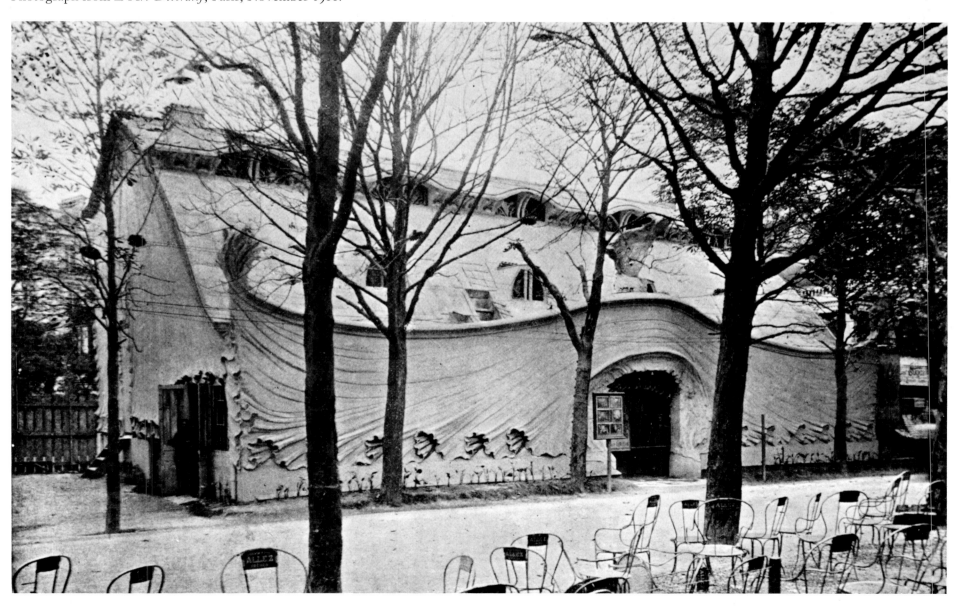

a figural, emblematic and sculptural conception that seems much shallower: here the myth of the dancer is no longer, as with Toulouse-Lautrec or Kolo Moser, or even Chéret and Bradley, "reinvested" and transformed by the technique and materials. Overlaid against the building, the purely descriptive line of the draperies has nothing of that "line of force" which Van de Velde was laying down in theory while working on his *Zarathustra*, and this ephemeral theatre sums up one of the issues underlying Art Nouveau, which at that time was represented by Nietzsche on the one hand and Loie Fuller on the other. At the Paris World's Fair it was the latter that prevailed—the ethereal flower-woman floating through space, as we see her in the statuettes by Raoul Larche and Pierre Roche (the latter also did the sculptures in the theatre) or in the thoroughly Japanese-style poster by Manuel Orazi. The latter forms a striking contrast to Carrière's poster for the pavilions of Mines and Metallurgy, both in the style of his prints of the 1890s and equally little known: while owing nothing to aestheticism, they stood then in the forefront of modernity.

Manuel Orazi (1860-1934):
Poster for the Theatre of Loie Fuller at the World's Fair, Paris, 1900.

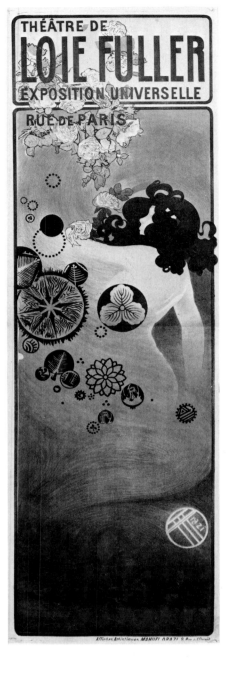

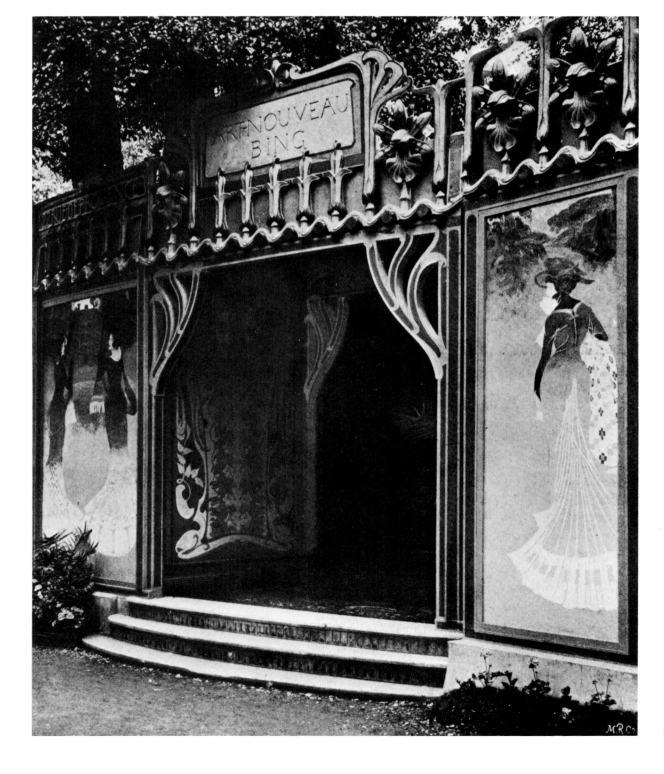

Georges de Feure (1868-1928):
The Art Nouveau pavilion of Samuel Bing at the World's Fair, Paris, 1900.
Photograph from *Deutsche Kunst und Dekoration*, Darmstadt, September 1900.

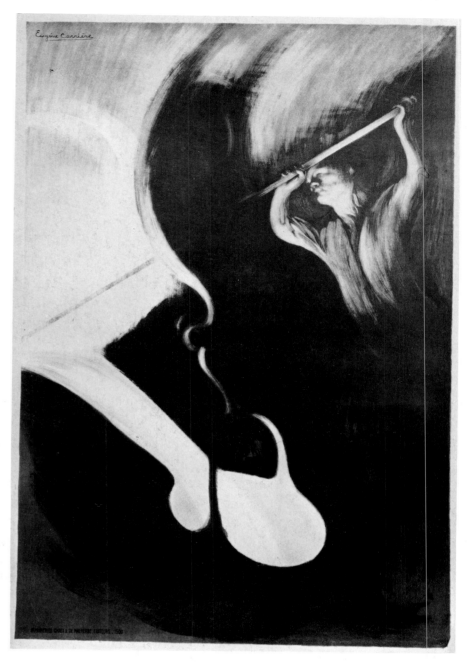

Eugène Carrière (1849-1906):
The Metal-Founder, 1900. Poster design for the Pavilion of Metallurgy at the Paris World's Fair of 1900.

Raoul Larche (1860-1912):
Loie Fuller Dancing, c. 1900.
Gilt bronze lamp.

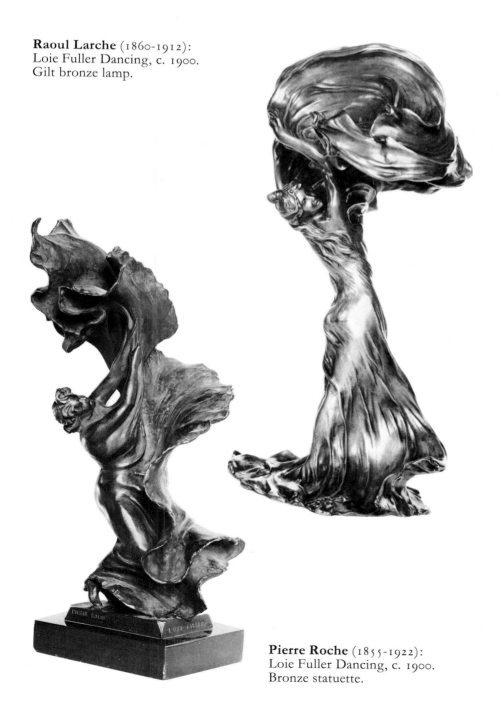

Pierre Roche (1855-1922):
Loie Fuller Dancing, c. 1900.
Bronze statuette.

Georges Hoentschel decorated the wooden hall of the French pavilion of the Union Centrale des Arts Décoratifs with a large, purely naturalistic wood carving whose "soft swoon" was at once reinterpreted by Gallé (it was reinstalled in 1905 in the Musée des Arts Décoratifs, Paris). Next to this hall was the "Art Nouveau Bing" pavilion which stands out as the main French contribution (and the one that gave its name to this New Art). Significantly, it was not designed by an architect, but by Georges de Feure, the most "aesthetic" of decorators. From both the exterior and the six rooms inside, the main impression is not one of volumes and spaces, but rather of a typically French sequence of decorative features added together by the "outfitter"—paintings, stained glass, furniture, hangings, objects. Here, as in an earlier French tradition (that of the eighteenth century most of all), a peculiar charm arises from the combined and juxtaposed manners of the three masters concerned: de Feure, Gaillard and Colonna. The evanescent preciosity of de Feure, the unfailing grace and fineness of his line, and the luxury of his gilt wood (the gilding now disguising the nature of the material); the bolder, firmer design of Gaillard who, while working in the spirit of rationalism, still dallies

Georges de Feure (1868-1928):

◁ Dressing room in Samuel Bing's Art Nouveau pavilion
at the World's Fair, Paris, 1900.
Photograph from *Deutsche Kunst
und Dekoration*, Darmstadt, September 1900.

▽ Sofa of gilt wood, 1900, exhibited
in Samuel Bing's Art Nouveau pavilion.

▽◁ **Louis Majorelle** (1859-1926):
Wardrobe exhibited at the World's
Fair, Paris, 1900.

with abstract forms, melting them into a smoky haze, and rounds
off the corners of his furniture; the discreet elegance of Colonna,
whose drawing-room furniture upholstered with silk and cotton
brocade refines on the wallpaper and the English fabrics (in con-
trast with the dynamism of Van de Velde's furnishings).

The craftsmanship displayed in Bing's Art Nouveau pavilion
is of very high quality (even if lapsing at times into prettiness), but
it naturally turns its back on industrialization and also on architec-
ture, and it tends to reduce each piece of furniture to an object
(both de Feure and Colonna were also potters). Priority was no
longer given to the expression of function, though this aesthetic
deviation is less marked than it is in the school of Nancy—in a fine
wardrobe by Majorelle, for example, also shown at the Fair, whose
simple structure is lost sight of behind the decorative inlays and the
abstract ornament of the iron fittings and hinges, superadded and
having no reference to the purpose this piece of furniture was
meant to serve. In this respect the French exhibits were in sharp
contrast with those of the Germans and Austrians which, though
displayed more discreetly, were publicized in the pages of Meier-
Graefe's Munich magazine *Dekorative Kunst* and attracted a good
deal of attention.

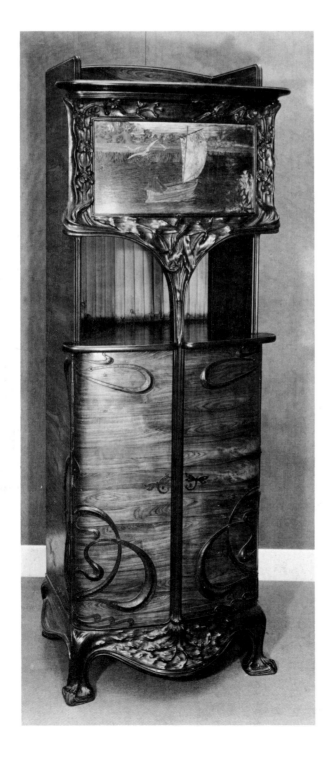

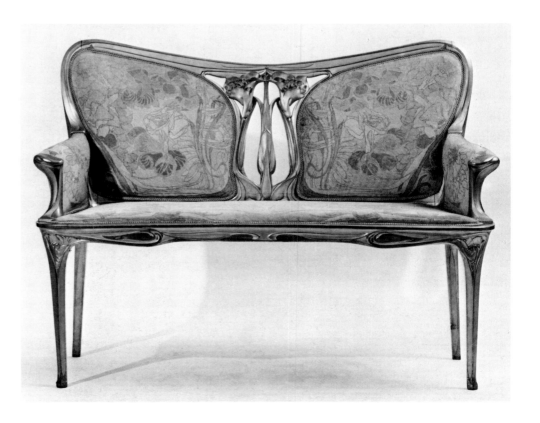

Edward Colonna (1862-1948):
Silk and cotton brocade, c. 1899-1900,
exhibited in Samuel Bing's Art Nouveau pavilion
at the World's Fair, Paris, 1900.

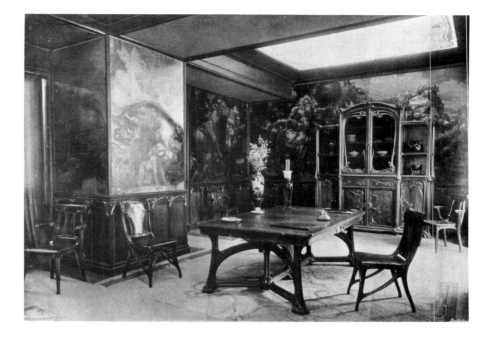

Eugène Gaillard (1862-1933):

△ Dining room in Samuel Bing's Art Nouveau pavilion, 1900.
Photograph from *L'Art Décoratif*, Paris, January 1901.

▽ Walnut sideboard with bronze fittings, 1900.
Photograph from *Deutsche Kunst und Dekoration*,
Darmstadt, September 1900.

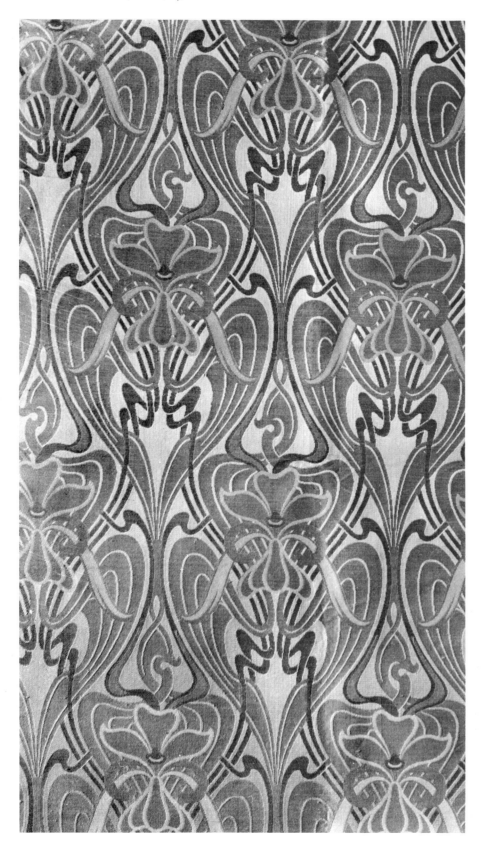

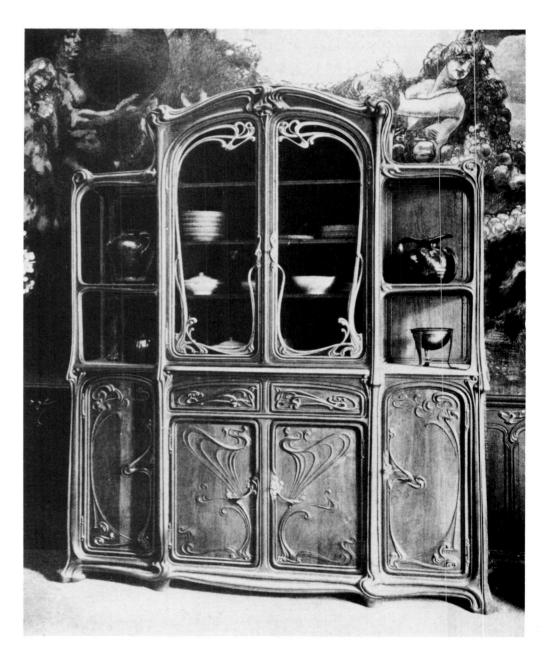

The tables and chairs designed by Gaillard for Bing's Art Nouveau pavilion have outcurving legs and curving cross-members (in keeping with that avoidance of the straight perpendicular which Viollet-le-Duc had recommended, and which Grasset had followed up in 1880 and Guimard around 1899). It is interesting to compare Gaillard's furniture with the chair which Riemerschmid exhibited at the Paris World's Fair in the "Zimmer eines Kunstfreundes" (and which he had originally made for the Dresden Music Hall in 1899). With Gaillard, a delicate moulding of legs and members, merging into the mahogany, which makes one forget the narrowness and hardness of the chair; with Riemerschmid, an oak chair of challenging simplicity, but functional and

Bernhard Pankok (1872-1943):
Drawing room exhibited at the World's Fair, Paris, 1900.
Period photograph.

▷ **Eugène Gaillard** (1862-1933):
Mahogany chair, 1896-1900, designed for Samuel Bing.

Richard Riemerschmid (1868-1957):
Room of a Connoisseur exhibited at the
World's Fair, Paris, 1900.
Photograph from *Deutsche Kunst und
Dekoration*, Darmstadt, October 1900.

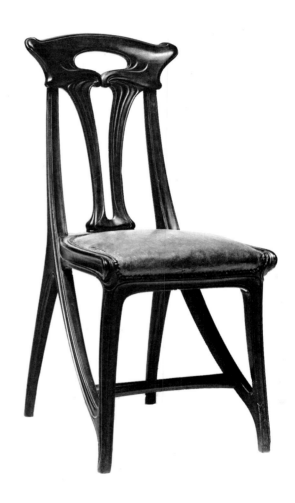

comfortable, whose clean new shapes have nothing in common with "1900 Art" but keep to the principles of Art Nouveau.

Riemerschmid's "Room of a Connoisseur" also included embroideries by Hermann Obrist and furniture by Bernhard Pankok. The astonishing frieze running along the base of the ceiling and around the doors can hold its own with Guimard's unerring interlaces (and it strangely recalls his designs for the Humbert de Romans building in Paris), but it serves first of all to emphasize the articulations and the transition from the curvature of the ceiling, and it leaves the wall surface empty. The drawing room designed by Pankok again shows Van de Velde's influence, unmistakable in this organic, architectural and abstract whole whose keynote is line, ornamentation being played down. Bruno Paul's Hunting Room completed the display offered by the Vereinigte Werkstätten of Munich, small in scope but of so fine a quality that a gold medal was awarded to Riemerschmid. Germany stands out too as the only country to issue a distinctly Art Nouveau catalogue of its exhibits; and even here Pankok's beautifully ornamental endpapers, with their broad sweeps of flat colour, make a curious contrast with the naturalistic landscapes on other pages.

The Austrian display at the Paris World's Fair was equally forcible and coherent. In the Fine Arts section the Secession was well represented, notably by Klimt (whose *Philosophy* for Vienna

Bernhard Pankok (1872-1943):
Page ornament from the catalogue of the
German section, Paris World's Fair, 1900.
From *Deutsche Kunst und Dekoration*,
Darmstadt, August 1900.

Joseph Maria Olbrich (1867-1908):
Room with corner fireplace at the World's
Fair, Paris, 1900. Photograph from *Deutsche
Kunst und Dekoration*, Darmstadt, October 1900.

University was awarded a grand prize) and Otto Wagner. But the Secession was on the same footing there as the official Viennese Society of Fine Arts, and it was discovered with "a unanimous cry of pleasure" (Arsène Alexandre) that the Austrians had the audacity to exhibit "only a single row of pictures" in the main room —a fact which revealed itself as part of an overall decorative scheme. The Industry and Applied Arts sections were presided over by Olbrich (also represented in the German pavilion by his Darmstadt work), Hoffmann (less "Quadrat" than ever), Otto Wagner and Max Fabiani (another eminent pupil of Wagner's): they offered the same clear, linear, well-aired presentation of Austrian design, in which the plane set the style, and the sober play of

Josef Hoffmann (1870-1956): Reception room for the Vienna School of Applied Arts, exhibited at the Paris World's Fair, 1900. Photograph from *Art et Décoration*, Paris, 1901.

ornament was calculated to enhance the surfaces. This unitary conception of the whole as a Gesamtkunstwerk (ironically emphasized, in Olbrich's corner fireplace, by the painted flames flickering over the walls) is again in sharp contrast with the juxtaposed elements of the Bing pavilion and the profuse vegetable ornament of Hoentschel and the school of Nancy. The English critic of the *Art Journal*, D. Croal Thomson, made no mistake when he wrote: "The expression *art nouveau*, seen and heard on every hand at this Exposition, has its best justification in the displays of Austrian furniture, where the latest tendencies in decoration are applied without exaggeration and never lapse into caricature."

The "consecration" accorded Art Nouveau at the 1900 World's Fair was not without its dangers, for French Art Nouveau in particular, which was less homogeneous and less well structured. By treating it as a purely decorative art, the Fair deflected its ambitions and reduced its scope. The consequence was, revealingly, the isolation and then the disfavour suffered by Guimard, at the very time when the fashionable goldsmiths and decorators were prospering by merely adding a touch of asymmetry or a wavy line in keeping with the taste of the day.

Van de Velde, Horta, Mackintosh and the Scots were absent from the Paris World's Fair of 1900. The balance was partly restored at the Turin Exhibition of 1902, but too late for the French. Their apparent triumph in 1900 was only the avowal of their underlying weakness.

Edouard Vuillard (1868-1940):
The Blue Hills, 1900. Oil.

The Reign
of French
Art Nouveau

HE success of the 1900 World's Fair together with the inadequate representation of foreign movements made it seem in Paris, despite the interest aroused by the Austrian exhibits, that Art Nouveau had come into being as a typically French creation. It was clear, however, that it was a fragmentary art, engaged in a vain search for unity and a future: Bing's Art Nouveau pavilion was in every respect contrary to the aesthetic creed of Nancy, represented by Hoentschel in the Union Centrale pavilion, while neither had much in common with the architecture of Guimard or Sauvage, the painting of Denis and his friends, Carrière's prints or the sculpture of Rodin (who held his own exhibition at the Alma, outside the fair grounds).

Several factors were responsible for the fragility of this ephemeral triumph. Although the principles had been firmly laid down by Viollet-le-Duc and the rationalists, then by the painters, they lacked the support of a global theory backed by great architecture. Guimard was a lone wolf; his art, which had shocked the public with the novelty of his subway entrances, was too personal to give the lead to a coherent and vaster movement. At the World's Fair he was only, all too discreetly, represented by painted wallpapers and vases. Consequently, the centre of gravity shifted to the more unstable ground of the decorative arts, implicitly abandoning the attempt to create a new space, and the Modern Style was in danger of losing its identity in the midst of the large repertory of the different schools.

In this area, the market played a dominant role, particularly the influence of fashion. Bing, unable to become the guide and moving spirit of the French movement, which he might well have been, saw this clearly and noted bitterly, as early as 1903: "Throughout the course of history no great idea expressing an ideal has ever arisen, which has not been quickly counterfeited by the army of profit-seekers who have enrolled themselves beneath its banner to protect their purely mercantile schemes. But never, perhaps, has this phenomenon been so strikingly instanced as in the case in point... the more eccentric it was, the more quickly it was received as Art Nouveau." Van de Velde also was to make this superficial fashion, which condemned the French movement to early demise, the subject of his essay on *Le Nouveau* (1929): "We saw only too clearly that what attracted manufacturers was the 'novelty' of the forms and ornaments... This pernicious enthusiasm was enough to wreck the tenacious effort of the few who sought unremittingly to discover the formula that would give our movement its true significance and programme."

In Paris, the reaction to this danger took the form of an outburst of nationalism: the green of Guimard's Metro stations was

Victor Horta (1861-1947):
The Brussels department store
"A l'Innovation,"
1901 (demolished in 1967).
Period photograph.

deemed too Germanic, and Bing himself saw no way out but to revert to the French eighteenth century before "the sudden paralysis caused by the brutal shock of the French Revolution."

The handling of space was relegated to the background. A style and decoration stemming first of all from fashion and nationalist sentiment became predominant. Only a few isolated creators were to succeed in making their escape by a change of direction (Sauvage) or forward flight (Guimard).

In 1901 the famous Jules Lavirotte building at 29 Avenue Rapp was almost enough on its own to represent a synthesis of this disturbing situation. The completion of the building was enthusiastically acclaimed, and in France it is still regarded as one of the most representative productions of Art Nouveau. With its concrete structure concealed by a stone base and a façade in which freestone is used in an attempt to give an appearance of masonry, it only succeeds, mainly in the lower part, in providing the ornamental cover, which the same architect moreover replaced in other works by neo-Baroque or neo-Louis XV adjuncts. The symbolically significant contrast with Horta's Brussels department store, *A l'Innovation* (demolished in 1967), put up at the same time, with its large functional metal-frame bays, the homogeneity and purity of its design, the sober ornamentation following the lines of the structure, is enough to show clearly how far removed is borrowed postiche from "faith in the effort of intelligence, reason and the application of acquired knowledge" (Van de Velde). The same could be said of Yvette Guilbert's Paris house by Xavier Schoellkopf (1900, now demolished), which has been unwarrantedly compared to the powerful creations of Gaudí.

Xavier Schoellkopf (1870-1911):
Paris town house for Yvette Guilbert,
1900 (demolished).

Jules Lavirotte (1864-1924):
Apartment house at 29 Avenue Rapp,
Paris, 1901. Entrance with terracotta
decoration by Jean-Baptiste Larrivé.

In painting, there is the same basic difference between Vuillard's *Blue Hills* (1900) and Aman-Jean's *Confidence* (1898). The first, following up the Nabi principles practised by Vuillard for nearly a decade now, tends towards abstraction and maximum integration into the picture plane. Aman-Jean's very creditable picture, while responding to the new climate, none the less keeps to symbolism and the descriptive line; in 1905 it was hung in Georges Hoentschel's 1900 Room at the Musée des Arts Décoratifs in Paris. In the Musée Grévin the brilliant theatre curtain by Chéret, another 1900 product, is only akin to the pastiche of the architecture (and Bourdelle's sculpture) in its wholly intellectual reference to the eighteenth century, and this highlights even more clearly the incoherence of the pictorial means employed.

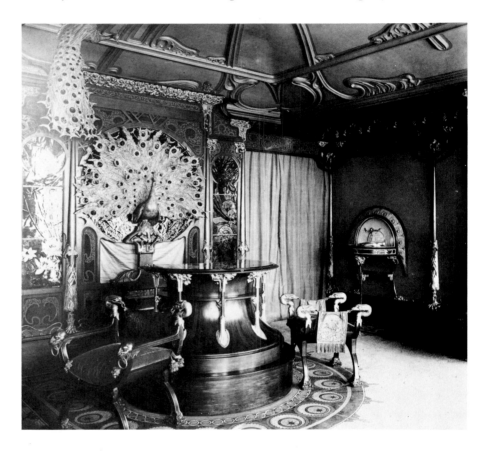

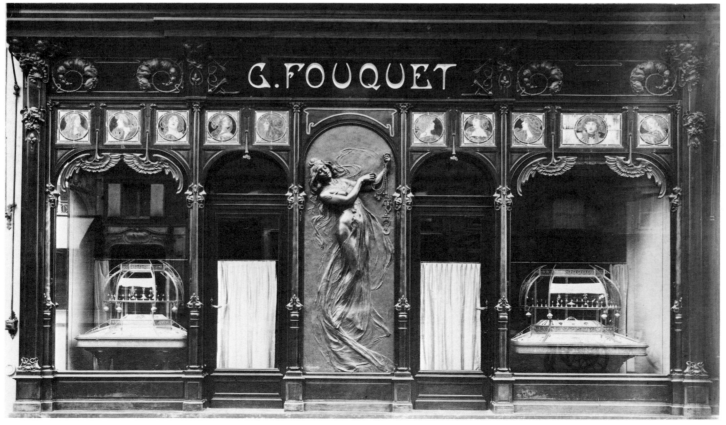

Edmond Aman-Jean (1860-1936):
Woman in Pink, c. 1900-1902.
Pastel.

Alphonse Mucha (1860-1939):
Fouquet jeweller's shop at
6 Rue Royale, Paris,
1900-1901. Interior and front.

In the absence of an architecture and a global project, Art Nouveau took refuge in interior decoration where it most often assumed, in commercial premises, a representational function, particularly by its luxury and imagery, and not, as in the works of Horta in Brussels, or Van de Velde in Berlin, by the rational and unifying arrangement of forms and the remodelling of interior space.

Nothing could be more different, for example, from Haby's hairdressing saloon fitted up by Van de Velde (Berlin, 1901) than Mucha's decorations for the shop of the jeweller Fouquet (Paris, 1901), one of the most completely satisfying and brilliant achievements of 1900 Art. In Mucha's transposed version of Second Empire decoration it is hardly surprising to note that the Whistler-like

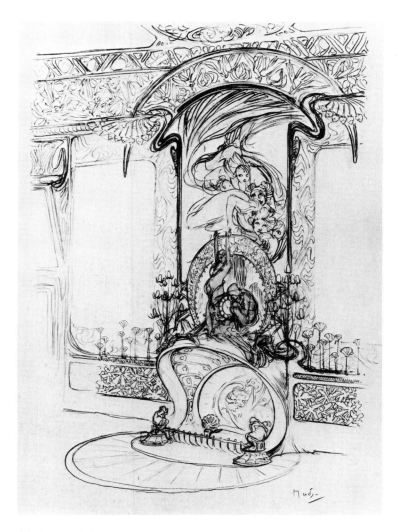

Alphonse Mucha (1860-1939):
Sketch for a fireplace in the Fouquet jeweller's shop, Paris, 1900-1901. Pencil and watercolour.

Gustave Serrurier-Bovy (1856-1910): Billiard room in a castle.
Photograph from *L'Art Décoratif*, Paris, May 1902.

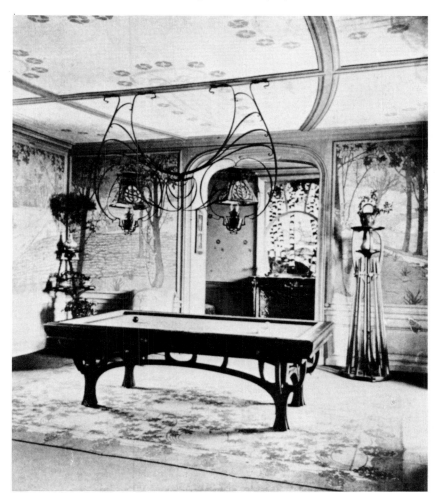

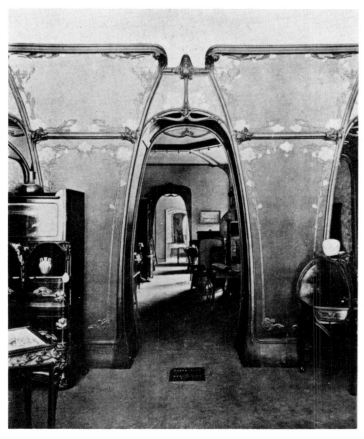

Henri Sauvage (1873-1932): Interior of the Jansen shop
at 9 Rue Royale, Paris, c. 1900 (demolished).
Photograph from *L'Art Décoratif*, Paris, 1903.

peacocks have lost their areas of flat colour and that one of them very significantly spreads its tail at the centre of the Fouquet shop. Without always attaining the same controlled luxury, there was thus a proliferation in Paris of shops and especially restaurants (Maxim's in 1899, Lucas-Carton in 1903 and many less renowned rivals) in which the art of appearances reached its apogee, although Art Nouveau clung above all to the superficial borrowing of a decorative manner initially designed to provide a guarantee of modernity. There were very few genuine creators who, like Sauvage at the Café de Paris (1899) or the Jansen shop (c. 1900), both since demolished, sought, after the German example, a specific and functional space in which ornament was subordinated to structure, as Frantz Jourdain very justly stressed in 1900 in his article on "Modern hotels and cafés" in the *Revue des Arts Décoratifs* (No. 20).

The periodicals, however, and quite newly in France the German magazine *Innendekoration*, (badly) translated from 1902 onwards, disseminated foreign examples, and the fine Serrurier-Bovy billiard room published in the same year in *L'Art Décoratif* was a model of this kind of simple and clear décor in which the figurative motifs on the walls avoided breaking the surface and harmonized with the linear layout of the space.

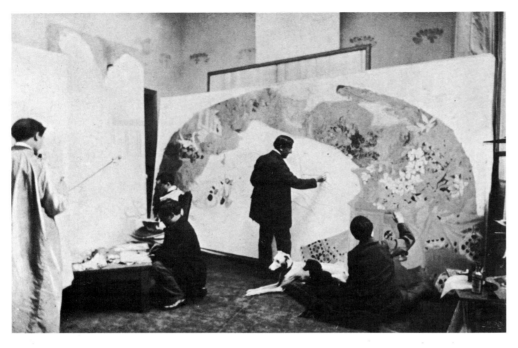

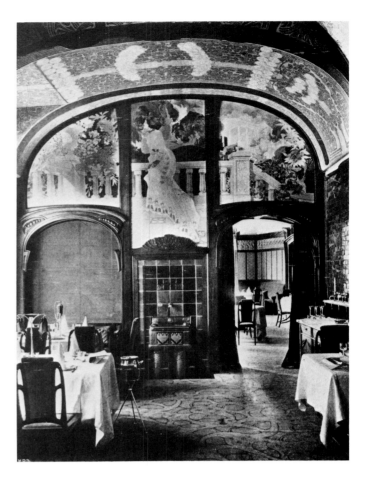

Photograph of Georges de Feure at work in his Paris studio.
From *Zeitschrift für Innendekoration*, Darmstadt, January 1902.

▷ **Bruno Möhring** (1863-1929):
Blue Salon in the Konss restaurant, Paris, 1901, with paintings by Georges de Feure.
Photograph from *Zeitschrift für Innendekoration*,
Darmstadt, 1902.

Alexandre Charpentier (1856-1909) and **Alexandre Bigot** (1862-1927):
Dining room in Adrien Bénard's villa at Champrosay, near Paris, 1901.

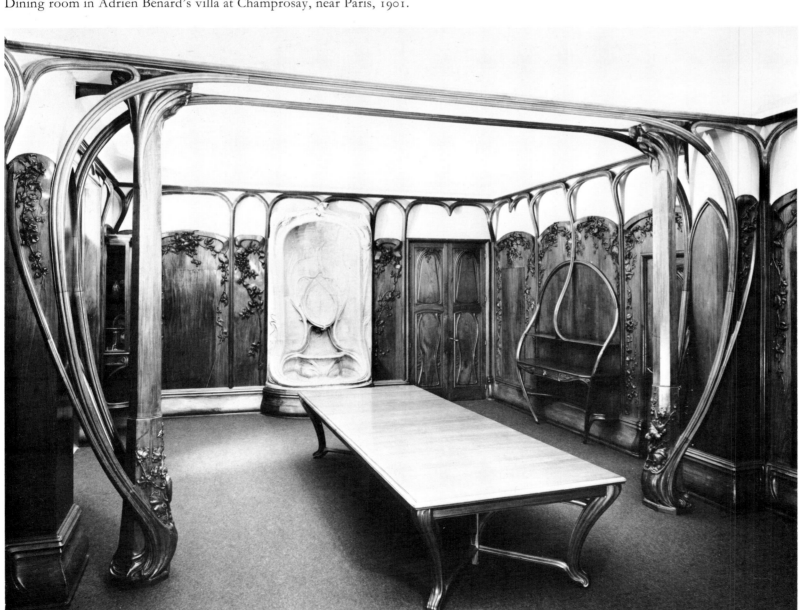

Alexandre Charpentier (1856-1909):

▽ Music stand, c. 1900. Hornbeam.

▷ Cabinet for musical instruments, c. 1900.

▽ ▷ **Louis Majorelle** (1859-1926):
Three-legged table, 1902. Mahogany,
tamarind and gilt bronze.

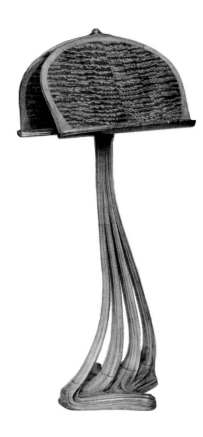

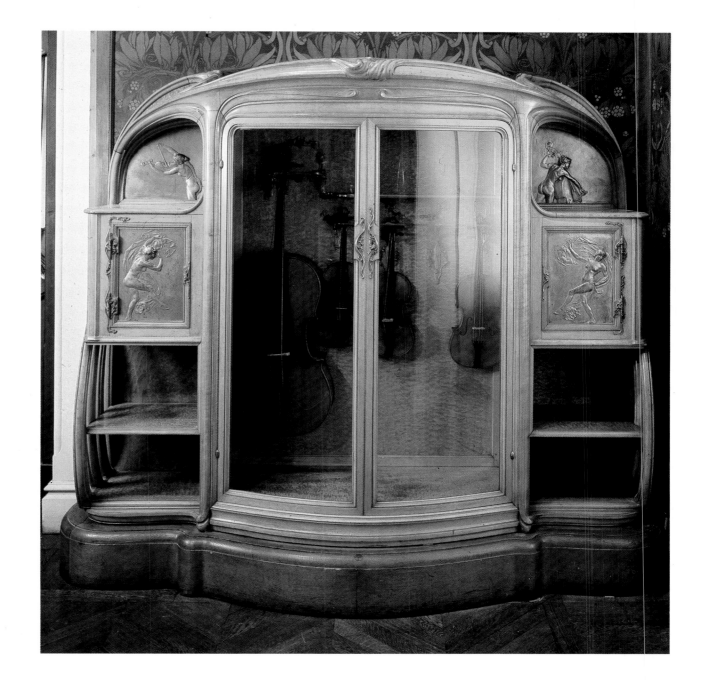

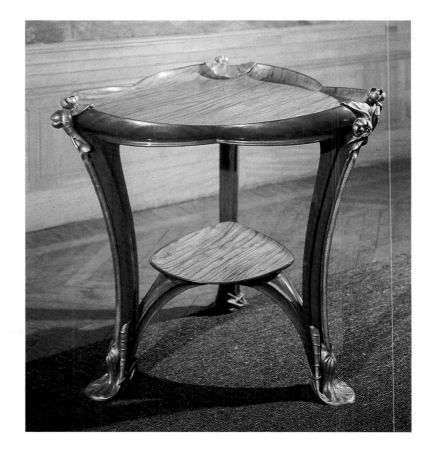

Paris had an isolated and too little known example of this kind of décor in the Konss restaurant, where the strong structures of Bruno Möhring (the architect of the Berlin elevated railway in 1903) afforded an apt setting for the aestheticism of Georges de Feure's paintings. The dining room designed by Alexandre Charpentier for the Champrosay villa of Adrien Bénard (defender of Guimard) was one of the rare attempts to create what might have been a typically French Art Nouveau interior space.

It was thus above all in furniture and handicraft products that French art triumphed, and most often independently of architecture. In this area also, tendencies were varied and contradictory. In Gallé's "speaking furniture" and sometimes also in Majorelle's work—a typical feature of the Nancy school—attention was drawn away from a deliberately functional simple structure and directed towards the decoration and some extremely attractive marquetry, developed, however, regardless of the logic of the forms. The "Work is Joy" table shown at the Paris World's Fair was a good example, and the fine 1900 firescreen was another. In the work of Alexandre Charpentier, representing the Group of Six and Art in All *(L'Art dans Tout)*, joined by Sauvage in 1897, line became on the contrary abstract without, moreover, taking account of the properties of the material and putting the figurative representations on tablets designed independently by the sculptor. The Music Room, shown at the Société Nationale des Beaux-Arts in 1901, was a superb model of this work.

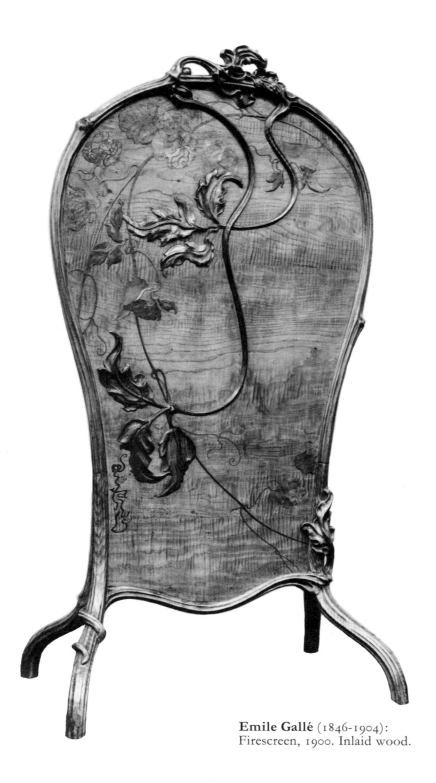

Emile Gallé (1846-1904):
Firescreen, 1900. Inlaid wood.

Maurice Dufrêne and **Lucien Bonvallet**:
Silver mounted stoneware vase
with relief decoration, c. 1899.

Pierre Selmersheim:
Pedestal for a vase,
plant or sculpture,
c. 1900. Padouk wood.

*Does our present furniture have any style or not?
This question, I confess, is a matter of indifference to me.
I have made no attempt to give mine any... Our style
lies in bringing out, with beauty, the useful features
of our unspeaking servants, our furniture, vases,
hangings, just as we see an animal's bone structure
and muscles clothed with flesh—and how skilfully
clothed, with what a decorative effect! Our one wish is
to have worked in the past and to work from now on in
such a way that one may recognize our contribution
from this double characteristic: a true and simple
ornamentation, arising as if of itself from the surface
of the construction, under the influence of a naïve
scrutiny of nature!*

Emile Gallé, *"Le mobilier contemporain orné d'après nature,"*
in Revue des Arts Décoratifs, *Paris,*
November-December 1900.

Conversely, the art of Gallé before his death in 1904 was never finer than when he succeeded in overcoming the seemingly irresistible need to be sentimentally effusive and symbolical which cluttered up more than one of his works and writings, and when, in his glassware, he transcended the naturalistic motif to reach, like Tiffany, expression in terms solely of material and form, as in his tall, slender vases around 1900, such as the masterly Iris-bud vase on the theme of an Art Nouveau fetish flower, which was conceived expressly for the World's Fair and beside which Bing's delightful pieces of china seem only pretty and almost uninspired.

At Meier-Graefe's Maison Moderne in Paris there was something different again, a simpler and more virile art which—Abel Landry's furniture in particular—was designed for commercialization. The Maurice Dufrêne vase, bought in 1899 by the Musée des Arts Décoratifs and fitted with a stand by Bonvallet in order to be shown at the Union Centrale pavilion in 1900, should be contrasted, in the austere and abstract ruggedness of its glazed stoneware (after the manner of Chaplet), with the famous Gallé *Africana*

Georges de Feure (1868-1928):
Lady in the Snow: porcelain vase
with painted underglaze decoration, c. 1901.

Emile Gallé (1846-1904):
Iris-bud vase, 1900.

exhibited at the same time but inspired by Victor Hugo's verse engraved on its side.

With the L'Art en Tout group there finally emerged a milder, more classical French Art Nouveau, which rejected ornamental excesses and was usually practical and rational, but which also moved away from the aims of Modern Style and therefore often seemed to be a more humdrum version of Bing's Art Nouveau or that of the Belgians. Charles Plumet and the brothers Pierre and Tony Selmersheim represent the aftermath of a form at that time quite close to the "happy medium" of the Société Nationale des Beaux-Arts.

Billiard room, Villa La Sapinière,
Evian, 1899-1900.
Overall design and woodwork
by Félix Bracquemond.
Paintings by Jules Chéret.
Billiard table by Alexandre Charpentier.

René Lalique (1860-1945):
Pendant with woman's head
and poppies, c. 1900.
Gold, enamel, chalcedony, pearl.

Philippe Wolfers (1858-1929):
Pendant with swan and hyacinth, 1900.
Gold, enamel, diamonds,
pear-shaped pearl.

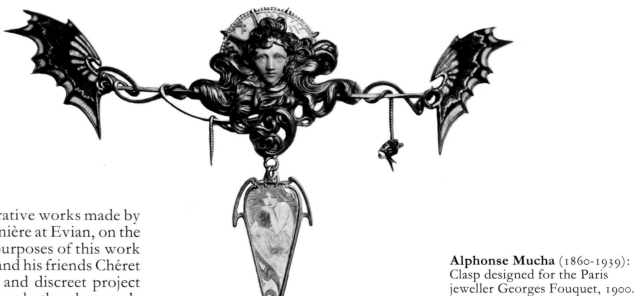

In 1902 that Society showed several decorative works made by
Bracquemond for Baron Vitta's Villa La Sapinière at Evian, on the
Lake of Geneva. The collaboration, for the purposes of this work
begun several years before, of Bracquemond and his friends Chéret
and Charpentier was typical. The luminous and discreet project
conceived by Bracquemond, in which today only the glass made
by Falize is lacking, was the expression of a wholly different ap-
proach from that of Serrurier-Bovy. Space was not called in ques-
tion, and the distribution and details of the ornamentation harked
back first of all to the great classical tradition (Bracquemond him-
self referred to Versailles panelling) evincing the limited ambition
but also the mastery and refinement of this—yet another—form of
French Art Nouveau.

Alphonse Mucha (1860-1939):
Clasp designed for the Paris
jeweller Georges Fouquet, 1900.
Gold, ivory, enamel,
pearl, opals, shell.

The same art is represented by the fabulous hand mirror made for Baron Vitta in 1900 (likewise shown in 1902 and recently rediscovered) with its ivory handle, translucent enamels and, backing the mirror, a gold plaque by Rodin, collaborator and close friend of Bracquemond, by whom the whole was designed with flexible and subtle lines centred first of all, beyond the calculated equilibrium of the precious metals, on the logical distribution of light values. This exceptional piece, in which the conception no longer stemmed solely from the skill of the specialized jeweller, after the style of the contemporary works of Lalique, but from the global aesthetic approach of a designer, should modify our view of French jewellery around 1900.

One and all escaped from the over-decoration which sometimes marred the jewels Mucha designed for Fouquet (hair thickened with the vapour of perfumes), with their reiterated orientalism which was to reappear in the plates of *Documents Décoratifs* published in 1903. One and all were, however, far also from Van de Velde's abstract jewellery and were soon to be far from the simpler new jewellery of the Wiener Werkstätte as well. It might seem incredible that the aesthetic aims were the same as those of a Guimard or a Sauvage. The revolutions in jewellery were largely due to the fashion and novelty denounced by Van de Velde; far from supporting the researches of Art Nouveau, their extraordinary vogue heralded, in France, its premature demise.

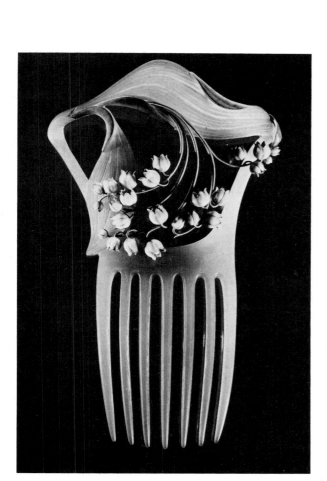

René Lalique (1860-1945):
Ornamental comb with lilies of the valley, c. 1900.
Horn, gold, enamel.

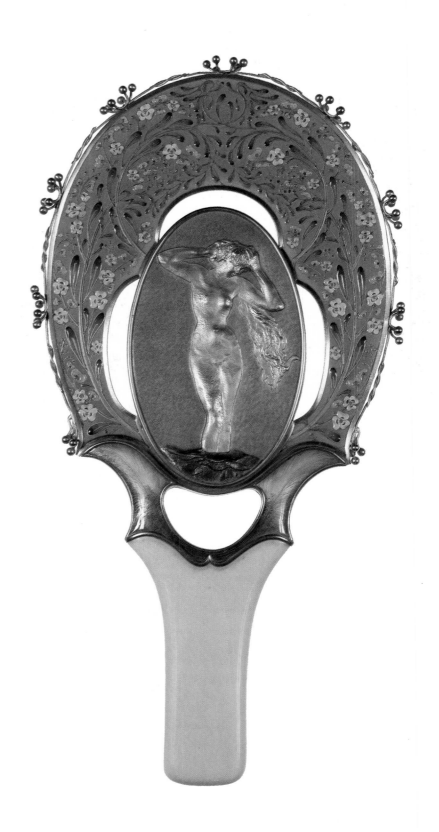

Hand mirror, 1900, designed by Félix Bracquemond, with gold relief figure by Rodin, enamelwork by Alexandre Riquet, metalwork by Alexis Falize. Gold, enamel, ivory.

Although he seemed to use a similar floral art recalling again the eighteenth century, Lalique, one of the outstanding successes of the 1900 World's Fair, in reality only rubbed shoulders incidentally, in a more "worldly" naturalism than that of Gallé, with the basic ambitions of Art Nouveau. The astonishing and often admirable ingeniousness of his mountings enabled him to associate, for example, the flower and leaf of the lily of the valley with the normal shape of the comb to attain a harmonious assemblage of curves (not always as happily emulated in the work of Lucien Gaillard or the achievements of the firm of Vever), or when a profile, by definition asymmetrical, gave him an occasion to pass from the line of the hair to the line of a stalk and finally to an abstract line. Often, however, the mounting was more temperate, as in the productions of Philippe Wolfers, and recalled that innovation lay first of all in the rejection of traditional forms, the use of semi-precious stones and the liberation of inventive fantasy.

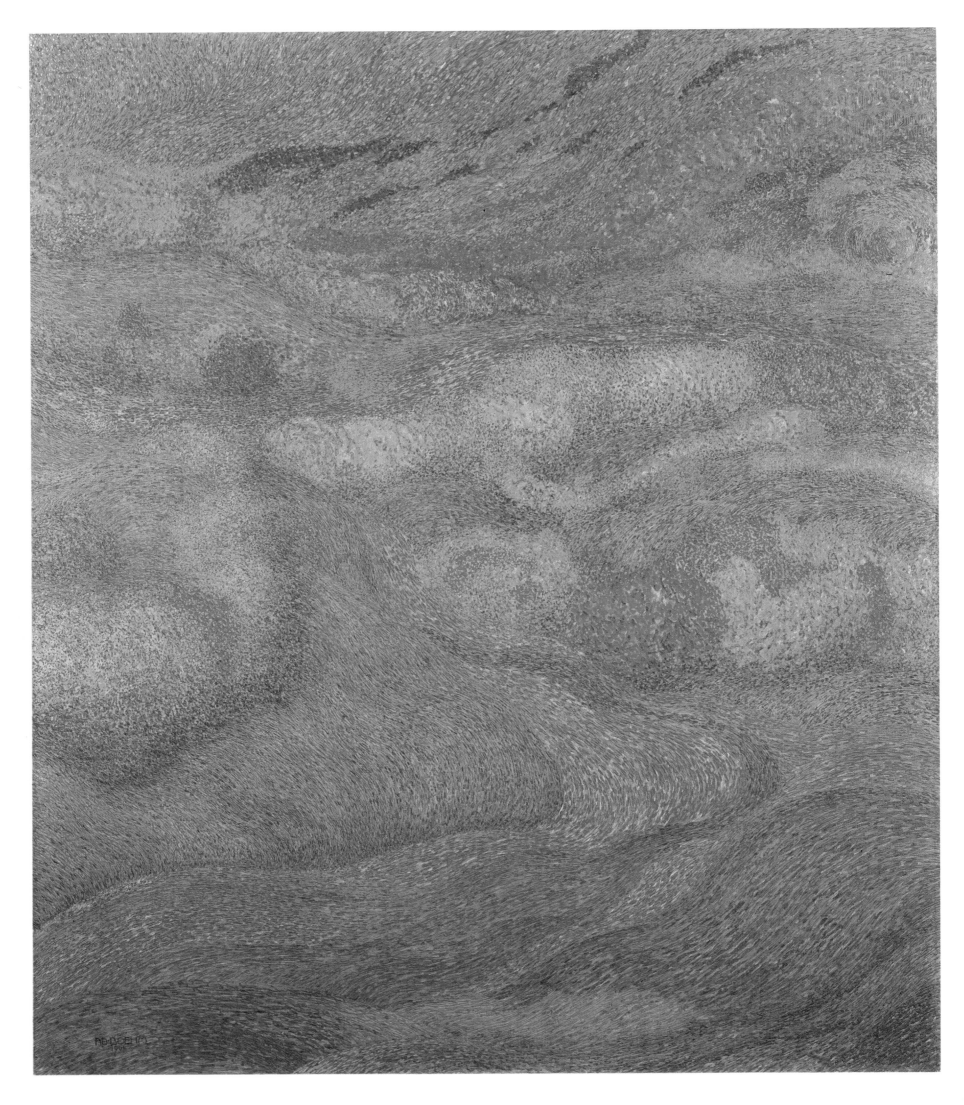

Adolf Böhm (1861-1927):
Landscape, 1901. Oil.

The Splendour of Autumn

Outside France, especially in Germany and Austria, the triumph of Art Nouveau rarely assumed a rowdy and "carnivalesque" character. In Germany, after Van de Velde settled there, it was a quiet force that developed logically towards architecture and monumentality after the decorative fantasies of early Jugendstil had been brought to an end. In Vienna the full blossoming occurred after 1900; it was only then that Klimt's painting reached maturity and achieved a masterly synthesis of his earlier conquests. On its own ground, however, Art Nouveau was still disputed. The Glasgow school found real success, paradoxically, only by exiling itself to Vienna. And it was symptomatic that the last great group exhibition, echoing the Paris World's Fair of 1900, was organized in 1902 in Turin: Liberty Style, as it was there called, was in Italy only a secondary phenomenon and, in spite of isolated achievements, without any personalities of the first rank since the death of Segantini.

That is also why one may ask, as in front of the latter's last triptych, whether this high-water mark of a current that seemed doomed to self-expatriation really represented dawn or twilight; birth or the harbinger of a coming demise. Between 1900 and 1902 there was perhaps an autumnal splendour, expressed in the leaves of *Ver Sacrum*, which, prematurely withered, disappeared in 1903. Adolf Böhm was one of the most regular and representative contributors. His astonishing *Landscape* of 1901, which alone would suffice to explode the myth of a Secessionist style devoted solely to the circle and the square, was also one of the last avatars of a composition based on arabesque alone. Böhm's horror of emptiness, which summarizes one of the modes in which Art Nouveau embarked on the conquest of surfaces, also brought him to the brink of abstract painting; but his essentially decorative aim kept him firmly inside that boundary line. His luxuriance and autumnal sensuality take him close to Klimt, but hesitation in working method and uncertain borrowing of the Neo-Impressionist brushstroke and the contrast of complementary colours leave him on the sidelines. His "fullness," finally, in every sense of the term, does not prevent an uneasy agitation from running through his work: an apotheosis in a way fragile and threatened.

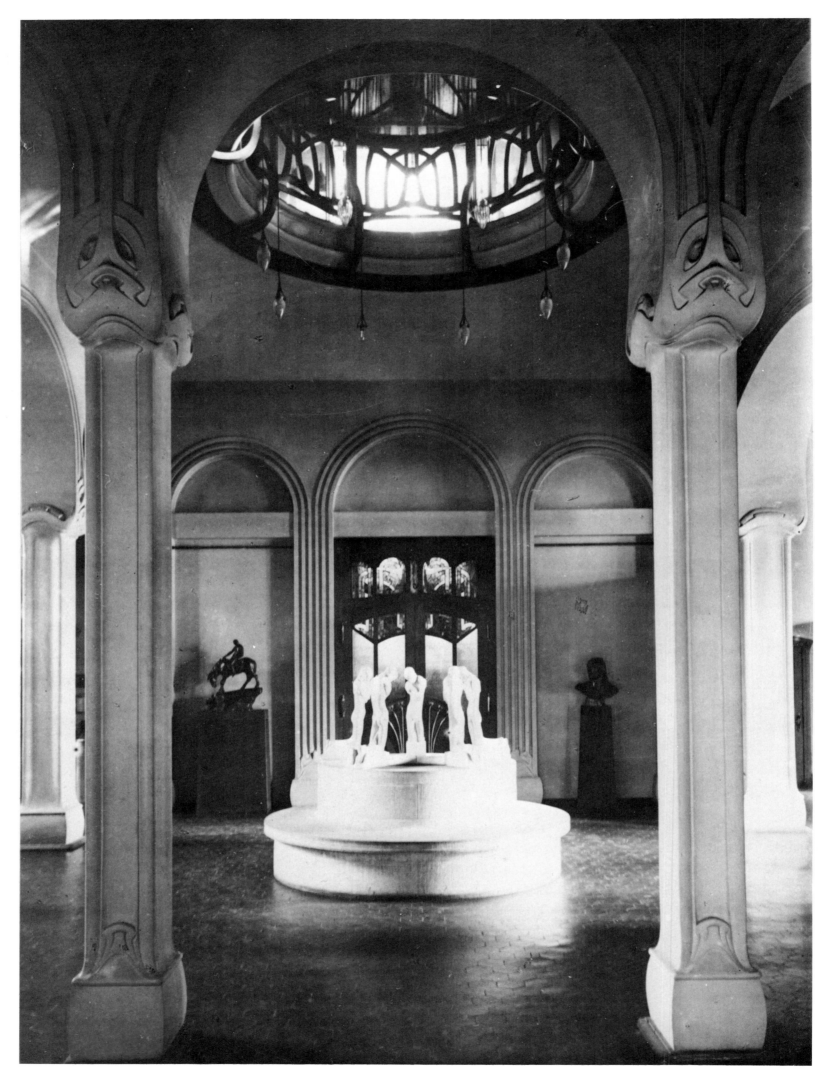

Henry van de Velde (1863-1957):
Entrance hall of the Folkwang Museum, Hagen, 1900-1902.
Well with stone bench and statuettes by George Minne, 1898.

TRIUMPHANT ART NOUVEAU
THE CENTRES AND THE OUTSKIRTS
1900-1902

The Zenith of Jugendstil

 ELATEDLY converted, Germany too, around 1900, carried Art Nouveau to its summit, but to lead it this time as far as the threshold of the modern movement. There is, however, nothing mysterious about this "transfiguration" of Jugendstil. The German periodicals and their illustrators amply revealed the aspiration to new forms. Even outside the applied arts, the rational use of techniques and materials had naturally found its place in a country in full industrial expansion—as witnessed, for example, by the great Tietz department stores of Berlin put up by Bernhard Sehring in 1898-1900, whose immense glass and metal façades went, in point of rationality, well beyond those of Sullivan and anticipated Horta's Innovation department store in Brussels. But in the Tietz building, as in the Wertheim department store by Alfred Messel (1896), style was still lacking: the solid stone masses of Tietz were neo-Baroque, those of Wertheim neo-Gothic.

The purposeful move towards style was made by Van de Velde when he settled in Berlin in 1899. His activity there as a designer contributed to it quite as much as did the numerous writings he now published in German. The Dresden rooms in 1897, the interior decorations commissioned by Meier-Graefe, and Van de Velde's long article published by Meier-Graefe in 1898 in *Dekorative Kunst*, and the desk exhibited at the Munich Secession in 1899, finally led to Van de Velde's lecture tour in Germany in the winter of 1900-1901, during which he explained his artistic principles. These lectures were published as *Kunstgewerbliche Laienpredigten* (Leipzig, 1902): "Lay Sermons on the Applied Arts."

On the first of May 1900, the Hagen banker Karl Ernst Osthaus was persuaded by the reading of Van de Velde's article published by Meier-Graefe to make in his turn the pilgrimage to Uccle. Van de Velde finally agreed to remodel the interior of the Folkwang Museum which Osthaus had just had built at Hagen by the Berlin architect Karl Gerard in neo-Renaissance style (today it is known as the Karl Ernst Osthaus Museum). A highly symbolic undertaking, this doing over from the inside of a historicist museum, soon to be dedicated to contemporary art, along the lines of Art Nouveau!

Van de Velde indeed was gaining recognition as one of the foremost designers of the day, one of the foremost masters of line: the artist to whom his friend Theo van Rysselberghe paid homage, by the choice of pose and linear pattern, in the fine portrait he made of him in 1900. At Hagen Van de Velde could not change the already existing spaces, and in particular the metal piers and brick arches in the entrance hall. And yet in designing the stucco sheath rendered necessary for reasons of security, he managed, by line-work alone, to create around the central well with circular bench

In Darmstadt the Grand Duke of Hesse, Ernst Ludwig, himself took the initiative, in 1899, of founding an "artists' colony," whose exhibition in 1901 marked the zenith of Art Nouveau in Germany. In Berlin the moving force was AEG, the general electric company, one of the largest industrial concerns in the country, whose founder, Emil Rathenau, and afterwards his son Walter, commissioned work from avant-garde artists (notably Otto Eckmann) before finally appointing Behrens general artistic adviser (in 1907).

These diverse personalities had in common their advanced liberal opinions (Ernst Ludwig of Hesse was nicknamed "the Red Grand Duke"; Walter Rathenau, whose biography would be written by Kessler in 1928 after his assassination by the extreme Right in 1922, was a prominent figure of the German Democratic Party) and a pronounced Anglophilia: Ernst Ludwig was himself a grandson of Queen Victoria, and Kessler, who studied with him at the University of Leipzig, has told in his fine *Recollections of a European* (written and published in Paris in 1936) of his own education in England. This liberal-minded patronage in Germany, well aware of the moralizing intent of the Arts and Crafts movement, thus fell quite naturally into agreement, as occurred nowhere else, with the essential approach of Art Nouveau and that of Van de

Theo van Rysselberghe (1862-1926):
Portrait of Henry van de Velde at Work, 1900. Pencil.

Cover of *Deutsche Kunst und Dekoration*,
Darmstadt, November 1900.

and statuettes by his compatriot George Minne, the illusion of a homogeneous volume, completely unified and dynamized by that supple line which rebounds from the column bases to their capitals, sets out to storm the first floor by way of the staircase banister and the wavelets accompanying the steps, reappears on the balcony of the large central round-window and from there goes on to the superb stained-glass skylight window that crowns the whole. This "ornamental spray" actually imposes the idea of a new structure, in which it integrates Minne's sculpture by stripping it of its obliging symbolism, leaving perceptible only the abstract rhythm, in the Hodler manner, on the circular arrangement of the round-window and stained-glass skylight. The Folkwang Museum was opened on 19 July 1902: an admirable conquest of three-dimensionality that epitomizes the effort of those two years and marks the advent of Van de Velde the architect, whose career would take off from there, the immediate follow-up being the Esche House at Chemnitz in 1902.

His outstanding personality would not have been enough, however, nor the support of Meier-Graefe, who was forced to suspend *Pan* in 1900, if socio-economic conditions had not then been at their most favourable. For an art lover like Adrien Bénard in Paris and a few others who supported Guimard, Horta or the Nancy craftsmen, here was the flowering, on a vast scale and with considerable means, of an enlightened patronage of exceptional quality. At Hagen, Osthaus, who in 1920 published what remains the basic work on Van de Velde, would again commission him, together with Behrens, for works lasting several years. In Weimar Count Harry Kessler, one of the most distinguished figures of European culture, himself also a pilgrim to Bloemenwerf (in 1897), and already a financial backer of *Zarathustra* (in 1898), was instrumental in leading Van de Velde to settle in Weimar in 1902, where the Grand Duke of Saxe-Weimar would enable him to create, in his own words, "the advanced citadel of the New Style."

Velde in particular. The competition between these different cities and States in a Germany at the height of an economic boom did the rest. In Weimar the Parliament of Hesse financially supported the generous gesture of its Grand Duke the moment it seemed likely to have "repercussions on the productivity of the national industry of applied arts," as was said during the debates. Hence the artistic vitality of these rival, art-conscious cities: Berlin, Munich, Darmstadt, Hagen, Weimar, against which Nancy, for example, the only art centre in France that could be set up against Paris, cut a very poor figure.

It was undoubtedly Darmstadt which, with its 1901 exhibition, between Paris and Turin, best expressed this situation. The city was already benefiting from the bustling activity of the publisher Alexander Koch and from the three art periodicals that were published there. And in 1897 the Grand Duke had called upon Baillie Scott and Ashbee on one hand and Eckmann on the other for the renovation of his palace. Two years later, seven artists were asked to found the new colony: Habich, from Darmstadt itself; Bosselt and Christiansen, just back from Paris; Bürck and Huber, themselves also associates of Koch; Behrens, called in from Munich; and a single foreigner, Olbrich, the "scandalous" architect of the Vienna Secession. Their programme, presented in November 1899, called for the construction of workshops and family houses on the Mathildenhöhe, a neighbouring hill belonging to the Grand Duke. This programme was carried out and led to the exhibition of 1901, ambitiously called *Ein Dokument Deutscher Kunst*, to which the "Darmstadt room" shown in Paris in 1900 formed an initial approach.

The posters already indicated the two tendencies into which this new architectural phase of Jugendstil was divided. The poster done by Olbrich, who was responsible for the overall programme, integrated, as for the Secession, a flattened representation of the main building into a harmonious decorative arrangement tending towards geometric abstraction. The poster done by Behrens, the only builder of his own house, took over the slender figures of Glasgow in an ascending design charged with spirituality, between the egg from which it springs and the ideal ovoid shape that

Peter Behrens (1868-1940):
"A Document of German Art": poster for the exhibition of the Darmstadt artists' colony, 1901. Colour lithograph.

▷ **Joseph Maria Olbrich** (1867-1908):
Poster for the exhibition of the Darmstadt artists' colony, 1901. Colour lithograph.

echoes it and radiates in the heavens. The superb door to Behrens' own house, obviously just as "sacred," like some entrance to Sarastro's temple, carries the symbolic abstraction further. Here the line spreads out in a powerful dynamism that confesses what it owes to Van de Velde more discreetly than does the cover design of *Die Kunst*, visibly plagiarized from *L'Art Décoratif*; but in so doing it in fact draws the emblematic motif of the Nietzschean eagle, found in more legible form, along with the glassware, in the exhibition *Festschrift*. Comparably to Van de Velde, Behrens too did the binding for a *Zarathustra*, shown at the Turin exhibition in 1902.

Beneath the discreet appearance of a variation on the rustic style of Arts and Crafts and the Nordic tradition (the gables), Behrens' whole house, the German aftermath of Morris's Red House and Van de Velde's Bloemenwerf, thus derives from the same pagan celebration of a "Mass of Life," to adopt the title of a book by his friend Richard Dehmel *(Eine Lebensmesse)*, which Behrens vainly hoped to stage in Darmstadt, but which would receive only, with the publication of Dehmel's poems, the ornamental interlacing taken from the *Kiss* that suited with his tumultuous lyricism, also of Nietzschean inspiration.

Peter Behrens (1868-1940):
Behrens House, Mathildenhöhe, Darmstadt,
1901. Door and north front.
Cover design of *Die Kunst*, Munich, November 1900.
Cover design of Richard Dehmel's "Selected Poems," Berlin, 1902.

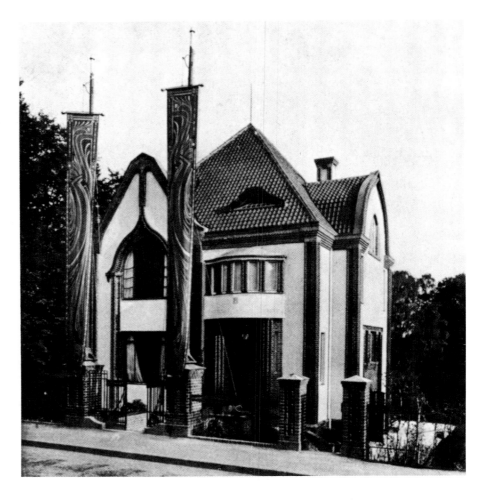

In no case, however, was there a question of relapsing into symbolism. Art Nouveau continued to express itself here through form alone, as testified by those two great banners placed at the entrance of Behrens' house for the inauguration. They are the apotheosis of abstract ornament, taking over and transposing the lateral framing designs of his woodcut, *Stream*, where between the central motif and the borders there was masterfully achieved the passage from a stylized natural form to a Van de Veldean line, abstract but preserving within it all the energy of life. Inside Behrens' Darmstadt house the dining-room chairs, whose convexities derived from those of Bloemenwerf, now answered to the sideboard, the ceiling design and even the table service, in which Behrens again used that repeat motif of interlacing lines. Van de Velde was a guide (again in the library desk, whose curve corresponds to the bow-window) but first of all a spiritual guide: the Darmstadt house and the Hagen museum take the same step forward. By reconciling in his turn the utilitarian with the beautiful, Behrens became "neither truly a painter, nor an architect, nor a designer, but rather an artist of life" (Heinrich Pudor, 1905).

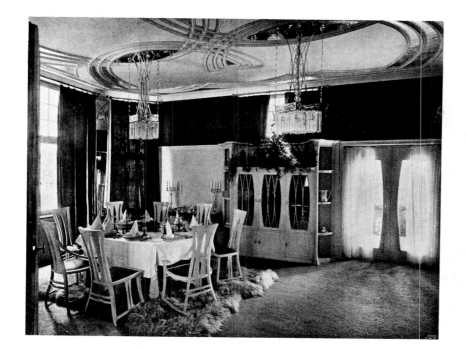

Peter Behrens (1868-1940):
Dining room and library,
Behrens House,
Mathildenhöhe, Darmstadt,
1901.

Architecture is the art of building, which means that two concepts have to be defined: the mastery of a skill and the art of the beautiful. And one rejoices at being able to bring these two ideas together in one: the idea of practical utility and the idea of abstract beauty, which unfortunately have been too often opposed.

This growth of artistic perception, connected with technical progress and the discovery of new materials, is a further guarantee of fruitful results from the modern style, and a justification of it. So thanks to the combination of these two art concepts we may speak of an architecture answering perfectly to the spirit of our time.

<div align="right">

Peter Behrens, 1901.

</div>

Peter Behrens (1868-1940):
Stream, before 1901.
Colour woodcut.

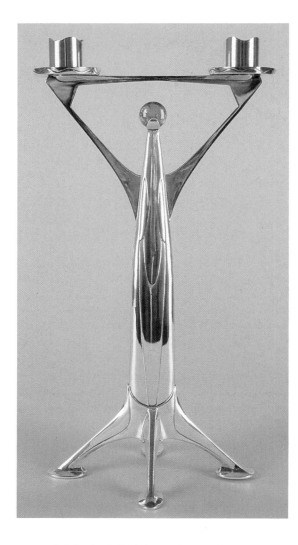

Joseph Maria Olbrich (1867-1908):
Silver candlestick with amethyst, 1900-1901,
designed for the Olbrich House,
Mathildenhöhe, Darmstadt.

Of a more cheerful hedonism, like the graciously undulating champagne glass that would again be put on show at Turin in 1902, or the smart-looking porcelains of Hans Christiansen, the constructions of Olbrich had none of that massively heroic grandeur. With their stylized flowerets and precious colours, his other individual houses repeated the model of the villas around Vienna and their flat-colour decoration typical of the Secession. But this decorative choice could also be a forceful one, as when Olbrich, for instance, transcended fine material to create a fascinating form, even if it remained imperfect in its unstable and almost painful tension: the futuristic candlestick of his own house that would make the more finished one by Van de Velde, although roughly contemporary, appear out of another age.

Joseph Maria Olbrich (1867-1908):
Champagne glass, c. 1901.

Hans Christiansen (1866-1945):
Porcelain plate with blue and green leaf design, 1901.

The omega-shaped door, Olbrich's hallmark, reappears in the main building of the Mathildenhöhe colony: the Ernst Ludwig House, which contains the workshops and where refinement reaches its peak. Its functional design looks back to the Glasgow School of Art, with its continuous band of windows along the corridor and its large north windows. But the inscription (by Hermann Bahr) on the archivolt, between *Strength* and *Beauty* by Habich, well sums up the basic idealism—and unreality—of an undertaking reserved to a chosen few: "Let the artist show his world, which has never been and will never be." The ritual inauguration ceremony, on 15 March 1901, with the staging by Behrens of Georg Fuchs's *The Sign*, heralding a "new life" for the Grand Duke and his people, carried to its highest pitch what remains one of the most beautiful utopias of Art Nouveau.

Joseph Maria Olbrich (1867-1908):

▷ Large Glückert House,
 Mathildenhöhe, Darmstadt, 1901.

▽ Ernst Ludwig House,
 Mathildenhöhe, Darmstadt, 1901. Entrance.

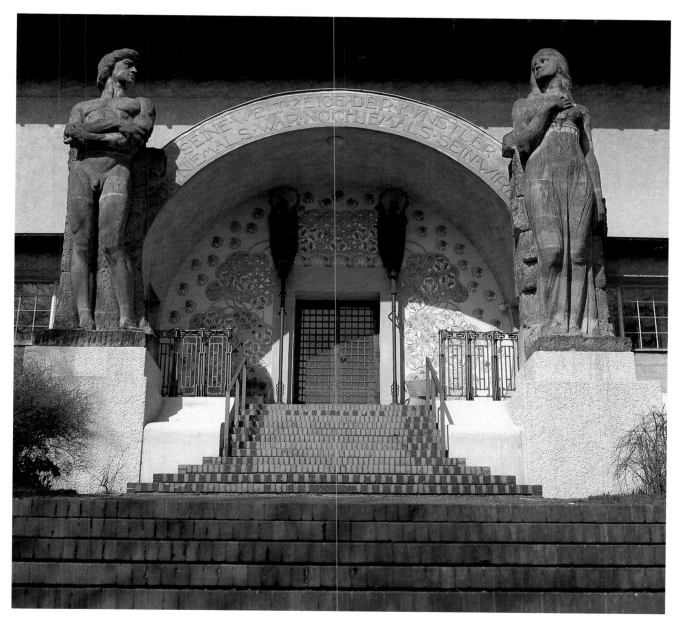

It also helps explain the irritation of Kessler and Van de Velde, who came to Darmstadt during the summer of 1901: "I feel really repelled. I shall not use any more decoration for two years. I am glad I saw it. You can also see what not to do. I am going to become even more simple; I shall no longer seek anything but form," Van de Velde said to Count Kessler. An understandable reaction to the preciosity of Viennese surface decoration, and perhaps also to the neophyte's zeal of Behrens, but a reaction that also announced the end of decorative and illustrative Jugendstil—that of *Pan, Jugend* and the Elvira photo studio.

"Enough of this so-called Jugendstil that has absolutely nothing to do with the spirit of the new trend!" Van de Velde had written in *Deutsche Kunst und Dekoration* in 1900. The same opposition was then to be found in other places: between August Endell's *Buntes Theater* (1901) in Berlin, for example, a strange aquarium in which floated corals, sea-horses and curious insects that continued to illustrate the *Kunstformen der Natur* of the biologist Ernst Haeckel (1899), and Riemerschmid's admirable Munich Playhouse (1901), recently restored, an organic volume powerfully modelled and soberly decorated, in which the abstract line of the ornament merely emphasized the structures, as in the furniture in which Riemerschmid adapted to Bavarian dimensions the austere sobriety of Arts and Crafts and Van de Velde's comfortable simplicity. And Behrens' increasingly spare and monumental concep-

Richard Riemerschmid (1868-1957): Armchair, 1902-1903.

August Endell (1871-1925): Das Bunte Theater, Berlin, 1901 (destroyed).

Richard Riemerschmid (1868-1957):
The Munich Playhouse, 1901.

tion of book illustration and design was opposed to that of a
Heinrich Vogeler, an overabundant decorator, who for the Insel
editions in Berlin continued, with excessive virtuosity, to cultivate
the complex and proliferating patterns of Morris and Beardsley.

With Van de Velde, Behrens and Riemerschmid we stand on
the threshold of the modern movement. Gabriele Münter would
later recall that when she first came to study painting in Munich,
in 1901, "Jugendstil was beginning in its way to destroy old-style
naturalism and to devote itself to pure line." An astonishing con-
nection then began to form between Behrens and Kandinsky. The
former, in 1903, invited the Russian painter to come and teach at
the Düsseldorf School of Art. Kandinsky, on his side, invited
Behrens to take part in the first exhibition of the Phalanx group
which he had founded in Munich in 1901. In the famous poster
Kandinsky designed for the occasion, one may recognize antique
or classical motifs used by his master Franz von Stuck—or by
Klimt in Vienna—but this struggle of the Phalanx against the
Philistines also called for a new decoration, a quest for flat colour
that merged figure and ground and would prove so fruitful for
painting, an aspiration to unity that combined letters with what
still remained of the image. In Germany the triumph of Art
Nouveau was still, and in the short term, the bearer of a rich future.

Heinrich Vogeler (1872-1942):
Frontispiece and title page for
Hugo von Hofmannsthal's "The Emperor
and the Witch," Berlin, 1900.

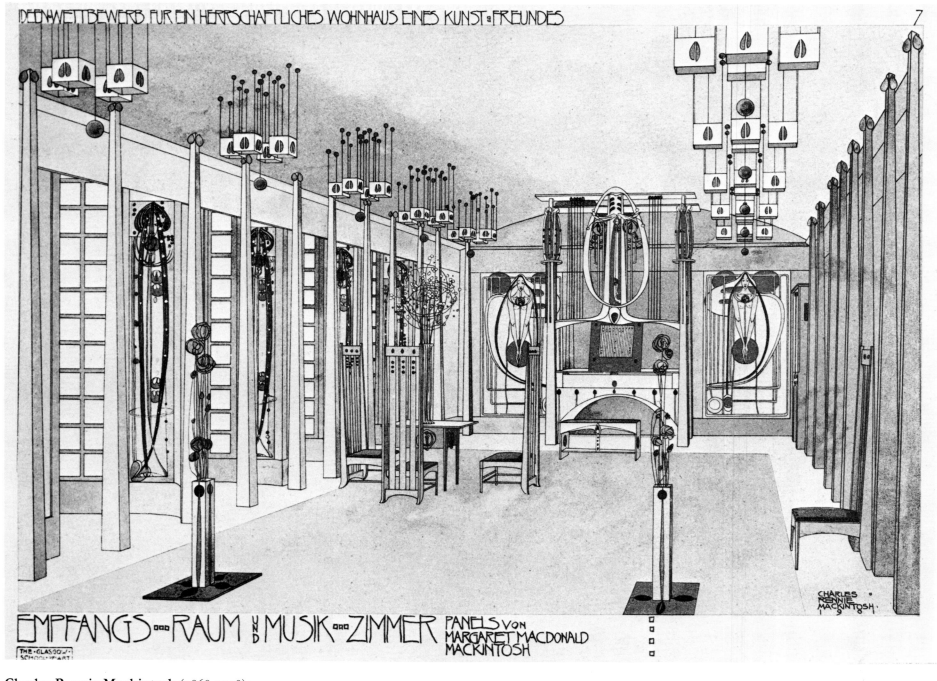

Charles Rennie Mackintosh (1868-1928):
Design for the House of a Connoisseur, 1901.
Reception room and music room, with panels
by Margaret Macdonald Mackintosh.

From Glasgow to Vienna

IVEN the leading role henceforth played by Germany, it is not surprising that the relaunching and dissemination of the Scottish movement should have started from this country, and quite specifically from Darmstadt. For it was the Darmstadt publisher Alexander Koch who in December 1901, under the auspices of his journal *Zeitschrift für Innendekoration*, organized a competition for the House of a Connoisseur *(Haus eines Kunstfreundes)*, including its interior decoration. The three best designs were published by Koch in 1902, with a preface by Hermann Muthesius, who as attaché at the German Embassy in London did so much to make English architecture and design known in Germany. For technical reasons it was not Mackintosh who won first prize, but Baillie Scott, with a design of remarkable ingenuity moreover, but keeping in its essentials to the "rustic" model of Arts and Crafts. By contrast, Mackintosh's design, which took second prize and made a considerable impression, was dominated by the will to style.

Again, in Mackintosh's House of a Connoisseur, one finds the rationalism of the Glasgow School of Art (already followed up on a more modest scale in his Windy Hill House at Kilmalcolm, of 1899-1901), with its free plan that still descends remotely from Philip Webb's Red House. And the exterior, of a highly modernist bareness of ornamentation and a provocative asymmetry, strictly derives its vigorous plastic quality from the interior arrangements: on the north-west side, for instance, with the turret of the main staircase, the high windows of the entrance hall which extends, English-style, over two floors (a disposition which Olbrich, a member of the jury, took over in the Glückert House); or again, on the west gable, the bulge of the breakfast-room, placed on the upper floor in proximity to the bedrooms. Conversely, on the inside the strict dividing up of the spaces is accompanied by an extreme refinement in the decorative implementation. But contrary to most of the French decorators, and to those in particular who worked for Bing, it was the architectural ensemble that decided the particular form of the objects, down to the linear design of the panels by Margaret Macdonald (whom Mackintosh married in 1900), which were not allowed to encroach on the structures. Thus may be justified for example, in the music room, those chair-backs with narrow, elongated slats which rise to meet the square suspended light-fittings. And the piano, carved in its honeycomb cell, can make no departure either from the severe ordering of the whole.

Mackintosh's furniture in fact can only seem overly "eccentric," particularly as regards the proportions of his chairs, if it is taken out of its context: it is precisely because it closely depends, beginning above all with Darmstadt, on a global conception of

171

volumes that it belongs, like the furniture of Van de Velde or Behrens, to the most novel and profound current of Art Nouveau. And its specific novelty lies first in that abandoning of traditional proportions, which enclose the object in itself, for a linear and flat expansion in space, which others would carry still further after the First World War. By forsaking stained wood for painting or lacquer, Mackintosh distanced himself equally from Arts and Crafts. But this forsaking (in this particular case) of the truth of the material also travelled in the direction of a fuller integration with an "abstract" space in which colour (and lighting) henceforth played, as with the Viennese, an essential role. And conversely, the distinction between the curvilinear contour that would define Art Nouveau and the rectilinear design of the "counter-movement," which would appear here at the same time as in Hoffmann, seems a secondary one and, no more than in the latter's case, genuinely relevant. Mackintosh's white-painted oak chair, with its stencilled canvas back, which would be shown in Turin in 1902 and afterwards stand in the music room of Fritz Wärndorfer in Vienna, testifies to that fact by the delicate and suave sinuosity crowning its back.

Mackintosh thus effected a masterly synthesis of the scattered elements of the British movement, the tradition of the Scottish house and of his own previous work, so as totally to transcend its national character, as confirmed by the success he now enjoyed in continental Europe.

In Great Britain itself these innovations remained in fact completely isolated. One need only compare them with the interior of Townsend's church of St Mary the Virgin, as fitted out by William Reynolds-Stevens in 1902-1904, to see what separates the last great

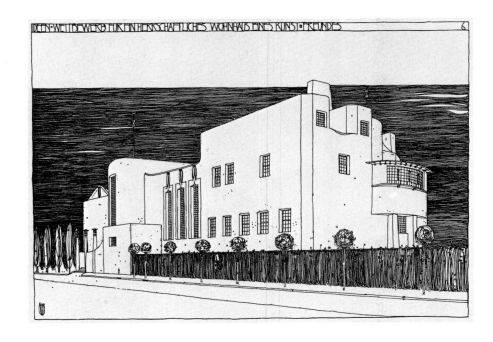

[The artist] must possess technical invention in order to create for himself suitable processes of expression—and above all he requires the aid of invention in order to transform the elements with which nature supplies him—and compose new images from them.

Charles Rennie Mackintosh, "Seemliness," 1902.

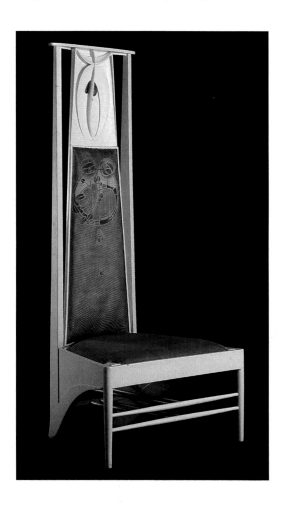

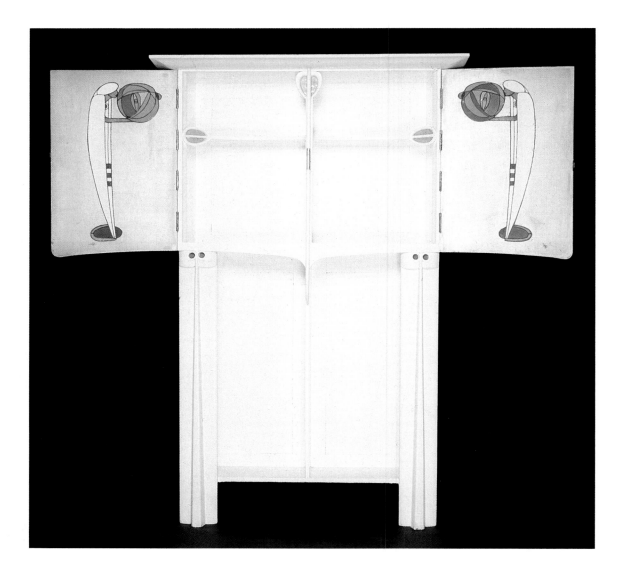

Charles Rennie Mackintosh (1868-1928):

△ ▷ Design for the House of a Connoisseur, 1901. View from the north-west.

△ Oak chair painted white with stencilled canvas back, 1900.

▷ White cabinet with inlaid figures of enamel and leaded glass, c. 1902.

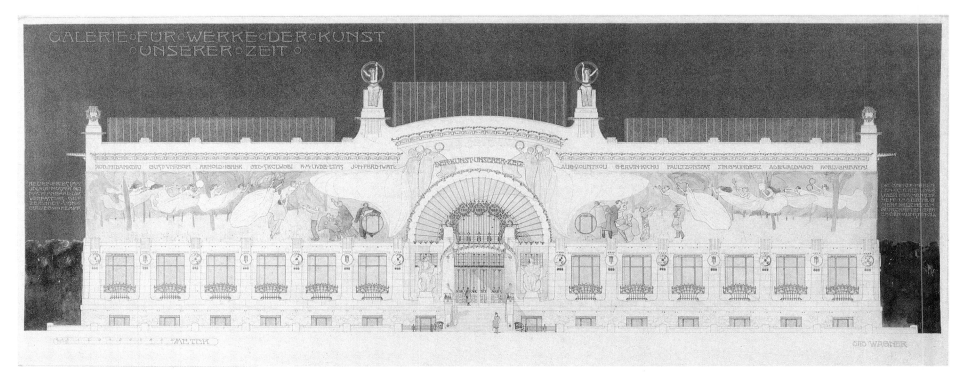

Otto Wagner (1841-1918):
Design for a Gallery of
Contemporary Art, 1900.

decorative effort of Arts and Crafts, with its assemblage of contrasted materials on the lines of stylized floral motifs, inspired by the Pre-Raphaelites and by William Morris, from an authentic Art Nouveau architect's design.

In Germany and Austria, on the other hand, Mackintosh's work naturally joined forces with the most recent conquests of Darmstadt and Vienna. Even the ornamental figures of his furniture, playing by their flat tints and colouring with the surface into which they are integrated, recall the principle if not the form of Behrens' emblems: here, the eagle and the crystal; there, the woman and the rose—and soon the willows of the Willow Tearooms in Glasgow (1903). But, despite the interpretation of Muthesius, who was pleased to see in Mackintosh's Darmstadt project for a Connoisseur's House the appearance of an entirely new form, Mackintosh in fact maintained more complex relations with tradition (in the use of standard materials, for instance). This brought him therefore still closer to the Viennese, beginning with Hoffmann, who in 1905 would remember very clearly the House of a Connoisseur in building the Stoclet House in Brussels. Mackintosh was welcomed with enthusiasm at the eighth exhibition of the Vienna Secession in 1900, and *Ver Sacrum* devoted a whole issue to him, along with the Macdonald sisters, in 1901. The following year there would come the commission for the Wärndorfer music room in Vienna, where the panel by Margaret Macdonald, *The Opera of the Seas*, would perhaps not be without influence on Klimt's famous *Kiss* five years later.

This meeting, however, was perhaps still more that of artists who had in common the fact of being "internal exiles." To Mackintosh's project for a connoisseur who was German, there corresponded the one drawn up by Otto Wagner at the same time for a gallery of contemporary art, which, like his many proposals for a Municipal Museum in the Karlsplatz, would never be accepted by the Vienna town council.

In this furthest advance on the terrain of Art Nouveau, Wagner was perhaps never closer to his young pupils, and it is not hard to see what brings the central arch of his contemporary art gallery, its continuous penthouse roof and vast blind wall above the row of windows, close to the Ernst Ludwig House in Darmstadt (and through it to the Glasgow School of Art). Over the front of this simple structure, following the principle of Hankar's unifying graffito technique, Wagner designed a wide-ranging composition in which the flying figures of Puvis de Chavannes' *Sacred Wood* are combined in a resolutely modern manner with the veils of Loie Fuller, around the entrance, and with the delicate linework of the Scots. It is indeed a temple of contemporary art, as further emphasized by the central inscription, which partially takes over that of the Secession exhibition building: *Der Kunst unserer Zeit* (To the Art of Our Time). By rejecting this project, sponsored by *Ver Sacrum* in 1901, the Vienna town council effectively cut itself off from the new art, as dreamed of and conjured up by Wagner and the Secession: an art in intimate association with the life of the city. Only a few of Wagner's brilliant pupils managed to make careers in the capital, such as Otto Schönthal, whose beautiful Villa Vojczik, completed in 1901, has recently been restored.

Otto Schönthal (1878-1961):
Villa Vojczik, Vienna, 1901.

Like *Pan* in Berlin, *Ver Sacrum* in Vienna was soon to cease publication (in 1903) and was then in the afterglow of a gorgeous autumn. Fittingly, it was the month of October which Adolf Böhm chose to illustrate in the beautiful calendar published by *Ver Sacrum* in 1901. This golden aftermath, again found in the Tiffany-style windows decorating the studio fitted out in 1900 in Wagner's first villa, and in the strange landscape painted in 1901 on the threshold of abstraction, also announces the end of compositions in undulating scrolls derived from the graphic arts, just as there was simultaneously an end of the Jugendstil of *Pan* and *Jugend*.

What now blossomed forth in Vienna was the great painting of Klimt, who reached maturity only after 1900, when he had fully assimilated his many previous sources of inspiration, from Whistler to Rodin, from Beardsley and Toorop to Mackintosh, from

Adolf Böhm (1861-1927):
Illustrated page for the *Ver Sacrum*
calendar, Vienna, 1901.

Otto Wagner (1841-1918):
Villa Wagner I, Vienna, 1900.
Studio with stained-glass windows
by Adolf Böhm.

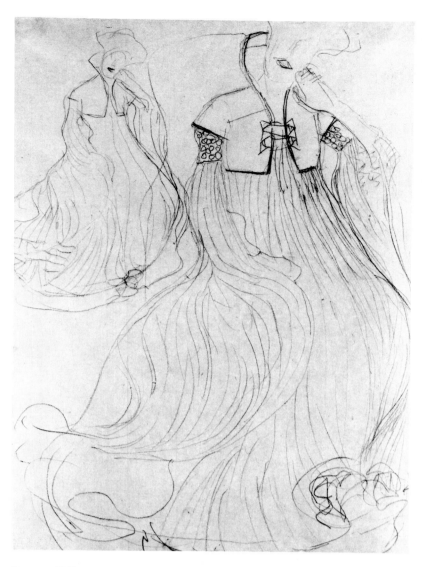

Gustav Klimt (1862-1918):

△ Two studies for the Portrait
of Adele Bloch-Bauer, c. 1902. Black chalk.

▷ Portrait of Emilie Flöge, 1902. Oil.

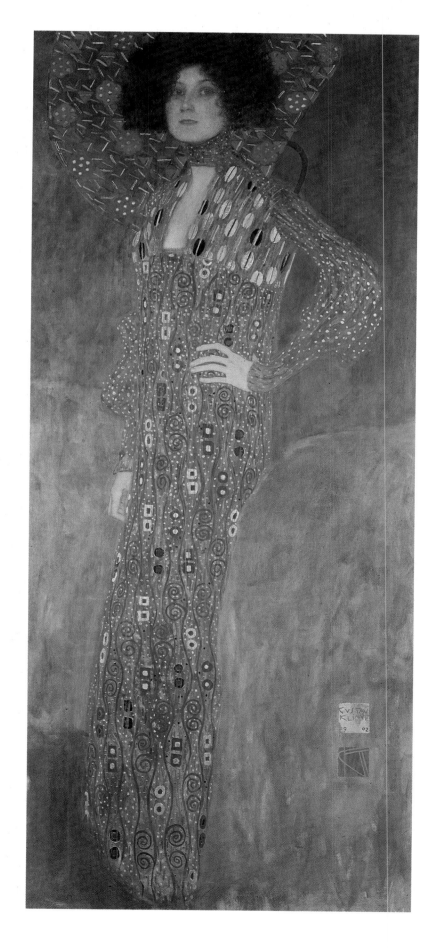

Japanese art (to which the Secession's sixth exhibition was devoted in January 1900) to the art of Ravenna (which Klimt visited in 1903). A belated fulfilment of the promises held out by Art Nouveau painting, and one that also permitted the integration of distinctively decorative processes which the painters themselves had helped to discover in the early 1890s.

It was in Klimt's figure paintings that this transmutation then occurred, between the *Portrait of Sonya Knips* (1898), for instance, which aroused the admiration of Arsène Alexandre at the Paris World's Fair of 1900, and the *Portrait of Emilie Flöge* (1902), where the Whistler-like background on which there had still stood out sharply a naturalistic portrayal of the model gave way to a pure ornamental arrangement, in the Nabi sense, with a mosaic of decorative flat tints making a setting for the face like one of the gems of the gown, and where the usual relation between body and setting tends to be reversed, like a glove turned inside out.

Now, in tackling his large portraits, Klimt was intent on line, on what Signac in 1899 had described as "curves and arabesques." These patterned the picture surface and set its tone, largely releasing it from those "decadent" obsessions of Klimt's on which too much stress has been laid, and which he now filtered into the plastic organization of his picture: witness the fine chalk drawing of about 1902, with the double figure of a lady in an armchair, the study which resulted in the great *Portrait of Adele Bloch-Bauer* (1907).

Gustav Klimt (1862-1918): Goldfish, 1901-1902.

The fact that Emilie Flöge, his faithful companion, ran with her sister a fashion shop fitted out by Hoffmann and Kolo Moser, was naturally not immaterial. Klimt had done some designs for the shop, and the finery in which he dressed Emilie, in photographs or paintings, had the same unifying function as the luxuriant vegetation of his landscapes, multiplied two or three times in the dozen photographs in which Emily poses, in clothes designed by Klimt, in the same teeming nature. Here too is celebrated a "Mass of Life," which is no longer that heroic and austere Mass of Behrens and Dehmel conceived for a conquering pre-war Germany, but a cult of organic and sensual life; a sense of the continuous flux of an essential force. That is what is expressed by those pictures of moving waters, fish, naiads and serpents closely joined together which blend in a purely ornamental composition, unlike the paintings of Böcklin and Klinger that prefigure them, the various "serpents" of Art Nouveau, from Voysey to Strathmann, as well as the spermatozoa of Munch and the endless undulations of his women's hair. Klimt's *Goldfish* of 1901-1902 sets the model, which would perhaps culminate in the *Water Snakes I* and *II* of 1904-1907. Despite the rich and obvious connotations of this painting in the Viennese cultural context, in particular that of Freud and Schnitzler, attention must focus on what, starting from forms, leads back exclusively to the painting. Answering the wishes of Maurice Denis, Klimt escaped the pitfalls of symbolism and attained with unprecedented force to expressive meaning through the decorative arrangement alone. A signal and major achievement of Art Nouveau: the appearance became the message; decoration alone the content.

This work naturally aspired to mural decoration. But here, too, failure appeared at the very heart of triumph: it was just when he succeeded in going beyond the representational function of painting, and no doubt for that reason, that Klimt was rejected by Viennese officialdom. On the ceiling of the University of Vienna his paintings of *Philosophy* (awarded a prize in Paris in 1900), *Jurisprudence* and *Medicine* no longer triumphed in the way desired by the manner of thinking and the hierarchical structure of that institution. But this was owing less to the symbolic significance of their imagery, much of which, besides, still remains to be deciphered, than to the "floating" organization of the whole; its provocative asymmetry; its placing on the same level and often with the size relations reversed, in the plastic sense, of the values

of Good and those of Evil. A failure which, concurrently with that of Otto Wagner's projects, developed especially over the years 1899-1903 (before Klimt, in 1905, took back his paintings—destroyed in 1945—for good).

This flat patterning of Klimt's was thus condemned to the ghetto of the Secession, where it found expression in his great, recently restored Beethoven frieze, painted for the presentation of Max Klinger's Beethoven statue at the fourteenth Secession exhibition in April-June 1902. The continuous run of the frieze, in the setting designed by Hoffmann with its simple, Mackintosh-style rectilinear planes (condensed in the famous "abstract" relief placed over a door), was more favourable to the development of this melody, which was also continuous. There once again, the symbolic evocation of the Ninth Symphony, leading from the "aspiration to happiness" to the reference to "hostile powers" and to "aspiration to happiness fulfilled in poetry," matters less than a plastic manifestation, if one may say so, of this faith in happiness that tends, playing with empty spaces and musical intervals, towards a few elementary, abstract signs: the sensuous curves, for good or evil, of women's bodies; the "embrace" of interwoven lines, as in Behrens' *Kiss*. But henceforth the embrace is egotistical and turns its back on the public. And the public, at the Secession itself, was to react sharply: there was left only the recourse to patronage and, for decorative work, exile to Brussels.

The eroticism which then powerfully developed in Klimt's painting is not to be approached solely on the level of the painter's fantasies, nor even on that of the peculiarities of the Viennese atmosphere. "My reign is not of this world," stated the motto chosen by the painter in 1902. The enthusiasm of personalities as different as Rodin, who came to Vienna in June 1902, or Hodler, who bought Klimt's "perverse" *Judith* of 1901 and adopted for his own *Truth II* of 1903 the most provocative nudes of the "hostile powers," confirms that motto. In spite of the seduction of the gold in which they are at that time clothed, Klimt's paintings stand first, like all authentic Art Nouveau, for the denunciation of hypocrisy, the search for truth, the celebration of life—through forms.

Beethoven Room at the 14th Secession Exhibition, Vienna, 1902, with Klimt's Beethoven Frieze and Josef Hoffmann's abstract relief. Photograph from *Deutsche Kunst und Dekoration*, Darmstadt, July 1902.

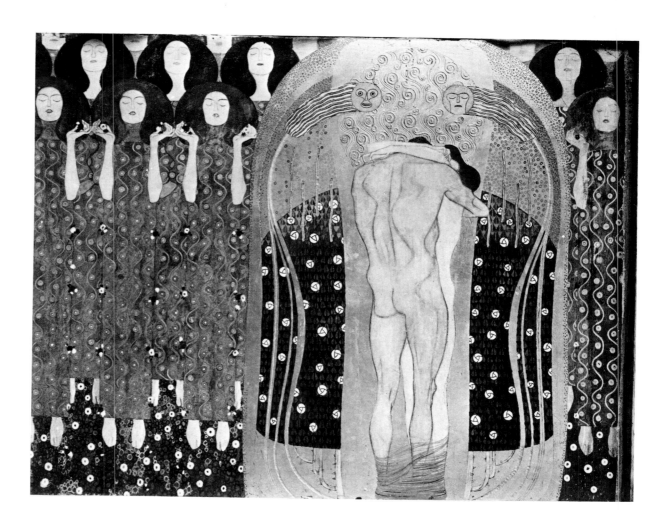

Gustav Klimt (1862-1918):
The Aspiration to Happiness Fulfilled in Poetry, part of his Beethoven Frieze at the 14th Exhibition of the Vienna Secession, 1902.

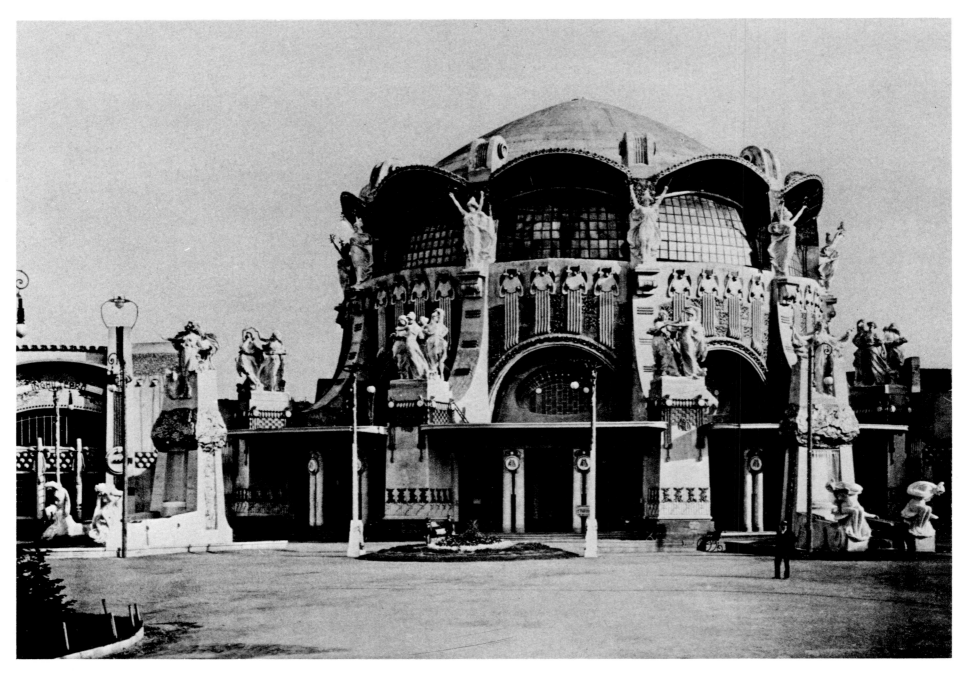

Raimondo D'Aronco (1857-1932):
Rotunda at the International Exhibition
of Modern Decorative Art, Turin, 1902.
Photograph from *Turin 1902*.

The Turin Exhibition
and the Breakup of the
International Movement

ELD in Turin from April to November 1902, the First International Exhibition of Modern Decorative Art brought together for the last time the different avant-garde movements of Art Nouveau. It even marked their triumph, since, contrary to their position in Paris in 1900, they were now largely in the majority. This success, however, could not conceal the contradictions and deep oppositions between the main tendencies, which were then taking entirely different directions. Spectacular in its way, as had been the Paris World's Fair, the Turin exhibition was first and foremost a brilliant fireworks display that actually heralded the irremediable breakup of the international movement.

The very conditions in which it was organized were significant. Since the mid-1890s Italy had been responsive to the spread of new forms from abroad: it was for this reason that Italian Art Nouveau, instead of calling itself Stile Moderno, Arte Nuova, Modernismo or even Stile Floreale, finally came to be known as Stile Liberty, after the London firm of that name. By the end of the century Italy aspired to full participation in the movement. This desire corresponded quite precisely, in the north above all and in Turin particularly, to the drive towards industrialization being made by the Italian middle classes now receptive to the economy and culture of the rest of Europe, while prominent intellectuals like Alfredo Melani and Vittorio Pica made themselves the spokesmen of that "aesthetic socialism" which Art Nouveau represented in Brussels or Vienna. The "Age of Giolitti," the Minister of the Interior and then Prime Minister (1901-1914), thus coincided with the full development of Liberty Style in Italy. Middle classes, progressivism, economic expansion, the determination to modernize: it comes as no surprise to find the socio-economic and political correlative of Art Nouveau in most European countries.

The Turin exhibition stands in precisely this context. "Art applied to the sphere of industry has a very direct influence on the prosperity of the nation," wrote Melani in *Arte e Storia* in 1902; and the two periodicals founded that same year in Turin, *Arte Decorativa Moderna* and *Il Giovane Artista Moderno*, the chief supporters of Art Nouveau after *Emporium*, started in 1895 in Bergamo in the spirit of *The Studio* and edited by Vittorio Pica, were placed in charge of propagating this view. *Arte Decorativa Moderna*, rather like Koch's publications in Darmstadt, was the moving spirit behind the exhibition, which accounts for its theme, Modern Decorative Art, and main orientation. As in Germany, emphasis was laid for economic reasons on the applied arts first of all and on architecture. This is also why the poster by Leonardo Bistolfi, a sculptor of symbolist inspiration, appears here somewhat off-balance, with its emphatic pictorial character deriving from

Previati, while at the same time, like the statuettes of Raoul Larche, and Pierre Roche, its ring-dancing figures were inspired by the art of Loie Fuller.

The architecture of the Turin exhibition, on the other hand, which was its most original and strongest point, expressed quite clearly this aim of insertion in the Europe of economic progress and avant-garde art. After a competition, its design was entrusted to Raimondo D'Aronco, an architect who had been academically trained but who had made the journey to Vienna and gave clear proof of his thorough acquaintance with the work of Otto Wagner and his pupils. The exhibition buildings were erected during his absence in Constantinople, where he had been working for the Sultan since 1896, and the execution of his plans (published in 1901 in the review *Memorie di un Architetto*) considerably weighed down, with its extra load of ornament, the verve and vigour seen in the preliminary watercolour designs which he did within a few weeks. D'Aronco's admiration for the Vienna school in any case stands out unmistakably in the main entranceway, for example, which takes over the facing pavilions with wide porch roofs designed by Olbrich for the 1901 Darmstadt exhibition. And even the small pavilion of the *Gazzetta del Popolo* owed much to the Karlsplatz station: Vittorio Pica did not hesitate to speak of "the slavish imitation of Austrian models."

But D'Aronco's mastery shows fully in the main building, the Rotunda, where an unexpected inspiration appears: that of St Sophia, which lends its dome, and above all its system of lighting, from wide glass windows disposed around its base, giving it the aspect, in the architect's words, "of an immense sail bellied out by the wind and held to the earth by light rigging"—a description that holds especially true for the fine interior space. This tyro's enthusiasm, quite typical of Italian wilfulness in a rather despairing quest for its cultural identity, was also in many respects superficial. The external groups of statuary show that leaning towards eclecticism which, in the end, came to dominate D'Aronco's work.

The New Art is not an isolated event, but stems from a movement which has arisen in European society and which is working a change in all aspects of human activity. So it is that those with half-hearted political convictions... and those unable to renounce the forms of the past, find it hard to grasp the ideology and beauty of the New Art.

Alfredo Melani, "Di fronda in fronda. Arte nuova e filosofia vecchia," in Arte e Storia, No. 11, 1902.

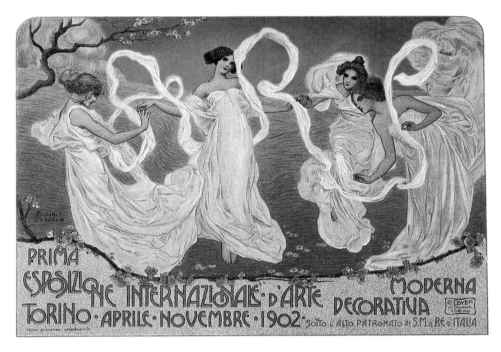

Leonardo Bistolfi (1859-1933): Poster for the Turin Exhibition, 1902.

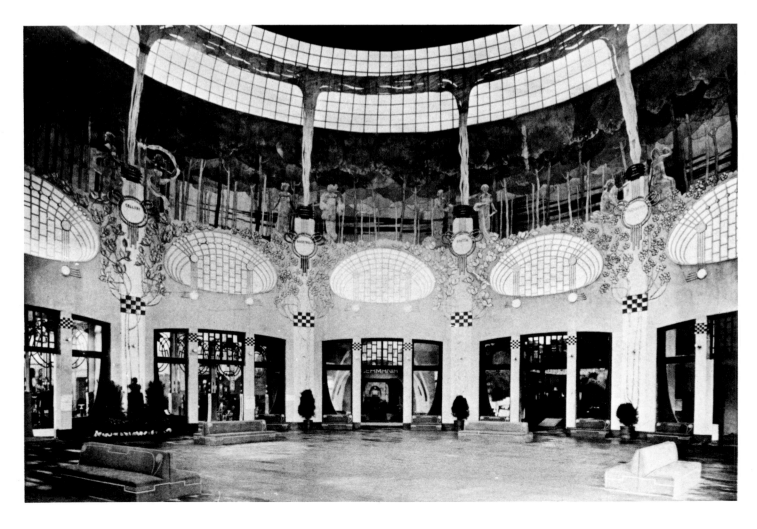

Raimondo D'Aronco (1857-1932): Interior of the Rotunda at the Turin Exhibition, 1902. Photograph from *Turin 1902*.

If the unity of its wood, canvas and stucco architecture, taken over from Darmstadt, gave the Turin exhibition a semblance of cohesion, inside the story was different.

First, a significant proportion of the exhibitors merely took over works or a style previously exhibited. Such was the case with Horta, who received a first prize but whose restful, heavy furniture was out of place in a setting for which it had not been designed; its old-fashioned forms contrasted with the works of his compatriots, especially Leon Sneyers, Adolphe Crespin and Antoine Pompe, who looked towards the Germans and Austrians. For his part, Bernhard Pankok displayed the same room as in Paris, and Bruno Paul, a Van de Veldean suite of furniture still tied to 1900: repetition and maintenance of the status quo.

But the most marked contrast, especially striking to Italian critics, was that between the organic ensembles, linked to a style of architecture, which the exhibition programme favoured, and the simple presentation of individual objects. Thus one of the major turning points of 1900 took shape: "ornamental" architecture against decor; space against object.

With Gallé, Majorelle, Lalique, and even Charpentier and the "rationalists" Plumet, Selmersheim and Sauvage, as with Bing's Art Nouveau rooms and Meier-Graefe's Modern House furnishings, the French too continued to look back to 1900 and ranged themselves in the second category: lined up along the walls of those vast rooms, far indeed from the intimacy of the 1900 World's Fair pavilions in Paris, their production seemed incongruous, as little integrated as could be. The same was true of the English, Voysey, Townsend, Crane, Day and Ashbee, typical representatives of the Arts and Crafts movement which had inspired the Italians in the later 1890s (at the Aemilia Ars in Bologna, for example) before the Italians discovered the German and Austrian

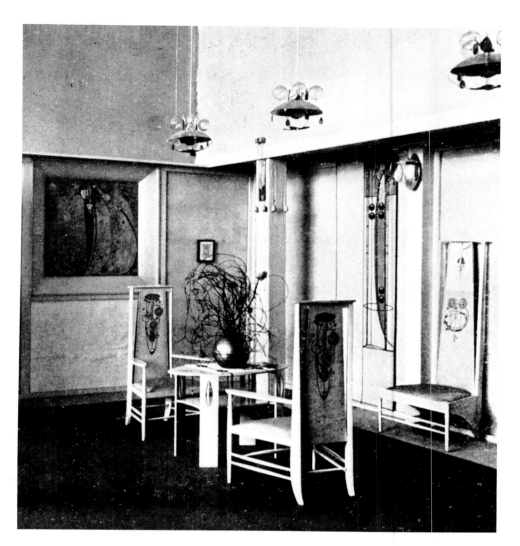

Charles Rennie Mackintosh (1868-1928) and
Margaret Macdonald Mackintosh (1865-1933):
The Rose Boudoir at the Turin Exhibition, 1902.
Photograph from *Deutsche Kunst und Dekoration*,
Darmstadt, 1902.

Bruno Paul (1874-1954):
Dining room shown at the Turin Exhibition, 1902.
Photograph from *Deutsche Kunst und Dekoration*,
Darmstadt, October 1902.

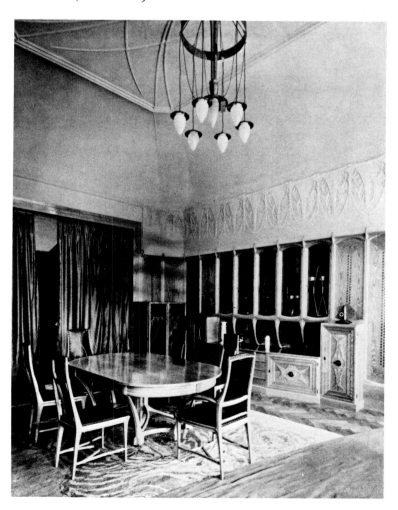

applied arts and design. Vittorio Pica now criticized the English for the museum-style presentation of their bindings, illustrations, wallpapers, textiles and silverware, which left the overall setting out of account.

At the opposite extreme, there was enthusiasm once again for the Scots, whose Rose Boudoir however had difficulty in adapting to an overlarge room, which Mackintosh had to remodel. The French and English, on the contrary, reacted with hostility. It was now that Walter Crane went on a rampage against Art Nouveau in the *Magazine of Art*, while *Art et Décoration* in Paris considered, through a characteristic misinterpretation, that the Glasgow style as it appeared in Turin "does not seem to be in harmony with our artistic aspirations and our everyday needs," and went on to wonder "what delirious Des Esseintes could live in this kind of interior decoration." (Des Esseintes, the hero of Huysmans' novel *A Rebours*, had become the type of the hyper-aesthete.)

Confronted by these deep discords, Germany, still more than Austria, which presented a villa by Ludwig Baumann, held aloof and exhibited apart in the galleries of an independent stone building, with displays by individual German states. Representing Hesse, ever anxious to promote its industry (the Grand Duke had come to Turin for the inauguration), Olbrich presented three rooms in the Darmstadt spirit, with furniture by the firm of Glückert. There were fine rooms and furnishings by Bernhard Pankok, Bruno Paul, and Bruno Möhring representing Prussia. Even finer, for their unity of design, were those of Behrens, now at the peak of his powers, asserting himself at international level.

Next to an austere study displaying the publications of Alexander Koch, and the solemn living-room by Ludwig Alter, another

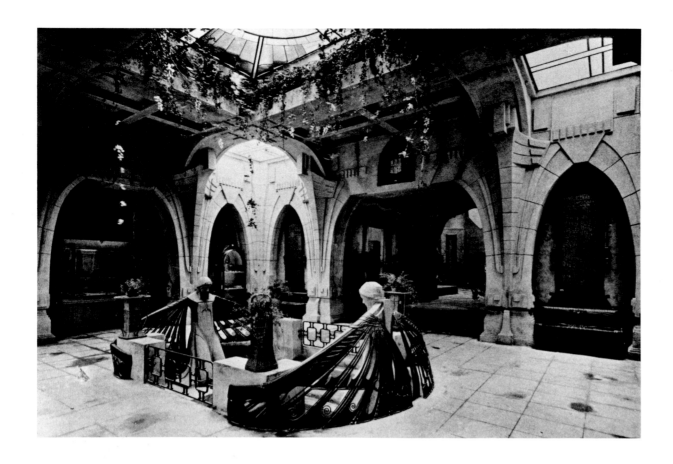

furniture maker from Darmstadt, the astonishing Hamburg Entrance Hall *(Hamburger Vorhalle)* was probably the newest and strongest achievement of the show. Its massive arches, its coloured overhead lighting (yellow for the central lamp, blue for the corner windows), its odd central pool with its cement statues spreading their wings down to the floor (and whose parabolic curve echoing that of the arches is again found in the sheath of a lamp designed at that time for the Grand Duke), its bronze panels and the presence in a glass cabinet of the copy of Nietzsche's *Zarathustra* bound by Behrens: all went to make of this fantastic, powerfully organized cavern, raised to the glory of the Hamburg shipyard industries, the manifesto of a will to power still subterranean and undeveloped but which, like the accumulated lava of a volcano, was only waiting its chance to overrun the world.

For the Italians, the exhibition was not the commercial success they had hoped for. The low-cost furniture displayed with a view to industrial production, by Famiglia Artistica of Milan, failed to arouse any enthusiasm. In this field it was the individual creations and the single-unit expensive pieces which rose to the level of the best European production: the furniture of Eugenio Quarti, for example (already given an award in Paris in 1900), with its refined variation on English and Austrian models, or, to a lesser degree, of Ernesto Basile for the Golia-Ducrot company of Palermo. A failure, then, of the dual objective announced at the inauguration by the Minister Nasi, to "distribute the profits of aesthetic education and create new job opportunities." In the short term, the historicist and nationalist reaction was strengthened: international modernism had nothing to give to Italy, where "by trying to be modern we had only succeeded in making ourselves exotic," as D. Angeli wrote in *Nuova Antologia* in 1902.

From the aesthetic standpoint alone, on the other hand, Turin set in motion many isolated experiments that from the north to the south of Italy would produce achievements of unequal quality in the quest for a national modern art which in fact wavered between the different European schools. The exhibition thus gave the signal for a greater dissemination and often for a popularization of the international movement.

The stained-glass windows of Tiffany, whose lamps were one of the great commercial successes of the workshops he founded in 1900 (the Tiffany Studios, which remained in business until 1936) and won him an award in Turin, found an echo throughout Europe; for example, in that admirable group, too little known and today unique, the windows of Fribourg Cathedral in Switzerland. These were made over several decades by Józef Mehoffer, a Pole who joined the Vienna Secession, where he exhibited some of his windows at the Eighth Exhibition in 1900, in a setting designed by Josef Hoffmann (*Ver Sacrum* devoted its twenty-fourth number to Mehoffer in 1902). In Eastern Europe another Polish artist, Stanislaw Wyspianski, did stained-glass windows for the Franciscan Church in Cracow (1897-1902); and his fine self-portrait (1902) shows well enough, in its decorative background, how close he was to the spirit of Art Nouveau. In the North, the Dane Jens Ferdinand Willumsen, a former Pont-Aven painter and friend of Gauguin, did his best paintings in 1902-1904: free now of symbolist allusions, and owing something to Munch, Hodler and Segantini, they employ a decorative interweaving of arabesques to express the artist's pantheistic faith. Finally, in the South, the young Picasso published his early drawings in *Joventut*, the equivalent of *Jugend* in Barcelona between 1900 and 1903, and in 1901 he founded in Madrid the short-lived magazine *Arte Joven*; he showed his virtuosity by combining for a brief period in 1901 borrowings from Whistler, Beardsley and Toulouse-Lautrec. Art Nouveau had become an unavoidable checkpoint, but for the young artists it was no more than that.

Józef Mehoffer (1869-1946):
Stained-glass window in Fribourg Cathedral, Switzerland, 1895-1936.

Jens Ferdinand Willumsen (1863-1958):
Mountain Under the Sun, 1902. Oil.

Wassily Kandinsky (1866-1944):
Night, 1907. Tempera.

Night

After 1902 there opened what is probably the least familiar period of Art Nouveau, and yet it is one of absorbing interest. Much had been expressed, the essentials perhaps, and the multiplication now of second rate works explains why most historians prefer to bring down the curtain and turn off the lights after the Turin Exhibition, or even after the Paris World's Fair. But there are no good grounds for stopping at this point. It was not yet the death agony of Art Nouveau, far from it. Van de Velde, Behrens, Hoffmann, even Guimard, evolved now in ways of their own, but there is no sign of any conscious repudiation of the recent past. And with some others, even some of the major creators, this last pre-war decade brought a deepening and enrichment of their style, a new concentration of its best features. Such was the case with Mackintosh and Gaudí, with Klimt and Hodler, all at the top of their form in the years 1902-1910. In France, too, there occurred a fresh flowering, with the appearance of a new avant-garde of painters, followed by a further extension of international architecture; for some, it was more than a flowering, it was a transfiguration, and their work is worth looking at for its own sake, and not merely as an aftermath.

While many were content to copy and popularize existing forms without going back to first principles, the masters were not: they were able to achieve a new and powerful synthesis. And among the younger artists, or those elders who had joined the avant-garde, the new forms offered a stimulating challenge, resulting in some curious transformations. After the autumn splendours, were the mysteries of night beginning to fall over Art Nouveau? Perhaps, if one re-examines the still enigmatic influences apparently exerted by Jugendstil, and also by Nabi painting, on the genesis of abstract art, or on picture design in general, independently of the abstract forms of the Elvira Studio, the Buntes Theater, the work of Obrist. With Kandinsky, in his woodcuts up to about 1913, the relation is reversed. There is no end to the sources on which he drew: Russian folklore, medieval German art, 1900 fashions, not to mention Gauguin, Munch, Beardsley, Vallotton. But the resulting work leaves these sources far behind. In Kandinsky's famous tempera painting *Night* (1907), even more than in Augusto Giacometti's *Night* (1903), the treatment is two-dimensional, and the counterpoint between figure and ground is so tensed as to dissolve the figures into the setting; the sorceress on the right, in particular, in her Klimtian costume. The patterning of stars in the dark sky, also on the ground and in the heroine's dress, contributes, together with the colour scheme, to cancel out the positive/negative contrast: one forgets the fantasticality of the scene and feels only the surface tensions. The problem from that point was to retain this *ornamental* quality without lapsing into the *decorative*; and without doing Klimt, Hodler or Segantini over again—for it was to those artists that Kandinsky had obviously looked. The "night" into which Art Nouveau was moving was rich in these sparkling constellations; but they passed and were followed by some surprising daybreaks.

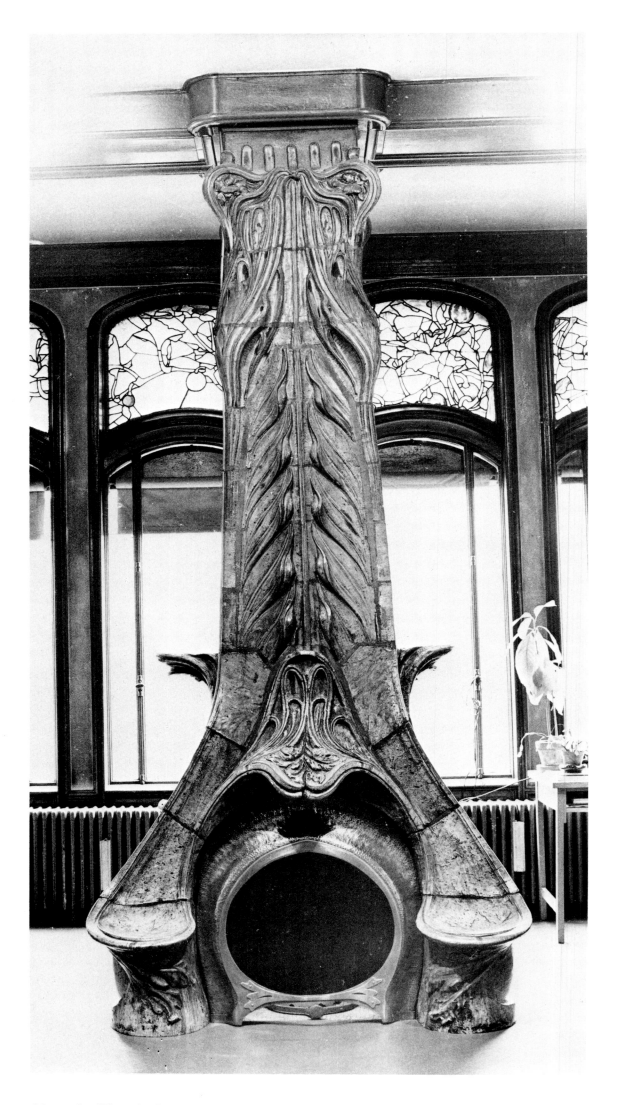

Alexandre Bigot (1862-1927):
Ceramic fireplace of the Villa Majorelle, Nancy, 1901-1902.

THE END OF AN ERA?
1902-1914

The Late-Comers

AMONG the late-comers to the movement, the School of Nancy is undoubtedly the most typical example in France, in its isolation, relative unity and long continued practice of certain forms of Art Nouveau.

Contrary to what might be thought, the presence at Nancy of Gallé and his large body of earlier work only gave rise to the official creation of a real movement in 1901 with the foundation, following the Paris World's Fair and for obvious commercial reasons, of the "School of Nancy, Provincial Alliance of Art Industries," which even then only held its first exhibition in Gallé's own villa in 1904. This late emergence as a group is partly explained by the nature of Gallé's productions. Marked by his strong personality and based on a few simple aesthetic principles, Gallé's glass and furniture are the expression of a highly individual handicraft art not implying any theoretical extension, any overall conception of space or any architectural organization. In the early 1900s Gallé's position as artist-decorator did not change. "We are painters and ornamentalists, the one and the other serving the same cult. We are worshippers of the natural beauty shed so freely over the world," he told his colleagues in Lorraine in 1901. In 1903 again, commenting on the Prix de Rome, whose value he questioned, he called for "the admiring, humble study of the beauty dispersed throughout the world..., the contemplation and rendering of coloured spaces and blades of grass, the knowledge and sympathetic expression of joy and pain"—an attitude very different from that of Van de Velde, Behrens or Mackintosh.

What changed things in Nancy was the building of the Villa Majorelle by Henri Sauvage (1901-1902), with furniture by Majorelle himself, decorations by Victor Prouvé and glass paintings by Jacques Grüber. It was completed with the ceramic fireplace by Alexandre Bigot, a fine example of the eclectic design which now attracted the attention of Van de Velde and Sauvage to Bigot, a ceramist who had previously worked with Guimard and Lavirotte. Hitherto a movement of painters and botanist decorators, it was only now that the Nancy artists realized the major importance of architecture. Nevertheless, in the development of the talented works that were to follow and make Nancy the first Art Nouveau group of France, Emile André and Lucien Weissenburger, its chief leaders, were not really going to call in question the approach of their friend Gallé.

A year before his death, when he presented in Paris, in March 1903, the Exhibition of the Decorative Arts of Lorraine, Gallé set forth what was in some sort the manifesto of the budding School of Nancy: "Unity of art in all branches of decoration, rational, sound, stable construction taking account of the qualities of each

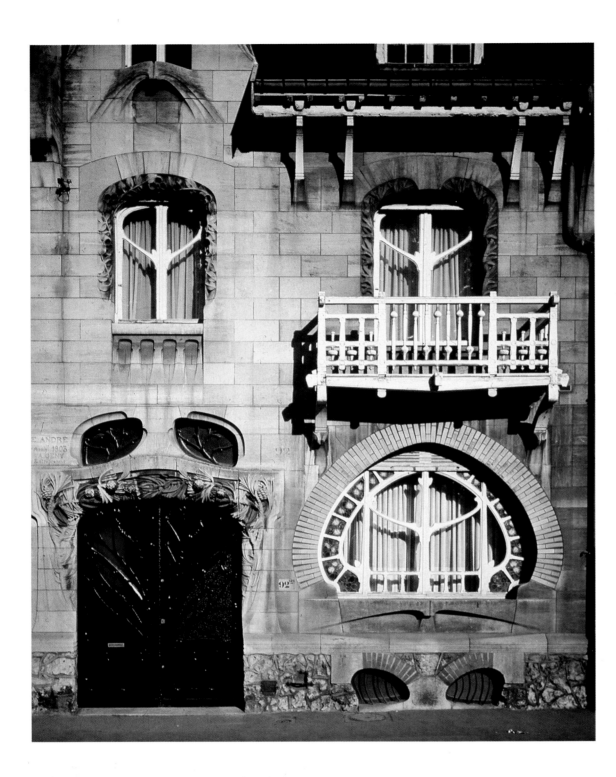

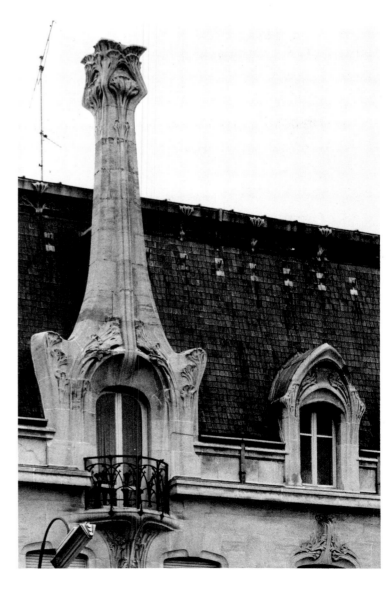

◁ **Emile André** (1871-1933):
House at 92bis Quai Claude-le-Lorrain, Nancy, 1903.
Main entrance and window with horseshoe arch.

▽ **Lucien Weissenburger** (1860-1924):
House at 1 Boulevard Charles-V, Nancy,
1904. Dormer windows..

of the materials used and having a clear and well-defined purpose."
Finally he called for "personal ornamentation" based on "scientif-
ic observation of living models."

This "naturalistic contemporary style, drawing its inspiration
from natural forms of art in order to use them to decorate build-
ings designed in keeping with their purpose and common sense"
(to quote Gallé again) reappeared in the best known work of Emile
André, the house in Nancy on Quai Claude-le-Lorrain (1903) with
its richly contrasted materials and the plant-life "signature" of pine
branches framing the main entrance. This picturesque com-
position, so deliberately asymmetrical, was much more striking for
its façade design than as the expression of an internal domestic
structure like that of the Majorelle Villa (or the internal structure
of the villas designed by André in Saurupt Park from 1901 on-
wards, which were stylistically less striking). The prominence of
the outsize gables and tall chimneys which held the composition
together and the pointed arch which appeared again in the dormer
window gables and finials of Weissenburger's buildings, high-
lighted the national, even Gallican, nature of this attempt—in
accordance with the wishes of Gallé—to revive the tradition of
"our fine fifteenth century French School," disregarding the Ital-

ianizing interlude that had succeeded it. Naturalism, insistent provincial patriotism, persistence of the floral style, a primarily decorative conception of architecture, rejection of modern materials (although Weissenburger had made brilliant use of them in 1900, in Nancy itself, in the Royer Printing Plant), handicraft finishing especially for the sculptured parts—in this deliberate reaction the Nancy movement turned its back on Darmstadt, Vienna, Brussels and Glasgow, where on the contrary the local components were assimilated and superseded.

Eugène Vallin, a handicraft joiner praised by Gallé in 1897 for his "honest and sincere" work recalling that of the "French woodworkers of the twelfth, thirteenth and fourteenth centuries," provided an equally typical example by moving on from cabinet-making to architecture simply by enlarging the size of his works. In his curious furniture of the years 1903-1906, culminating in the big dining-room now in the Museum of the School of Nancy, it would be a mistake to see a French equivalent of German rooms. Here the ensemble is "complete" but not "total"; the crowded space is produced by plant-like growth, an invasion of individually designed and independent forms, a "burgeoning" symbolized and summarized in the beautiful ceiling lamp, or the curious desk on a double tripod generated from a tangle of roots. This room is precisely the contrary of the Olbrich or Mackintosh room spaces, first divided up and "deducted" so as to set off the empty areas.

The School of Nancy has perhaps been appreciated beyond its true value, particularly in France, through ignorance of foreign movements, but it none the less produced some fine handicraft works. Louis Majorelle who made the wooden banister in his own house, in a style akin to that of Hoentschel, was at his best when, in 1903, he did the metalwork for the Weissenburger House (Rue Lionnois, Nancy) and revived—in a style remote from Horta, Guimard or Gaudí—the Nancy wrought-iron tradition represented in the eighteenth century by Jean Lamour. This typically French decorative art was to reach its height in 1910-1912 with Majorelle's staircase (destroyed in 1974) in the Galeries Lafayette department store in Paris.

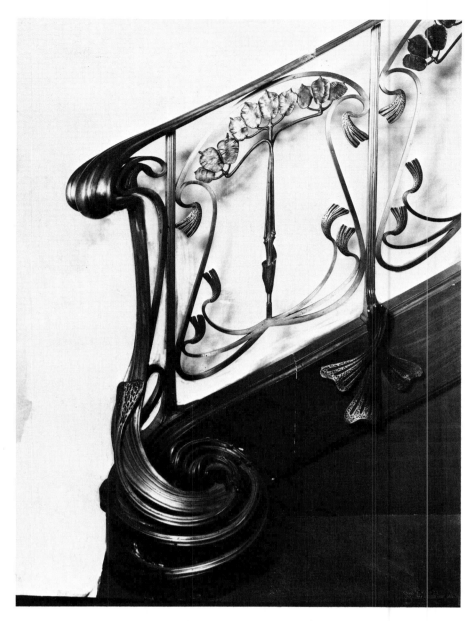

Louis Majorelle (1859-1926):
Wrought iron staircase railing, 1903,
for the Weissenburger House, Rue Lionnois, Nancy.

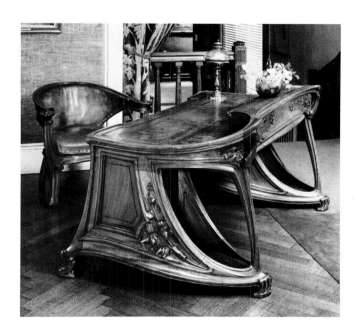

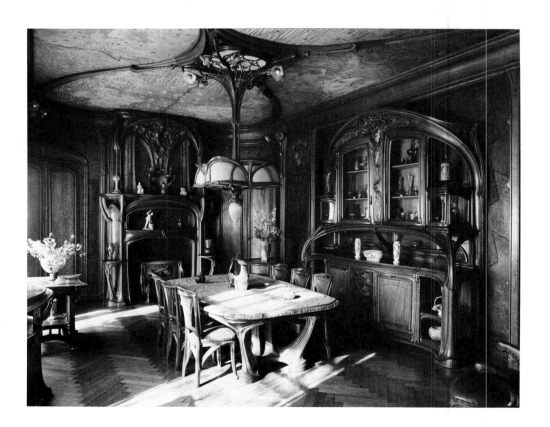

Eugène Vallin (1856-1922):
Desk, 1899.
Dining room, 1903-1906.

After 1900, apart from Guimard, French Art Nouveau continued on these lines, keeping (as Manuel Orazi's poster for the Maison Moderne put it about 1905) to "twentieth century house furnishings and adornment," instead of seeking fulfilment in architecture, and so renouncing the social aims implicit in its origins. Charles Meunier's fine bindings in the style of Grasset and the Paris success of the eggshell porcelain from the Dutch Rozenburg factory (1894-1916), a revelation of the 1900 World's Fair, were significant examples of this trend. The beautiful abstract brooch in translucent enamel, Bracquemond's gift to his wife Marie in 1904, with its concise, dynamic, almost Van de Veldean patterns, shows that in this area, too, there are still discoveries to be made.

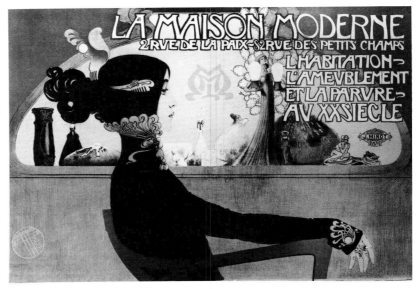

△ **Manuel Orazi** (1860-1934):
Poster of about 1905 for Julius Meier-Graefe's interior decoration shop La Maison Moderne, Paris.

◁ **Félix Bracquemond** (1833-1914):
Translucent cloisonné enamel brooch with the monogram of Marie Bracquemond, 1904.

▽ **Charles Meunier** (1866-1940):
Binding of 1910 for Robert de Flers,
Ilsée, princesse de Tripoli, Paris, 1897.

J. Jurriaan Kok (1861-1919):
Peacock and bird of paradise vase,
1904. Eggshell porcelain,
Rozenburg Factory, The Hague.

floors letting light traverse the entire building and the spirited polychromy of the enamelled lava panels, it was the final, belated triumph of nineteenth century space layout, materials and technology. But the ornamentation was more hesitant. It no longer had the aptness and restraint of Horta's Innovation department store in Brussels or Sullivan's Carson, Pirie and Scott in Chicago (then just completed, and from which the three-part windows were perhaps borrowed). Subordinated to the structure, the ornament of the Samaritaine, as of the Grand Palais, indulges freely in volutes and classical consoles, while the corner domes—a jarring note so close to the Louvre—soar up with a provocative lyricism typical of their designer. In 1926, Frantz Jourdain himself, assisted by Henri Sauvage, was to rebuild the Seine front of the Samaritaine, ridding it of what was then felt to be useless ornament.

Paul Cauchie (1875-1952):
Cauchie House, Brussels, 1905.

Frantz Jourdain (1847-1935):
The Samaritaine department store, Paris, 1905-1907. Detail of a corner dome.

The architectural ambitions of Art Nouveau were nevertheless upheld, in France and Belgium, in some isolated achievements based once again on the pre-1900 principles. In Brussels the house of Paul Cauchie, for example, elaborating on the schema of the Hankarian graffito and showing a sensitive response to the Scottish movement in the lower part and the balcony design, was another expression of façade architecture, designed by a man described in a 1904 biography as an "artist-decorator," not an architect. In Paris the Samaritaine by Frantz Jourdain (1905), almost contemporary with the Grand Bazar in the Rue de Rennes by Henri Gutton of Nancy (1906), was the last example of the big metal and glass structures embodying the principles of Viollet-le-Duc. Functional throughout, the Samaritaine was the first building in Paris which had a fully apparent fabric; with its glass slab

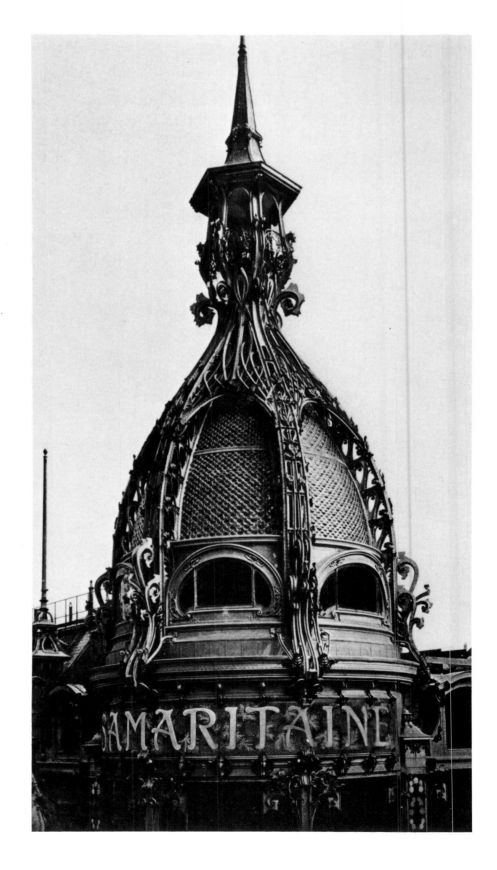

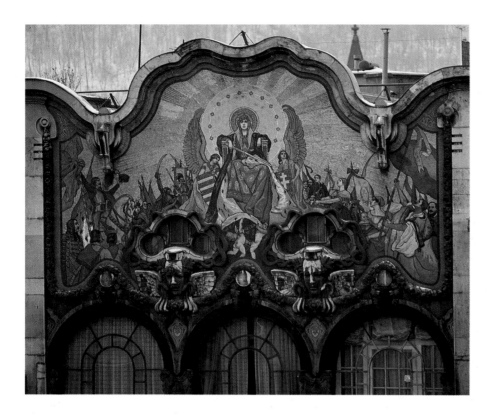

Armin Hegedüs (1869-1945):
The Török Bank, Budapest, 1906.
Detail of the front with mosaic
by Henrik Böhm.

Giovanni Michelazzi (1879-1920):
Villino Giulio Lampredi, Florence, c. 1910.
Detail of the front.

Outside France (and Germany too), although Art Nouveau enjoyed a certain vogue, its impact now was nowhere near as marked, except in the work of a few independent and solitary masters. As at Nancy, the nationalist element exercised a moderating influence and led to the adoption of hybrid solutions. This was particularly true in outlying countries: in Finland with Eliel Saarinen, whose medievalizing Finnish pavilion had made such an impression at the Paris World's Fair of 1900; in Russia with the Talashkino workshops and the Ryabushinsky mansion in Moskow by Shekhtel (1905); and in the Austro-Hungarian Empire with Otto Wagner's many pupils, such as Jan Kotera in Czechoslovakia (Prostejov Town Hall, 1905-1907) and, more original, two Budapest architects, Ödön Lechner (Savings Bank, 1902), and Armin Hegedüs, who is less well known, but whose big pediment for the Török Bank (1906), crowning a modernist façade with metal frame windows, brought Art Nouveau into the heart of Budapest, not without recalling the excesses of Gaudí.

In Spain, indeed, Gaudí had long since eclipsed the vitality of Catalan Modernismo, eager to join the European avant-garde but constantly menaced in its rationalist and modernist motivation by the decorative and symbolic exuberance of a too rich national past. Typical in this respect were the fanciful furniture of Clapés Puig and the extraordinary Palace of Catalan Music by Doménech i Montaner (1905-1908) in which the structure (the steel beams of

the concert hall ceiling, for example) and the logical use of material stemming directly from Viollet-le-Duc could be clearly seen through the superabundant decoration.

The same difficult dialogue between the national tradition and the desire to attain, through Art Nouveau, the economic and cultural level of the rest of Europe, appeared for example in the work of Raimondo D'Aronco at the Turin Exhibition (with, it so happened, the same detour via the Byzantine tradition). In Italy the outcome was a proliferation of uneven and heterogeneous works, such as the house of Pietro Fenoglio at Turin (1902), a rare adaptation of Horta's and Guimard's abstract ornamentation; the Galimberti House in Milan (1902-1905) by Giovan Battista Bossi with its contrasting eclecticism and the heavy 1900 figures of its earthenware tiles; the picturesque Villino Ruggeri by Giuseppe Brega at Pesaro (1902-1907), typical of seaside Liberty style, with a complete break between the traditional interior and the façade featuring, not without humour, seaweed and lobsters supporting the eaves and fanciful ornamental shapes reminiscent of the Elvira Photo Studio in Munich. There were very few genuine architects, like Giovanni Michelazzi in Florence, whose designs, often resembling those of the Belgians, gave first of all pondered consideration to the overall plan (as evidenced, for example, in the Villino Broggi-Caraceni of 1911), with an economical layout starting from the staircase round a central well.

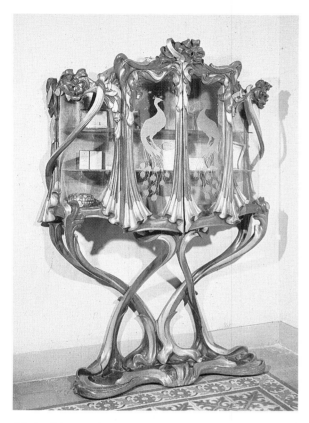

Alejo Clapés Puig (1850-1920):
Showcase, c. 1900.

Giovanni Michelazzi (1879-1920):
Villino Broggi-Caraceni, Florence, 1911.

Lluís Doménech i Montaner
(1850-1923):
Concert hall of the
Palace of Catalan Music,
Barcelona, 1905-1908.

Augusto Giacometti (1877-1947):
Night, 1903. Tempera.

Hermann Obrist (1863-1927):
Fountain for Krupp von Bohlen, Essen, 1913.

Léon Spilliaert (1881-1946):
Woman by the Water, 1910.
Watercolour, gouache, ink.

Björn Ahlgrensson
(1872-1918):
Glowing Embers at Dusk, 1903.
Tempera.

The list of names could be continued but would be to little purpose. It would show, with frequent lapses into mediocrity or monstrosity, that the vogue for Art Nouveau lasted long after the Turin Exhibition of 1902. Over and above geographical distinctions, the real cleavage now was between those who, like Picasso, temporarily turned to account the modernism of Art Nouveau, and those who merely imitated or popularized it. On one side were men like Kandinsky, who from his belated attachment to the Nabi aesthetic drew new resources of surface design; or Augusto Giacometti, who found in it a transition to abstract art; or Ernst Barlach, a contributor to *Jugend* from 1897 to 1902, who developed Jugendstil into a powerful expressionism already heralded in 1902 in the hall designed by Behrens in Turin (to which Barlach contributed a bas-relief); or Hermann Obrist, who opened the way to abstract sculpture. On the other side, how many respectable artists, from the north to the south of Europe, who remained in the shadow of the masters, borrowing from them their imagery and superficial decorative methods. Masters like Hodler, Munch, the Nabis or Rodin, now widely exhibited, inspired countless variations in which the charm of inventiveness masked the failure to come to grips with essential pictorial problems.

An intriguing example is that of the Belgian artist Léon Spilliaert, whose obsessive metaphors and personal myths fed on the line tracery of Art Nouveau. This was a betrayal of Art Nouveau's vocation as a clarifying and organizing agent over and above individual psychic idiosyncrasies; a betrayal, too, of its social objectives, its purposeful reform not only of design but of the whole setting of modern life. Into such oddities and minor works Art Nouveau gradually lapsed, dying out like the smoke from the candle drawn by Marcus Behmer (an Insel Verlag illustrator more than once confused with Beardsley) for a de luxe edition of Oscar Wilde's *Salome* (1903).

Marcus Behmer (1879-1958):
Illustration for Oscar Wilde's *Salome*, 1903.

Edward Steichen (1879-1973):
Rodin with his *Thinker* and statue of Victor Hugo, 1902. Photographic montage.

The Solitude
of the
Masters

HE solitude of the masters is admirably conveyed by Edward Steichen's photograph of 1902, showing Rodin in his studio, in rugged profile, silently communing with his *Thinker* and his statue of Victor Hugo. This wonderful image, with its *sfumato* reminiscent of Carrière, its well-knit composition, its rational working out of black and white tonal values, also goes to remind us that there existed an Art Nouveau photography whose most brilliant representative was Steichen. (It was also well represented by the Camera Club of Vienna.) Rodin had exhibited his work privately in 1900, outside the Paris World's Fair, as Courbet had done in 1855 and Manet in 1867: he held aloof from the Paris "art carnival." Aloof, too, from the fashion for Art Nouveau, which was now on the wane, Rodin was one of those who, until their death, kept single and intact what they had invented. Like Gaudí, he had followed a solitary path (with such eminent assistants, however, as Berenguer and Jujol) and found himself now in full accord with the movement which he, like Gaudí, had preceded, only to be rejoined by it. From the ironwork of the Güell Palace to the Güell Park, in Barcelona, both done for his patron Eusebio Güell between 1900 and 1914, Gaudí's work moved forward without a stop; witness the immense worksite of the Sagrada Familia church, which he took over in 1883, and still unfinished at his death in 1926. But it was only after 1900 that Gaudí found a totally original form, above and beyond the nationalist bias by which Doménech i Montaner and Puig i Cadafalch were still hampered.

Gaudí started from the study of Gothic, in the rational, analytical spirit of Viollet-le-Duc, and from his early acquired mastery of the right use of materials (iron in particular): two of the major components of Art Nouveau. But what he lacked up to the turn of the century was the invention of new form, that lack being compensated by an unequalled virtuosity in the handling of a form-repertory which remained eclectic even when it kept free of the academic tradition. The Casa Calvet (1898), which won a house-front award in 1901, marks the culmination of his early work—its modernism tempered by neo-Gothic. One need only compare it with the front of the Casa Batlló (1904-1906) to see the forward step Gaudí had accomplished, and accomplished thanks in part to the better knowledge he had gained of international Art Nouveau.

And yet the Casa Batlló, commissioned by a rich tradesman (shop downstairs, apartment above), was only a job of remodelling, permission to demolish the old building having been refused (the rectangular upper-floor windows betray this fact). Here one cannot help thinking of Van de Velde who shortly before had remodelled the Folkwang Museum at Hagen, for it was in this

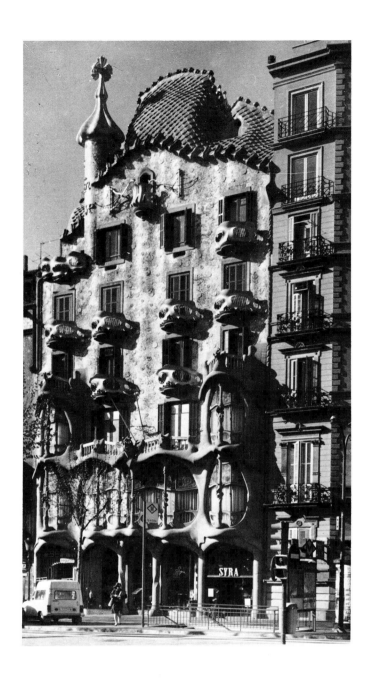

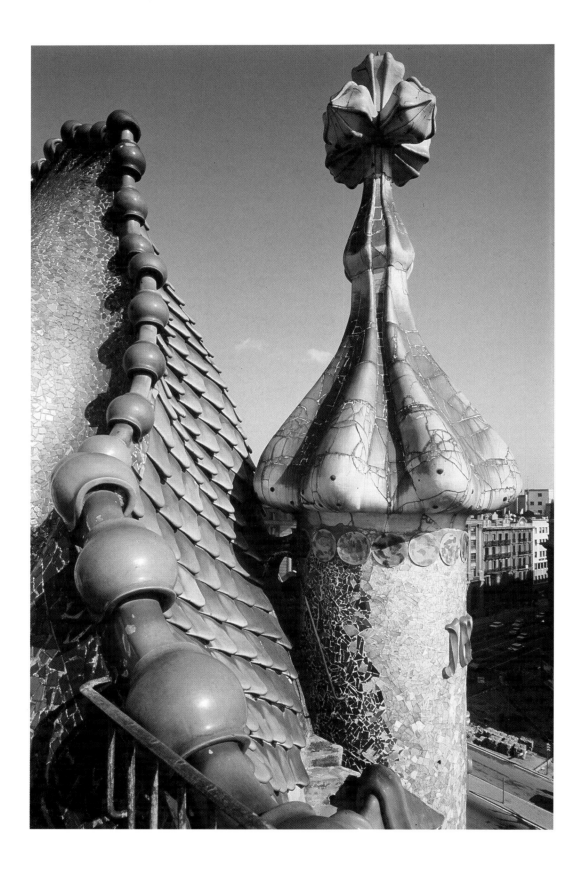

Antoni Gaudí (1852-1926):
Casa Batlló, Barcelona, 1904-1906.
View of the front.
Roof and turret.

work of refacing and replanning an existing structure that Gaudí showed his power of architectural design. He proceeded on the lines of Viollet-le-Duc, by imposing an organic unity not there before, and there is nothing in the result, even to the very "bone framing" of the lower floors, that one may not interpret as a literal application of Viollet-le-Duc's famous formula in the fifteenth *Entretien*: "Decoration adheres to the building not like a garment, but the way skin and muscles adhere to man."

He handled unusual materials with zest and colour (glazed tiles and other ceramic elements, for example), and other Catalan Modernismo designers vied with him here. But Gaudí was alone in now abandoning any stylistic reference and moving on to global form. And in a classic symmetrical layout the wavy room-walls and the moulded ceiling were so peculiarly his own that it was unthinkable to fill these rooms with any other furniture but that designed by Gaudí himself. For this reason, too, the emblematic imagery is

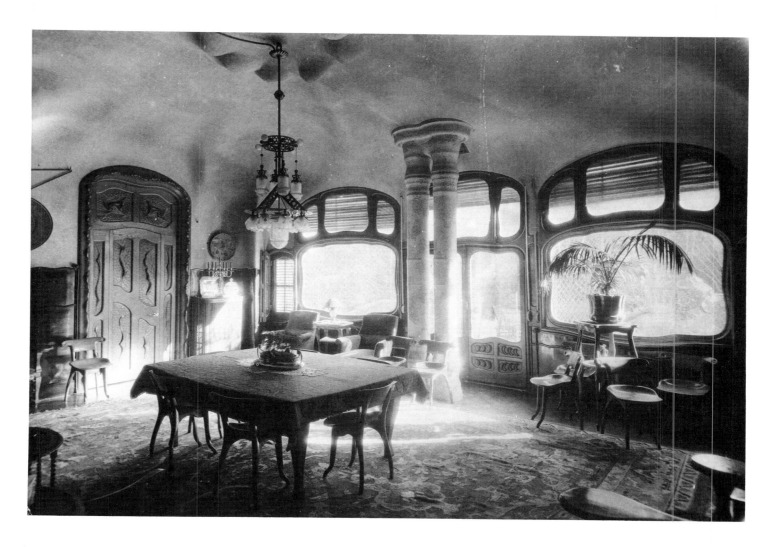

Antoni Gaudí (1852-1926):
Casa Batlló, Barcelona, 1904-1906.
Dining room on the main floor.
Gallery on the main floor.

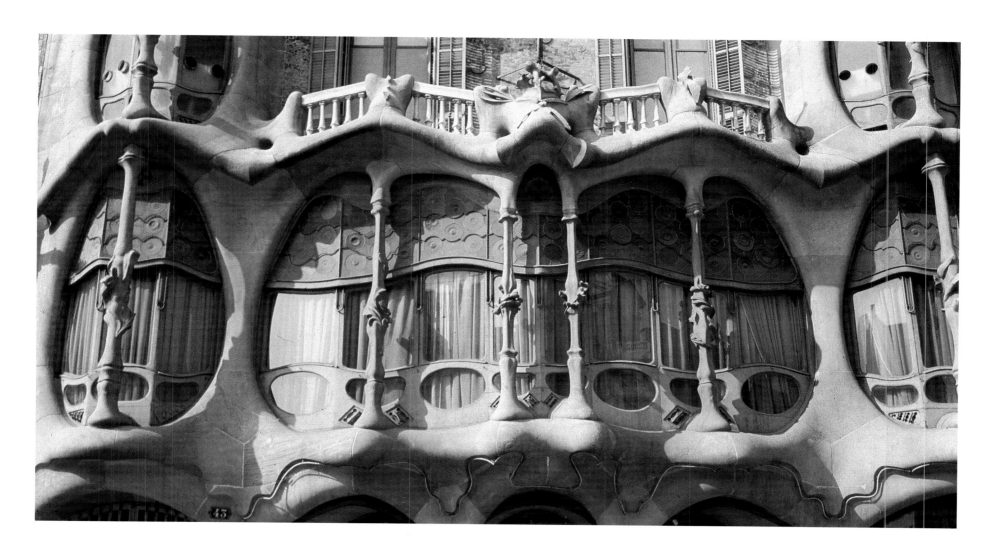

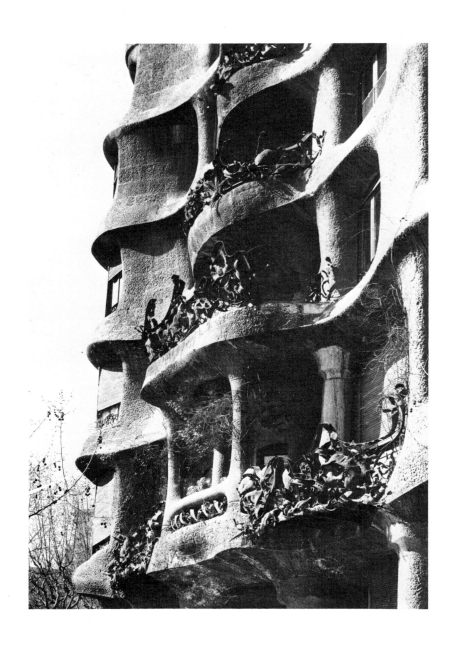

transcended by the form. The roof added as part of the housefront brought to mind a dragon, an armadillo, a cockscomb. But even more than the wave shape on the façade of the Elvira Studio, Gaudí's roof was first of all the plastic element permitting him to close off the elevation, and to ensure its connection with the neighbouring buildings.

With him, then, the invention of new form was guided and shaped by the rational use of the means at his disposal (as in the blue earthenware tiles of the interior lightwells, whose windows widen out at the bottom). Take the superb roof of the Güell Park entrance pavilion: it is not by chance that these continuous and coherent volumes, both in the glitter of their ceramic and glass mosaic and in the firm line of their arabesques, again apply the organizing principles used by Seurat.

The Casa Milá (1906-1910), Gaudí's last secular building, is like a pendant of his masterly achievement in the Güell Park. Their kinship is obvious, and the hollowed-out volumes of the Casa Milá, permissible now in a new construction, introduce only a secondary distinction. The form is more organic than ever, with its front of hammered stone, which has been likened to sea-waves, the balconies suggesting seaweed. (The house itself is known locally as the Pedrera, the quarry.) The interior pillars permitted the adoption of a completely free ground-plan, organized around two central courtyards.

Like Mackintosh, Gaudí set little store by Art Nouveau and paid little attention to it. But no other term so aptly describes his two major achievements, the Casa Milá and the Güell Park, which show him at the height of his powers. As with Van de Velde or

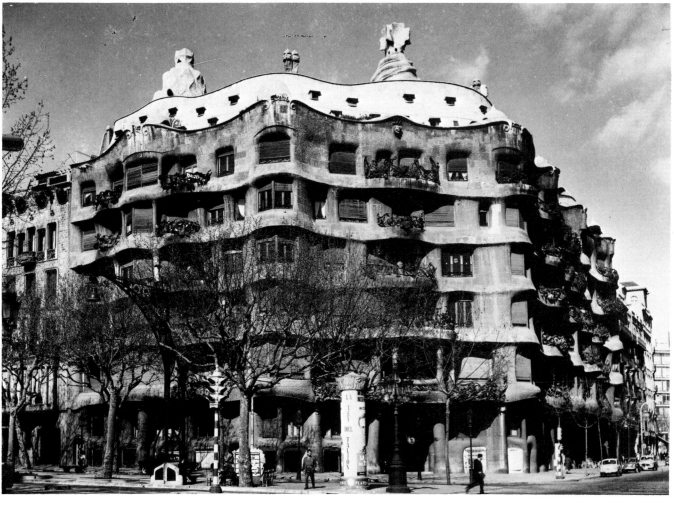

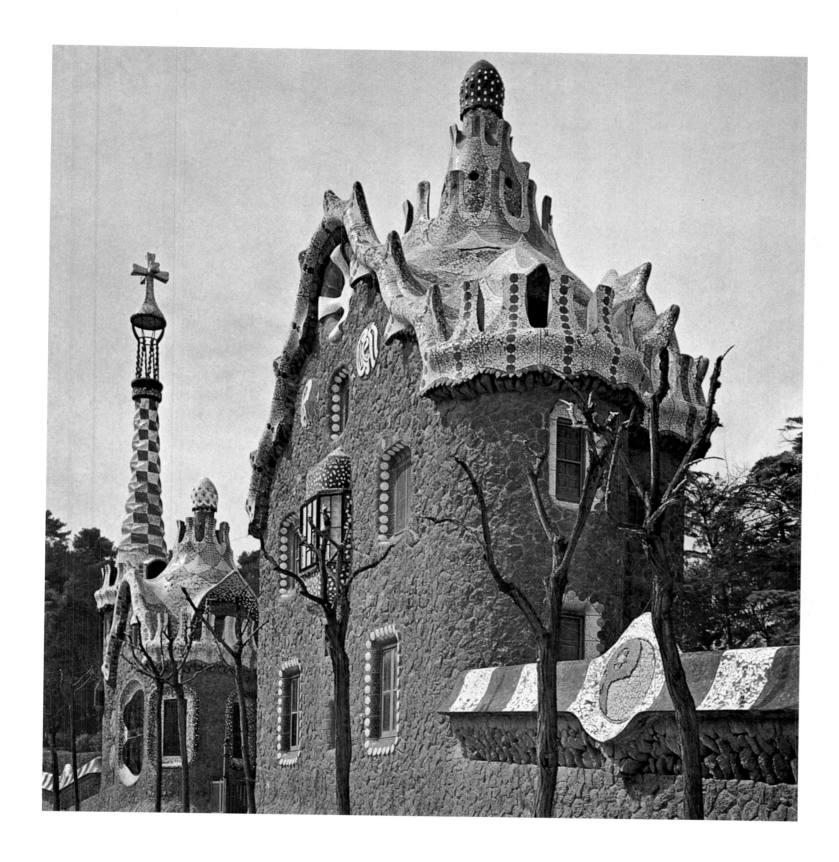

Behrens (and the link with the Turin hall is evident too), a single overall conception of structure, space and ornament is the hallmark of his work. The Sagrada Familia, above its orthodox neo-Gothic base, may border on madness. But in his secular buildings, "attacking the conception of structures by a continuous shuttle between the logic of construction and the evocative power of the image" (François Loyer), Gaudí demonstrated his force and lucidity, quite apart from the visionary side of his genius, which is too often emphasized.

It is in these qualities that, however paradoxical it may seem, Gaudí links up with Mackintosh at his best, and he was at his best at this very time (1902-1909). The confrontation of the antithetical forms of the Scotsman and the Catalan, of that straight "line of man" and that curving "line of God" (to use Gaudí's terminology), is indispensable for an understanding of the fundamental link between them.

Antoni Gaudí (1852-1926):
Casa Milá, Barcelona, 1906-1910.
◁ Detail of the front and overall view.
△ Entrance pavilion of the Park Güell, Barcelona, 1900-1906.

201

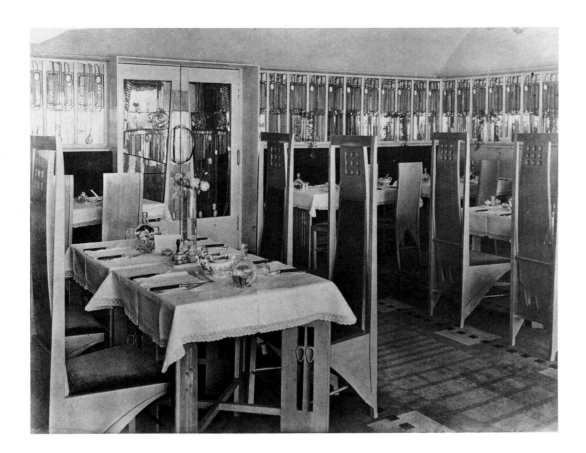

Charles Rennie Mackintosh (1868-1928):

△ Willow Tearooms, Glasgow, 1903-1904.
Period photograph.

▷ Glasgow School of Art,
Library, 1906-1909.

▽ Hill House, Helensburgh, near Glasgow,
1902-1904. Entrance hall.

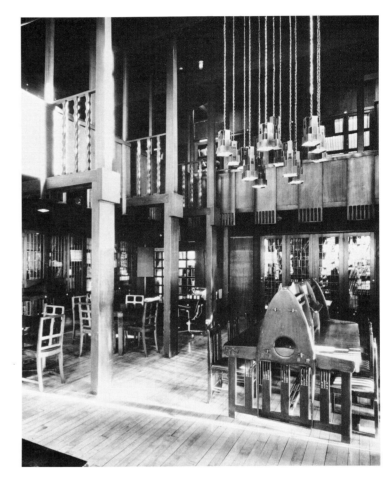

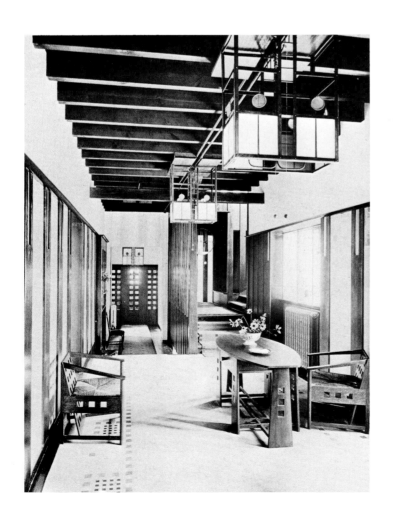

Commissioned from Mackintosh by the Glasgow publisher Walter Blackie, Hill House of 1902 is proof in itself that the Darmstadt project was not utopian. The functional conception of the whole is summed up in the entrance hall, with its differences of level separating the area of access to the working rooms from the family part of the house. Mackintosh made a point of living with Blackie, familiarizing himself with Blackie's life, before designing the house, with the result that it fitted its owner like a glove and he lived in it for fifty years without making any changes. Like Gaudí's Casa Milá, Hill House is governed by an organic, overall conception: structure, space and ornament are one. The abstract decorations, bold yet discreet, integrated into the panels, are re-echoed in the alignment of the squares in the rug pattern, which in turn answer to the openwork shapes in the furniture and front door.

With the Willow Tearooms in Glasgow, in 1903, Mackintosh achieved another masterpiece of rational harmony. Published in 1905 in Meier-Graefe's Munich magazine *Dekorative Kunst*, it is, of his public establishments, the most complete and refined. Mackintosh's work as an architect culminated in the west wing of the Glasgow School of Art (1906-1909). Here, as in Gaudí's Casa Milá, there is no further reference to the style of the past (whereas some-

faith in the necessary presence of ornament except in some small-town banks in the Middle West: there, using simple volumes, he played on the contrast between bare surfaces and (as always with him) richly adorned surfaces. The Owatonna Farmers' Bank in Minnesota (1907-1908) marks the high point of this work, but in smaller, equally flawless buildings like the Home Building Association Bank in Newark, Ohio (1914), and the Krause Music Store in Chicago (1922) one finds a more striking analogy with the style of the Wiener Werkstätte, as exemplified by Josef Hoffmann and Kolo Moser. In the year of his death, 1924, Sullivan published *A System of Architectural Ornament According with a Philosophy of Man's Powers*: in its title, text and plates, this book sums up the principles he had defended all his life.

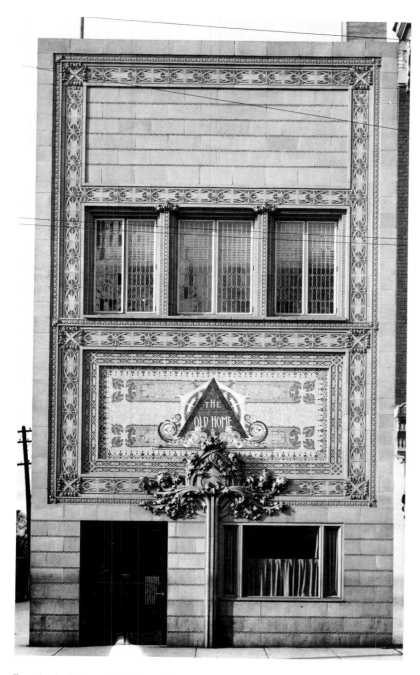

Louis Sullivan (1856-1924):
Home Building Association Bank, Newark, Ohio,
1914. Main front.

Charles Rennie Mackintosh (1868-1928):
Glasgow School of Art,
west front, 1906-1909.

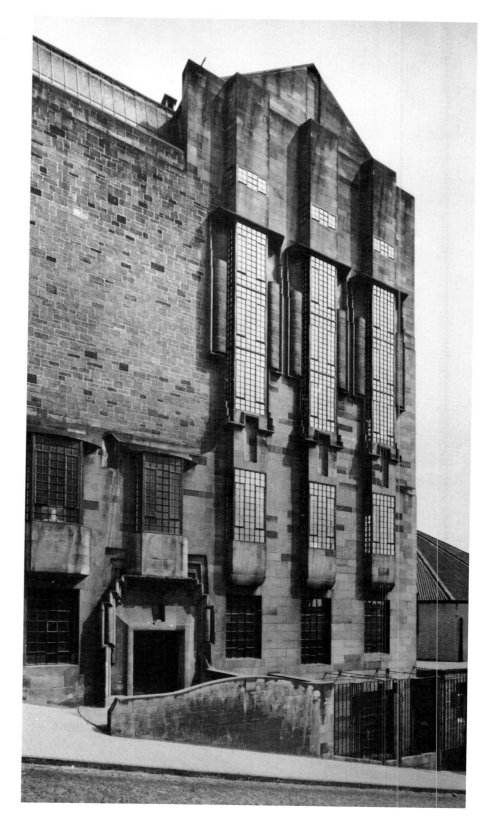

thing of Scottish Baronial had lingered on in the conical roofs and turrets of Hill House). Ten years after the north front of the Glasgow School, the library in the west wing now presents an apparently complex but primarily functional space. The beams supporting the gallery rest directly on those supporting the ceiling, and ornament is determined by structure. It is this internal space on two levels, together with the corresponding windows, which justifies the powerful vertical face of the exterior, with its contrasting treatment of surfaces and projections, which re-echo those of the north front.

It would be a mistake to see in the Glasgow School of Art, any more than in Gaudí or Guimard, a direct anticipation of the pure functionalism of the post-war period. It comes rather, with the importance given to ornament, as a follow-up of Arts and Crafts design, even of classical architecture and certain Japanese prototypes. The intention is not revolutionary, but the sentiment is modern, between Morris's addiction to the past and the futurism of the post-1918 international style. The Glasgow School is Art Nouveau at the moment of its greatest equilibrium.

Mackintosh the architect, for want of support, was now condemned to silence—like Sullivan in the United States, the third of these three great individualists. Sullivan was unable to assert his

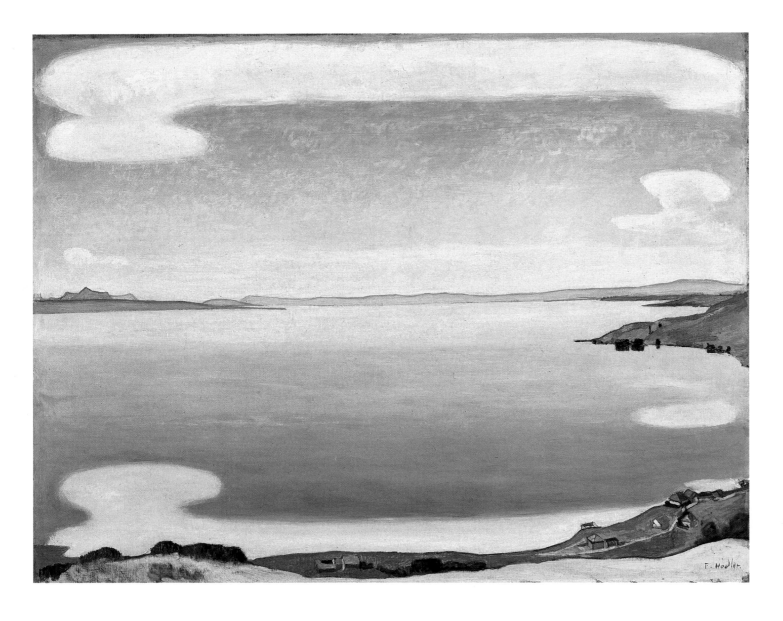

Ferdinand Hodler (1853-1918): The Lake of Geneva seen from Chexbres, c. 1908. Oil.

The Hodler Room at the 1904 Exhibition of the Vienna Secession. Hanging and arrangement by Koloman Moser.

I shall go on and paint other landscapes besides the ones I've done up to now. Look over there, on the other side. Do you see how everything merges into lines and space? Isn't it as if you were standing on the world's edge and communicating freely with the infinite? That is what I shall paint from now on.

Ferdinand Hodler, 1917.

It was in Vienna, where Mackintosh had visited the Secession exhibition in 1900, that another, equally significant conjunction of artists now took place: that of Hodler and Klimt. The cultural background of the two men was very different; so was their style, and especially their conception of the human figure: what a contrast between the "decadent," mannered refinements of the Viennese master and the rugged, ungainly peasant bodies and powerful rhythms of the Swiss painter! But in their way of presenting those figures there was a fundamental likeness, and Kolo Moser's arrangement of the Secession galleries for Hodler's triumphant exhibition there in 1904, alongside the Secession masters, showed how well Hodler's plane, orthogonal system of design harmonized with Klimt's fidelity to the arabesque.

It was Klimt personally who invited Hodler to exhibit with the Vienna Secession in 1900. In 1903 Hodler designed the poster for the nineteenth Secession exhibition, and it was for Viennese collectors, that same year, that he painted a replica of *The Chosen One* and a second version of *Day*. It was to Vienna, after 1904, that he owed his popularity and prosperity.

Hodler's work was then enriched with those extraordinary landscapes which, carrying on from Segantini and Munch, showed how the natural features of the visible world can be given a fuller meaning by their integration into an ornamental scheme. In this, a masterly application of the principles of symmetry, parallelism and reflection laid down by Maurice Denis. But Hodler was a law unto himself, an artist whose reign, like that of Klimt, "is not of this world": his work culminated in an ecstatic shuttle between the weathered landscape of his own face and the contemplation of sunrise over the Lake of Geneva, testifying to the essential faith of Art Nouveau in the unity of beings and things.

In the end Hodler had moved on to what he called "planetary landscapes," and the cosmic sweep of his late paintings has its counterpart in the late works of Klimt, who in 1905 left the Secession and with his friends formed the Wiener Kunstschau. Strangely, there was even a physical likeness between Klimt and Hodler, as Lichtwark noted in 1905, and as one can see from Moriz Nähr's fine portraits "with cat" of 1912-1914.

Klimt found fresh scope for his powers in the great mosaic decoration for the Stoclet House in Brussels (1904-1911), whose spirit was epitomized, in the manner of Hodler, in the two scenes of *Expectation* and *Fulfilment*—the kiss that corresponds to the embrace of all nature. Around 1907 Klimt took up a circular or elliptical scheme of design, which heightened and enhanced, with extraordinary force, the arabesque of Art Nouveau. This new compositional scheme is seen at its best in his *Danaë* (1907-1908), his *Young Girl* (1912-1913), also his *Leda* (1917), pictures which suggestively evoke the rolling swirl of galaxies: here the female form, virgin or wanton, stands beyond morality as man's promise of fusion with the cosmos.

Hodler and Klimt died the same year, 1918, one year after Rodin, whom Hodler had met in Vienna in 1902 and Klimt in Paris in 1913. With their passing, Art Nouveau ended in the plastic arts, and these men may be said to have brought it, in the years that followed the Turin Exhibition of 1902, to the peak of its splendour and power.

Gustav Klimt
with his cat
in the garden of
his Vienna studio in
the Josefstädterstrasse,
c. 1912-1914.
Photograph by
Moriz Nähr.

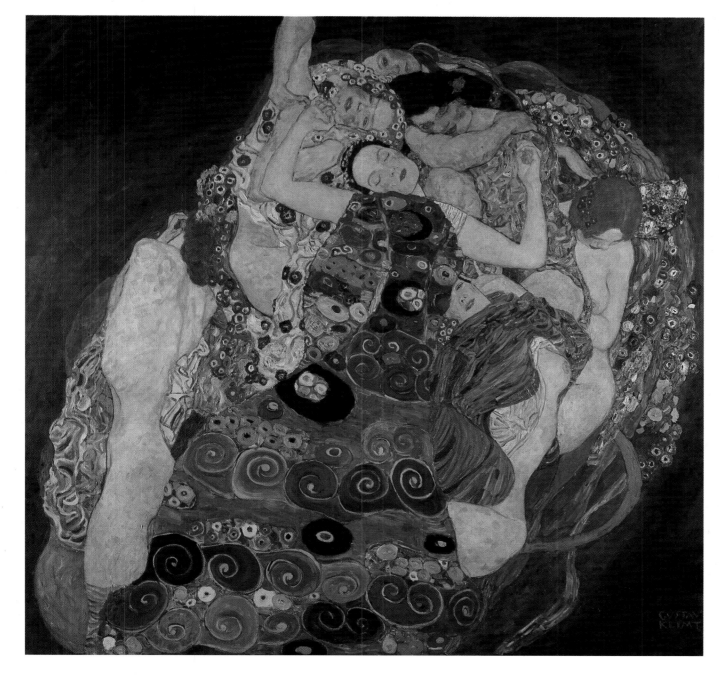

Gustav Klimt (1862-1918):
The Young Girl, 1912-1913.
Oil.

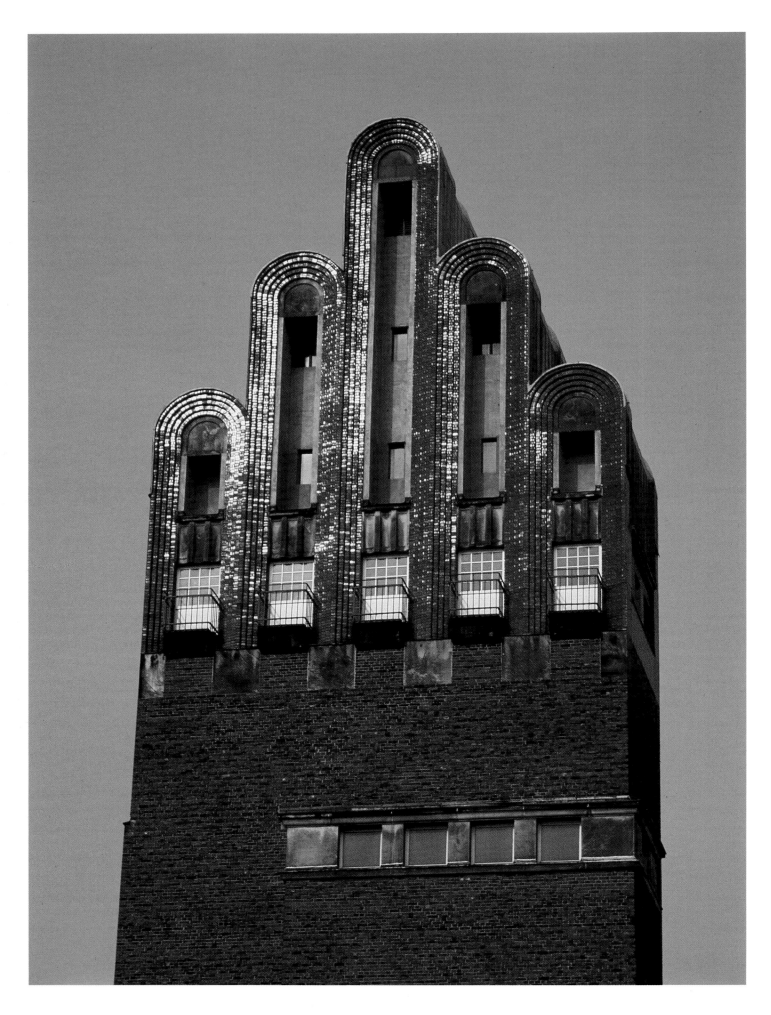

Joseph Maria Olbrich (1867-1908):
Hochzeitsturm ("Wedding Tower"), Mathildenhöhe, Darmstadt, 1907.

From One Utopia to Another

After 1902 the triumph of Art Nouveau tended to become that of isolated masters doomed to solitude: a triumph of individual creation, but with no echo and no posterity, marking in that respect the failure of the reforming aim of its origins. Klimt shut himself up in his concentric compositions; Gaudí in his faith; Hodler in his pantheism. By a reverse process to that of the early 1890s, Mackintosh even abandoned architecture for painting.

Alongside these preservers of the status quo, others nevertheless changed, modified their forms, debated theory, called principles into question. Among the problems they then came up against appeared in plain light the contradiction between inventing highly individualized forms—often elaborate and therefore costly—and the aim, no doubt utopian but part and parcel of the project, of creating the style of the coming age and assisting in the birth of a new society. Proceeding from the immense effort of the previous twenty years, it was necessary to go from the studio to production and dissemination; but with what resources, and on what social foundations? The inevitable recourse was industry, where Art Nouveau at every moment naturally risked losing its soul. Such was the central issue henceforth raised in Paris, Vienna and especially Germany. Pursuit and failure of the individualistic utopia with Guimard; drift towards decoration in Vienna; determined conversion to industry in Germany, which, however, was perhaps only a different form of utopia.

In 1907, to commemorate the marriage of the Grand Duke of Hesse, Olbrich built on the summit of the Mathildenhöhe of Darmstadt the Wedding Tower (Hochzeitsturm). A strange work, with complex significances: observation tower (planned for that location since 1900); commemorative monument (passing from the two towers connected by arches of the original projects, a clear symbol of marriage, to the five fingers of the "wedding-ring hand" which crowns the whole); symbol of the column; a pure work of form as well, with its opposition of verticals and horizontals, of symmetry and asymmetry, of plain and precious materials. It was certainly no longer Horta or Guimard, nor Van de Velde, nor even the Olbrich of the 1901 exhibition; no more was it Behrens and still less Gropius, despite those famous bands of windows projecting beyond the corners, a system which would come into widespread use between the wars.

Original form, symbolic form, decorative form, utilitarian form and unmotivated form: so many conflicting appeals to an uncertain future, yet which do not bring themselves either to break completely with the past (the traditional materials, the development of the stepped gables of Northern Germany). Olbrich himself, who died prematurely in 1908, seems to have wanted to come back afterwards to more reassuringly familiar models—in 1908, neo-Gothic for the Tietz department store of Düsseldorf and neo-classical for the Feinhals house in Cologne. The enigmatic signal he left on top of the Darmstadt hill was at the same time a message of farewell and a sign of persistent hope for the advent of a new world, between two utopias.

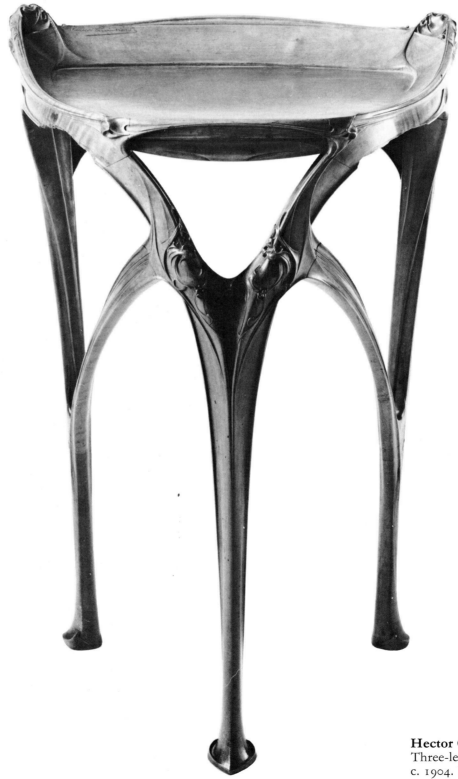

Hector Guimard (1867-1942):
Three-legged table with writing slide,
c. 1904. Pearwood.

TOWARDS A NEW ART NOUVEAU
1902-1914

Birth, Life and Death of the "Guimard Style"

FTER 1900 Guimard's work attracted less attention: most often it was spoken of as settling down and not renewing itself, with the implicit suggestion of a loss of interest if not of quality. Yet his production continued to have no less individuality, and in many respects it may be held that on the contrary, like Mackintosh or Gaudí, Guimard reached his prime and achieved balance between about 1902 and 1911. If there was undeniably a toning-down in manner, and in fact little or nothing that recalled the provoking forthrightness of the Castel Béranger or the Humbert de Romans auditorium (the destruction of which was begun in 1905), this development, which concerned secondary matters, should not make us forget what was essential: Guimard, at least up to his Paris town house in the Avenue Mozart in 1909, continued to defend and illustrate his global conception of architectural space or, more exactly, "living space," which is indeed the hallmark of Art Nouveau. In this he joined forces—and was alone in France in doing so—with Van de Velde, Horta, Behrens, Gaudí and Mackintosh.

It is significant that Guimard himself placed Van de Velde and Horta next to himself in the short but basic essay he published on Art Nouveau in 1902 (in *The Architectural Record*, a New York periodical). This essay is one of the rare "manifestos" of the movement written by a Frenchman. In its slightly awkward and even naive formulation of the definition he gave to the "Guimard Style" and would recapitulate more briefly in response to criticism that appeared in December 1903 in *L'Art Décoratif* ("Here are the principles on which the Guimard Style is based, which may be condensed into three words: logic, harmony and feeling"), it fully corresponded to what made the force and originality of a trend springing at once from French rationalism and English aestheticism, and in which the drive towards art (the "feeling") remains an essential factor.

Launched in 1903 on the occasion of the International Home Exhibition in the Grand Palais by a series of postcards on which were depicted in particular the Castel Béranger apartment house, the Humbert de Romans building and his Paris Metro stations, the "Guimard Style" had in fact no other meaning, and it would be wrong to see in it only the sign of a somewhat ridiculous megalomania. Unity of conception was essential in Art Nouveau vision: increasingly alone, Guimard worked less for himself than for the heroic defence of an idea. Hence the "totalitarianism" in effect of his realizations, which did not differ in nature from that of Gaudí, Behrens or Mackintosh, "temperaments" otherwise as dissimilar as could be. Guimard's singleness of purpose extended even to the design of the beautiful frame of his own photograph in 1907. No

doubt the signature was redundant, but Guimard was emphatically Guimard, which meant first of all style: the "subject" lies as much in the form of the frame as in the lock of hair that repeats its wavy line.

It was undoubtedly after 1900 that Guimard attained the greatest cohesion, just when the originality and quality of his façades in particular combined with that of his interior spaces. More than in the Castel Béranger apartment house or the inventions of the Humbert de Romans auditorium, Guimard at his peak is to be sought in a construction as complete and perfect as the Nozal House of 1902-1905 (destroyed in 1957, but its furniture is preserved in the Musée des Arts Décoratifs, Paris). On a rational and functional plan still indebted to Viollet-le-Duc (and to be quite precise, to a town-house design presented at length in the seventeenth *Entretien*), the architect here provides the Paris equivalent, not, as has been said, of the Güell Palace, but of the Casa Batlló or the Casa Milá which followed soon after (and the kinship with Gaudí is even more obvious in 1905, in the Castel Orgeval, a totally organic edifice, with its forcefully interlocking volumes and contrasting materials. As for the admirable furniture of the Nozal House, in which nothing remains of his pre-1900 aggressive ruggedness, it showed that Guimard was henceforth alone in France

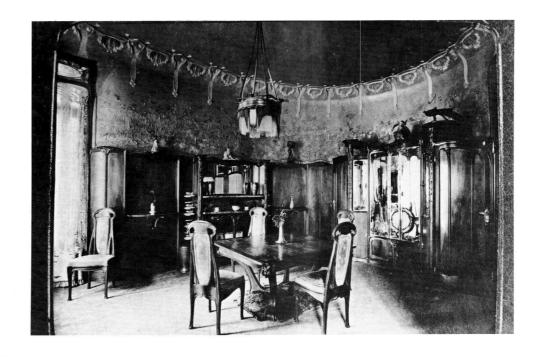

Hector Guimard (1867-1942):
Guimard House, Paris, 1909-1912.
◁ Entrance.
△ Dining room.
▷ Hall and stairs.
▷▷ Detail of the exterior.

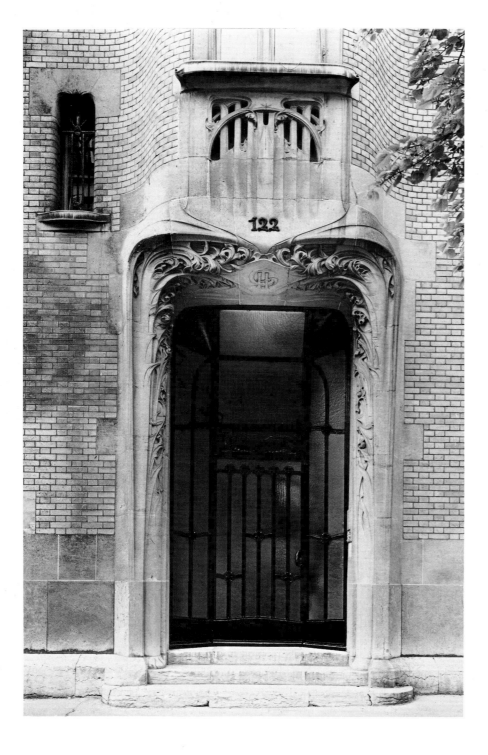

to practise this kind of design: the emphasis on an essential spatial continuity, notably with those oblique or triangular pieces of furniture in which the keen edges emerge from the material to blend into the ambient air, thus turning away from the self-contained, classically structured objects of Bing's interior designers. The form is wholly new, without floral reminiscences; the material exposed to view, with neither painting nor lacquer on this beautiful pearwood. There was undoubtedly a "purification" of the design, rendering these pieces less spectacular than those of the Castel Béranger or the Coilliot House, but above all, the deeper investigation of a coherent line of thought. And the reference to national tradition—again the French art of the eighteenth century—was, as in Gaudí and in contrast to what is found in Georges de Feure, for example, completely integrated and transcended.

The same quality appears once more in the Paris town house built by Guimard in 1909 at 122 Avenue Mozart after his marriage to the American painter Adeline Oppenheim. The general arrangement of the façades may this time lend itself to debate, but the plan, on a triangular building plot, attests to a remarkable ingenuity, with the integration of two artist's studios and, on the first floor, two connecting oval rooms: the drawing room and the dining room. It is significant that Guimard, following his usual practice, took over here for his own use a part of the furniture of the Nozal House (the small three-legged table, for instance). And the virtuosity shown in the disposition of spaces is accompanied, as in the highest achievements of Art Nouveau, by an exceptional quality in detail work: on the front, in the linking of volumes and the passage from brickwork to stone; in the interior, for example in the hall staircase, whose great mirror doubles and unifies the space across which travels the fluid lines of the banister (how much more refined and spare than his previous railings!), and where the discreet use of ornament on large empty surfaces (notably in the

I have discovered three principles which should have a dominant influence in all architectural work. (1) Logic, which consists in taking into consideration all the characteristics of the object which architecture handles, and they are infinite in both variety and number. (2) Harmony, which means that the buildings must be in total agreement not only with the requirements to be met and the funds available, but also with the surroundings. (3) Feeling, which, partaking at once of logic and harmony, completes them both and leads, by the emotion it arouses, to Art in its highest expression. Such are the principles which I have tried to embody in all the buildings I have put up, and in particular in the Castel Béranger and the Paris Metro stations. These are the works, together with those of men like Victor Horta and Van de Velde, which have inspired (chiefly in Germany, Austria and France) those productions which have been designated by the term Art Nouveau.

Hector Guimard, "An Architect's Opinion of Art Nouveau," in The Architectural Record, *New York, May 1902.*

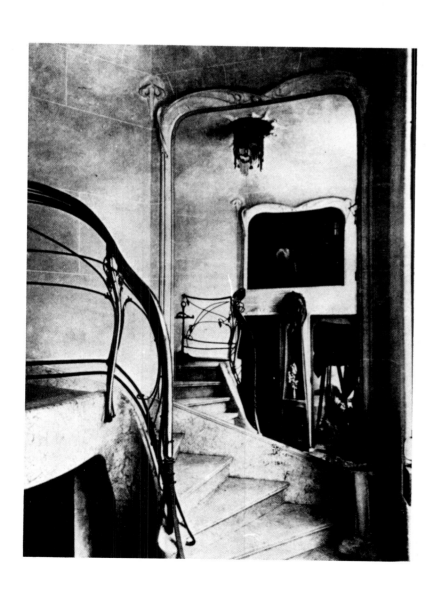

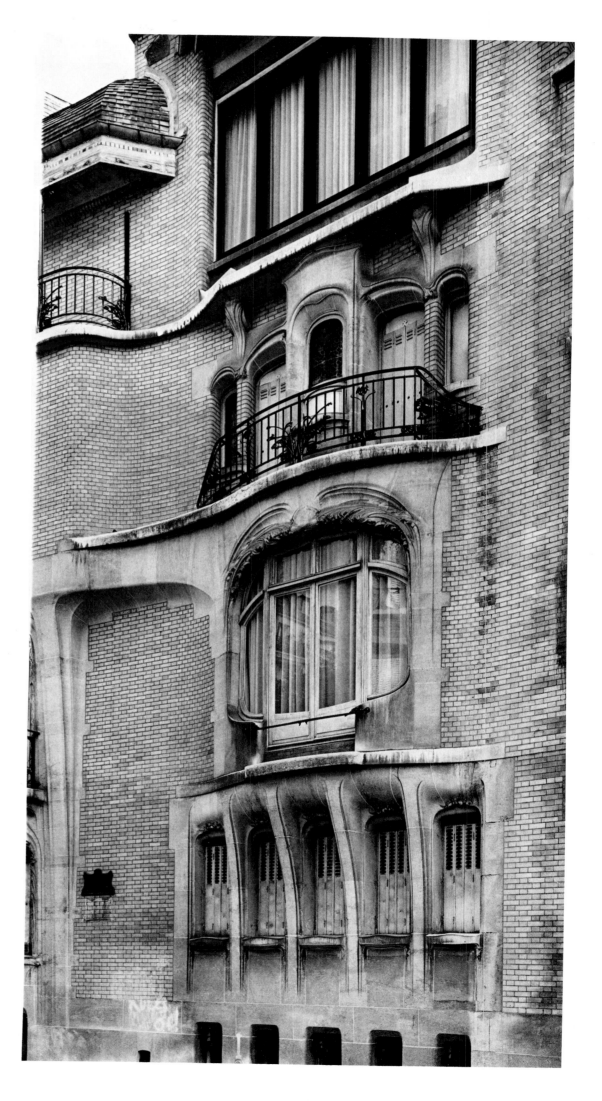

If the architect sets out to design everything, down to the least details of his construction, the expense on models represents an expenditure of time which makes it absolutely impossible for him to carry his work through. What is necessary then, to solve this problem, is for building manufacturers to renew their models and to draw up catalogues of new models which, when combined for the practical needs of our modern construction, would complete each other and thereby express a new sense, the sense of our time.

Hector Guimard, in La Construction Moderne,
Paris, 16 February 1913.

Hector Guimard (1867-1942): Ornamental cast iron balcony railing for the Deron-Levent House, Paris, and the Guimard House, Paris, 1907.

corners of the ceiling) is reminiscent of Mackintosh. In the dining room may be recognized the German system of "pieces" (with the frieze ensuring the continuity of wall and ceiling, as in Riemerschmid), and the plan of the room itself, as in the Casa Batlló, calls for unique furniture along the walls; but the design is much more personal, if not typically French. If Art Nouveau, for Guimard, ends here (although his Mezzara House in 1910-1911 provides a comparable example), this end, so far from marking a simple survival, is on the contrary an apotheosis, once more well after 1900.

Isolated and mocked at, must Guimard then be ranked among the solitary masters who stood firm to the very end? Not exactly. His work continued to evolve, for better or worse, after 1900 especially, by borrowing from the geometry of Art Deco design. And it had moments of hesitation or mannerism, as in the Deron Levent House in 1905-1908. But Guimard was also one of those in France at that time who faced up to the crucial problem of the dissemination of Art Nouveau: of its relation, therefore, to industry.

After he ceased to work for the Paris Metro, following the final failure of his Opéra station in 1904, Guimard depended on individual patronage, and he found it in the exclusive sixteenth arr-

ondissement. As with Horta, these one-off constructions (or, in the case of furniture, manufactured in small numbers) were wrought with care at high cost and could only be destined for a wealthy public: an absurd and contradictory situation in the case of an apartment house, like the large Jassedé building in the Avenue de Versailles, of 1903-1905. Above all, this went against the principle of the democratic spread of Art Nouveau. In 1907 therefore, reverting to the formula of mass-produced metal plates which he had used for the Paris Metro stations, Guimard commercially launched his "Guimard-Style Ornamental Cast Iron," made to his designs by a Saint-Dizier foundry; the models appeared in a detailed catalogue. A venture, naive perhaps in its form, but very serious in its aim, which coincided with that of the German artists and industrialists who successfully joined together that same year to found the Deutscher Werkbund. But Guimard was alone, and unlike Van de Velde and Behrens, failed to overcome the contradiction between his creative impulse (as individualistic as that of Gaudí) and the demands of industrialization: he was by far the chief user of his own castings, of which the building at 17-21 Rue La Fontaine displays a broad sampling. Placed elsewhere, in a different space, with the design of another architect, they lost their significance.

Title page and plate 36 of Hector Guimard's catalogue of "Ornamental Cast Iron for Constructions, Stoves, Gardening and Burial Articles. Guimard Style," Saint-Dizier Ironworks, 1907.

Henri Sauvage (1873-1932):
Majorelle Furniture Company
building, Paris, 1913.
Detail of the front.

This failure marks an important date in the history of Art Nouveau. The problem of the relations between art and industry, pointedly raised in 1856 in the Laborde report, now had to be resolved after the new forms had been designed in the workshop. After the Turin exhibition of 1902, it was for Art Nouveau a question of death or transfiguration. And others in France realized it, such as Verneuil, the editor of *Art et Décoration*, when he wrote in his journal in 1906 that "rational, even industrial production, alone permits the indispensable artistic difference." The alternative was to reduce Art Nouveau to the fabrication of art objects, soon condemned to the whims of fashion, as the firm of Gallé, after his death in 1904, continued to do in Nancy. The report of the French commissioners at the Milan World's Fair in 1906 makes this clear by explaining why the French decorative arts had been refused any subsidy: "The reason was that in France at that time fashion was turning away from this modern style of the late nineteenth century illustrated by men like Grasset, Gallé and Lalique, which was too much restricted to the trinkets, ornaments and furniture which the excesses of Modern Style had brought into disrepute. This error had caused a strong reaction in France, which showed itself in a return to former styles."

Guimard, for his part, refused to give up any of the claims of architecture. His manner changed, but not his ambition, even if some of his furniture (the chairs of his town house, for instance) seemed on the point of joining the tempered classicism of a Eugène Gaillard, who now vigorously criticized Art Nouveau (in *A propos du mobilier*, Paris, 1906) and heralded the transition to Art Deco. While Sauvage moved away, in the undecorated, reinforced concrete skeletons of his low-cost housing units of the years 1903-1904 (to say nothing of Tony Garnier and Auguste Perret), and while the Majorelle furniture store of 1913 in the Rue de Provence, although a prestige building, marked all the distance travelled since the Villa Majorelle at Nancy (1901-1902), Guimard, as a matter of fact, upheld in the middle-class building the utopia of salvation through style, by the determination to achieve stylistic unity starting from architecture.

Guimard's isolation, the dead end into which he had locked himself and from which, a few years later, he would dramatically attempt to break out by renouncing his personality (starting with the Paris office building in the Rue de la Bretagne in 1914-1919), in fact pointed to the end of Art Nouveau in France and the failure of its stubborn individualism.

213

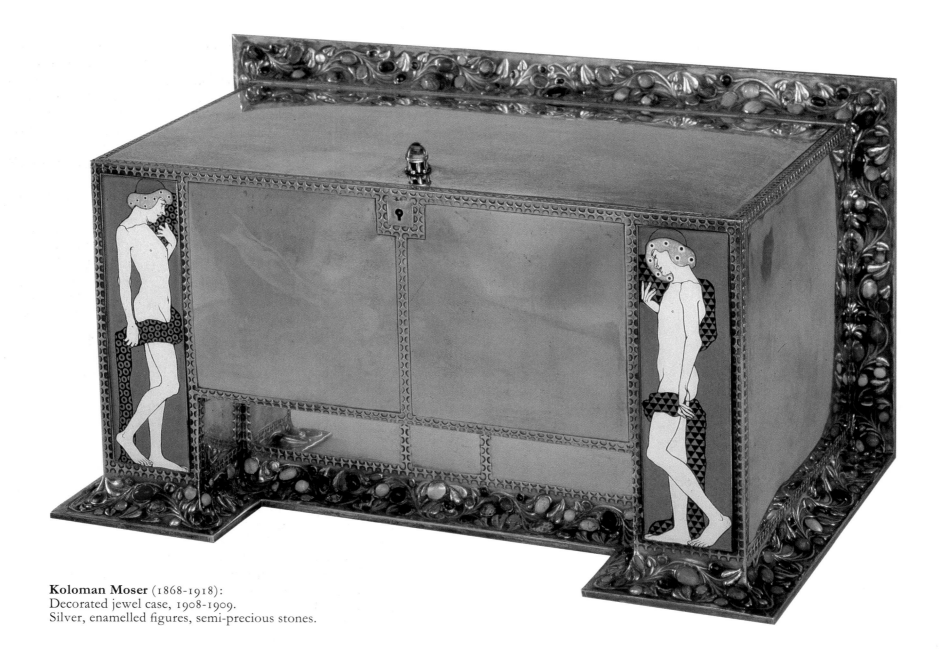

Koloman Moser (1868-1918):
Decorated jewel case, 1908-1909.
Silver, enamelled figures, semi-precious stones.

The Wiener Werkstätte and the Escape towards Art Déco

HILE in Paris just before the war Guimard, a loner architect, was shutting himself up in the blind alley of "style," Vienna found a way out, but one that in many respects was also only a loophole: the return to the decorative arts, which once again took the lead. That before all else was the significance of the founding in 1903 of the Wiener Werkstätte (Vienna Workshops) by Josef Hoffmann and Kolo Moser, with the support of the banker and patron Fritz Wärndorfer.

A way out, but, if one may put it thus, by the back door, whereas the Germans would soon propose going forward in an alliance with industry, by the creation in 1907 of the Deutscher Werkbund. The programme of the Wiener Werkstätte drawn up by Hoffmann displayed, as a matter of fact, an astonishing predilection for the past when it invoked the example, and sanction, of Ruskin and Morris to condemn industrial production and advocate the return to cottage industry: national, honest, modest, founded on the joy of labour and the respect for materials. In appearance a surprising retreat, harking back to the 1880s, to Arts and Crafts, and more precisely to Ashbee's Guild of Handicrafts, which clearly served as a model. There indeed is the most obvious explanation: the English example was a recent import, like the strong influence of Mackintosh which, on this level, operated no differently. Hoffmann went to London in 1902: there he met Muthesius (then an attaché at the German Embassy, with a brief to study English architecture and design); and, like Wärndorfer, Hoffmann made the journey to Glasgow. On being consulted, Mackintosh was lavish with encouragement and advice ("Every object that leaves your hands must carry an outspoken mark of individuality, beauty and the most exact execution"). Here was an unexpected extension of the Vienna-Glasgow axis.

But this sudden conversion of Vienna to the applied arts, after so much in the way of painting and architecture, was also explained by the difficulties the major arts were now experiencing in imposing the new style. The greatest professional successes of Otto Wagner (notably the Stadtbahn) were largely behind him; historicism was coming back in full force, and Olbrich, the fair flower of the Viennese springtime, had left for Germany. As for Klimt's paintings, just when the great project for the University decorations was about to fall through, it tended to withdraw back into its original nucleus. Even before the "Klimt group" left the Secession, in 1905, this helps to explain why Klimt joined the new workshops at the outset: the community of the Wiener Werkstätte offered a refuge, as did its support in techniques other than painting. It was now, in the spring of 1903, that Klimt made the journey to Ravenna to see the Byzantine mosaics there.

From then on there was a prodigious blossoming of objects and decorations, from jewelry to furniture, from stained glass to book illustration, widely disseminated throughout Europe by periodicals like the new Vienna monthly *Das Interieur*, founded in 1900. On the level of decoration, the Viennese movement kept what had been gained by the Secession: the setting-off of flat colour areas and the articulation of planes, ornamentation contained by structures and making use of contrast with empty surfaces. But now it was the decoration that would, in its turn, "reinvest" and relaunch painting and architecture, including that of the leading masters, Klimt, Hoffmann or Wagner, where it heightened the immobility of those spaces reduced to two dimensions which had already tended to characterize their previous work.

With its smooth and brilliant silver surfaces, its enamel panels, figurative but done in flat tints, its narrow bands of geometric motifs highlighting the structures, and its frieze of semi-precious stones, the jewel case by Kolo Moser (1908-1909) affords an excellent summing-up of this remarkably inventive production in which the distinction between curve and straight line is only secondary, as once more confirmed around 1905 in Hoffmann's fine silver wine pitcher with a Beardsley-style handle (which was exhibited at the Miethke Gallery in Vienna). Moser was not an

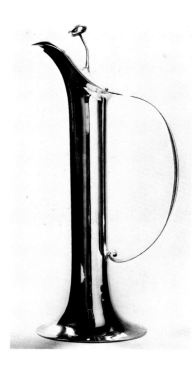

Josef Hoffmann (1870-1956)
Silver wine pitcher, 1905.

architect, and his style changed little after the large sideboard in maple, mahogany and cherry-wood (entitled "The Plentiful Catch") which caused a sensation, with its light-coloured bands in stylized decoration on a dark background and its functional design, at the eighth exhibition of the Secession in 1900.

It was this aesthetic of decoration integrated into the structure of simple volumes (which also strikingly recalls the later manner of Sullivan) that would appear in the new architecture, and first of all in that of Hoffmann, in which the transition is achieved precisely by the interior decoration. In his Hohe Warte houses between 1900 and 1902, those for Carl Moll and Kolo Moser to begin with, the exterior, with its gables and half-timbering, still derives from Austrian Heimatstil, as well as from the English house and the Viennese villas of Olbrich. But the interior appointments (as they appear, for example, in the fine paintings Carl Moll made of his house beginning in 1903) already had everything of the Wiener Werkstätte. As in the Beethoven Rooms of the Secession in 1902, the room designed under Hoffmann's supervision in 1904 for the St. Louis World's Fair (and in which appeared Klimt's *Jurisprudence* panel for the University) shows the systematic application

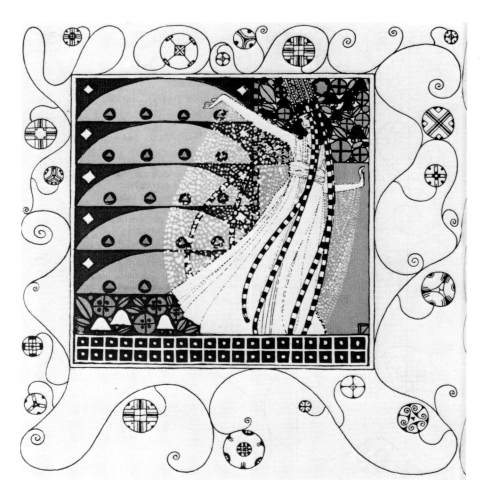

Fritz Zeymer (1886-1940):
Dancer, illustration in the first programme booklet of the Fledermaus Cabaret, Vienna, 1907. Border designs by Carl Otto Czeschka.

Workshop of **Josef Hoffmann** (1870-1956):
Design for a Vienna Secession room at the St. Louis World's Fair of 1904, from *Ver Sacrum*, Vienna, February 1904 (special issue devoted to the St. Louis Fair).

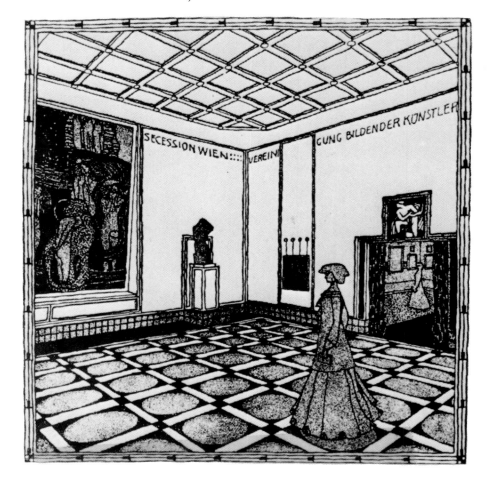

of his principles, with its total space, where the ceiling echoes the floor, and the well spaced-out display of paintings closely associated with the architecture. It is significant that this project was turned down precisely on the pretext that it did not allow the presentation of a sufficient number of works of art!

This decorative principle, found again in 1907 in the fitting up of the Fledermaus Cabaret, frequented by the Viennese intelligentsia, and at the *Kunstschau* of 1908, was also applied by Hoffmann to the exterior in the Purkersdorf sanatorium in 1903-1905, where the arrises are simply marked by blue and white tiles. But it finds its highest expression in the Stoclet House in Brussels, which Hoffmann built between 1905 and 1911, and of which the Purkersdorf building is like a working sketch.

In the Stoclet House comes together and culminates once more, after 1900, the whole of the movement. And it is highly symbolic that, through the workings of patronage, this achievement should be located in Brussels, the city of Horta, roughly half-way between Glasgow and Vienna.

Yet in its external appearance it is a pure product of the Wiener Werkstätte, and like an enlarged version of Kolo Moser's furniture and jewel casket, down to its preciosity, with its facing of marble plaques bordered by gilt bronze edges. But the Stoclet House is also indeed the work of an architect, who now takes over from Mackintosh's House of a Connoisseur its functional plan freely reassembling symmetrical groupings (particularly perceptible looking over the garden). Even the entrance hall, on two floors and at first offering its well-lit structure to the eye, makes it tempting to compare it with the Glasgow library—at that time still to be built.

If the conception is coherent, and global, it is also distinguished from that of Guimard's Nozal House because it rests first on simple principles and on the work of a team. Klimt's participation in the dining-room decoration is exemplary in that regard: his distinctive set of themes is condensed there with an extraordinary force, as has been seen; but here it was a mosaic frieze, executed between 1909 and 1911 by the Wiener Werkstätte from Klimt's meticulously annotated cartoons, and which linked up without a

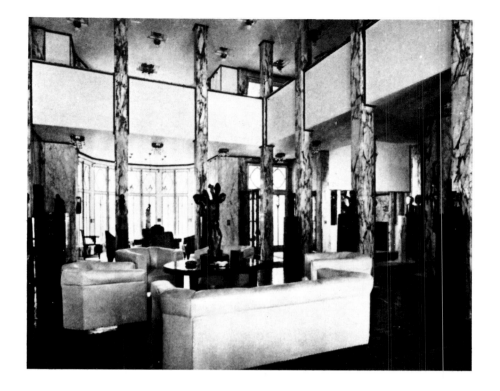

break with the facing of the walls and floor. And Klimt's "feminine" ocelli, obsessively repeated, are "married," appropriately, with the verticals of their environment: in *The Kiss* which, in 1907-1908, took over independently the group of his *Fulfilment* panel, those "masculine" verticals would be transferred, in their majority, onto the man's coat. There again the interplay of curve and straight line (found in the initial design of the entrance hall), beyond the contrast of manner and period which have been insistently seen in it, unites to make the greatest glory of "total" form —as it does, in a minor key, in the ornament seemingly remote from Viennese "purism" that Carl Otto Czeschka strewed in the margins of the Fledermaus Cabaret programmes.

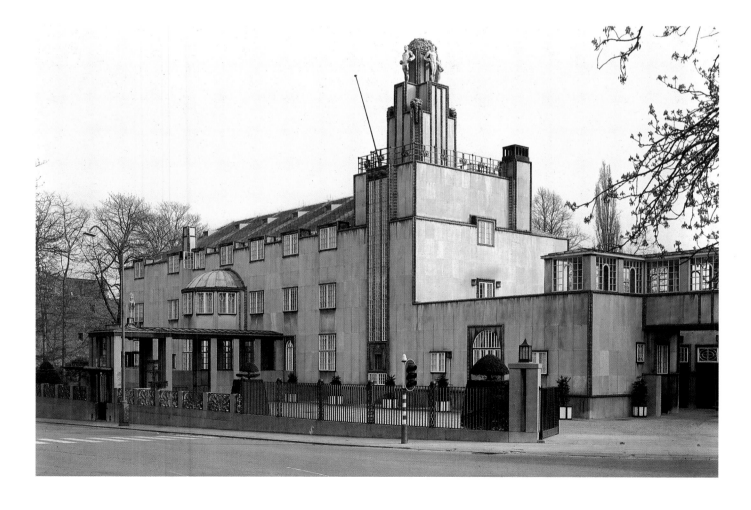

Josef Hoffmann (1870-1956): Stoclet House, Brussels, 1905-1911.
△ The great hall, looking towards the bow window.
◁ Overall view, with entrance surmounted by the bow window.

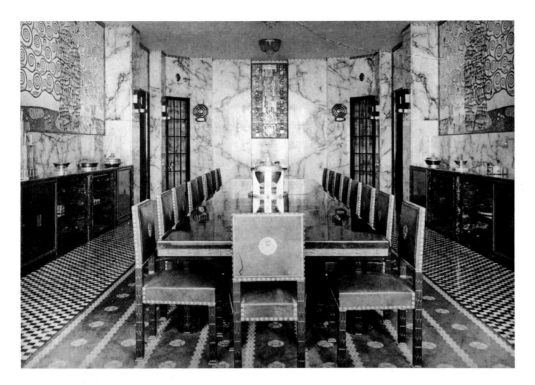

Josef Hoffmann (1870-1956):
Stoclet House, Brussels, 1905-1911.
Dining room with mosaic frieze by Gustav Klimt.

But the Stoclet House marked a dead end comparable to that of Guimard's town houses: like Mackintosh's unbuilt House of a Connoisseur, it was paradoxically an ideal and abstract realization, cut off from the Brussels context, in which it appeared as the dazzling but somewhat unreal materialization of a utopia. A measure of the social unreality of the Wiener Werkstätte, whose productions were meant for a well-to-do clientele, in the restricted space of a villa or palace.

In these circumstances the architecture of Art Nouveau found itself in danger. Hoffmann's later villas in Vienna (for example the sumptuous Villa Skywa-Primavesi in 1913-1915), like his exhibition pavilions in Paris in 1911 and Cologne in 1914, tended to favour a neoclassical vocabulary cut off from its syntax (flutings, columns without capitals, triangular pediments)—features which indeed began to seem "decadent."

Wagner himself did not entirely escape this danger, and the Steinhof Church in Vienna which perhaps marks the peak of his career (1905-1907) has been considered without exaggeration as the pendant to the Stoclet House. There, too, the Wiener Werkstätte gained a foothold, in the interior, with Kolo Moser's stained-glass windows and Rudolf Jettmar's mosaics, and the decoration which tends to nibble away at the spaces and cause the volumes to be forgotten: the dome, significantly, does not correspond to an internal cupola. And its "quite Palladian beauty," as Josef August Lux wrote in 1914, betrays, like the columns of the façade, the neoclassical temptation.

But Wagner's rationality kept him safe and steady. The Post Office Savings Bank (Postsparkasse), his only construction on the Ring, was again an extraordinary success which belongs entirely to Art Nouveau: function, structure, material and ornament continue to go hand in hand. In front, with the discreet rows of blue ceramic tiles and the exposed rivets (as in the Tassel House in Brussels) of the thin marble panels, which attain to style while respecting the surface of the wall. In the main hall, with a metal and glass space that yet is no simple factory bay (like the one Muthesius would design in Berlin in 1913 on the same lines), but where each functional element (counter position, radiator, applied ornament),

its proper material (including aluminium, in one of its first applications), and the very design of the floor, the glass roof and its supporting pillars are integrated into the structure to form its ornament—in the exact line of the vestibule radiator from the Horta House. If, in this important construction, which remains decidedly on the upper slopes of Art Nouveau, there may be an impression of a maximum stripping-away of ornament, it is far indeed from being abolished; and Sigfried Giedion was right to insist that, despite its discretion, which sets it against Guimard, the architect's hand was here "everywhere present: in the curves, in the colours and in the handling of space."

Otto Wagner (1841-1918):
Villa Wagner II, Hüttelbergstrasse 28,
Vienna, 1912-1913.

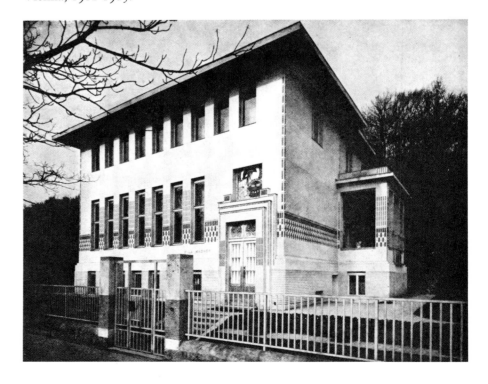

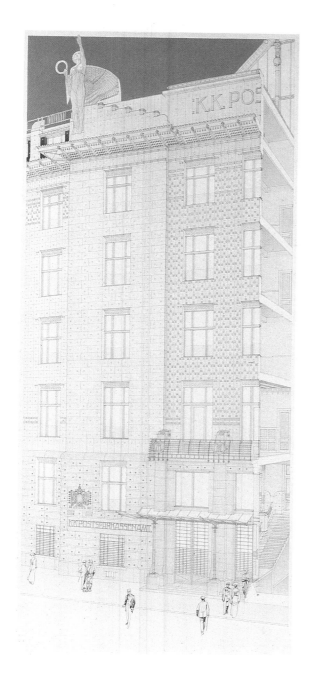

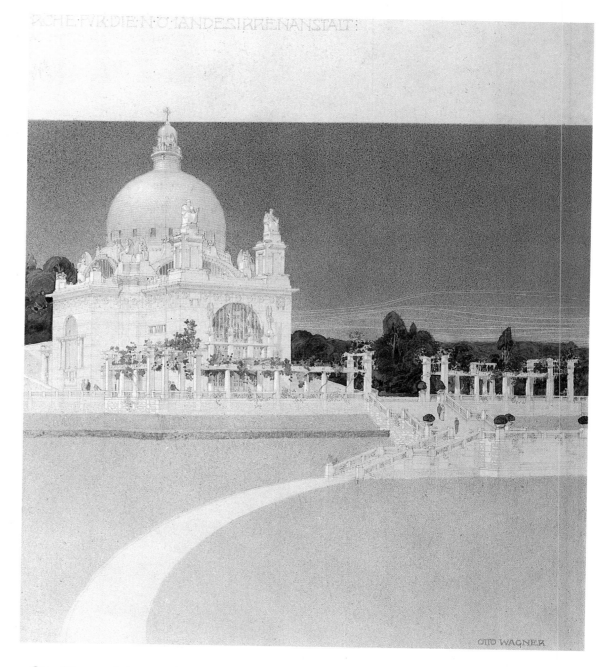

Otto Wagner (1841-1918):

◁ Watercolour design of 1903 for the
Post Office Savings Bank, Vienna, built 1904-1906.

△ Watercolour design of 1904 for the
Steinhof Church, Vienna, built 1905-1907.

It was the farthest point that Wagner reached, and his limit. His volumes, which became refined and leaned towards simple relations, remained closed; and ornament was always indispensable to them. His second villa, in 1912, allows us to see the road travelled since the brilliant historicist variation of the first, in 1888, situated alongside it—the transition being supplied by the pergola modified in 1900 and the stained-glass window by Adolf Böhm. There too the decoration was by Kolo Moser: geometric and simplified, but essential, notably by its colour. The whole remains, in the most classical sense, complete and harmonious: Pallas Athene and the Gorgon continue to watch over the entrance.

Against this limitation rose up Adolf Loos, who had already described Wagner's Majolika-Haus as "tattooed architecture" and practically eliminated ornamentation in his Café-Museum in 1899, where only standard furniture was used. Loos was not a pure rationalist, and in his way of posing problems at least he remained on the same side of the barrier. But in forcefully asserting in his writings the necessary separation of the useful and the beautiful, of construction and ornamentation, of art, industry and handicrafts, he broke, in effect, the "charm" of Art Nouveau, which, in Vienna, remained enclosed in Kolo Moser's jewel case, and came to a dead stop before the First World War with Wagner and Hoffmann.

The way out through the decorative arts led straight to Art Deco: the Paris Exhibition of Decorative Arts in 1925 (at which Hoffmann built the Austrian pavilion) was, among other things, an attempted reply to the growing success of the Viennese workshops. In Paris, Guimard had condemned himself to the solitude of a creator of style: in Vienna, Loos rescued architecture, but by re-establishing former divisions. It would no longer be surprising that it was Loos who in 1908 snatched the young Oskar Kokoschka away from the trap of the Wiener Werkstätte—where he was using up in posters and postcards the fine talent shown in his *Dreaming Boys*, a text with lithographs published that same year by the Vienna workshops—in order to restore him to painting alone. Kokoschka's great and tragic *Bride of the Wind* of 1914 (Kunstmuseum, Basel), with its entwined couple carried away in the whirlwind of brushstrokes, is by a Klimt broken loose from his moorings, those of the wall, of decoration, of Art Nouveau altogether, and from the happiness of its vanished unity.

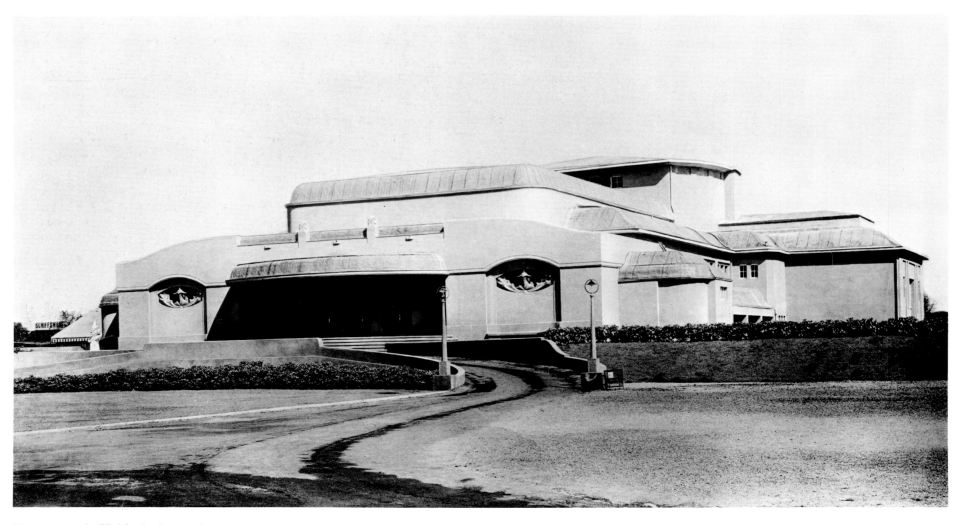

Henry van de Velde (1863-1957):
Werkbund Theatre, Cologne, 1914 (destroyed).
Overall view with entrance.

The Werkbund and Salvation by Industry

FTER the Turin Exhibition (1902), where its section was almost alone in evincing genuine vitality, especially with Behrens' Hamburger Vorhalle, the centre of living Art Nouveau shifted for good to Germany. It was of course no longer the Jugendstil of the turn of the century, but the basic interrogations continued to be conducted on space and its relation to materials, structure, ornament, style. It was entirely characteristic, for example, that the work of Frank Lloyd Wright, a pupil of Sullivan who developed in a totally original way his own conception of an organic and unitary space, expanding from a central focal point of the house (Dana House, 1903), was first published in Berlin in 1910. Berlage, the reformer of Dutch architecture, had his main theoretical essay published in Leipzig in 1905. Van de Velde had been in Weimar since 1902. Olbrich, after Darmstadt, settled in Düsseldorf in 1907.

In a parallel development, Hermann Muthesius, returning to Germany from London in 1903, popularized the English movement by his many publications culminating in the three volumes of *Das Englische Haus* (1904-1908). Beyond this work of information and description, the effects of which were rapidly felt, this praise of houses built first of all to live in, "with neither pomp nor decoration," along the lines of Morris's Red House, relaunched the key concept of *Sachlichkeit* (objectivity): simplicity, unity, respect for materials, rejection of styles—this time on a theoretical basis and no longer from the purely decorative point of view of the Viennese.

Muthesius had important responsibilities in Berlin. Councillor of the Ministry of Trade of Prussia, he undertook the reform of German schools of art (and in particular had Behrens appointed to direct the one in Düsseldorf). Above all, he was behind the foundation, in October 1907, of the Deutscher Werkbund, an association uniting industrialists and artists, whose statutes of 1908 indicated its directing purpose: "to lend nobility to industrial labour by cooperation between art, industry and handicrafts."

This programme, which was made specific in 1911, naturally raised many questions that would be closely argued during the following years. But in bringing together producers and designers for quality production on a large scale and in a resolutely modernist perspective, it attempted to supply a new answer to the questions asked since the middle of the nineteenth century concerning the relations between Art and Industry—and this time in a way quite opposite to that of the English or the Wiener Werkstätte founded shortly before—while at the same time it enabled the Art Nouveau artists to escape from the dead-end of "style" and

individual creation in order to bring to fruition the social scheme which, since Morris, lay at the heart of their venture. Among the founders and some eight hundred members who soon belonged to the Werkbund, it is therefore not surprising to find Behrens, Paul, Pankok, Riemerschmid, Olbrich and Van de Velde, all of whom rejected the isolation of a Horta, a Gaudí or, despite his efforts, a Guimard.

At the same time, however, this conversion to modern industry, which went beyond the semi-industrial production of the workshops of Uccle, Munich or Dresden, risked jeopardizing precisely what made the originality of their way of proceeding: the quality of a unique talent imposing its conception and the mark of

powerful, profound, solemn, hallucinated genius of domination, which suits this job and this era, as well as the contemporary German temper." In becoming nationalistic and imperialist (it is seen even better in Behrens' design of the German Embassy in St Petersburg in 1911-1912), Art Nouveau gave up its universal and democratic vocation, and disappeared: by then, in retrospect, it seemed only a matter of "ornaments" and "curves."

Passionately attached to creative independence, Van de Velde could not help being uneasy in such a context. His manner then sobered down, as is seen especially in the house he designed for Count Kessler in Weimar (1903), where the smoothed curves of his furniture, now white-enamelled, like Mackintosh's, har-

The relations between form and ornament can only be complementary. Line takes charge of evoking these complements whose form is still unprovided but whose presence we feel to be indispensable. These relations are structural relations, and the task of line, which establishes them, is to suggest the striving of an energy.

Henry van de Velde, Formules de la beauté architectonique moderne, *1917.*

Now attributed to **O.E.G. Voigt**:
Chocolate service designed for the Meissen Factory, c. 1905. Porcelain with underglaze decoration.

Henry van de Velde (1863-1957):
Dining room in the house of
Harry Graf Kessler, Weimar, 1902-1903.

its style on the totality of a production. There henceforth lay the central question, the highest stake of Art Nouveau, the condition of its survival.

The contradiction, painfully experienced by Van de Velde, was overcome by Behrens; but at the cost of a change of system and a shift in concepts, which, precisely, makes it no longer possible to speak in his regard of Art Nouveau in the pre-war years. Appointed general artistic adviser to the AEG (General Electric Company) in Berlin in 1907, he was the classic Werkbund man par excellence. And in designing the totality of his firm's productions, from posters to lamps and the buildings of the biggest factories, he indeed seemed to remain as well the classic artist-architect of Art Nouveau. But the attentive study of classical models (of Tuscan Romanesque in particular) led him to shift the essential part of his research onto the character of the form and the establishment of a typology.

The celebrated AEG Turbinenfabrik, in 1909, provides its exemplary end result. Here there would remain the functional character, modern material, personal and original design of Art Nouveau. But all these were made subject to the powerful outline of a "representative form" in which they tended to get forgotten: on the gable the great steel and glass window became *first of all* the forepart of the building, "crowned" by a pediment bearing the monogram of the firm. The "will to power," already noticeable in the Darmstadt house or the Turin hall, now completely took over the "will to art." Behrens' success rested on the power of the firm, whose size he magnified by the invention of form, and more generally on the economic power of Germany at the time. And Le Corbusier, on leaving Behrens' Berlin office in which he had worked five months, in 1910, acutely observed: "Behrens is the

Henry van de Velde (1863-1957):
▷ Watercolour design for the front of the
 Louise Dumont Theatre, Weimar, 1903-1904.
▽ School of Art (Kunstschule), Weimar, 1904-1911.

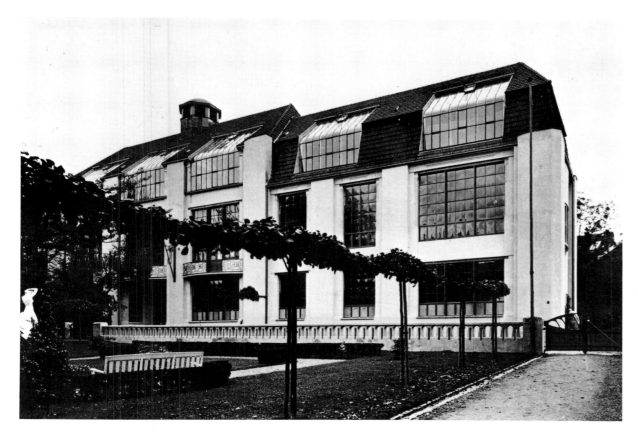

monized beautifully with the arabesques of his friend Maurice Denis. But to the end Van de Velde remained faithful to the theory of line, laid down since 1902 and revived once more in his *Formules de la beauté architectonique moderne*, published in French in Weimar in 1917. "Ornament completes form, of which it is the extension, and we recognize the meaning and justification of ornament in its function! That function consists in 'structuring' the form and not in 'adorning' it... The relations between this 'structural and dynamographic' ornament and the form or surfaces must appear so intimate that the ornament shall seem to have 'determined' the form!" These telling formulas which take us right to the heart of Art Nouveau seem nowhere better applied than in those superb pieces of Meissen porcelain of about 1905, today indeed no longer attributed to Van de Velde himself, but proving at once the validity of the system separate from its author, and the possibility of its application to industrial production.

Responsive to recent inventions, Van de Velde also knew how to assimilate them. Hoffmann's marble facings are found in the Hohenhof, the house Van de Velde built for Osthaus in Hagen, in 1908; and they lend themselves to a general denuding of ornament indebted to the severe classicism of Behrens. Even the external ironwork of the Horta House and the glazed framework of the People's House by his old enemy Horta are found again in Van de Velde's handsome plan for the Louise Dumont Theatre in Weimar in 1903-1904. In the same city, between 1904 and 1911, the School of Art adopted the wide windows of Glasgow without giving up discreet roundings off in the volumes and ironwork in the central section that recall the parallel development of Sauvage in the Majorelle building in 1913. But this "synthesis of art" also remains marked by the personality of a moderate but still dynamic and sensuous line.

In the Weimar School of Decorative Arts which he built opposite the School of Art, Van de Velde ran an institute which "was the first experiment, in Europe, with an art school whose programme *systematically prohibited* the study of styles, repudiated every model and appealed, *without any other preparation*, to the innate faculty of invention, governed by the logic of the most rational conception of all things," (Van de Velde, *La Voie Sacrée*, 1933).

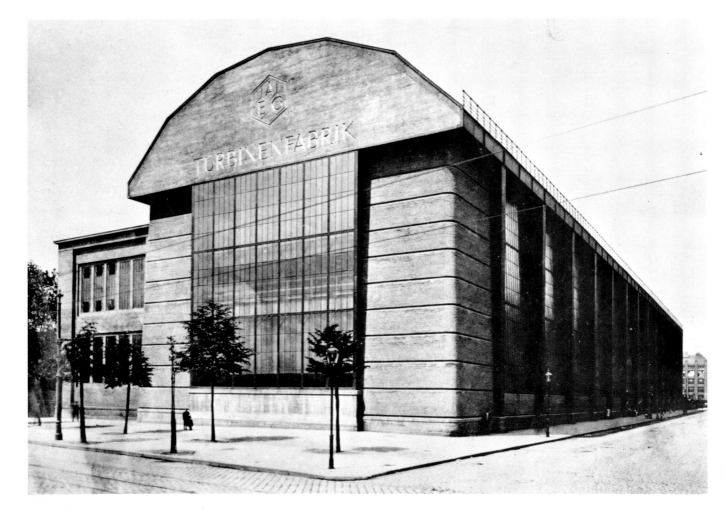

Peter Behrens (1868-1940):
AEG Turbine Factory, Berlin, 1909-1910.

*We do not want an aesthetic whose rules arise out of a romantic reverie,
but an aesthetic which rightly takes its place in the vast movement of life. We do not
want a technique either which goes its own way, but a technique whose spirit is receptive
to the artistic will as that will appears at any given time. It is in such terms as these
that German technique and art will move towards one goal: the power of the German
nation recognizable in a material wealth spiritualized in polished forms.*

Peter Behrens, "Kunst und Technik,"
lecture of 1910 reprinted in Der Industriebau, 1910.

The activity of Behrens and the radicalization of the positions of Muthesius, however, were not to permit any further prolongation of ambiguities. The crisis burst into the open at the Werkbund Exhibition in Cologne in 1914, which in many respects put finis to the history of Art Nouveau. In the famous polemic which pitted him against Muthesius, who for his part advocated standardization *(Typisierung)*, Van de Velde once more defended the individual point of view: "As long as there are artists in the Werkbund... they will stand opposed to every fixed canon and to standardization. The artist is essentially a passionate individual, a spontaneous creator. He will never voluntarily submit to a discipline which forces upon him norms and canons."

Alongside the neoclassicizing constructions, each in his own manner, of Hoffmann and Behrens, and alongside the glass pavilion of Bruno Taut, who redirected materials towards expressionistic effects, it was nevertheless the buildings of Van de Velde and Gropius that best epitomized the stake of the moment, and the fact that for the former it was a theatre and for the latter a factory (with its administrative buildings) was already in itself highly significant.

In the Werkbund Theatre was concentrated all Van de Velde's faith, and into it also went everything that had missed success in the disappointing experience of the Théâtre des Champs-Elysées

(1910-1911), taken over by Auguste Perret for his own benefit. It was a rational and innovative conception, with an amphitheatre for an auditorium, a proscenium, a circular "horizon" (or "distant wall"), and especially the three-part stage, the principle of which would be revived by Van de Velde at the Paris Exhibition of Decorative Arts in 1925; a discreet and integrated ornamentation; and on the outside a continuous and massive form that, with succeeding projects, shed its Viennese borrowings to keep only the Van de Veldean line: a form at first sight disconcerting, but which in fact expressed, like the Greek temple, "by curves and suggestive bulges the drama of weight bearing on materials that resist to an extent of which the moment is determined by an informed sensibility" (Van de Velde, *Formules de la beauté architectonique moderne,* 1917).

For material, Van de Velde then pinned his hopes on reinforced concrete, not in imitation of Perret (or even of Hoffmann in the ceiling of the Purkersdorf refectory, with its right angles and form-work left rough), but because this low-cost process, already suggested in the Champs-Elysées theatre, "connects these reinforcements embedded in cement with the skeleton clothed in flesh, with the forms and the characteristic and individual features of man and various animals," as he wrote further in the *Formules*: an amazing reunion with the definition of decoration given by Viol-

let-le-Duc in the fifteenth *Entretien*! But in 1914 the comparison began to date: in Gropius' project for the Chicago Tribune building in 1922, reinforced concrete would return to rectangularity, along with other subtleties, but far from those feline undulations. And after 1914, as a matter of fact, Van de Velde was above all a committed spectator.

In the courtyard front of his Werkbund office building, Gropius, who more systematically readopted the course he had followed for his Fagus factory in 1911, did, precisely, just the opposite and put glass on display: on set-back columns it projected forward and even, on the sides, beyond the limits of the building the idea of a continuous and abstract space, drawing fully upon the latest discoveries of painters and expressing the very negation of the enclosed form. There was nothing more here, either, of the emblematic solemnity of Behrens; and no trace left of the architect's heavy and opaque "hand." To the powerful tomb of the showcase-theatre replied the ideal transparency of this simple working instrument turned wholly towards light and the future.

Gropius himself, whom Van de Velde put forward along with Endell and Obrist to succeed him in his art school at Weimar, would stress continuity rather than rupture with the past. In the booklet he published in 1923 on "the conception and realization of the Bauhaus," Gropius insisted on what he owed to the long tradition of his Art Nouveau predecessors, citing Ruskin and Morris, then Van de Velde, Olbrich, Behrens, and finally the Werkbund. But the division is undeniably present: between abstract space and the line of Van de Velde which "takes its force from the energy of the hand that traced it," between that indifference to the values of representativeness and the assertive power of Behrens; between that spareness of ornament and the decorative refinements of the Viennese; and even between that organizing intelligence to which nothing is alien and the separation that Loos once more laid down between the beautiful and the useful.

That Gropius' architecture and what it heralded was also dependent on a utopia is another story. What matters is that, as in all the major movements in the history of styles, a new physical and social space came into play. By 1914 Van de Velde had come to believe only in the virtue of individuals. Gropius already hoped that a collective reconstruction of a better world would be possible once the slate had genuinely, this time, and oh how painfully, been wiped clean. That really marked the end of Art Nouveau.

Walter Gropius (1883-1969):
Office building at the Werkbund Exhibition,
Cologne, 1914 (destroyed). View from court.

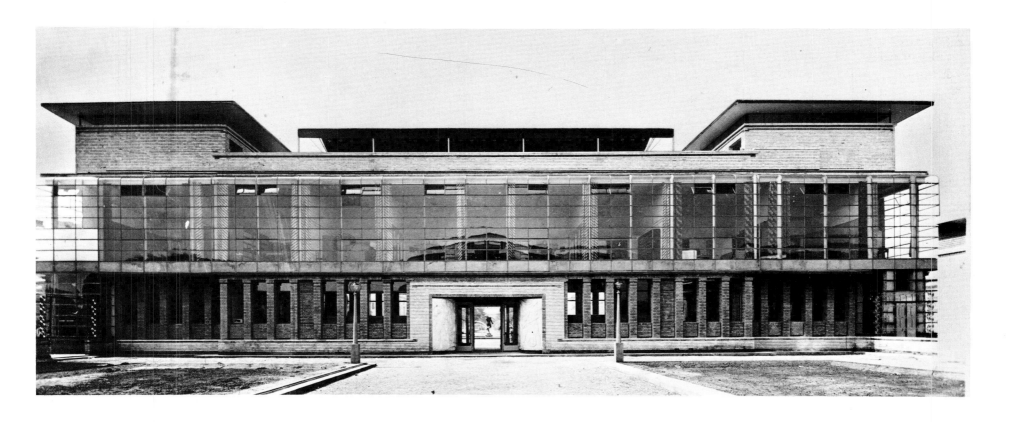

The End and the Future of an Illusion

The span of Art Nouveau must be seen as ranging from 1870 to 1914: these four and a half decades cover the whole of its exemplary path. It cannot be confined to the short period between 1895 and 1902, when a superficial fad created as it were a froth on the crest of its powerful wave. It has too often been regarded as a mere transition between the historicism of the nineteenth century and the functionalism of the International Style which gradually asserted itself after the First World War. It was thought to have permitted, first, a break with the past; to have made possible, for others, the conquest of our modernity.

Such was the sense of Le Corbusier's famous words in 1929: "Towards 1900, a magnificent gesture: Art Nouveau. We shook off the outworn toggery of an old culture." A partial and reductive interpretation, partly explained by the context. This pioneering movement must be accorded its full value as a specific and unique moment, between the golden age of systems and that no less deceptive one of false certainties: the age of the finest of utopias; the one that believed in the regeneration of the world through style and the invention of new forms—which was not quite the case either before (when content carried a decisive weight) or after (when form, until recently, resulted less from design than from a setting in order).

Odilon Redon (1840-1916):
Portrait of Violette Heymann, 1910.
Pastel.

The works of Horta, Mackintosh, Wagner, and to a certain extent Gaudí, do not constitute a simple stopping-place on the road allegedly leading straight from Van de Velde to Gropius or Le Corbusier; such was the thesis once brilliantly argued by Sigfried Giedion and widely accepted since. No, they form complete and homogeneous ensembles that contain their ends and explanations within themselves. And ornament with them is not an adventitious element which may simply be eliminated in order to go on to the next phase. The challenging of the International Style has, on this point, helped us to stop separating the top and bottom parts of Sullivan's Carson, Pirie & Scott building or Mackintosh's architecture from his furniture.

Later Van de Velde tried to resituate this "desire for a style" in the broader framework of the "tradition of the eternally new": "Thus, since humanity's beginnings, 'the new' has followed the new, and each new link was welded on to the chain of the great family of pure, sovereign, new and eternal forms" (*Le Nouveau*, 1929). But, despite the conviction of the apostle, the demonstration is not wholly convincing: formalism, too, has its history.

Even in what it undertook to do, Art Nouveau was divided between two conflicting aims that would finally bring about its downfall: the hope which it placed in the creative power of the artist's hand, as the inventor of new forms, and its desire to accede to mass production, implicit in its plan for social reform. This indispensable outlet to the market-place in fact could only lead to an industrial standardization which was the very negation of the "will to art" or, on the contrary, to a vulgarization of forms and a degradation of values in the "1900" imagery or knick-knackery that for a long time would tarnish its memory.

Withdrawn into herself, Danaë thus could not help dreaming of the golden rain: the rain that the Wiener Werkstätte hoped for and did actually receive from their rich clientele. Meanwhile, at the other extreme, the virtuous isolation of single artists contented itself with the rain of flowers watched open-eyed by Violette Heymann as portrayed by Redon. "Art takes nothing from philosophy, and has no other source than the soul in the midst of the world surrounding it. Its essence is unknown, like that of life; and its ultimate purpose is art itself," wrote Redon in his diary the year before he did this pastel. But the Art Nouveau artist had to be converted to the world, and that was just the reason, for more than one, why they turned away from painting. Where, then, lay the purpose of art?

The system of patronage made it possible for too long to put off really answering the question. In Brussels, Glasgow, Vienna, Weimar, and even down to the sixteenth arrondissement in Paris, a section of the liberal bourgeoisie saw in the artists' way of proceeding at worst the warrant for its own progressivism, at best a convergence of ideals. Or of utopias, rather, which the remorseless series of economic and political mechanisms was to undermine in 1914. The failure of Art Nouveau did not arise, as too many narrowly formalist analyses would have one believe, from the tiredness of forms, the death throes of style: it lay, above all, in the rise of nationalism and the sharpening of the class struggle, in the failure of liberal individualism. And that was also one of the reasons why Van de Velde, who descended from Van Gogh, remained, over and above the successes of his own work, the model figure of this secular and ultimately vain conversion.

It was also why the architects, who had been the main actors, were also the main losers. Their end was a sorry one, for it necessarily meant, for Horta, Guimard or Mackintosh, self-confessed bankruptcy, repudiation or silence. And Van de Velde himself after 1914 would be above all a "committed spectator." Starting from "drawing," it was finally in painting that Art Nouveau, after fine detours through architecture, ceramics or furniture, preserved its virtue to the end, in Klimt, Hodler—or Redon. And Adolf Loos was undoubtedly right on this point in being the first to expose the great illusion: what was right for painters was not so for architects; the work of the studio in search of "the ultimate purpose of art that is art itself" had nothing to gain by projecting itself into the life of the city.

Yet the illusion had a fine future. Gropius started it up again, in principle on new foundations, and this time entirely under the banner of architecture. But he continued in fact to follow the painters' example, even though it was now the new painting and a different kind of space—that opened up in 1907 by the *Demoiselles d'Avignon*. And again it was to the painters that Gropius entrusted the destinies of the Bauhaus. At the same time, and until an inevitable conjunction, Mondrian and his disciples believed it was possible to extend over the entire social sphere the principles of a pictorial meditation on the essence of art and the world. If Art Nouveau opened the door to contemporary art, it actually did so under the banner of the great utopia dear to Kandinsky. The beautiful dream of Danaë before her golden rain or the equally selfish contemplation of Mademoiselle Heymann before her rain of flowers, also marks the renunciation of the chimeras of this "revolution of aesthetes" (Nikolaus Pevsner): "the soul in the midst of the world surrounding it" had other ways to make us share its pleasures.

Gustav **Klimt** (1862-1918):
Danaë Visited by Zeus
in a Shower of Gold,
1907-1908. Oil.

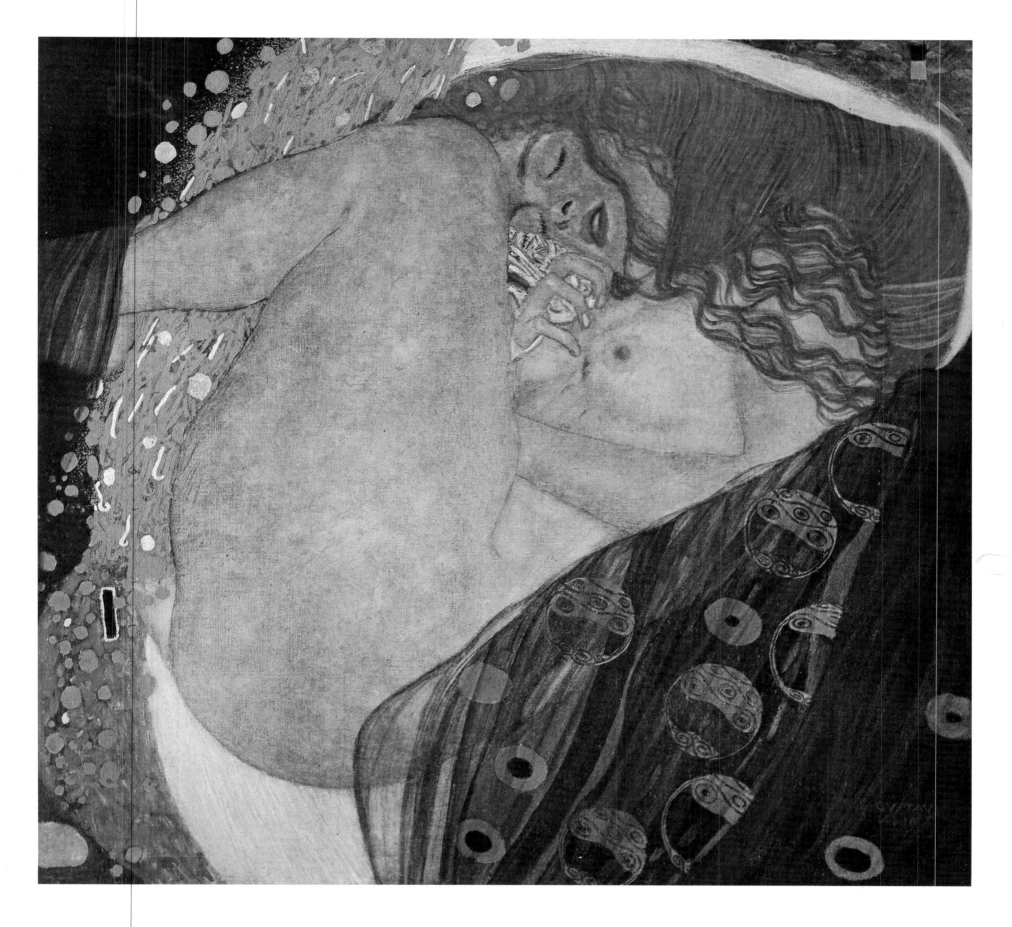